PAINTINGS BY OLD MASTERS
AT CHRIST CHURCH · OXFORD

PHAIDON

PAINTINGS BY
OLD MASTERS AT
CHRIST CHURCH
OXFORD

CATALOGUE BY J · BYAM SHAW

PHAIDON

© 1967 BY THE GOVERNING BODY OF CHRIST CHURCH · OXFORD

PUBLISHED IN GREAT BRITAIN BY PHAIDON PRESS LTD · 5 CROMWELL PLACE · LONDON SW7

US DISTRIBUTORS · FREDERICK A. PRAEGER INC · 111 FOURTH AVENUE · NEW YORK · NY 10003

GB STANDARD BOOK NUMBER 7148 1315 X

US LIBRARY OF CONGRESS CATALOG CARD NUMBER 67–29887

MADE IN GREAT BRITAIN

TEXT PRINTED BY R. & R. CLARK LTD · EDINBURGH

PLATES PRINTED BY HENRY STONE & SON LTD · BANBURY · OXON

CONTENTS

PREFACE

by the Dean of Christ Church

THE first critical catalogue of the paintings at Christ Church, then known as the 'Library Collection', was prepared by Tancred Borenius and published in 1916. In 1957 Sir Roy Harrod, at that time Curator of Pictures, called the attention of the Governing Body to the fact that the book was out of print; and it was decided to sponsor a new catalogue under his guidance. To find a scholar to prepare it was a difficult matter. Ours is not a very large collection, but it covers a varied field. The task of sifting the massive amount of new evidence and opinion that had accumulated during a half-century of great activity in the discipline of art history called for a rather rare combination of qualities. Mr. James Byam Shaw's qualifications need no comment or commendation from me. The House was fortunate indeed that he felt able to accept the invitation of his old College to undertake the work.

This work had at first been conceived in the far too modest terms of a spare-time occupation. I would like to record here the gratitude of the Governing Body to Messrs. P. and D. Colnaghi, who in 1964 agreed to release a substantial amount of Mr. Byam Shaw's time in order to expedite the completion of the catalogue, so that its publication would coincide with the transfer of the Collection to the new art gallery made possible by the generous benefaction of Mr. Charles Forte.

The 'Library Collection', the growth of which is traced in Mr. Byam Shaw's Introduction, has now become the 'Gallery Collection' and enters upon a new and, we hope, an even happier phase of its history in a building specially designed for its care and display; and it is fully recorded, so far as the paintings are concerned, in this volume. It is our hope that by the provision of the catalogue and of the gallery we have made some worth-while contribution not only to the needs of scholars in art history but to the education of Oxford men and women and to the enjoyment by a wider public of the treasures in our care.

One urgent task remains. The Collection includes a very important corpus of some 1800 drawings by old masters, which are increasingly used by scholars throughout the world but have never been adequately catalogued. It will inevitably be some years before this need can be fully met but I am able to report that, as I write these words, the work has begun under the direction of the present Curator, Mr. Daniel Bueno de Mesquita.

September 1967 C. A. SIMPSON

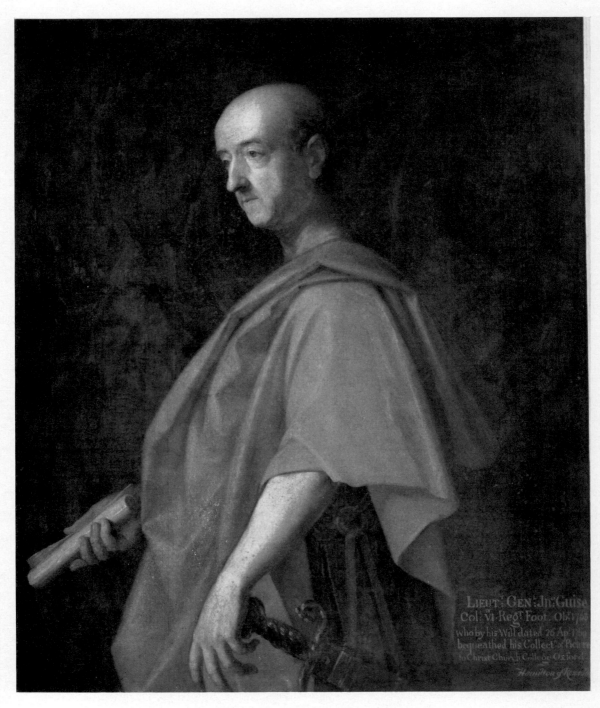

General John Guise in the dress of a Roman General. By Gavin Hamilton.
In the possession of Sir Anselm Guise, Bt., at Elmore Court

INTRODUCTION

THE collection of paintings by old masters formerly in the Library at Christ Church – as distinct from the portraits in Hall, which have been described in Mrs. Lane-Poole's *Oxford Portraits* and are not included in the present catalogue – derives for the most part from four benefactions: the bequest of General John Guise in 1765; the gifts of the Hon. W. T. H. Fox-Strangways in 1828 and 1834;[1] that of Miss C. E. Landor and Miss Duke, great-nieces of Walter Savage Landor, in 1897; and the bequest of Sir Richard Nosworthy in 1966. Some important works are among the exceptions: the two portraits attributed to Scorel (nos. 235, 236) bequeathed by Dr. Stratford, who died in 1729, thirty-six years before General Guise; the large *Continence of Scipio* by Van Dyck (no. 245) presented by Lord Frederick Campbell in 1809; and the panel by the Master of Delft (no. 232) presented by Dr. Vansittart in 1833.[2] Of sixty paintings, representing the cream of the collection before the accession of the Nosworthy bequest, that were lent in 1964 for two years to the Walker Art Gallery at Liverpool, twenty-six were from the Guise Bequest, fourteen from Fox-Strangways and fifteen (of which nine were fragments of the same panel) from Miss Landor and Miss Duke; but of the 266 numbers catalogued here, a large majority came from Guise.

★ ★ ★

GENERAL JOHN GUISE General John Guise (1682 or 1683–1765) was the son of William Guise of Winterbourne in Gloucestershire, and second cousin to Sir John Guise, third Baronet of Elmore.[3] Having matriculated at Gloucester Hall on July 6, 1697, and again (for some unexplained reason) at Merton College on July 12, 1698, and having been admitted a student of the Middle Temple in 1700, he took his degree of B.A. from Christ Church on March 20 1701 (1702 N.S.), and became Captain and Lieutenant-Colonel[4] in the First (or Grenadier) Regiment of Foot Guards on April 9 1706. He was present at the battle of Oudenarde in 1708,[5] was probably serving with the Duke of Ormonde in 1712, and commanded seven companies of the Grenadiers in the Vigo Expedition of 1719. In 1741 he was on service in the West Indies, and distinguished himself in the attack on the forts at Cartagena. In 1738 he had become Honorary Colonel of the Sixth Foot,

1. For the second gift of Fox-Strangways, see W. G. Hiscock, *A Christ Church Miscellany*, 1946, p. 78. This explains the absence of certain Fox-Strangways pictures from the 1833 Catalogue.

2. The fragment of a supposed Raphael cartoon (Borenius 78), presented by Miss Anne Cracherode in memory of her brother in 1799 or 1800, is now classed as a drawing (with the three companion pieces from the Guise Collection), and will be included in the appropriate catalogue.

3. Soon after this baronetcy became extinct in 1783, the General's nephew John (1733–94), son of his elder brother, became the first baronet of Highnam, also in Gloucestershire – a property acquired in 1837 by another well-known collector, Thomas Gambier Parry. It is from Sir John that the sixth and present

baronet of the second creation, Sir Anselm Guise, is descended, though his seat is at Elmore.

4. So described in the Nominal Roll of Officers which appears as Appendix H of Sir F. W. Hamilton's *Origin and History of the First or Grenadier Guards*, 1874 (vol. III, p. 441). This appellation no doubt indicates that the officer in question had purchased a Lieut.-Colonel's commission without previous service in any other rank. In February 1720, George I attempted to correct such abuses of the purchase system by ruling that an officer could only purchase the rank immediately above his present one (Hamilton, *op. cit.*, vol. II, p. 73).

5. He is listed (as 'Lieut.-Col. John Guise') among the 'captains of companies of the First Guards' battalion' (Hamilton, *op. cit.*, vol. II, p. 28).

which regiment took part in the Scottish campaign of '45; and in 1753 he was appointed Governor of Berwick. His further promotions were: Major-General, January 1 1742; Lieutenant-General, 1745; General, 1761. His death is recorded in *The Gentleman's Magazine* (vol. XXXIV, p. 299) on June 12 1765: 'Gen. Guise, Col. of the 6th R. of foot, and governor of Berwick'.[6]

Guise was evidently well known to the celebrated antiquary George Vertue, who was nearly his contemporary (1684–1756). In notebooks of 1724 he gives some account of 'Coll. Guise' as the patron and promoter of the colour-print factory of Jakob Christoffel Le Blon, of which I shall have more to say below;[7] and has also a note on his collection: 'Colonel Guise, a great Lover of painting & Conoisseur, as by his fine collection may be seen. He seems to have an excellent Taste collecting those peices of the greatest Italian Masters only, & chiefly pictures in their best manner, Sparing no price when they are excellent, equal to those of the greatest Fortune here. Many of these paintings he has bought himself in foreign parts & brought over. Besides these he has a fine collection of drawings of the Italian Schools. Amongst the many fine pictures which all the virtuosi visit they much admire a fine picture by Salvator Rosa, a fine Poussin, a Claude Lorain, a Rubens, landskips, figures of Parmigione, a noble and most Valuable picture by Domenichino, many others of high price, & also a head finely painted by Rubens on board which I take to be Ben Johnson, a Madonna & Child painted at large by Le Blond; it is in imitation of Rubens or Vandyck, by much not so good.'[8]

In February 1724 Vertue gives credit to 'Coll. Guise' for some information on the early provenance of the cartoon attributed to Raphael, *The Massacre of the Innocents*, of which the General himself acquired three fragments thirty years later at Dr. Mead's sale.[9] In recording the visit of the painter Antoine Pesne to England later in the same year, to make portraits of Frederick Prince of Wales and the young Princesses, Vertue adds that Pesne also made one of Colonel Guise, 'much more approved

6. The dates of his promotions were kindly checked for me by Colonel Francis Jefferson, Lieut.-Colonel commanding Grenadier Guards, from the regimental records. He was promoted 2nd Major in 1724, Major (Field Officer) in 1727, 1st Major in 1729 and Lieut.-Colonel on July 5, 1735. Guise's contemporaries were apparently not particular about his rank: George Vertue refers to him as Colonel Guise in notebooks of 1722 and 1724 (Walpole Society, Vertue, I, 128 and III, 10, 17 and 20). But it must be observed that in the Army List of 1761 (as Col. Jefferson has pointed out to me) his promotion to Colonel is dated July 7 1724 – inexplicably, unless this is a confusion with his cousin John Guise, afterwards fourth baronet of Elmore, who was also a Colonel in the Brigade of Guards. For other details, see H. Manners Chichester in the *Dictionary of National Biography*, and Hamilton, *op. cit.*, vol. II, pp. 28 and 71.

7. Walpole Society, Vertue, III, 10. See *Excursus* on pp. 21 ff. below.

8. Vertue III, 17. I have rationalized the punctuation for the sake of clarity. Of the pictures to which Vertue refers, the Rosa is no doubt no. 223 (*Erichthonius*), the 'Poussin' probably no. 147 (by Codazzi), the 'figures of Parmigione', nos. 168–171 (by Bertoia), and the Domenichino perhaps one of the two landscapes, no. 196 or 197. The others are no longer in the collection. The Claude may have been sold or given by the General to Frederick Prince of Wales, for though it was engraved by J. Mason in 1744 as in the Guise Collection, it is now in Buckingham

Palace (Röthlisberger, *Claude*, 1961, I, p. 525 and II, fig. 341). The Madonna and Child is very probably the picture now belonging to Sir Anselm Guise at Elmore Court, which is mentioned in the *Library of the Fine Arts*, vol. IV, 1832, as one of two relinquished to John Guise (the General's nephew) by Christ Church in 1767 'somewhat as a peace offering' (see below, pp. 8–9) and now belonging to his descendant. This picture was once attributed to Van Dyck and is in fact an imitation of his style such as J. C. Le Blon might well have painted (see *Excursus* below, p. 21). In the privately printed catalogue of the Elmore pictures, compiled by Sir W. B. Guise Bt. (1880), it is said to have been 'claimed by the family as a portrait of Guise's wife and child, family portraits being exempt from the bequest'. This must be fanciful, since so far as we know the General was not married; but there may have been some sentimental history attached to it. Certainly the other picture relinquished by the House was a family portrait – of the General himself by Gavin Hamilton (see reproduction on p. 2).

9. Vertue, I, 36 and 128. The largest fragment of this cartoon, for the tapestry of the Scuola Nuova in the Vatican, is now in the Coram Foundation for Children at 40 Brunswick Square, London (formerly the Foundling Hospital). The three Guise fragments (heads only) are included among paintings in Borenius' Christ Church Catalogue together with the one presented by Miss Cracherode (Borenius, 78–81); but these are now classified as drawings.

on than those other pictures'.[10] Elsewhere he mentions that Guise owned a portrait of Edmund Spenser;[11] and on a visit to Wilton in 1731, he says that the Italian Gamberini, having engraved a section of the Wilton Collection, is likely to engrave other English collections, including that of 'Coll. Guy' – by which he probably means Guise. Finally, in later notebooks, Vertue suggests that the General (as he was from 1742 on) was one of the favourite advisers on artistic matters of Frederick Prince of Wales. Describing a visit to Leicester House, he notes that the Prince has taken Joseph Goupy into his favour . . . 'and uses his advice & Sʳ Luke Schaube in most of the purchases of pictures with Genˡ. Guise – &c'; and in 1749, not long before the Prince's death, in praising him as a patron of the arts, Vertue particularly mentions again Sir Luke Schaub, General Guise and Goupy, with George Knapton, as those with whom His Royal Highness conversed freely on painting.[12]

Guise is also referred to several times in the correspondence of Horace Walpole, chiefly in letters to Sir Horace Mann, who was British Resident in Florence 1760/85 and himself related to the General.[13] On July 7, 1742, he wrote to Mann from London: 'Your relation Guise is arrived from Carthagena, madder than ever. As he was marching up to one of the forts, all his men deserted him; his Lieutenant advised him to retire; he replied "He had never turned his back yet, and would not now", and stood all the fire. When the pelicans were flying over his head, he cried out: "What would Chloe give for some of these to make a pelican pie!" When he is brave enough to perform such actions really as are almost incredible, what pity it is that he should for ever persist in saying things that are totally so.'[14] To the transcript of this letter, Walpole added the note: 'General Guise, a very brave officer but apt to romance, and a great connoisseur in pictures. (He bequeathed his collection of pictures, which is a very indifferent one, to Christ Church College, Oxford.)' In a letter of April 2–3, 1750, Walpole refers to Mann's relationship to the General: 'Your genealogical affair is in great train . . . General Guise has been attesting the authenticity of it today before a Justice of the Peace';[15] and from Strawberry Hill on August 1 1760, reporting to Mann the arrival in London of the younger Baron Stosch, nephew and heir of the celebrated collector Philipp von Stosch, who had lately died in Florence,[16] he concludes his letter: 'I forgot to tell you that Stosch was to dine with General Guise. The latter has notified Christ Church Oxford, that in his will he has given them his collection of pictures.' To this he subsequently added: 'General Guise did leave his collection as he promised; but the University [sic] employing the son of Bonus, the cleaner of pictures, to repair them, he entirely repainted them, and as entirely spoiled them.'[17]

10. Vertue, III, 20. This portrait has disappeared.

11. Vertue, I, 58. Not traced. But it is interesting that a portrait of Spenser is among the subjects engraved in colour-mezzotint by Guise's *protégé* J. C. Le Blon. See *Excursus* on p. 22 below, and Singer, cat. of J. C. Le Blon, no. 44.

12. Vertue, III, 152 and I, 14.

13. Mann's mother, Eleanor Guise, was the General's first cousin.

14. Walpole *Letters*, Toynbee ed., 1903, I, pp. 250–251. A 'pelican' was a kind of shot. Chloe, according to Walpole's own note, was the Duke of Newcastle's cook. The story was repeated by Walpole in another letter to Mann dated from Arlington Street October 6, 1754; and he there adds: 'I have heard Guise

affirm that the colliers at Newcastle feed their children with fire shovels' (*op. cit.*, III, pp. 254–255).

15. *Op. cit.*, II, p. 442.

16. The younger Stosch's name was properly Muzel, but he seems to have assumed that of his uncle. Walpole wonders if he had come to London to sell his uncle's collection.

17. *Op. cit.*, IV, p. 413. Mr. Brinsley Ford kindly drew my attention to this. On the condition of the Guise pictures, see below, p. 12. The author of the notice of the Guise Collection in the *Library of the Fine Arts*, IV, 1832, repeats the story of the activities of the German restorer Bonus, but very fairly adds: 'This circumstance having been generally known, the public voice was turned to disparagement instead of former fame; yet with no small injustice as to the Collection in general.'

These personal accounts are filled in to some extent by other writers, whose sources of information we do not know, long after the General's death. Dallaway, in his *Anecdotes of the Arts in England*, 1800, says that he 'served under Field Marshal Wade, and acquired a love of painting from him', and that he was much patronized by the Duke of Cumberland;[18] while the anonymous author of an article on the Guise Collection at Christ Church in the *Library of the Fine Arts*, vol. IV, 1832, adds that the collection 'was formed during a long residence on the Continent and especially at Rome'. This confirms to some extent the contemporary account of George Vertue (see above, p. 4).

There is in the Victoria and Albert Museum a manuscript record, probably compiled by Richard Houlditch and his son, of sales of pictures held in London between 1711 and 1760, in many cases with prices and buyers' names,[19] which is of considerable interest in this connexion, since the period covered is almost exactly that of General Guise's life as a collector. Where the buyers' names are recorded, I have come across that of Colonel or General Guise in more than a score of sales between 1722 and 1758, predominantly in the years about 1750. Yet only in one or two cases did he buy more than one lot,[20] and generally he expended very small sums.[21] In fact, of the thirty-odd paintings recorded as his purchases in the Houlditch manuscripts during these years only about half seem to have remained in his collection and those, with one exception, were of trifling importance. The exception was Carracci's *Virgin of Bologna* (no. 183), which we know from another source[22] was bought at Sir James Thornhill's sale 1735, and was in fact there knocked down to the dealer Bacon. It seems therefore likely that most of the best pictures in the collection, the provenance of which is unknown, were acquired by the General on the Continent and imported into England, as was stated by Vertue and the anonymous writer in the *Library of the Fine Arts*. That he should frequent the London sale rooms at a period when the market for old masters here was greatly developing, and when this was one of the most fashionable diversions of the nobility and gentry,[23] is natural enough, but his most advantageous purchases, we may guess, were made, or had already been made, elsewhere. One of the Christ Church pictures (no. 239, then attributed to Peruzzi) still bears the signature on the back of the panel of the distinguished French collector Pierre Crozat; and the inscription on the back of a small monochrome head (no. 208, probably Bolognese of the XVII century but then attributed to Titian) suggests that General Guise was still importing pictures at the very end of his

18. His service brought him in contact with Wade at the time of the Vigo Expedition, 1719, which Wade commanded, and with the Duke of Cumberland, no doubt, in the '45 Rebellion.

19. These MS. volumes were first described by Frank Simpson in a valuable article in the *Burlington Magazine*, vol. 93, 1951, p. 355 *ss*. See also *ibid*., vol. 95, 1953, p. 39 *ss*. It was Mr. Simpson who first drew my attention to the occurrence of General Guise's name among the recorded buyers.

20. In one of Pariss's sales of 1738 he bought a pair of flower subjects by 'Vogilier' (probably Karel van Vogelaer, called Carlo dei Fiori), in the Earl of Orford's sale of 1751 a pair of large Solimenas, and in one of Dr. Bragge's sales in 1750 he bought seven pictures in all. None of these can now be traced at Christ Church.

21. The highest prices among those recorded as paid by General Guise in the London salerooms were £100 for a Cignani of 'Our Saviour and Joseph' at Cock's in 1744, and £43. 1. 0 for a G. C. Procaccini, 'The Virgin our Saviour and St. John', in Major's sale, 1751; besides £53. 11. 0 paid presumably on his behalf by the dealer Bacon for Annibale Carracci's *Virgin of Bologna* at the Thornhill sale of 1735.

22. Dallaway, *op. cit.*, p. 491.

23. In the Houlditch MSS., among the buyers' names, we find those of Frederick Prince of Wales, nine dukes, and more than thirty other peers, besides many other fashionable collectors, ladies as well as gentlemen. Presumably they attended the auctions in person, mingling with the dealers whose names so frequently occur.

life. The fact that he owned seven pictures from the collection of Charles I[24] certainly does not imply that he bought them in England.

Nor was his taste, perhaps, exactly that of the fashionable English amateur of the middle years the of XVIII century. It is true, as Borenius says, that he had a conventional respect for the Italian schools of the High Renaissance and the *Seicento*, particularly for the great Venetians, and this meant the inclusion in his collection of a large number of pictures of common religious subjects – the Nativity, the Adoration of the Shepherds, *etc.* – if they were the work, or supposed to be the work, of the great masters – Leonardo, Raphael, Titian, Tintoretto, Veronese. Of these, in the fashion of the time, he would buy copies rather than leave them unrepresented – for we need not suppose that he believed his small versions of Titian's Pesaro altarpiece, or Raphael's *Transfiguration*, for instance, (nos. 82, 130) to be anything but copies.[25] But as Mr. Frank Simpson has pointed out, in reference to the Houlditch manuscripts,[26] it was a time when certain Flemish and Dutch masters of the XVII century – Jan Brueghel, Teniers, Ruysdael, Metsu, Dou, Van Goyen, Both and Wouwermans – were eagerly collected in England, and these, it would seem, did not appeal to Guise at all;[27] nor does he seem to have been interested in the comparatively modern French masters – Watteau, Lancret, Pater, Chardin – who were already popular in England before the middle of the XVIII century, and whose works often appear in London sales of that period. Prettiness, frivolity and bourgeois realism were apparently not for him. On the other hand the collection seems to me to reveal a certain predilection for strange, even macabre subjects. The great Carracci (no. 181) – 'A Butcher in his Shambles selling Meate to a Swiss', as John Evelyn described it – is surely an extraordinary picture to have caught the fancy of a connoisseur of that time, especially considering its size, even if Dallaway's report, that the General paid £1,000 for it, is open to doubt. The large and dramatic Salvator Rosa (no. 223), depicting the daughters of Cecrops driven mad by the sight of the monster-child Erichthonius; two paintings of Judith holding the severed head of Holofernes, one attributed to Salviati (no. 64),[28] the other by Strozzi (no. 217); a *Head of Medusa* attributed to Rubens;[29] and a small canvas of two male heads with repulsive goitres (no. 226) – these, with *The Butcher's Shop*, seem to characterize the General's peculiar

24. Six of them are at Christ Church, nos. 74, 79, 88, 132, 181 and 257 of the present catalogue. Four have the royal crown and cipher on the back of the panel or canvas. The provenance of the *Butcher's Shop* (no. 181) seems probable; that of Girolamo da Treviso's *Adoration of the Shepherds* is attested by *London and its Environs*, 1761, and *The English Connoisseur*, 1766. The seventh, called Parmigianino, 'Our Lady with the two babes Jesus and John laying hold of a Lamb, and two angels devoutly looking on them' (*English Connoisseur*, II, 53–54), may have been disposed of before his death by General Guise. No such painting by Parmigianino is known, but for the composition Mr. A. E. Popham refers me to a drawing in Amsterdam, exhibited in Paris, Rotterdam and Haarlem, *Le Dessin italien dans les collections hollandaises*, 1960, cat. no. 105.

25. Copies of such celebrated pictures sometimes fetched respectable prices in the auctions, even though they were correctly described. In Lord Halifax's sale of March 1740 were copies of Daniele da Volterra's *Descent from the Cross*, Domenichino's *Last Communion of St. Jerome* and Raphael's *Transfiguration* – the three paintings which Poussin is said to have considered the supreme

achievements in the art. All three are represented among the Guise pictures at Christ Church.

26. *Burlington Magazine*, 1951, *loc. cit.*

27. It is true that he is recorded as the buyer of certain Dutch pictures of this kind – Van der Meer, Ruysdael – in one of Dr. Bragge's sales in 1750; but they are not at all characteristic of his taste, the prices do not suggest that they were very good, and none of them seems to have remained in his collection.

28. The attributes of Judith in no. 64 proved to be a later addition, and have since disappeared in cleaning, but they certainly date from before General Guise's time.

29. This is no longer in the collection, but is mentioned in several of the early accounts, particularly in the *Library of the Fine Arts*, 1832, as 'once the Duke of Buckingham's: sold at Antwerp to Mr. Duart: the only Rubens in Oxford. It is a singularly excellent and curious picture, in its original oval frame'. The picture from the Buckingham Sale was in fact bought for the Archduke Wilhelm of Austria, and is now in Vienna; the Guise version was probably a copy of that, though the Vienna picture is not oval.

taste, and would surely not appeal to the squeamish, or indeed to the popular preference of the day.[30]

No doubt, towards the end of his career, he was considered old-fashioned by the younger generation of collectors. Horace Walpole, thirty-five years his junior, writes to Lord Nuneham some years after the General's death: 'I submit to Bassan with an *o*, but Titian*o*, I doubt, will sound too formal and in the style of General Guise.' So he appears, rather stiff and very much 'a character', in the portrait which Reynolds painted of him in old age, finished in 1757, and presented to the House by Lord Morley before the end of that century (no. 264). The earlier portrait by Antoine Pesne, which Vertue tells us was painted in England in 1724, and which might have been enlightening, has disappeared. The only other known to have been done from life, by the young Gavin Hamilton, now at Elmore, cannot be much earlier than the Reynolds: in the character of an ancient Roman, *Pretoriae Cohortis Tribunus*,[31] with shaven head and toga – that, one may guess, was a revealing little piece of masquerade. It is from that portrait, generally supposed to have been painted in Rome about 1750,[32] that the posthumous marble bust by Bacon, dated 1773, is evidently derived.

The exact number of paintings that came to Christ Church from the Guise Bequest is uncertain. According to Hiscock[33] 257 were eventually delivered, of which two were returned to the Guise family. The list of the General's pictures printed in *London and its Environs described*, 1761, during the owner's lifetime, and repeated in the *English Connoisseur*, 1766, comprises only 137; while the so-called 'A' Catalogue of 1776, the first to describe the collection in the Library at Christ Church, gives more than 260 from this source.[33a] But these numbers can only be taken as approximate, since it is certain that they include some framed drawings, and not all the works described in the early lists were still in the collection when the General died. At the same time it is evident, from the disparity between the numbers given in the early lists and those in the 'A' Catalogue of 1776, that well over a hundred paintings were acquired by Guise in the last five years of his life, after he had made his will on April 26, 1760; and it was these additional pictures that were the subject of the law-suit brought by the college in 1766 against Guise's executor Mr. Barrow, who had interpreted the will to mean that only those pictures and drawings that were already in the collection at the date of the will should be included in the bequest. The story is told by Borenius,[34] and elaborated by Hiscock.[35] Only 143 pictures were sent to Oxford on the General's death; 115 were retained in London, together with a

30. The same predilection is noticeable in Guise's collection of drawings. I refer, for example, to the large grotesque head by Leonardo, two drawings of Witches and Monsters by Jakob de Gheyn II, and a singular, not to say blasphemous, caricature of the Holy Family by a follower of Michael Angelo, perhaps Tribolo (Bell Handlist, 1914, C. 8, as Bandinelli).

31. So called in the dedication of a facsimile etching of one of the Guise drawings, by Arthur Pond, 1735.

32. But perhaps rather later. Gavin Hamilton was born in 1723 and went early to Rome, before 1748. The writer in the *Library of the Fine Arts*, 1832, says that the portrait was done in Rome, but Guise was chiefly in England at this stage in his career, and Hamilton returned there for short periods between 1752 and 1755.

33. *A Christ Church Miscellany*, 1946, pp. 77–78.

33a. According to the 1776 Catalogue (p. 13), three of the Guise pictures were hung in the Anatomy School, now called Dr. Lee's Laboratory or the Lee Gallery, which had been built in 1767, the year that the final consignment of Guise's bequest was delivered to Christ Church. They were *Leda and the Swan*, after Michelangelo (then attributed to the master), *A Sleeping Venus*, after Titian (see *Excursus*, p. 26) and *Ariadne*, half-length (unattributed). Presumably these nude figures were considered appropriate to the place. All three are now in store, in ruined condition, the third is untraced.

Dr. Paul Kent has made the interesting and plausible suggestion that Dr. Matthew Lee (1694–1755), by whose benefaction the Anatomy School was built, and who (from 1739) was physician to Guise's patron, Frederick Prince of Wales, may, like Guise himself, have shared the Prince's interest in pictures.

34. Cat., 1916, pp. 8–9.

35. *Op. cit.*, p. 77.

large number of drawings. The action of the Dean and Chapter for the recovery of these was however successful;[36] and the whole collection was re-united at Christ Church in 1767. 'Somewhat as a peace offering' (as the writer in the *Library of the Fine Arts* puts it), the portrait of General Guise in ancient Roman dress, by Gavin Hamilton, and a *Madonna and Child*, were handed over *ex gratia* to the Guise family.[37]

The present catalogue includes 184 paintings certainly, or almost certainly, from the Guise Collection; but by no means all of them are exhibited in the new gallery. Some have been placed elsewhere in the House; many of them, which are of inferior quality or in very bad condition, are in the new picture-store, where they are available to students.[38] It is true, as Borenius says, that among the Guise pictures are many copies, many that bore pretentious attributions but are in fact of little interest or value, and many in bad condition. On the condition of the pictures from this source I shall have more to say later; and the *Excursus* printed at the end of this introduction offers some explanation of the large number of copies of well-known masterpieces. In the meantime I will only say that Borenius' appraisal of the Guise Collection as a whole[39] is something less than fair. It is not true to say, of a collection that includes two fine Tintorettos, a splendid Veronese, four acknowledged works by Annibale Carracci and three Van Dycks, as well as excellent examples of Lotto, Girolamo da Treviso, Cambiaso, Strozzi, Domenichino, Giaquinto, Ricci and Zuccarelli, that it 'does not contain any works of the first importance from the artistic or historical point of view'. Cleaning has revealed the importance of some that were hitherto neglected; and taste has changed in the last fifty years, so that lesser masters of those days have become the focus of attention in these. Few of us now would subscribe to Dr. Waagen's objection to the *Butcher's Shop*.[40]

<p style="text-align:center">★ ★ ★</p>

THE HON. W. T. H. FOX-STRANGWAYS The second great benefactor of Christ Church, the Hon. William Thomas Horner Fox-Strangways, was born in 1795, the first son by his second wife of the 2nd Earl of Ilchester. He was admitted a Queen's Scholar of Westminster in 1809 and elected to Christ Church in 1813; took his B.A. degree in 1816 and became M.A. in 1820. Having entered the Diplomatic Service in December 1816, he was Secretary of Legation at Florence from 1825 to 1828, and it was in the latter year that he made his first gift of paintings to Christ Church, adding others in 1834. He was subsequently in Naples and Vienna, and in 1835 became Under-Secretary of State for Foreign Affairs. After serving as Minister Plenipotentiary to the Diet of the Germanic Confederacy from 1840 to 1849, he retired; in January 1858 he succeeded his half-brother as 4th Earl of Ilchester; and he died without issue in 1865.[41] Evidently he continued to collect early Italian paintings after his time in Florence; he presented a

36. Court of Chancery, February 6, 1767. Ambler's Reports, I, 640 (641) (1828 ed.).

37. These two pictures are still at Elmore. See above, p. 4, note 8.

38. Except for nos. 65, 85, 237 and 241, the present catalogue takes no account of the sixty-five which were omitted by Borneius and represent the missing numbers in his catalogue (see Borenius, pp. 16–17, and below, pp. 13 and 25).

39. Cat., 1916, p. 7.

40. 'A picture by Annibale Carracci, painted in a masterly manner, offended me by the vulgarity of the idea.' *Treasures of Art in Great Britain*, 1854, III, p. 47.

41. Curiously enough he is not included in the *Dictionary of National Biography*. My information is derived from Joseph Welch, *The List of Queen's Scholars of . . . Westminster . . . elected to Christ Church, Oxford*, 1852, and Doubleday and Howard de Walden, *The Complete Peerage*, vol. VII (1929).

SIR RICHARD NOSWORTHY Latest in the list of our principal benefactors is Sir Richard Lysle
 Nosworthy, K.C.M.G. (1885–1966), of whom several present mem-
bers of the House besides myself will have personal recollections. The son of Richard Nosworthy,
Chief Justice of Jamaica, he came to Christ Church as a Rhodes Scholar in 1904. He began his career
in the Consular Service in 1911, and was called to the Bar at the Inner Temple in 1921. Much of his
service was in Italy – as Consul in Turin 1922, Commercial Counsellor in Rome 1934–40, and again
in Rome as (Commercial) Minister from 1944. He was knighted in 1945, and retired in the following
year; and it was during his retirement, between 1949 and his death at the age of eighty, that he acquired
in the London market the eleven paintings that are now at Christ Church. Two are English portraits
of the XVIII century (nos. 265, 266), and one is Dutch (no. 253); the rest reflect his interest in Italy.
In the two hundred years since General Guise's time the wheel of taste had turned a circle, and Nos-
worthy's accorded rather to the taste of Guise than to that of Fox-Strangways or Landor: he preferred
the High Renaissance and the *Seicento*. The beautiful little Mazzolino (no. 157) and the two wild
landscapes by Salvator Rosa that were once in the celebrated collection of Lord Cowper (nos. 221,
222) would certainly have appealed to the General. On the other hand the landscapes by Dughet
and Vermeer of Haarlem are of a sort not otherwise represented in the gallery. Nosworthy himself,
modest and diffident as he was in proposing this bequest, would have been gratified to see how well
these pictures supplement and enhance the existing Christ Church Collection.

<p style="text-align:center">★ ★ ★</p>

CONDITION AND RESTORATION Walpole's remarks on the rough handling of the Guise Col-
 lection by the restorer Bonus, to whom the pictures were
entrusted by the Christ Church authorities soon after they received the bequest, have already been
quoted. As Mr. Hiscock has recorded,[50] no less than £450 was in fact paid by the college to a German,
Richard Bonus, who lived in Oriel Street, for the restoration of the Guise pictures between 1770 and
1773, and that he severely maltreated them is certain.[51] Not only may we suspect that his methods of
cleaning destroyed much of the original surface, but the varnishes which he used, turning the paint-
ings almost black in the course of time, have proved extremely difficult to remove even by the most
skilful modern practitioners. This blackening of the canvases, in the literal sense, from the attentions
of Mr. Bonus, reported with such malicious gusto by Walpole, contributed to a general denigration
of the Guise bequest which went beyond the bounds of justice, as the writer in the *Library of Fine
Arts* observed,[52] and was probably partly responsible for further neglect. Walpole's strictures were
repeated by later writers, until Graves and Cronin, for instance – not the best authorities on Italian
painting – in cataloguing the portrait of the General in their celebrated work on Reynolds, went so
far as to say in their biographical note on the sitter: 'He left a collection (a very poor one) to Christ
Church, Oxford'.

It is true, as a glance at the present catalogue will show, that many of the Guise pictures are so

50. *A Christ Church Miscellany,* 1946, p. 78.

51. One Bonus, probably the elder, frequently appears as a buyer in London sales of General Guise's time – for example, in the John van Spangen Sale, February 10–12, 1747/8. He was no doubt a dealer as well as a restorer.

52. See above, p. 5, note 17.

damaged as to make them impossible to attribute exactly, and practically worthless; it is also true that some which are probably or certainly by important artists are so damaged that their value is rather historical than aesthetic. Titian's *Adoration of the Shepherds* (no. 79) is a case in point. That the collection contains a large number of copies of well-known works, some of which masqueraded in the earlier lists as originals, is undeniable, but we cannot be sure that the General himself, undiscriminating though he may have been by modern standards, believed them all to be by the master's hand. As I have said, it was certainly the fashion among collectors of his time to have copies made of famous paintings, or to buy them for what they were, as preferable to black and white prints, in the days when no photographs existed. In any case it would be quite wrong to say that all the Guise pictures are in poor condition. *The Carrying of the Cross* from Mantegna's studio, the Girolamo da Treviso, the two Tintorettos, the great Carracci of the *Butcher's Shop* and the splendid *Horseman* by Van Dyck, to name a few, are tolerably well preserved in spite of the old restorations; the Veronese *Marriage of St. Catherine* is undamaged; and it is reasonable to suppose that the Zuccarelli *Adoration* and the brilliant Corrado Giaquinto, which were certainly bought within the painters' lifetime and are both almost intact, escaped the attentions of Mr. Bonus altogether.

As for the other pictures, which came to Christ Church from the Fox-Strangways, Landor/Duke and other gifts some time after the Bonus episode, their condition in general is no worse than that of the majority of old collections; and in particular that of the 'Orcagnesque' fragment (no. 5), the Master of the Bambino Vispo, the so-called Utili (no. 43) and the Giovanni di Paolo is exceptionally good.

What restoration was undertaken, after Bonus had done, between that time and comparatively recent years, is not known. H. Merritt, who advised on the removal of certain pictures from the Library in 1869,[53] was a restorer, and payments to him are recorded in 1870; but there is no record of the pictures attended to by him. I understand that Ayerst Buttery, who died in the early 1930s, was employed by the college; and his son, the late Horace Buttery, who was restorer to H.M. the Queen until his death in 1962, and was generally acknowledged to be one of the most reliable restorers in Europe, told me that the first Christ Church picture cleaned by him after his father's death was the best of the three panels by the so-called Utili (no. 43), in November 1936. From that date until his death he was the principal restorer concerned, working chiefly on XV century and earlier XVI century paintings; the restoration of the two panels with the *Sibyls*, from Botticelli's studio (nos. 35, 36), is an outstanding example of his skill. His work at Christ Church was interrupted by military service, but resumed soon after the war, and besides the majority of earlier Renaissance work he also tackled the difficult problems set by pictures from the Guise Collection – the Carracci portrait and the Domenichino landscapes are examples – which were of evident importance but in much damaged condition. In the meantime, during the war and just afterwards, some further cleaning was undertaken in Oxford by the late Sebastian Isepp, and to the latter is due the restoration of the *Supper at Emmaus* by Lorenzo Lotto (no. 84). The most difficult tasks, however, were reserved for Mr. J. C. Deliss in quite recent years, when he was called upon to deal with other Guise pictures of potential importance, among them the large Proccaccini (no. 177), the *Erichthonius* by Salvator Rosa (which

53. The late W. G. Hiscock drew my attention to this in the MS. extracts relating to pictures which he had made from the minutes of the Governing Body. These pictures were omitted by Borenius (see above, p. 9, note 38).

is particularly lauded in several of the early accounts of the collection), and the Strozzi; and it was here that the intractability of the old varnishes and the previous maltreatment of the original surfaces demanded special patience and correspondingly tactful handling on the part of the restorer. In some cases what was revealed may have seemed hardly worth the time spent; but in others the results were sufficient reward. The rehabilitation of the small triptych from Fra Angelico's studio (no. 20) was one of Mr. Deliss's most successful operations, and one of the most exacting.

Some other recent restoration ought to be recorded. We are profoundly grateful for what Mr. Rees-Jones, Director of the Scientific Department at the Courtauld Institute of Art, has achieved, with the collaboration of his pupils, in the case of the two panels by Cambiaso (nos. 214, 215). In the summer of 1965, when such tasks demanded more time than Mr. Deliss could afford, Miss Jacqueline Pouncey came to work in the Lee Gallery; and among other things the transformation of the brilliant sketch attributed to Domenichino (no. 198) is due to her. And last, 1966–67, the Hon. Thomas Lindsay undertook, and successfully completed, the restoration of two severely damaged paintings: the *Madonna with the Cherries* (no. 54) of Leonardo's school, and the *Young Man drinking* (no. 180) by Annibale Carracci.

<div align="center">★ ★ ★</div>

EARLIER ACCOUNTS & CATALOGUES OF THE COLLECTION There is not much to add to the account that Borenius gives of the early lists and notices of the Christ Church Collection. I have already referred to some of these. *London and its Environs described* (printed for R. and J. Dodsley in Pall Mall) bears the date 1761; but since it refers to George II as the reigning sovereign, as C. F. Bell pointed out, it must have been written before that king's death in October 1760; and this is confirmed by Horace Walpole's note in the *Journal of the printing office at Strawberry Hill* of November 1, 1760, in which he says that his list of General Guise's pictures is 'taken from a new work called *London and its Environs* in six volumes'.[54] Volume III of this anonymous guide-book contains an eloquent but decidedly undiscriminating description of the Guise pictures as they hung in the General's London house in George Street, Hanover Square. From this we learn that the 'left hand of the stair-case' was thickly hung with more than twenty pictures, including the large Ricci (no. 123 of the present catalogue), the *Christ carrying the Cross* of Mantegna's school (no. 74), and Tintoretto's *Martyrdom of St. Lawrence* (no. 101); while the Carracci *Butcher's Shop* (no. 181), Titian's *Adoration of the Shepherds* (no. 79) and many others recognizable by their description were in 'the first and second rooms of the ground floor'. In the rooms of the first floor can be identified, among others, the Girolamo da Treviso (no. 88), the Paolo Veronese (no. 106), the large Salvator Rosa (no. 223) and both landscapes by Domenichino (nos. 196, 197). The Tintoretto portrait (no. 100), the Zuccarelli (no. 126) and Van Dyck's *Horseman* (no. 246) were among those on the second floor. In so far as it evokes to some extent the arrangement of pictures in a fashionable London house, the account in *London and its Environs* has the advantage over that in the second volume of T. Martyn's *English Connoisseur*, printed for L. Davis and C.

54. See Frank Simpson in *Burlington Magazine*, vol. 93, 1957, p. 356.

Reymers in 1766;[55] but in almost every detail the lists are identical, the descriptions in the latter being copied nearly *verbatim* from the former, in the same order. Again we read of 'A noble work, by Guido Reni' (here catalogued, no. 148, as Cozza), 'a valuable performance, by Andrea Sacchi' (no. 198, attributed to Domenichino), 'a renowned Piece, by Leonardo da Vinci' (no. 53, *Madonna of the Yarn-winder*), and so on throughout in similarly enthusiastic terms.[56] The first catalogue of the collection after it was established in Christ Church Library, called by Borenius the 'A' Catalogue, and now exceedingly rare,[57] is of 1776;[58] but it is no more than a handlist, and remarkably uninformative. It lists the pictures as they were hung, fifty or more in each of the three bays in both the West and the East rooms on the ground floor, so that the general scene must have been much as it appears in Rowlandson's caricature of 1807.[59] We learn that Bacon's bust of the General was placed over the door in the West room, and that of the Bishop of Durham over the door in the East room; but so far as the pictures are concerned, only very rarely is there anything more than the most meagre identification; often no painter's name, and sometimes not even the subject, is recorded: 'a Sketch', 'Our Saviour's resurrection', 'A portrait, less than half length' – in many cases that is as much as is said.

In 1833 W. Baxter of Oxford printed *A Catalogue of the Collection of Pictures in the Library at Christ Church, Oxford, bequeathed to the College by the late General Guise, 1765, and of the additions made by subsequent donations; also a Catalogue of the Portraits in Christ Church Hall.* The author is not named, but there are frequent quotations of a generalizing sort from the Rev. John Thomas James, Student of Christ Church 1804–19, and afterwards Bishop of Calcutta, who had published in 1820 an account of the Italian Schools of Painting. James died five years before the 1833 catalogue was printed, and before the Fox-Strangways pictures, which it includes, had been added to the collection; but it is possible that he left notes on the Guise Collection in the Library, and that this catalogue is to some extent based on his work. Certainly it is more pretentious than the handlist of 1776. It again describes the pictures in the order in which they hung in the West and East rooms; but they had now been re-arranged more or less according to schools, and the catalogue is prefaced by lists, taken from James's work, of 'some of the most celebrated Professors of Painting of the Italian Schools, of the Works of most of whom there are specimens in this Collection', as well as a list of the busts and other sculpture in the Library hall and staircase. The pictures are numbered for the first time,[60] and occasionally there are notes which do some credit to the author's interest and industry, if not always to his judgement.[61] At the same time there are many less informative entries – no. 9 'A Head', no. 63 'A small Sketch', no. 135 'A small Landscape', *etc.* without the painter's name – in the style of the

55. On the sources used in this publication, see Frank Simpson, *loc. cit.*

56. Borenius supposes (p. 14) that these lists were identical with a catalogue prepared for Guise by the Italian artist G. B. Cipriani in 1760, which is referred to in the report of the law-suit between the Dean and Chapter of Christ Church and Guise's executor.

57. The Christ Church Library possesses only a photostat from the copy presented to the British Museum by C. M. Cracherode (d. 1799). It is entitled: *A Catalogue of the Collection of Pictures in the Library at Christ-Church which were bequeathed to the College by the late General Guise. To which is added a Catalogue of the Portraits in Christ-Church Hall.*

58. W. G. Hiscock discovered the date from the Peckwater

Library Account Book, which records a payment of £1. 17. 0 'for Printing a Catalogue of the Pictures' on November 11 0 that year.

59. See below, p. 19. Hiscock says that the name of Mrs. Showwell, the guide in Rowlandson's print, occurs in the college books.

60. There is now no indication of corresponding numbers on the frames or stretchers.

61. A typical entry is no. 33 (no. 79 of the present catalogue): 'A Nativity. Titian. This is called a most elaborate performance of this great Master. It was in the Collection of King Charles the First, and bears his mark C.R. under a crown at the back. It is an undoubted original, and in good preservation [!]. There are two Engravings from it; an ancient one in wood, the other on copper.'

'A' Catalogue of 1776; and though most of the 'Raphaels' are correctly described as 'from' or 'after the manner of' the master, there are eleven 'Titians', with no indication of any doubts as to their authenticity, in the first bay of the West Library, and the attributions of the Fox-Strangways pictures – not surprisingly, considering the standards of scholarship at the time – are wild in the extreme.

I will not delay the reader further with the accounts of the Guise Collection given by James Dallaway in his *Anecdotes of the Arts in England . . . chiefly illustrated by specimens at Oxford*, of 1800,[62] or by the anonymous writer in the *Library of the Fine Arts* of 1832;[63] or in various old Oxford guide-books, such as *The New Pocket Companion for Oxford*, 1791, and *The Perambulation of Oxford, Blenheim and Nuneham*, 1824. Occasionally they contain some entertaining if inaccurate information, but a great deal of the material is simply repeated from earlier works. The idea of producing and printing a modern catalogue of the pictures (as well as drawings and coins) in the Library was proposed by F. York-Powell to the Governing Body as early as 1883; but apparently nothing was done until 1909, when an invitation was extended to Roger Fry, then Director of the Metropolitan Museum, New York, to make the picture catalogue. Fry accepted,[64] but since there is no further record of any correspondence with him on the subject, we may suppose that he finally abandoned the assignment, and it is not difficult to guess the reason. Though he had made a considerable reputation before that date as an art historian, having published among other works an edition of Reynolds' *Discourses* (1905), and having been since 1905 Director of the Metropolitan Museum, from 1910 onwards – the date of the famous Post-Impressionist Exhibition in London, which he organized – Fry became more and more absorbed in the study of modern painting and less concerned with the older masters in general. It was not until three years later, in 1912, that it was decided to ask Dr. Tancred Borenius to undertake the task.[65] Finnish by birth and a graduate of Helsingfors University, but resident in England, Borenius had already distinguished himself as the editor of an admirable revision of Crowe and Cavalcaselle, *History of Painting in North Italy*, and was well equipped by his studies in the principal museums of Europe; no one then available could have produced a better catalogue within the severe limits imposed by the exigencies of the times. But from 1914 onwards, until the catalogue was published in 1916, the museums of Europe and the scholarship of European colleagues were virtually inaccessible to him; and the necessity of war-time economy in paper and other requirements must have restricted the scope of his work and made his task exceptionally difficult. The help of German and Austrian scholars in particular, who were in those days concerned far more than any in England with the history of European art in the later XVI, XVII and XVIII centuries, was not of course available. Within these limits, Borenius' short catalogue deserves high praise.

That catalogue has long been out of print; and since the end of the second World War, especially, the attention of Italian, English and American scholars has turned more and more to the study of Italian Mannerist and Baroque art, of which so many examples, good and bad, are included in the

62. Printed for T. Cadell and W. Davies, Strand, pp. 483–494.

63. vol. IV, pp. 116–123. The list of paintings, on seven pages, includes 'A portrait, less than half length, by Rembrandt' to which I have found no reference in other works; also a 'St. Peter, about half length, larger than the life, by Caravaggio'.

64. Letter addressed to H. W. Blunt, then Librarian, from Chantry Dene, Guildford, June 6, 1909: 'I should be glad to undertake the task of cataloguing yr. wonderful collection if it is possible for me to do so within a sufficiently short period of time to satisfy you.'

65. Librarian's Minute Book, May 8, 1912.

collection at Christ Church. As for the earlier Italian painters, it should be remembered that Berenson's invaluable Lists have appeared in various editions since Borenius' catalogue was published; and that in comparatively recent years many obscure corners in the history of Italian *Trecento* and *Quattro-cento* art have been illuminated, while the masters of the High Renaissance, great and small, have been re-examined and appraised by some of the most perceptive scholars of Europe and America. The relevant literature is immense; and the comprehensive collection of photographic material initiated by Sir Robert and Lady Witt, now incorporated in the Witt Library of the Courtauld Institute, has been so much enlarged in the last two decades that the task of a cataloguer is enormously facilitated by that alone. From all this it may appear that the deficiencies of the present catalogue are less excusable than those of Borenius, since they cannot be attributed to lack of facilities. I can only plead the impossibility of reading or examining, within what remains of my life-time, all that might be relevant to this work.

<div align="center">★ ★ ★</div>

ACKNOWLEDGEMENTS In any case I am well aware that without the immediate help of certain friends and colleagues, I could not have ventured to produce, in this age of specialization, a catalogue which implies after all some pretensions to knowledge of a very wide field. To all these I make most grateful acknowledgment. First, because they gave me most of their time and great experience, I must thank Mr. A. E. Popham, Mr. P. M. Pouncey and Dr. Federico Zeri. On their authority it would be impertinent to insist. I have also had the advantage of looking at many of the pictures with Mr. Martin Davies and Mr. Michael Levey of the National Gallery, Dr. John Shearman of the Courtauld Institute, Dr. Giuliano Briganti, Dr. Vitale Bloch, Mr. Jacob Bean and Mr. Roderic Thesiger, who all visited Christ Church while I was at work on the catalogue, and whose opinions and suggestions, in their various ways, have all been valuable to me; and of discussing photographs, either personally or by correspondence, with Dottoressa Luisa Becherucci, Director of the Uffizi Galleries, Professor E. K. Waterhouse of the Barber Institute at Birmingham and Mr. Everett Fahy of Harvard. The Earl of Crawford and Balcarres, Count Antoine Seilern, Professor D. Talbot Rice, Mr. Oliver Millar, Mr. John Gere, Mr. John Hayes, Mr. D. E. Rodgers, Dr. F. Grossmann, Dottoressa A. Griseri, Dr. A. Ballarin, Dr. Karl Arndt and Miss Ellen Callmann have all been helpful to me in particular cases; M. Pierre Rosenberg and Mme. Sylvie Béguin of the Louvre, Dr. L. Magagnato of Verona, Dr. Walther of Dresden, Dr. Erik Fischer of Copenhagen and Mr. Andrew Ritchie of Yale have been kind in providing or ordering photographs of related paintings in other collections.

In a more general way, I owe sincere thanks to Mr. Hugh Scrutton and his staff of the Walker Art Gallery at Liverpool, where many of our best pictures were carefully housed from 1964 to 1966. I am particularly grateful to Mr. Frank Simpson for drawing my attention to references to General Guise in the Houlditch MSS. at South Kensington. In this connexion I must thank also the Keeper of the National Gallery (Mr. Davies) for allowing me to consult at my leisure the photostat of the Houlditch document and various other early catalogues in the National Gallery Library; and I

should add here that in preparing the short biographical notes on the artists represented in the collection I have used frequently (and in some cases unashamedly copied) the admirably concise and accurate entries in the recent National Gallery catalogues, especially those of Mr. Davies himself and of Mr. Cecil Gould; on the principle that when a thing is well done already, it is foolish to try to improve it.

I have referred to the Witt Library in Portman Square, and have I hope sufficiently suggested how deeply indebted I am to the staff of that invaluable establishment, whose service to students of art is so freely and efficiently given. Sir Anthony Blunt, Director of the Courtauld Institute, has helped my work and benefited Christ Church also through the scientific department under his charge, where Mr. Stephen Rees-Jones, the director of that department, has given important advice and practical assistance. I have already mentioned the case of the two Cambiaso panels, and a reference to my catalogue entry for nos. 214 and 215 will show the extent of Mr. Rees-Jones's co-operation there. One other institution has been indispensable to me: the art library of the Ashmolean Museum, where I have worked almost continuously for the last several years, and have never failed, with the help of Mrs. Gunn and Miss Hughes, to find those books of reference and learned periodicals, in various languages, that I needed so often to consult. In the library of the Athenaeum, too, I have found several rare books that were useful to me; and in connexion with the Nosworthy bequest, Messrs. Agnew, Leggatt and Colnaghi have put records at my disposal. Mr. Leslie Bell of Colnaghi's has been particularly helpful to me in many ways besides this. And in acknowledging my general debt to the care and experience of the Phaidon Press, I should like particularly to thank Dr. I. Grafe for information on the present whereabouts of certain pictures that would otherwise have been incorrectly recorded.

Finally I must express my gratitude to my colleagues at Christ Church. My appointment to a lectureship in 1964, for the purpose of completing this catalogue, and also the privilege of a lodging in the Deanery, were especially gratifying to one who became an undergraduate here more than forty-five years ago, and have of course greatly accelerated my work. For this I must thank the Dean and the whole Governing Body. But it will not be invidious if I mention certain friends by name, whose offices or interests have brought them into closer touch with me. When I began this task some ten years ago, Sir Roy Harrod had lately taken over as Curator of Pictures, in 1956, from Dr. Humphrey Sutherland. He was succeeded in 1964 by Mr. Daniel Bueno de Mesquita. To all these I owe special thanks for the help they have given me when they had many other duties to perform; and I cannot sufficiently say how much I am indebted to the last in particular, since it is during his curatorship that the work involved in his charge has so greatly accumulated. The building of the new Picture Gallery, made possible by the generosity of Mr. Charles Forte during the curatorship of Sir Roy Harrod, began after Mr. Bueno de Mesquita had taken over; and not only has he been responsible for continuous negotiations with the architects, in planning details in that connexion, but he has also been increasingly concerned with the preparation of the catalogue – finance, photography and other things – and with the programme of restoration implemented after the last war by Dr. Sutherland and Sir Roy. The Librarian, Dr. Mason, the Treasurer, Mr. F. A. Gray, and

the Steward, Mr. Evan James, have given me kind co-operation. Apart from these, Dr. S. L. Green-slade has lent me books and given valuable advice on points of ecclesiastical iconography, Mr. Bernard Richards has lent me books on W. S. Landor, and Professor Dimitri Obolensky has helped in the interpretation of the Slavonic icon (no. 73). Two undergraduates, Mr. Francis Russell and Mr. Christopher Lloyd, whose interest qualified them for less mechanical tasks, have assisted in the last stages by checking measurements and references. Other members of the Senior, the Graduates' and the Junior Common Rooms have from time to time expressed a wish to see more of this collection, which in the *interim* has been necessarily difficult of access; and I sincerely hope that the opening of the Gallery and the publication of the new catalogue will help to promote the study and love of old masters that our benefactors surely felt to be a proper part of every man's education.

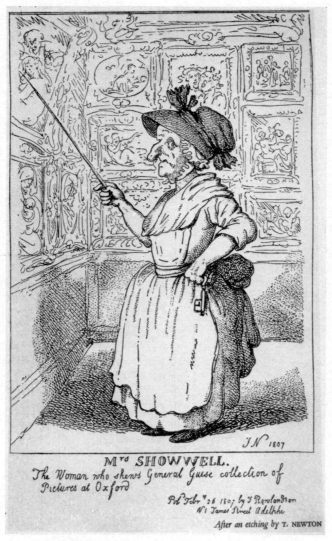

Mrs. Showwell explaining the Guise Collection at Christ Church.
Etching by T. Newton after T. Rowlandson, 1807

EXCURSUS

GENERAL GUISE AND JAKOB CHRISTOFFEL LE BLON

ABOUT the year 1720 there came to England Jakob Christoffel Le Blon, an artist born in Frankfort in 1667, who had worked under Maratti in Rome in 1696–97, and had tried his fortune also in Holland and France.[1] He had invented a method of printing mezzotints in colour. Inspired by the Newtonian theory of three primary colours, blue, yellow and red, he claimed to be able to reproduce exactly the colouring of an original painting by using these or by over-printing one on another. The invention had met with no success in the Hague or in Paris, but Le Blon's practical application of Newton's precepts seems to have attracted some notice in learned circles. The Italian *dilettante* Antonio Conti, who had met Sir Isaac Newton in London in 1715,[2] wrote in one of his essays of the desirability of publishing, at a time when the Newtonian theory of colour was beginning to be applied, a manuscript of Leonardo da Vinci in the Ambrosiana Library, in which Leonardo speaks of the harmony of colour in painting; and he adds: 'This' (the Newtonian theory) 'was the source from which that German painter derived his secret, in making colour-prints of pictures; an art of which he produced several examples in London – one of them in the collection of Signor Antonio Zanetti here in Venice. I met this painter in the Hague, and he assured me that by following Newton's principles of the immutability, refrangibility and reflexibility of the rays of light, he had established the degrees of strength or weakness that must be given to colours in order to bring them into harmony.'[3] That the 'German painter' referred to by Conti was in fact Le Blon is proved by a passage in a letter from Count Francesco Algarotti of the very year in which Conti's essay was published. On

May 13 1756, he writes to his friend Eustachio Zanotti at Bologna, with whom he had been corresponding on the usefulness of the Newtonian theory of colour for the practising painter: 'You add, in corroboration (so to speak) of what I say, that it was Newton's principles which led Le-Blond to invent those colour-prints of his, which reproduce not only the composition and chiaroscuro of a painting, but also the actual colour, with all its various modulations, in accordance with what may be found in the sixth volume of *Philosophical Transactions*. That is true; and only the other day I happened to find the same point made in the second volume of the recently published works of the Abbé Conti.'[4]

On his arrival in London Le Blon immediately found a patron in Colonel John Guise,[5] who may have met him already in Holland or France. He procured his presentation to King George I, and Le Blon received a Royal patent for his invention. A company, named the Picture Office, under the chairmanship of Guise himself, was formed to exploit it.

The following is an extract from one of George Vertue's notebooks dated 1722: 'Monsr. Le Blon painter came into England.[6] Had been in France and came hither from Holland. He had long had a project to Engrave prints pictures in Colours. Did make some essays abroad but met with no Encouragement. Here he came being a Man of a forward spirit, a tollerable assurance & a good Tongue of his own. Found people who much admir'd his project & cry'd it up, but he finding the inclination of our people to stock-jobbing, made Friends & interest whereby he got a Patent from the King for the sole vending and publishing such pictures. This came in play just about the time of Ye Bubbles & was cry'd up by the proprietors as one of the most surprizing & most advantageous so that a Stock was rais'd & workmen imployed. At their first beginning all the Artists in general condemn'd their proposal & works

1. The first modern account of Le Blon, with a catalogue of his prints, was given by H. W. Singer in *Mittheilungen der Gesellschaft für vervielfältigende Kunst*, Vienna, 1901, pp. 1 ss. Further information, and a lucid account of Le Blon's method, is to be found in Campbell Dodgson's *Old French Colour-Prints*, 1924, pp. 6–9. Much of my information is derived from these invaluable publications.
2. The Abbé Conti attempted to mediate in the controversy between Newton and Leibnitz in that year.
3. *Prose e poesie*, II, 1756, p. cxlviii. I translate freely from the passage quoted (in another connexion) in Francis Haskell's admirable book *Patrons and Painters*, 1963, p. 319, note 2. The reference to A. M. Zanetti is interesting, for that distinguished amateur was practising at the time a somewhat similar method of overprinting colour-blocks in his chiaroscuro woodcuts after Parmigianino and other masters.

4. Algarotti, *Lettere sopra la pittura*, *Opere*, 1793, VIII, p. 49. Again, freely translated.
5. Guise's actual rank at the time was Captain; but he had already, apparently, purchased a Lieutenant-Colonel's commission, and is constantly referred to as Colonel in these years, by Vertue and others. See Introduction pp. 5–6 and notes thereto.
6. It may be seen from what follows that Vertue, in 1722, is writing of past events; we are therefore probably justified in dating Le Blon's arrival in England *c.* 1720.

falling far short of what they Promis'd, haveing given out that their works could not be known from paintings, without the help of paint or pencil. All false, because in some degree all their prints were touch't with the pencil. A picture of K. George a wretched thing. Since that they have done better. The place they wrought them, in the Duchy house in the Savoy. They have many hands at work; first the master to draw for them & correct the pictures, several workmen of Metzotint – some Engravers, printers, colourers, frame makers, &c. Collonel Guise their great Patron & promoter of these works, swears and Bullies for them to everybody. He with several others promote & share the profit & Loss.' Here follows a list of seventeen prints which the Picture Office offered for sale in October 1722. 'By another Catalogue since printed', Vertue continues, 'the number of peices amount to 40. Some how or other they have lately turned Mr. Le Blon out of the Office of Director of the Works & have taken in his place. . . . Prudehome, who paints, especially copys Italian pictures well & draws well.'[1]

It appears from this that Guise was president or chairman of a commercial concern, with Le Blon as general manager, supervising mezzotinters and other craftsmen engaged.[2] Letters from Lord Percival of August 30 1721, and March 27 1722, report on the progress and decline of the business. The Picture Office failed, and was bankrupt in 1723; Guise declared that he had lost six or seven hundred pounds over it.[3] But for a time Le Blon continued in London, sending specimens of his work to Rome, Dresden and elsewhere, and between 1723 and 1726 he published a treatise (now exceedingly rare) under the imposing title: 'Coloritto; Or, the Harmony of Colouring in Painting: Reduced to Mechanical Practice, under Easy Precepts, and Infallible Rules; together with some Coloured Figures, In order to render the said Precepts and Rules intelligible, not only to Painters, but even to all Lovers of Painting*; with a dedication to the Chancellor of the Exchequer, Sir Robert Walpole.[4] In 1731 it seems to have attracted the attention of the Royal Society, whose secretary

wrote an account of Le Blon's method; and about this time, if not before, certain distinguished Italians, as we have seen – Antonio Conti, Eustachio Zanotti and Anton Maria Zanetti the elder, as well as Count Algarotti himself – had been impressed by his discovery. But his ambitious plans for the establishment of a tapestry factory to work on the same principles led to a second bankruptcy, and the artist fled to Holland in 1732. His subsequent (and less stormy) career in Paris, where he died in 1741, need not concern us here. He obtained a patent from the King of France, and may be considered, with his successors the Gautier-Dagoty family, as the founder of the distinguished school of colour-printing which flourished in Paris throughout the XVIII century.

Horace Walpole[5] described him as 'an universal projector, and with at least one of the qualities that attend that vocation, either a dupe or a cheat'; and goes on: 'I think the former, though, as most of his projects ended in the air, the sufferers believed the latter. As he was much of an enthusiast, perhaps like most enthusiasts he was both one and the other.' Walpole had little sympathy with enthusiasts. The whole story seems to me an interesting, perhaps rather pathetic example of that widespread interest in Newton's discoveries, which seized the imagination even of would-be intellectuals who scarcely understood them. Algarotti's publication of 1737, Il Newtonianismo per le dame, though it certainly achieved more fame at the time, probably deserves no more consideration, according to the verdict of posterity, than Le Blon's invention; and had it not been for Piazzetta's charming title-page would perhaps have been equally disregarded.

There are in the Guise Collection at Christ Church several works which illustrate the General's interest in J. C. Le Blon. There is a good example of one of the famous colour-mezzotints, the portrait of General Ernst Wilhelm von Salisch, Governor of Breda (Figure A), which is mentioned by Le Blon's contemporary, Gool,[6] as the first plate produced by the new invention, and by Singer[7] as one of the best. All these prints are now very rare; which is surprising, since thousands are known to have been printed at the time. Many must have been destroyed, but it is possible (as Singer suggests) that many are still masquerading as oil paintings in the country houses of England. The Christ Church example has an XVIII century mount of the same type as most of the drawings from the Guise Collection,

1. Walpole Society, vol. XXIX, 1947, Vertue, III, 10. I have rationalized the punctuation for the sake of clarity, but retained the spelling.
2. That Le Blon was later replaced by another manager, Prudehome, is known only from Vertue; there is no mention of this in Gool (as quoted by Singer), although Gool had his information about Le Blon in England from General Guise himself. According to Thieme-Becker, Künstlerlexicon, vol. XXVII, a painter of the name of Preudhomme [sic] was born in Berlin of French parents in 1686, settled in England in 1712, and died at Wilton in 1726. He was a pupil of Pesne in Berlin, studied also in Italy, and was known as a copyist and draughtsman for the engraver. This must be the man to whom Vertue refers, and if his report is true, it is also possible that some copies of Italian masters by him were incorporated in the Guise Collection and passed with it to Christ Church.
3. See the documents published by Singer, op. cit., p. 2.
4. Singer knew only five copies, including those in the British Museum and the Victoria and Albert Museum. The work was incorporated in L'Art d'imprimer les tableaux, by A. Gautier de Montdorge, Paris, 1756 and 1768, and there is a modern edition of the text by N. G. van Huffel, 1916. See Dodgson, op. cit., p. 7, note 1.

5. Quoted by Singer, op. cit., p. 5.
6. De nieuwe Schouburg, the Hague, 1750, I, p. 343.
7. Cat. no. 42. Singer gives other impressions at Dresden and in the British Museum, both inscribed with the initials of the original painter (v. K, unidentified), and with Le Blon's signature, in gold; also one at Maihingen. If this was Le Blon's first plate, it must have been produced in Amsterdam (where the artist had removed from Frankfort) before 1711; for in February of that year Zacharias Uffenbach visited him in his studio there and saw other examples of his prints (Merkwürdige Reisen durch Nidersachsen, Holland und England, Ulm, III, 1754, p. 534, quoted by Singer, p. 2).

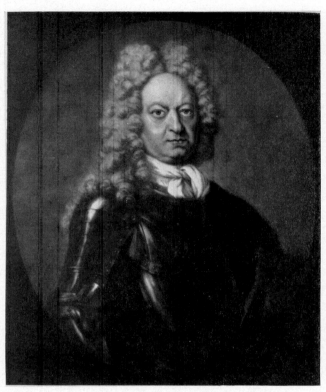

Fig. A. J. C. Le Blon: *Portrait of General Ernst Wilhelm von Salisch.*
Colour-mezzotint (Singer 42). Christ Church, Guise Collection

with a 'Guise' number (Q. 20)[1] on the back, and was included among the drawings until lately.

Besides this, three paintings included in the present catalogue seem to have been the immediate models from which other colour-mezzotints were made: nos. 259, 260 and 261. A Prospectus of the prints produced by the Picture Office ('Liste de ce qui a été Imprimé en Couleur, Jusques a present') was issued about 1720, when the undertaking was begun in England; the subjects are described, and the authorship, dimensions and whereabouts of the originals are in most cases recorded.[2] As may be seen from my catalogue entries below, these three paintings, *The Napkin of St. Veronica*, *The Virgin and Child* (in a feigned roundel) and *The Infants Christ and St. John embracing*, tally with the descriptions in this Prospectus of nos. 1, 13 and 9 respect-

ively, and colour-mezzotints of all are in existence (Singer Catalogue, nos. 10, 14 and 9 respectively). The original of *The Napkin of St. Veronica* is actually stated to be in the collection of Colonel Guise, and we may therefore suppose that that plate was mezzotinted directly from the painting (see Figures B and C). In the other two cases, where the originals are stated to be in the Royal Collection, it is unlikely that the prints could have been produced without the aid of an intermediate copy, and it seems a reasonable assumption that the two Christ Church paintings, *The Virgin and Child* (no. 260) and *The Infants Christ and St. John* (no. 261), are in fact copies painted by Le Blon for this purpose and used in the mezzotinter's studio (see Figures D–H).[3] Several other paintings then at Kensington

1. In fact these numbers were probably inscribed by the Christ Church Librarian soon after the accession of the Guise Collection in 1765.

2. A transcript in the handwriting of L. A. Fagan, who was Assistant in the Department of Prints and Drawings 1869–94, is in that department at the British Museum (Singer, pp. 6–7). There is no general heading, and there seems to be no record of the source from which Fagan's copy was made, but presumably it was one of the 'catalogues' to which Vertue refers (see above). Fourteen subjects are listed as already mezzotinted (nos. 1–14). Then follow 'Pieces ou L'on travaille' (nos. 15–18), and 'Pieces qu'on a Dessein d'imprimer' (nos. 19, 20 and six others unnumbered). Finally there is a page and a quarter of description of the theory and practice of the invention, written in the first person, evidently by Le Blon himself.

3. The original of the *Virgin and Child* (no. 260), said in the Prospectus to be a fresco by Raphael 'dans la Gallerie du Roi a Kinsington', is still to be seen in the King's Gallery at Kensington Palace (Figure F), and deserves more consideration than it has so far received from the students of Raphael. It is listed (as ascribed to Raphael) by Passavant, *Raphael d'Urbin*, 1860 ed., II, no. 277 and by Ruland 1876, p. 85, no. XIII. Whether the original of *The Infants Christ and St. John embracing*, which the Prospectus says was in King William III's palace at Loo, is to be identified with the version of this composition now at Hampton Court, is less certain. The Hampton Court painting, now attributed to Marco d' Oggiono, has a background of rocky landscape in place of the bed and curtains; in this respect the Christ Church painting (Figure G) and the mezzotint (Figure H) are nearer to the version at Naples, which is by Joos van Cleve. See the catalogue entry for no. 261 below.

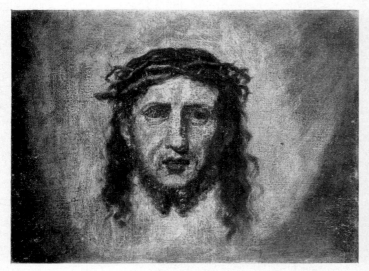

Fig. B. J. C. Le Blon: *The Napkin of St. Veronica*.
Christ Church, Cat. No. 259

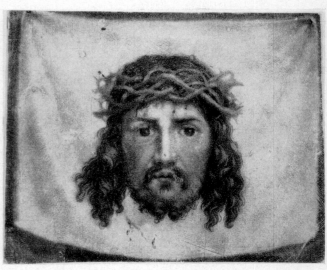

Fig. C. J. C. Le Blon: *The Napkin of St. Veronica*. Colour-mezzotint
after Christ Church no. 259. (Singer 10.) Vienna, Albertina

Palace seem to have provided subjects for the Picture
Office enterprise; and no doubt Guise's standing at Court
facilitated the arrangements for copies to be made.
Although the colour-mezzotints are always catalogued
under Le Blon's name, it may be doubted whether he
executed any of the plates himself. In England, at least, we
know from Vertue (quoted above) that he had a group of
mezzotinters working for him at the Picture Office, and

he himself was no doubt 'the master to draw for them &
correct the pictures'. He is generally described as a painter,
and besides *The Napkin of St. Veronica* two other prints
are stated in the Prospectus, or by other contemporary
authority, to be reproductions of paintings by his own
hand.[1] His style was no doubt chiefly derivative, and the
Hercules introduced to Olympus, a small Correggesque panel

1. Singer Cat., nos. 27 and 29.

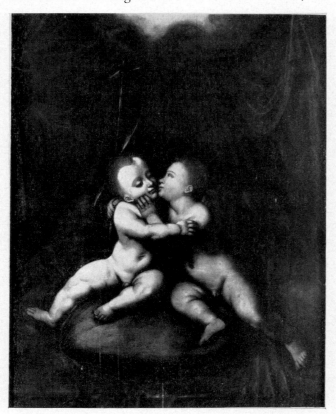

Fig. D. Attributed to J. C. Le Blon, after Leonardo da Vinci:
The Infants Christ and St. John embracing. Christ Church,
Cat. No. 261

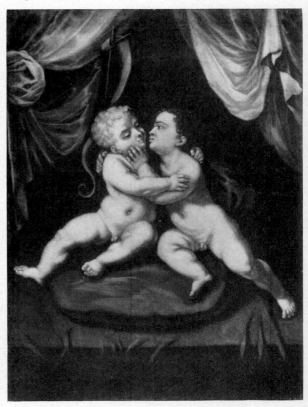

Fig. E. J. C. Le Blon: *The Infants Christ and St. John embracing*.
Colour-mezzotint after Christ Church no. 261.
(Singer 8.) Dresden, Printroom

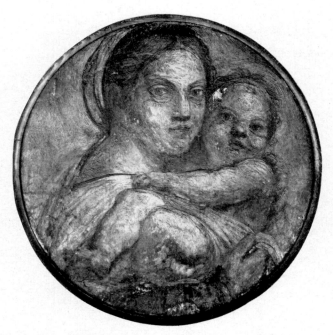

Fig. F. Attributed to Raphael: *The Virgin and Child*. Kensington Palace.
Reproduced by gracious permission of Her Majesty the Queen

now in the Christ Church Collection (no. 164 of the present catalogue, *q.v.*) may be an example of his original work, so far as it is original at all, for a small panel of this none too common subject appears among the thirteen paintings which Singer states (*op. cit.*, p. 6), on the contemporary authority of Uffenbach, Gool and others, to be his. But he must have been much more frequently engaged in copying paintings of the great masters to provide immediate models for his mezzotinters.

Among the paintings which were excluded from the Christ Church Library by decision of the Governing Body nearly a hundred years ago, removed from their frames and stretchers and stored in the attic of Tom VIII,[1] there are three more which must or may have been the immediate models for colour-mezzotints by Le Blon: *Rebecca at the Well*, described as by Guido in the 'A' Catalogue of

1. See Introduction, p. 13. These paintings are not included by Borenius, or in the present catalogue.

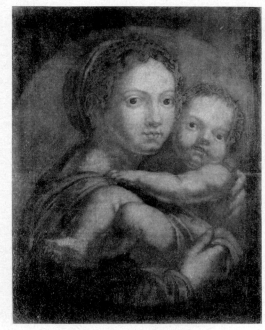

Fig. G. Attributed to J. C. Le Blon, after Raphael (?): *The Virgin and Child*. Christ Church, Cat. No. 260

Fig. H. J. C. Le Blon: *The Virgin and Child*. Colour mezzotint after Christ Church no. 260. (Singer 14.) London, Colnaghi

1776 (p. 4) and in the 1833 Catalogue (no. 52), which corresponds exactly, in the same direction, to Singer 2 (Prospectus no. 11, said to be after a painting of the School of Annibale Carracci, 'L'Original dans La Collection du Colonel Guise');[1] *Venus reclining* ('A' Cat., p. 13, as by Titian), which corresponds, again in the same direction, to Singer 28 (included in the Prospectus without a number, among subjects to be engraved later, from a Titian at Kensington Palace);[2] and *Cupid shaving his Bow* (L. & E. III, 33; E.C. II, 63; 'A' Cat., p. 3; 1833 Cat., no. 99, as by Correggio), which accords with Singer 23 (Prospectus no. 18, stated to be after a copy by Carracci, at Kensington

Palace, of Parmigianino's famous original in Vienna).[3] Besides these, there are among the discarded paintings a considerable number of copies of very celebrated works – Guido's *Cleopatra* in the Prado and *St. Sebastian* at Genoa, Poussin's *Martyrdom of St. Erasmus* in the Vatican, and several others – which are exactly of the sort that the Picture Office might have planned to reproduce, had the enterprise proved successful, and might well have been made to that end. The matter is perhaps no longer of any aritstic importance. The inclusion of a certain number of copies of the most famous Italian paintings of the High Renaissance and *Seicento* is of course characteristic of many English collections formed in the XVIII or early XIX centuries; but there is sufficient evidence to suggest that many of the copies assembled by General Guise may have been made for a more particular purpose, and that the story may not be without a certain interest to students of the byways in the history of art.

1. The fact that the original painting was said in the Prospectus to be in Guise's Collection is overlooked by Singer. Only one impression (in Vienna) is known of each of two different versions of this print, which are both reproduced by Singer, p. 7. The Christ Church painting corresponds more closely to the larger version – Singer 2 rather than Singer 1 – with Abraham's servant (on L.) looking downwards.

2. Only one impression is known, at Dresden, reproduced by Singer. The original of this, as he points out, is still in the Royal Collection, but now at Hampton Court (Law Cat., 1898, p. 64, no. 164, reproduced). It is a studio variant of the famous *Venus of Urbino* by Titian in the Uffizi Gallery at Florence. The Christ Church picture (so far as it can be judged from its present state) and Le Blon's print both leave out the figures in the background, but agree with the Hampton Court version rather than the Uffizi original in omitting also the sleeping dog and the drapery in Venus's L. hand.

3. It must be noted, however, that the ruined canvas at Christ Church does include the two *putti* in the background, as in the Vienna original, which do not appear (according to Singer) in the painting now at Hampton Court, nor in Le Blon's print. The only known impression of the print, which is in the same direction as the painting, is at Dresden.

Mr. Bueno de Mesquita skilfully contrived to make recognizable photographs of the three badly damaged canvases at Christ Church.

CATALOGUE

C

ABBREVIATED TITLES OF WORKS FREQUENTLY QUOTED

L. & E.
London and its Environs Described. Printed for R. and J. Dodsley, Pall Mall, 6 vols., 1761.

E. C.
[T. Martyn] *The English Connoisseur*. London, 2 vols., 1766.

'A' Cat., 1776
A Catalogue of the Collection of Pictures in the Library at Christ-Church, which were bequeathed to the College by the late General Guise. To which is added a Catalogue of the Portraits in Christ-Church Hall [1776].

1833 Cat.
A Catalogue of the Collection of Pictures in the Library at Christ Church, Oxford, bequeathed to the College by the late General Guise, 1765, and of the additions made by subsequent donations; also a Catalogue of the Portraits in Christ Church Hall. Oxford, printed by W. Baxter, 1833.

Borenius Cat., 1916
Tancred Borenius, *Pictures by the Old Masters in the Library of Christ Church, Oxford*. Oxford University Press, 1916.

Crowe and Cavalcaselle,
(a) Painting in Italy
J. A. Crowe and G. B. Cavalcaselle, *A History of Painting in Italy. Umbria, Florence and Siena*. Ed. Langton Douglas and Tancred Borenius, 6 vols., London, John Murray, 1903–1914.

(b) Painting in North Italy
A History of Painting in North Italy. Ed. Tancred Borenius, 3 vols., London, John Murray, 1912.

Venturi, *Storia*
Adolfo Venturi, *Storia dell'arte italiana*, Milan, U. Hoepli, 11 vols. in 24 parts, 1901–1939.

Van Marle
Raimond van Marle, *The Development of the Italian Schools of Painting*, 19 vols., The Hague, Martinus Nijhoff, 1923–1938.

Berenson, Lists, 1932
Bernhard Berenson, *Italian Pictures of the Renaissance*, Oxford, Clarendon Press, 1932.

Berenson, Venetian Lists, 1957
Bernard Berenson, *Italian Pictures of the Renaissance, Venetian School*, 2 vols., London, Phaidon Press, 1957.

Berenson, Florentine Lists, 1963
Bernard Berenson, *Italian Pictures of the Renaissance, Florentine School*, 2 vols., London, Phaidon Press, 1963.

Berlin *Jahrbuch*
Jahrbuch der Königlich Preuszischen Kunstsammlungen, Berlin, 1880–1943 (*Jahrbuch der Preuszischen Kunstsammlungen* after 1918).

Vienna *Jahrbuch*
Jahrbuch der Kunsthistorischen Sammlungen des Allerhöchsten Kaiserhauses, Vienna, from 1883 (*Jahrbuch der Kunsthistorischen Sammlungen in Wien* after 1918).

TUSCAN AND UMBRIAN PAINTERS

LATER IMITATION OF THE FLORENTINE SCHOOL OF THE XIII CENTURY

1. BUST OF ST. FRANCIS. Panel, 52·5 × 42 cm.

Fox-Strangways Gift, 1834 (?) (not in 1833 Cat.)

As Borenius points out, this is a copy of part of the early Florentine altarpiece of St. Francis, full length, surrounded by scenes from his life, in the Bardi Chapel of Sta. Croce, Florence, dating *c.* 1250–60. (Venturi, *Storia*, vol. v, 1907, fig. 74.) The Christ Church painting is in tempera, and might be as early as *c.* 1500, though the gold background has been renewed later. Since the original was no doubt supposed to be an authentic contemporary portrait, such a copy would not be unlikely, even at that date.

Exhibited: Manchester; *Art Treasures*, 1857, no. 14 (as by Margaritone d' Arezzo).

Reproduced: Frontispiece to Father Cuthbert's *Life of St. Francis*, 1912.

Literature: Borenius Cat., 1916, no. 5.

TUSCAN SCHOOL, EARLY XIV CENTURY

2. A SMALL ALTARPIECE, WITH NINE SCENES FROM THE PASSION; AT THE TOP, THE VIRGIN AND CHILD BETWEEN ST. PAUL AND A FEMALE SAINT. Panel, 58·3 × 45·9 cm. (the top panels R. and L. triangular).

Plates 2–3

Landor-Duke Gift, 1897. From the collection of W. Savage Landor.

Garrison (see below, *loc. cit.*) connects this panel with two others formerly in the Sessa Collection, Milan, which he believes to be the wings of the Christ Church painting. This reconstruction appears to be convincing: from the reproductions, the Sessa panels seem certainly to be by the same hand as ours, and their eighteen scenes from the Life and Passion of Christ supplement and complete the nine in the Christ Church panel, in the correct order. There are similar half-length figures in triangular compartments at the top, on the inner side, and hinge-marks also on the inner side. I have been unable to trace the Sessa panels, and their dimensions are not known. In Garrison's reconstruction (*Gazette des Beaux-Arts*, 1946, *loc. cit.*, fig. 3) the individual compartments containing the scenes from the Life of Christ appear smaller than those at Christ Church. The top section of the Christ Church panel is separate from the rest, and it is conceivable that part of the panel has here been cut out; but it is difficult to suppose that a missing part could have contained further scenes from the Passion, since the series is iconographically complete as it is between the Sessa and Christ Church panels.

Garrison supposes the painter, whom he names the 'First Romanizing Florentine Master', to have worked *c.* 1310–1320, 'within the shadow of Assisi, where leading painters from both Florence and Rome worked side by side'. He refers to the influence both of Cimabue and of Cavallini. The panel was cleaned by J. C. Deliss in 1963, and is now in fair condition for a painting of such early date, with some local damage. What Garrison supposed to be wings at the Virgin's back (and therefore suspected to be a later addition) is in fact drapery over the back of the throne on which she sits.

Exhibited: Liverpool, Walker Art Gallery, 1964, no. 46.

Literature: Borenius Cat., 1916, no. 69 (as Sienese, XIV century).

E. B. Garrison, *A tentative Reconstruction of a Tabernacle and a Group of Romanizing Florentine Panels*, in *Gazette des Beaux-Arts*, Sér. 6, vol. 29, June 1946, pp. 321 *ss.*, and *Italian Romanesque Panel Painting*, 1949, p. 136.

SCHOOL OF DUCCIO

Duccio di Buoninsegna, *c.* 1255–1319, the first great painter of the Sienese School. Most modern scholars agree that the so-called Rucellai Madonna from S. Maria Novella in Florence, now in the Uffizi, is the work commissioned to Duccio in 1285. His great altarpiece known as the *Maestà*, the main part of which is now in the Museo dell' Opera at Siena, was commissioned for the high altar of Siena

Cathedral in 1308. From his predecessor, Guido da Siena, Duccio seems to inherit nothing but the 'Byzantine manner' which pervades Sienese painting throughout the XIV century and beyond; his grace of form, his delicate colour, and his exquisite finish, are entirely his own, and exercised an overwhelming influence on his successors for a hundred years.

3. TRIPTYCH: THE VIRGIN AND CHILD ENTHRONED, SIX ANGELS AND A DONOR; CRUCIFIXION (L. wing); S. FRANCIS RECEIVING THE STIGMATA (R. wing); in the spandrels of the centre panel, THE LAST JUDGEMENT. Panel; central compartment, overall, 37 × 25·3 (main subject, 32 × 21·8) cm.; wings, overall width, 12·6 (painted surface, 9·2) cm. Plates 4–5

Fox-Strangways Gift, 1828.

Garrison (see below, *loc. cit.*), in a careful study of this small triptych, which though much damaged is of high quality, supposes that it is incomplete, and suggests that another panel, containing Christ as Judge and two trumpeting angels, was originally hinged above the centre panel, shaped in such a way as to fit into the wings when the triptych was completely closed. He adduces evidence of similar

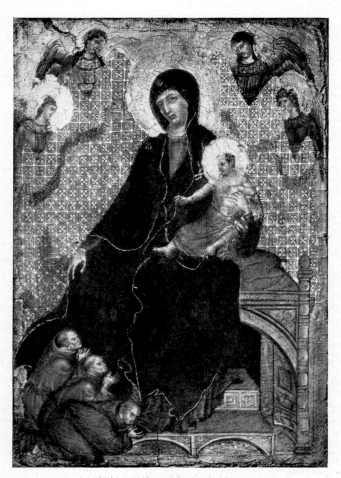

Fig. 1. Duccio: *The Virgin and Child with three Franciscan Monks.*
Siena Gallery (*Cf.* Cat. No. 3)

arrangement in Northern goldsmiths' work from the XIII century onwards. The composition of the centre panel is related to that of Duccio's Rucellai Madonna, and Garrison considers that it may be an early work (*c.* 1300–10) of the Master of Città di Castello, a close follower of Duccio, so called from the large altarpiece formerly in S. Domenico, now in the Pinacoteca of that city.[1] There are certainly resemblances, allowing for the difference in scale, particularly in the muscular body of the Child Christ, and in the heads of some of the angels. But the head of the Virgin in Città di Castello is flatter at the top (under the hood) and fuller at the sides, and her hands are more formalized in Byzantine style. It seems to me that there is a closer relationship in these respects, and in others, between the Christ Church triptych and the exquisite little panel of the *Virgin enthroned with four Angels and three Franciscan Monks*, no. 20 of the Siena Gallery (Figure 1). There the Virgin's hood has the same domed shape as in the Rucellai Madonna, and though the top of the Child's head is missing and unrestored, so that it appears smaller, the type must have been almost the same as in our picture. Similar, too, are the square ornamental panels on the lower part of the throne in both. The quality of the painting in the figures of the three Franciscans, which are nearly of the same scale as the donor at Christ Church, is undeniably better; but it is difficult to judge how much must be allowed for the inferior condition of our painting. In any case it is apparent that the triptych is extremely close in style to Duccio himself; and the best preserved parts – for instance the figure of St. John and the rocks below the Cross in the L. wing – are enough to show its original quality. An exceptional feature is the Cross, which is painted blue.

Lightly cleaned by H. Buttery in 1949. The robe of the Virgin is badly damaged, and there are disfiguring retouches, which are discoloured, here and below the throne. The spandrels of the centre panel are much rubbed. No indication of individual strands or curls remains in the hair of the Child or the angels, but generally speaking, the figures of the angels are in tolerable condition. The hinges are original.

Exhibited: Manchester 1857, no. 7 (as Cimabue); Matthiesen Gallery, London, 1960, no. 4, pl. 1; Liverpool, 1964, no. 13.

Literature: 1833 Cat., no. 117 (as Cimabue); Borenius Cat., 1916, no. 70 and p. XXI (as School of Duccio).
Crowe and Cavalcaselle, *Painting in Italy*, 2nd ed. (L. Douglas), I, p. 184, no. 2 (as follower of Duccio); L. Douglas (*ibid.*), III, p. 28, note 1 (as Segna); Van Marle, *Development of the Italian Schools of Painting*, II, 1924, p. 144 (as School of Segna); Berenson, Lists, 1932, p. 295 (as 'Ugolino Lorenzetti'); E. B. Garrison in *Burlington Magazine*, vol. 88, 1946, pp. 214–233, and *Italian Romanesque Panel Painting*, 1949, p. 138; R. Offner, *Corpus of Florentine Painting*, sec. III, vol. V (1947), p. 253, note 6; C. Brandi, *Duccio*, 1951, p. 135, pl. 20.

1. Van Marle, II, fig. 48.

FLORENTINE SCHOOL, FIRST YEARS OF THE XIV CENTURY

4. ST. JOHN THE BAPTIST ENTHRONED. Panel, cut above, 101 × 59.5 cm. Plate 1

Fox-Strangways Gift (1834?) (not in 1833 Cat.).

This important early Florentine picture was engraved (by M. Carboni after a drawing by G. Miller) in *L' Etruria Pittrice*, Florence 1791–95, vol. I, pl. V, under the name of Buffalmacco (whose name occurs on a label on the back). It was then in the collection of the Florentine painter Vincenzio Gotti, having been acquired by him (so it is stated in the text) from the Sacristy of the very ancient church of S. Maria degli Ughi in Florence, which had lately been suppressed.

Venturi, Suida and Sirén have all wished to identify this Buffalmacco, whose first name was Bonamico and to whom certain documents of *c.* 1336–40 refer, with the painter of the St. Cecilia altarpiece now in the Uffizi, who was also certainly the painter of some of the scenes from the Life of St. Francis in the Upper Church at Assisi. If the Christ Church picture is also by the Cecilia Master or from his studio, as most modern writers from Sirén onwards have supposed, the old attribution to Buffalmacco might seem to support this identification. But that is no more than hypothesis; and in fact the comparison of the Christ Church picture with the most typical works of the Cecilia Master is by no means convincing. It is much less Giottesque; the treatment of the hands and drapery, and the proportions of the figure, in the Assisi frescoes and the Cecilia altarpiece itself, are quite different; only the treatment of the eyes is somewhat similar. There is perhaps some relationship, in the solemn hieratic pose, to the St. Peter enthroned, dated 1307, which came from the church of S. Pier Maggiore in Florence to that of S. Simone (Berenson, Florentine Lists, 1963, fig. 90); but the attribution of that painting to the Cecilia Master seems far from obvious. Rather closer seems to be the relationship to certain works of the master identified by Professor Offner as 'Lippus Benevieni' (or Lippo di Benevieni), concerning whom there are documents in 1296, 1314 and (probably) 1327 in the Florentine State Archives. See especially the *Baptist*, half length, in the collection of Mr. Maurice Salomon, New York (Offner, *Corpus*, sec. III, vol. VI, 1956, p. 42), which belongs to other panels in the Acton Collection and at Ottawa. The last was once attributed, like the Christ Church *Baptist*, to the close following of the Cecilia Master.[1] Professor Roberto Longhi, in reviewing the Royal Academy exhibition of 1959/60 (*Paragone*, no. 125, May 1960, p. 59), comments on the Christ Church picture: '*E l'importante maestoso dipinto proveniente da S. Maria degli Ughi. Nessun rapporto altro che di generazione col Maestro di Santa Cecilia. Di altro nobilissimo maestro fiorentino protogiottesco, probabilmente operoso in Umbria.*'

1. I am indebted for this hint to Mr. Philip Pouncey.

The author of the text of *L' Etruria Pittrice*, after remarking that the saint is giving the blessing '*pressappoco alla greca*' (but with a 'capricious variation' in the position of the fingers), goes on to say that the same figure occurs on the gold florin of the Republic as first struck in 1252. There is in fact no example of a seated figure of the Baptist on any gold florin illustrated in *Corpus Nummorum Italicorum* (vol. 12, 1930); though a somewhat similar figure appears on Florentine silver coins as early as the *fiorino guelfo* of 1318–1321 (*ibid.* vol. 12, pl. 15, no. 24), and is common in the XV and early XVI centuries.

On S. Maria degli Ughi, see W. and E. Paatz, *Die Kirchen von Florenz*, 1952, vol. IV, p. 71 *ss.* The building was secularized in 1785, when the pictures were no doubt disposed of. It was restored as a church in 1816, but pulled down *c.* 1890.

The picture was cleaned by H. Buttery in 1959, and apart from slight damage at the tip of the nose is in good condition.

Exhibited: Manchester, 1857, no. 13; Royal Academy, 1959–60, no. 280; Liverpool, 1964, no. 20.

Literature: Borenius Cat., 1916, no. 6 and pl. 1.
W. Bürger, *Trésors d'Art en Angleterre*, 1865, p. 21; W. Suida, *Monatshefte für Kunstwissenschaft*, VII, 3, and *Burlington Magazine*, vol. 37, 1920, p. 177 (as The Master of St. Cecilia); Van Marle, III, 1924, pp. 276, 277 and 287 (as the same); R. Offner, *Corpus of Florentine Painting*, sec. III, vol. I, 1933, pp. 55, 56, 120 and pl. XIII (as Close Following of the Cecilia Master); Berenson, Florentine Lists, 1963, p. 145 (as Studio of the Cecilia Master).

FLORENTINE SCHOOL
c. 1340–50

5. FOUR MUSICAL ANGELS, kneeling at the foot of a throne, with part of the figures of St. John the Baptist (in hair-shirt and mauve cloak) left, and of a Saint carrying a banner and book right. A fragment. Panel, 44 × 53.3 cm.

Plates 6–7

Fox-Strangways Gift, 1828.

Klara Steinweg, in *Mitteilungen des Kunsthistorischen Institutes in Florenz*, vol. 10, pt. II, Dec. 1961, pp. 122–153, published a reconstruction of a *Coronation of the Virgin* in the collection of Heinz Kisters at Kreuzlingen (Offner, *Corpus*, sec. III, vol. VIII, 1958, p. 150, pl. XL: 'close to the Assistant of Daddi'), in which our fragment appears as the lower part (see Figures 2 and 2a). Traces of the heads and haloes of the two saints, whose bodies are partly visible in the Christ Church fragment, were revealed by X-rays at the base of the Kisters picture, where restoration had obviously occurred.

Since the connexion with the Kisters *Coronation* may be taken as certain, the old attribution to Taddeo Gaddi,

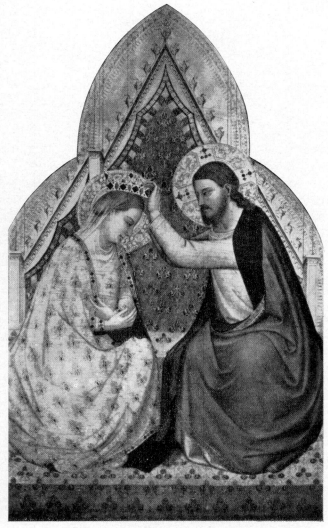

Fig. 2. Florentine, *c.* 1340–50: *The Coronation of the Virgin.*
Kreuzlingen, H. Kisters Collection (*Cf.* Cat. No. 5)

Fig. 2-a. Reconstruction by Dr. Klara Steinweg of
The Coronation of the Virgin (*Cf.* Cat. No. 5)

which had some support in comparatively recent times, must be abandoned; the *Coronation* is certainly not by him, and indeed both fragments are much less Giottesque than anything of Taddeo's. But the exact attribution remains uncertain. Berenson's view, that the Christ Church angels are by Andrea di Cione, called Orcagna (active 1343/4–1368), the elder brother of Jacopo di Cione (see this Cat., No. 6), is not immediately convincing,[1] though Dr. Klara Steinweg, in her reconstruction of the whole picture, calls it 'Orcagnesque', and dates it *c.* 1345, a very early date for Orcagna himself. Offner's attribution to that close disciple of Bernardo Daddi whom he names 'The Assistant of Daddi' seems to me still the most enlightening, in so far as it draws attention to the resemblances between the Kisters/Christ Church *Coronation* and the polyptych with the same subject surrounded by Saints in the Accademia, Florence – the principal work given by Offner to that master (*Corpus*, sec. III, vol. V, 1947, pl. XXII). I see also striking resem-

blances between our musical angels and those attending the Virgin in Daddi's own S. Pancrazio polyptych now in the Uffizi.[2] In the spandrels of the centre panel of that work again are four angels looking down to adore the Virgin, whose heads[3] are remarkably similar to those of the two playing the organ in the Christ Church fragment.

Dr. Steinweg, however, insists that certain features in the Kisters/Christ Church *Coronation* – particularly the way the group of angels is no longer conceived in such direct relationship to the scene above – reveal a more advanced style than that of 'The Assistant of Daddi', whom Offner presents as an archaiser. If we could suppose, on the other hand, that the 'Assistant' was a young disciple, and if, as Berenson suspected, Orcagna was Daddi's pupil, then there might be some ground for considering our *Coronation* an early work of Andrea Orcagna himself.

Cleaned by H. Buttery, 1960. The condition is very good.

1. Contrast the musical angels in the Strozzi altarpiece at S. Maria Novella, signed and dated by Orcagna in 1357.

2. See especially Offner, *Corpus*, section III, vol. III, 1930, pl. XIV[8].
3. Very well reproduced in Offner, *loc. cit.*, pl. XIV[9].

Exhibited: Manchester, 1857, no. 17; Liverpool, 1964, no. 33.

Literature: 1833 Cat., no. 113 (as Giottino or Gaddi); Borenius Cat. 1916, no. 7, pl. II (as Florentine, *c.* 1340). Suida, *Monatshefte für Kunstwissenschaft*, VII, p. 3 (as probably studio of Giotto); Van Marle, III, 1924, p. 321 (as Taddeo Gaddi); Philip Hendy, *Burlington Magazine*, vol. 52, 1928, p. 295 (as Taddeo Gaddi); Offner, *Corpus*, sec. III, vol. V (1947), pp. 115–116 and pl. XXIV (as by 'the Assistant of Daddi'); Berenson, Lists, 1932, p. 403; Florentine Lists, 1963, p. 163 (both as Orcagna).

JACOPO DI CIONE
mentioned 1365–98

Jacopo, the youngest of the Cione brothers, was probably active considerably before his earliest documentation, and survived his brothers Nardo (d. 1366) and Andrea (d. 1368) by more than thirty years. A pupil and assistant of his brother Andrea, he collaborated later with Niccolò di Pietro Gerini (see nos. 8 and 9). The altarpiece with the *Coronation of the Virgin* formerly in S. Pier Maggiore in Florence, the greater part of which is now in the National Gallery, London (nos. 569, 570–578), is ascribed to him by most authorities, and is probably his most important surviving work.

6. ST. PETER, HALF-LENGTH, with part of the arm of another figure (in a mauvish cloak) to L. Panel, 67·2 × 45 cm. Plate 8

Label at back: 'Cimabue'.

Fox-Strangways Gift (1834?) (not in 1833 Cat.).

Published for the first time as Jacopo di Cione by Offner in a review of the *Mostra Tesoro di Firenze Sacra*, in the *Burlington Magazine*, vol. 63, 1933, p. 84, footnote 59, and pl. III D.

Obviously part of the L.-hand wing of a triptych, originally containing two Saints, full length. Borenius considered this as part of the same altarpiece as no. 8. The width measurement is the same, but I see no other connexion. In fact Offner's attribution is almost certainly correct. There is a striking resemblance between the Christ Church St. Peter and the same Saint in the L. wing of the *Coronation* altarpiece from S. Pier Maggiore, Florence, now in the National Gallery (no. 569), which is catalogued by Martin Davies as 'style of Orcagna', but in the opinion of most authorities is by Jacopo di Cione, Orcagna's youngest brother (see the bibliography in Offner, *op. cit.*, pp. 43–47). A detail of that head of St. Peter is given in Offner (pl. III[8]). Similar heads of St. Peter occur also in the predella pieces of the same altarpiece, which are now dispersed (*e.g.* Johnson Collection, Philadelphia, and with L. Koetser, London, 1964) (Offner, pls. III, 25–27 and 29); all show the

same curious treatment of the hair, like cottage thatch, which the artist seems to have reserved for this saint only. A halo of almost identical pattern surrounds the head of the Virgin in the centre panel of the same work. The S. Pier Maggiore altarpiece was painted 1370–71.

The panel was cleaned by Horace Buttery early in 1962. There is a good deal of rubbing, revealing red ground, in the gold background and especially in the key; some, but not much, in the flesh (in the darks and half-tones). There is now practically no repaint, restoration being confined to local damages, as at the top R. corner.

Exhibited: Manchester 1857, no. 36.

Literature: Borenius Cat., 1916, no. 10 (as Florentine, *c.* 1350).
Richard Offner and Klara Steinweg, *Corpus of Florentine Painting*, sec. IV, vol. III, 1965, p. 84 and pl. V.

FLORENTINE SCHOOL
c. 1360

7. THE CORONATION OF THE VIRGIN, with sixteen Saints standing or kneeling; above, God the Father and four Angels half length; below, in the predella, The Man of Sorrows with the Virgin and St. John, between two blank Shields. Panel, arched top; the whole, including the original framework, 91·1 × 48 cm. (main subject, 74·5 × 42·5 cm). Plate 9

Landor-Duke Gift, 1897.

The late Professor Offner was kind enough to send me in 1960 a list of ten other works which he believed to be by this artist, whom he named the 'Master of the Christ Church Coronation'.[1] Some of the paintings to which Offner referred were in the hands of dealers or private collectors, and are unknown to me; but one, a representation of the same subject as ours with eighteen surrounding saints and two musical angels kneeling in front, is now at the Philbrook Art Center at Tulsa, Oklahoma (from the Kress Collection).[2] This is very close to ours in composition, style and types, but shows the Coronation taking place under a graceful Giottesque canopy. Other paintings, which both Offner and Federico Zeri agree are by the same hand, are in the Museums of Dieppe (no. 80, *Virgin and Child with seventeen Saints and five Angels*), and San Diego, California (a Tabernacle, with the *Virgin and Child and four Saints*, *Christ on the Cross*, and *The Annunciation* above).

The central motive, especially the figure of the Virgin with her hands crossed low over her lap, derives from the famous Baroncelli altarpiece in Sta. Croce, which bears

1. I am uncertain whether he intended to use this appellation in his *Corpus of Italian Painting*. This group of paintings will be described in section IV of the *Corpus*. See Offner, *op. cit.*, sec. III, vol. V, p. 249.
2. Fern Rusk Shapley, *Kress Cat.*, 1966, p. 32 and fig. 32.

the signature of Giotto but may have been executed in his studio by Taddeo Gaddi (Berenson, *Florentine Lists*, 1963, pl. 63). The style of our picture (and of that from the Kress Collection) is old-fashioned, and the quality is not high; but the date may not be much later than the middle of the Trecento. Of the two pictures which W. Suida refers to very shortly as by the same hand as ours (*Monatshefte für Kunstwissenschaft*, vol. VII, 1914, p. 4), the *Coronation* in Altenburg (Oertel, *Cat.*, 1961, p. 116, no. 16) is surely by a rather better artist, more related in style both to Bernardo Daddi and to Orcagna.[1] Also superior, though related, is the much larger *Coronation* in the Bargello at Florence (Carrand Collection, no. 2009) which Dr. Zeri believes is by the same hand again.[2]

Cleaned by J. C. Deliss in 1965. Some severe cracks (especially through the drapery of the Saints lower R.) had to be filled in, and the draperies generally (of the Virgin and Christ particularly) were badly damaged; but the cleaning was remarkably successful, considering the previous state of the panel.

Literature: Borenius Cat., 1916, no. 11.

NICCOLÒ DI PIETRO GERINI
active 1368–1415

A typical exponent of debased Giottesque style, working in Florence, Pisa and Prato, who sometimes collaborated with other painters, Jacopo di Cione, Spinello, and especially his own son, Lorenzo di Niccolò. He died in 1415.

8. BUST OF THE VIRGIN, full face, with hands joined in prayer. Whole panel, 64·2 × 48·3 cm; picture surface, 59·2 × 44·2 cm. Plate 10

Label on back: 'Madonna di Cimabue'.

Fox-Strangways Gift, 1834 (?) (not in 1833 Cat.).

The face is over life-size, and the panel might be supposed to be part of a very large altarpiece; but in fact, as Mr. Horace Buttery pointed out to me when he cleaned it early in 1962, it is not cut below, since one can see the edge of the painted surface, and unpainted wood continuing beyond it, where the frame moulding is broken away at the bottom.

The attribution is Offner's, and surely right. Borenius' suggestion, that this is part of the same altarpiece as no. 6, which is by Jacopo di Cione, is certainly mistaken, though Niccolò did occasionally collaborate with that master.

A vertical crack through the outer corner of the R. eye

1. According to Offner (*Corpus*, sec. III, vol. V, pp. 235–237) it is from the studio of the 'Master of the Fabriano Altarpiece'.
2. Repr. Marcucci, *Gallerie Nazionali di Firenze*, 1965, no. 51, as Giottino (?).

widens upwards through the headdress and halo to the top, and downwards through the dress and the R. wrist to the bottom; but generally the painting is in good condition, and the gold background is almost perfect.

Literature: Borenius Cat., 1916, no. 9.
Crowe and Cavalcaselle, *Painting in Italy*, 2nd ed., I, 184, no. 2 ('by some late Giottesque'); R. Offner, *Studies in Florentine Painting*, 1927, p. 92, and *Burlington Magazine*, vol. 63, 1933, pp. 166, 169; Berenson, *Lists*, 1932, p. 396; *Florentine Lists*, 1963, p. 160.

NICCOLÒ DI PIETRO GERINI

9. ST. PHILIP. Panel, the painted surface arched above and cut at the top, 68 × 38·7 cm. Plate 11

Fox-Strangways Gift, 1828.

An excellent example of the artist, no doubt a fragment of a large altarpiece. According to Borenius, the late Earl of Ilchester thought it likely that this was originally part of the same altarpiece as two panels formerly at Abbotsbury Castle, one of *St. James the Greater*, the other of *SS. Catherine and Barbara*, which were destroyed by fire in 1913. Cleaned by H. Buttery in 1961. There is some damage on the R. upper arm, but the condition is generally very good. No doubt the figure was once full-length.

Exhibited: Manchester, 1857, no. 10 (as Giotto); Liverpool, 1964, no. 32.
Literature: 1833 Cat., no. 128 (as Giotto); Borenius Cat., 1916, no. 12, pl. IV.
Van Marle, III, 1924, pp. 614, 616 (as Niccolò di Pietro Gerini); Berenson, *Lists*, 1932, p. 396; *Florentine Lists*, 1963, p. 160 (the same).

FLORENTINE SCHOOL, LATE XIV CENTURY

10. THE VIRGIN AND CHILD ENTHRONED, with a female Saint (Margaret?) (crowned, holding cross and book) and St. Julian R., SS. Anthony Abbot and John Baptist L.; two angels holding a brocaded canopy behind. Panel, arched top, overall, 102·5 × 60·7 (painted surface, 94 × 52·4) cm. Plate 13

Landor-Duke Gift, 1897.

Label at back: 'Cimabue'.

The painting, which is in badly damaged condition, was cleaned and restored by Miss Lucy Rothenstein in 1959. In the face of the Child, particularly, very little of the original paint remains, and the gold background is much rubbed.

The condition makes it hard to judge, but this seems almost certainly to be by the artist whom Berenson called the 'Master of the Arte della Lana Coronation' (from a tabernacle in the Palazzo dell' Arte della Lana at Florence). See Berenson, Florentine Lists, 1963, p. 138 and pls. 382–385, especially the altarpiece in the Vatican Gallery (pl. 385). He was evidently a follower of Niccolò di Pietro Gerini, and according to Berenson the group of paintings so named may be early works of his son, Lorenzo di Niccolò, who is recorded 1391–1411.

The present picture is not included in Berenson's Lists, 1932 or 1963.

Literature: Borenius Cat., 1916, no. 13 (as Florentine, second half of XIV century).

TUSCAN SCHOOL, LATE XIV CENTURY

11. VIRGIN AND CHILD ENTHRONED: in a medallion above, Christ blessing. Panel, whole, 102·2 × 47·2 cm.; main subject, 74·7 × 45 cm. Plate 12

Landor-Duke Gift, 1897.

There seems to be no justification for Berenson's attribution of this panel to Spinello. Dr. Federico Zeri believes,

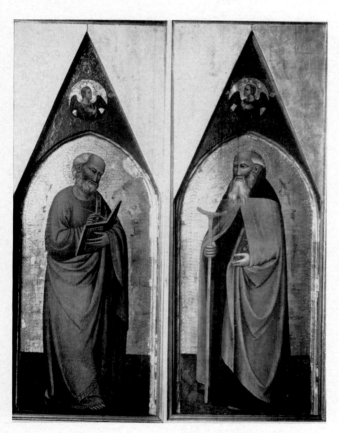

Fig. 3. Tuscan School, late XIV century: *Saints John Evangelist and Anthony Abbot.* Altenburg Gallery (*Cf.* Cat. No. 11)

with good reason, that two panels representing St. John the Evangelist and St. Anthony Abbot in the Altenburg Gallery (cat., 1961, p. 118, nos. 30–31, attributed to the Florentine School) (Figure 3), formed the side panels of our Madonna. They are of appropriate dimensions,[1] the tooling of the gold backgrounds and haloes is the same, and so is what remains of the arabesque pattern surrounding the roundels in the cusps. The long slit eyes, the hands, the inflated forms, are notably similar.

Cleaned and restored by J. C. Deliss, 1963. The flesh parts and the gold background are in very good condition, the Virgin's robe is much damaged; so too is the arabesque pattern enclosing the roundel above.

Exhibited: Liverpool, 1964, no. 42.

Literature: Borenius Cat. 1916, no. 8, pl. III (as Florentine, c. 1350).

Suida, *Monatshefte für Kunstwissenschaft,* VII, p. 4 ('Master of the S. Spirito altarpiece'); Berenson, Lists, 1932, p. 545; Florentine Lists, 1963; p. 205; in both as Spinello (g.p.).

TUSCAN SCHOOL, LATE XIV CENTURY

12. THE VIRGIN AND CHILD, SEATED ON CLOUDS, with a *Mandorla* of winged Cherubs' Heads above, SS. Lawrence and James on L., and Catherine and Anthony Abbot on R. Panel, ogival, picture surface 65·5 × 43·5 cm., including frame, 98 × 51·5 cm. Figure 4

The frame is for the most part original and of fine quality, but the twisted columns to R. and L., which were missing, have been restored. Label at back: 'Taddeo Gaddi'.

Fox-Strangways Gift, 1828.

A rather crude painting, probably by a provincial artist, remotely influenced by Bernardo Daddi. A *Madonna enthroned with Four Saints* in the church of S. Martino dei Buonomini at Florence (*Dedalo,* vol. VIII, 1928, p. 630) might be by the same hand.

The condition is fair; there are some worm-holes, and some surface rubbing in the flesh parts and the light foreground. An obviously false signature: 'GIOTTO DI BONDONE F.' between the grid of St. Lawrence and the wheel of St. Catherine disappeared during cleaning by Miss J. Pouncey June/July 1965.

Literature: 1833 Cat., no. 120 (as Giotto); Borenius Cat., 1916, no. 15 (as Florentine, late XIV century).

Crowe and Cavalcaselle, *Painting in Italy,* 2nd ed., vol. II, p. 112.

1. In fact, slightly smaller, according to the Altenburg Cat.: 92·5 × 35·5 and 93 × 35 respectively (main subjects, 69 × 33 and 69 × 32·5). But the difference would not be incompatible, considering that these are side panels. It is possible that there were once further panels to R. and L.

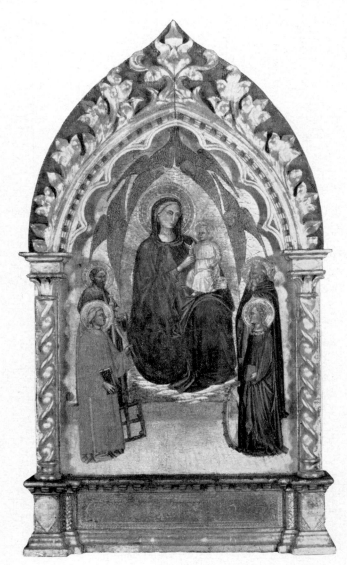

Fig. 4. Tuscan School, late XIV century:
The Virgin and Child with four Saints (Cat. No. 12)

TUSCAN SCHOOL, LATE XIV CENTURY

13. The Virgin and Child enthroned, with eleven Apostles and four musical Angels. Panel, arched top, 74·7 × 40·3 cm. Figure 5

Landor-Duke Gift, 1897.

Label at back with attribution to Giottino. Inscribed on back of panel: 'Antica Scuola Senese'.

The picture is much damaged and restored, but is in any case of very poor quality, somewhat related in style to no. 12, and no doubt by a provincial artist. Dr. Zeri confirms my impression that a *Madonna enthroned with four Saints*, no. 21 in the Museo Bandini, Florence, may be by the same hand.

Tested by J. C. Deliss, 1964.

Literature: Borenius Cat., 1916, no. 14.

FLORENTINE, LATE XIV CENTURY (MASTER OF THE STRAUS MADONNA)

14. St. John the Baptist. Panel, 99·2 × 26·8 cm.

Landor-Duke Gift, 1897. Plate 14a

As Borenius remarks, Suida's attribution (see below) involves much too early a dating for this and no. 15. They seem in fact to be by the same hand as an altarpiece in the Walters Gallery at Baltimore (no. 37. 729), by a follower of Agnolo Gaddi called (by Offner) the 'Master of the Straus Madonna'. Smaller Madonnas attributed to him by Berenson are in the Museum of Houston, Texas (from the Straus Collection), and in the Bargello at Florence. All

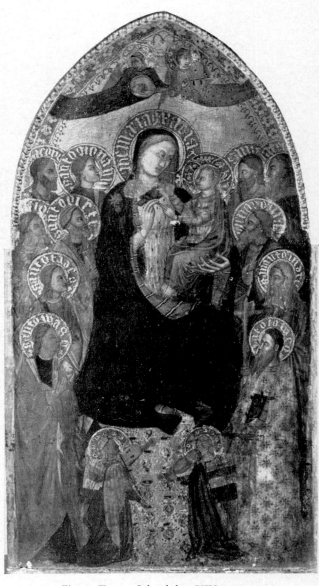

Fig. 5. Tuscan School, late XIV century:
The Virgin and Child with Apostles and musical Angels (Cat. No. 13)

have the same patterned halo as the Christ Church St. Dominic (Berenson, Florentine Lists, 1963, figs. 355, 357 and 358). For a note on the master, and other attributions, see R. Offner in *Burlington Magazine*, vol. 63, 1933, p. 170. It is possible that two panels in the Vatican Gallery, with Sta. Eustacia and Sta. Paola (nos. 1 and 3, 'Scuola Fiorentina s. XIV'), both holding scrolls, with gold backgrounds and roughly marbled floors, were originally part of the same altarpiece as ours – if we may suppose that our panels are a little cut at the top, and the others a little below. The frames of the Christ Church panels are modern.

Both panels were cleaned by H. Buttery in 1955, when the black backgrounds were removed, and the original gold revealed. This is much damaged, but in general the present condition is very fair.

Exhibited: Liverpool, 1964, no. 21.

Literature: Borenius Cat., 1916, no. 16.
Suida, *Monatshefte für Kunstwissenschaft*, VII, p. 3 (as Pacino di Buonaguida, Florentine, early XIV century); Van Marle, III, 1924, p. 250.

FLORENTINE,
LATE XIV CENTURY
(MASTER OF THE STRAUS
MADONNA)

15. ST. DOMINIC. Panel, 99·3 × 30·3 cm. Plate 14b

Landor-Duke Gift, 1897.

Companion panel to no. 14, and probably part of a large altarpiece.

Exhibited: Liverpool, 1964, no. 22.

Literature: Borenius Cat., 1916, no. 17.

STUDIO OF
MARIOTTO DI NARDO
recorded 1394–1431

A decadent Giottesque, following Niccolò di Pietro Gerini.

16. THE VIRGIN WITH THE CHILD HOLDING A ROSE, in a *Mandorla* of winged Cherubs' Heads, with six Saints and two musical Angels below. Panel, arched top, including the frame, 105 × 49·3 cm.; picture surface only, 75 × 44·5 cm. Figure 6

Fox-Strangways Gift, 1828.

The frame is at least partly original, and there are two coats-of-arms at the lower corners: L., that of the Albizzi family; R., unidentified (or, a cross sable, five stars of the first).

This feeble little picture is attributed to Mariotto di Nardo by Berenson, as well as by Sirén and the late Hans Gronau

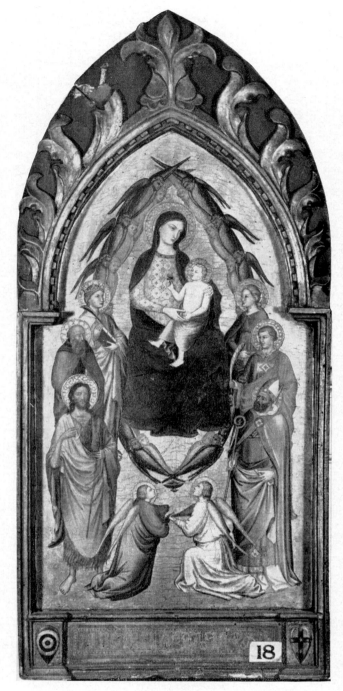

Fig. 6. Studio of Mariotto di Nardo: *The Virgin and Child with six Saints and musical Angels* (Cat. No. 16)

(verbally); but Van Marle (*loc. cit.*) and Offner (verbal opinion) thought it too weak for Mariotto himself, and it seems in fact to be no more than a studio work.

The picture was cleaned by H. Buttery in 1939. The condition is generally good.

Literature: 1833 Cat., no. 122 ('T. Gaddi'); Borenius Cat., 1916, no. 18 (as Florentine, early XV century).
O. Sirén, *Burlington Magazine*, XXVI, 108 (as Mariotto di Nardo); Van Marle, IX (1927), 219 and 255; Berenson, Lists, 1932, p. 332; Florentine Lists, 1963, p. 132.

TUSCAN SCHOOL, EARLY XV CENTURY

17. THE VIRGIN AND CHILD SEATED ON A CUSHION (Madonna of Humility). Panel, arched top, 80·2 × 46·5 cm.

Plate 15

Landor-Duke Gift, 1897.

Label at back: 'Ugolino Sanese'.

Berenson attributes the painting to Lorenzo di Niccolò di Pietro Gerini. It seems, however, more provincial and individual, less in the late Giottesque manner of Florence, than the work of that third-rate traditionalist; and in the drapery there is something of Lorenzo Monaco, though the clumsy forms – long upper lip, wide mouth, thick fingers – are far from the elegance of that master. But the colour is gay, and the painting has a certain naïve charm. Dr. Federico Zeri has drawn my attention to a group of paintings which seem certainly to be by the same hand, though inferior to ours: they include another *Madonna of Humility*, with a brocade curtain behind, no. 178 in the Vatican Gallery (not exhibited at present), and certain other works in which the characteristics I have referred to are even more exaggerated. In several of these the artist has represented the Madonna of Humility as here, with the drapery and cushion arranged so that she appears at first sight to be enthroned, rather than seated on the ground. Dr. Zeri believes he was a follower of Agnolo Gaddi, rather close to Cenno di Ser Cenni, who is documented in 1415, and painted extensively in fresco in S. Francesco at Volterra (see Berenson, Florentine Lists, 1963, I, p. 47). The panel was cleaned by Miss Jacqueline Pouncey in July 1965, and is in very fair condition; there are only slight local restorations.

Literature: Borenius Cat., 1916, no. 19 and pl. v (as School of Lorenzo Monaco).
Van Marle, IX (1927), p. 177; Berenson, Lists, 1932, p. 303; Florentine Lists, 1963, p. 123 (in both as Lorenzo di Niccolò).

Sirén's later attempt to identify the master with Parri Spinelli (*Burlington Magazine, loc. cit.*) is unacceptable, though he belongs to the same group of late Gothic artists working in Florence about the first quarter of the XV century. Berenson (*loc. cit.*, 1963) remarks: 'No other Italian artist came so near to the Franco-Flemish, Valencian and German painters practising before the triumph of the Van Eycks'; and Professor Longhi (*Paragone*, 1965, no. 185, pp. 38–40) goes so far as to suggest an identification with the Valencian Miguel Alcañiz.[1] In any case it seems probable that this excellent painter was not of Italian origin, and at least plausible that he was Spanish. The motive of the Madonna of Humility, with the Virgin seated on the ground, occurs frequently in Northern art. Other Madonnas of Humility by the master are recorded by Berenson in the Uffizi (no. 6270), in the Museo Horne in Florence (no. 99) and in the Lederer Collection, Vienna (Berenson, 1963, fig. 471). In the last the headdress of the Virgin is very similar to that in our picture.

Cleaning by H. Buttery (1960) revealed that the gold border of the Virgin's robe and the star on her shoulder were false, and these additions were removed. The general condition is good. The panel, in its present form, is rectangular above, but two triangular insertions, top R. and L., show that it was originally pointed and that the point has been cut off. The top corners of the front surface, now under the frame, are gilt and decorated with incised rays; but these are coarsely tooled, obviously not original, and it is clear that the composition was designed for an ogival frame, approximately on the lines of the present one, but more acutely pointed above.

Exhibited: London, Matthiesen Gallery, 1960, cat. no. 9, pl. II; Liverpool, 1964, no. 29.

Literature: Borenius Cat., 1916, no. 20, pl. VI.
O. Sirén, *Burlington Magazine*, vol. 25, 1914, p. 24; Van Marle, IX, 1927, p. 198; A. Colasanti, *Bollettino d' Arte*, 27, 1933/34, pp. 155, 337 *ss.*; Berenson, Lists, 1932, p. 340; Florentine Lists, 1963, p. 140.

THE MASTER OF THE BAMBINO VISPO
working in Florence, early XV century

18. THE VIRGIN AND CHILD SEATED ON A CUSHION (Madonna of Humility). Panel, 83 × 50·5 cm. (the pointed arch cut at the top).

Plate 16

Fox-Strangways Gift, 1834 (?) (not in 1833 Cat.).

A particularly good and characteristic example of this anonymous master, whom Sirén was the first to distinguish under this name (on account of the lively type of Child Christ which occurs in many of his works).

ROSSELLO DI JACOPO FRANCHI
c. 1376–1456

Florentine School, an archaizer, maintaining the style and gay colouring of Lorenzo Monaco and the Florentine miniaturists throughout the first half of the XV century. Documented as his are the miniatures of one of the choir-books in the Duomo at Prato (1429).

19. FAITH. Whole panel, 49·5 × 53·5 cm.; picture surface, 41·8 × 46 cm.

Figure 7

1. For the difficulties involved in this identification, see Post, *History of Spanish Painting*, vol. 13 (1966), Appendix, p. 310.

Fig. 7. Rossello di Jacopo Franchi: *Faith* (Cat. No. 19)

Old label: 'Margheritone Aretino fecit (?) 1316'.
Landor-Duke Gift, 1897.

Perhaps one of a series, rather roughly painted to decorate the wall of a small chapel, or the end panel of a *cassone*. The style is typical of the late Gothic artists of Florence working in the earlier decades of the XV century, apparently undisturbed by the more modern vision of Masaccio. Haloes of the same curious shape as here (like an open umbrella) occur in a *cassone* panel of *The Seven Liberal Arts* by another painter of the same group, Giovanni dal Ponte, in the Prado at Madrid (Berenson, Florentine Lists, 1963, pl. 487); but the head in our picture is typical of Rossello.
Somewhat rubbed, and much darkened by old varnish. Lightly cleaned by J. C. Deliss in 1962.

Literature: Borenius Cat., 1916, no. 30 (as Florentine, first half of XV century).

STUDIO OF FRA ANGELICO
c. 1387–1455

Guido di Pietro, commonly known as Fra Giovanni Angelico, il Beato Angelico or simply Fra Angelico, was born probably in 1387 near Florence, and entered the Dominican monastery at Fiesole in 1407. Between 1436 and 1443 he was continuously engaged as a painter at the church and monastery of S. Marco in Florence (now a museum of Fra Angelico's work), decorating in fresco the chapter-house, the monks' cells and the corridors, besides painting various altarpieces. He was in Rome three times towards the end of his life, and painted the frescoes in the chapel of Nicholas V in the Vatican. He died in Rome and was buried there, 1455.

A profoundly religious painter, deriving his exquisite workmanship from the miniaturists of the school of Lorenzo Monaco, not an innovator himself, but by the end of his career by no means untouched by the influence of the early Renaissance style in Florence. He had a large following among painters and miniaturists, and the attribution and dating of certain supposedly early works is still widely disputed.

20. A SMALL TRIPTYCH. Centre-piece: the Virgin and Child seated before a brocade Curtain, with four Saints (L., St. Dominic standing, St. Thomas Aquinas kneeling; R., St. John Baptist standing, St. Peter Martyr kneeling, presenting a Child to the Virgin); an Angel playing the violin between the two kneeling Saints. L. wing: Christ carrying the Cross, with Soldiers and the Holy Women; the Angel of the Annunciation above. R. wing: Christ Crucified, with the Magdalen kneeling, clasping the Cross, and a Dominican *Beata* kneeling in profile on L.; the Virgin Annunciate above. Panel, centre-piece 38·3 × 20 cm.; L. wing, width, 10·9; R. wing, 11·4 cm.

Plates 17–18

Fox-Strangways Gift (1834?) (not identifiable in 1833 Cat.).

This charming little triptych, a production of the immediate school of Fra Angelico, had been entirely disregarded since Borenius suggested in his catalogue that it was no more than a late imitation, a sort of forgery of a Florentine work of the XV century. This seemed unlikely, in view of the fact that it was presented by Fox-Strangways in 1834 (if not in 1828), and must have been acquired by him at a time when very few collectors interested themselves in paintings of the Trecento or Quattrocento and it was probably easier for a dealer to find such a picture than to forge it. Closer examination, and some tests, with the help of an X-ray photograph, made by Mr. Rees-Jones at the Courtauld Institute, showed that it was in fact a genuine painting of the mid XV century. Perhaps because the three original panels were badly worm-eaten, they had been planed down and backed by a single rectangular panel. Then, to conceal the joins, two pilasters had been painted in to R. and L. of the main compartment; and to fill the two triangular sections of wood which had to be inserted above to make up the rectangle, two tablets were added, in pseudo-Renaissance style. This in turn had necessitated the repainting and varnishing of most of the rest, and the resulting *craquelure* was such as at least to account for, if not entirely to excuse, the adverse judgement of Borenius. All old varnish and repaint were removed by J. C. Deliss in 1965/66, and the panel was restored to its original triptych form. Now that the wings are again separate from the centre part, the damage at the edges of all three compartments is less obtrusive; indeed the general condition is by no means bad, and almost all the heads are intact. In the centre panel, there is serious damage along the bottom

edge and in the Virgin's dark blue robe, and the hair and neck of the kneeling angel are somewhat rubbed. In the L. wing, there are damages across the legs and about the helmet of the soldier leading the procession, who turns his back; in the robe of the Virgin, extreme L.; below the waist of the soldier L. of Christ; and at the extreme edges all round. The R. wing is on the whole better preserved, but the lower part of the Nun's robe is damaged at extreme L., and both hands of Christ are destroyed. Owing to the planing-down of the wood at the back, no trace of painting remains on the outside of the two wings, if such ever existed.

The colour throughout is brilliant, and typical of Fra Angelico's studio; but the quality of the painting in the wings, especially the R. wing and the Annunciation above, is noticeably inferior to that in the centre panel; these parts must be by some second-rate assistant of Fra Angelico.[1] The centre panel (and, so far as I can judge, the *Carrying of the Cross* in the L. wing) is decidedly better, the heads of the Virgin and of St. Thomas Aquinas being particularly beautiful. Whether any part can be attributed to Fra Angelico must depend to some extent on the attribution of more familiar works, previously supposed to be his, and anciently documented as such, which Mr. Pope-Hennessy nevertheless believes to be by the miniaturist Zanobi Strozzi, a close associate of Angelico himself: I mean the four small reliquaries from Sta. Maria Novella, representing (1) the *Virgin and Child standing* ('*Madonna della Stella*'), (2) the *Annunciation and the Adoration of the Magi*, (3) the *Coronation of the Virgin*, and (4) the *Dormition and Assumption of the Virgin*, the three first in the Museo di San Marco, the last in the Gardner Museum at Boston. Of these Mr. Pope-Hennessy (*Fra Angelico*, Phaidon, 1952, pp. 199–200) says 'all four are by Zanobi Strozzi', and suggests a date *c.* 1435/40. Angelico's authorship, on the other hand, is maintained by most earlier writers, and if they are his they must be dated much earlier. But there is in fact some difficulty in fitting these four reliquaries, and other related works, into Angelico's chronology at any point. The Virgin and Child, for instance, in the *Madonna della Stella*, or those in the predella of the reliquary with the *Annunciation and the Adoration of the Magi* are much less anaemic than those of Angelico's best established Madonna-pieces, whether early or late; the types generally in these reliquaries are stocky, round-faced, almost Masacciesque.

It is to the works of this supposed Strozzi that the Christ Church triptych is most nearly related, and the best parts of our painting might be by that hand. The Virgin bears a strong resemblance to the Virgin in the two reliquaries to which I have just referred; the Child, in his long dress, clasping his mother's neck, is full-faced and short-haired, a 'Masaccio', or at least a 'Masolino', rather than an 'Angelico' type; and the St. John is of a type that occurs

among the Apostles surrounding the Virgin's deathbed in the reliquary at Boston.

Dr. F. Zeri has been good enough to inform me that a free derivation (almost a copy) from our triptych is in the Johnson Collection, no. 2034, in the Museum of Philadelphia.

Literature: Borenius Cat., 1916, no. 47 (as late Imitation of Florentine XV century School).

TUSCAN SCHOOL
c. 1440–50

21–29. SCENES FROM THE LIVES OF THE HERMITS. All on panel, fragments of irregular dimensions, average approximately 34 × 44 cm. Plates 22–30

Landor-Duke Gift, 1897.

Borenius's short note on these nine panels is correct so far as it goes: they are, as he surmised, fragments of a large panel, resembling one of the same subject in the Uffizi at Florence (no. 447) and two in the possession of the Earl of Crawford at Balcarres; and, as he said, our fragments had all been made up to a standard size by coarsely painted additions. But much has been discovered about their origin and connexions since the Borenius Catalogue was published in 1916; and the later additions to the Christ Church fragments have recently been removed.

Besides the nine pieces here, ten others in three different collections originally belonged to the same panel: eight in the Kunsthaus at Zürich (exhibited Wildenstein, London, *Painting in Florence and Siena 1250–1500*, Feb.–April 1965, cat. nos. 40–47), one in the Jarves Collection at Yale University (Sirén, cat., 1916, no. 37, and *Addenda*, p. 280), and one at Edinburgh in the National Gallery of Scotland (cat. 1957, no. 1528). These nineteen pieces appear to make up the whole composition, with only small strips missing. A valuable reconstruction of the whole picture, as it once was, was published by Miss Ellen Callmann in the *Burlington Magazine*, May 1957 (*A Quattrocento Jig-saw*) (see p. 41).

There are several such representations of the Lives of the Hermits in Tuscan art from the mid XIV to the mid XV century; most famous is the enormous fresco in the Campo Santo at Pisa, now attributed to Francesco Traini and his assistants (see Enzo Carli, *La Pittura Pisana del Trecento*, 1959, vol. I, pp. 50 *ss*.). The subjects depicted are derived from the Lives of the Fathers (*Vitae Patrum*), a compilation of legends by Palladius, St. Jerome and others, of which an abridged Italian version, attributed to Domenico Cavalca, was produced at the beginning of the XIV century, and several printed versions appeared before the end of the XV. For the iconography, I quote E. Wallis Budge, *The Paradise of the Holy Fathers* (revised ed., 1907), from which I have been able to identify most of the scenes in our

1. Contrast the Angel Gabriel with the fragment by Angelico himself, once in the Walter Gay Collection and now in the Louvre (Schottmüller, *Klassiker der Kunst, Angelico*, 2nd ed., 1924, p. 35).

Tuscan School, c. 1440–50: *Scenes from the Lives of the Hermits*. Reconstruction based on the reconstruction published by Miss Ellen Callmann in the *Burlington Magazine*, May 1957.

Top row: Zürich no. 1455. – Zürich no. 1456. – Christ Church Cat. no. 21. – Zürich no. 23. – Zürich no. 1458. – Christ Church Cat. no. 22.

Middle row: Zürich no. 1457; below, Christ Church Cat. no. 1663. – Zürich no. 1528. – Edinburgh no. 1455. – Christ Church Cat.no. 25. – Christ Church Cat. no. 24; below, Christ Church Cat. no. 26. – Zürich no. 1661.

Bottom row: Yale no. 1871.37. – Zürich no. 1662. – Christ Church Cat. no. 27. – Christ Church Cat. no. 28. – Zürich no. 1664. – Christ Church Cat. no. 29.

fragments, since this is a convenient and accessible work, though the manuscript there published was not of course available to the painters with whom we are concerned, or to those who dictated their subjects to them.

An interesting article by J. R. Martin in *Art Bulletin*, 1951, vol. XXXIII, pp. 217 *ss.*, *The Death of Ephraim, in Byzantine and early Italian Painting*, shows that *The Death of Ephraim* was a popular subject in Byzantine art. It occurs in the dismembered panel with which we are concerned (the fragment now at Edinburgh); also in that in the Uffizi and in both those belonging to Lord Crawford, and it may be reckoned in some degree the *clou* of the composition as a whole. Since St. Ephraim himself was a Syrian, and since various other saints and hermits appear who were Syrian, Palestinian or even Italian (Malchus the monk, Benedict, Jerome), the title *Thebaid* so often applied to these panels, referring to that part of the Egyptian desert where many of the early hermits lived, is not exact: not all the incidents are to be identified in the *Lausiac History of Palladius*, or the *Sayings of the Fathers* (both included in Sir Wallis Budge's publication), which deal chiefly with the hermits of the Thebaid and the other Egyptian deserts. It may therefore be better to abandon the specific title. There is no doubt that by the middle of the XV century various sources of monastic history had acquired a common currency; and the inclusion of St. Benedict in all the paintings to which I have referred may in fact imply some intention to bring the series of the Lives of the Hermits up to date.

The panel to which the Christ Church pictures belonged must have been cut into the present fragments in Italy, and sold piecemeal, more than a hundred years ago. The Yale panel was among the pictures brought to the U.S.A. by John Jarves in 1860; and Walter Savage Landor, who owned the Christ Church and Edinburgh fragments, did most of his collecting during his first residence in Florence, from 1821 to 1835. The eight panels in Zürich, which were exported from Italy only in 1912, and were in the Chillingworth Sale at Lucerne in 1922 (lot 105), have been cleaned; but the additional pieces of wood, making them up to rectangular shape, with the surface roughly painted to imitate the original style of landscape, have been retained. The same is the case with the panel at Edinburgh, which was sold by W. S. Landor to William Bell Scott (b. 1811). The Yale authorities assure me that their panel is authentic throughout. The Christ Church panels were cleaned in 1961 by Mr. J. Deliss, who removed the false edges and introduced the neutral-coloured mounts to avoid irregular shapes; so that all that is now visible is original, except for some internal restoration where cracks and damages were revealed in the process of cleaning. All our fragments belong to the centre and R. hand side of the original panel as reconstructed by Miss Callmann; those with bright blue sky above were at the top; those showing grey-green water were towards the bottom, where a broad river flowed across the landscape. Several of our pieces were contiguous at some point, and between two of them the composition runs through (cat. no. 27 and 28).

Berenson, in his latest Florentine Lists (1963), includes the Uffizi panel and both Lord Crawford's panels in the same category as the Christ Church/Zürich/Edinburgh/Yale fragments, *i.e.* among *Unidentified Florentines c. 1420–1465*, and by implication suggests that our dismembered panel and the *larger* Crawford one (Berenson, *op. cit.*, vol. II, pl. 681 – the one reproduced by Miss Callmann with the wrong dimensions) are close to one another in style, if not by the same hand, since he characterizes both as 'between Giovanni di Francesco and Neri di Bicci'. That these two works (the larger Crawford panel and that now broken up between Christ Church, Zürich, Edinburgh and Yale) are very closely related, I think no one will dispute; the faces, the beards of the monks, and other details of the figures are the same in both, and where the same incident is depicted – for instance the black Abbâ Moses beaten by a devil (as in our no. 23 and towards the R. foreground of the larger panel at Balcarres) – the composition of the group is so similar that it cannot have been independently conceived. These two panels, in fact, may well have been painted by the same hand; for besides the resemblances in the figures, we find in both the same conventions for rocks and stones, trees and plants, and buildings. Since the larger Crawford panel is rather cruder in detail, I should suppose the dismembered panel to be the later.

The figures in the Uffizi painting are different, earlier in style, still sometimes reminiscent of Lorenzo Monaco, and the elegant stylization of the rocky landscape also recalls that master. The figures in the *smaller* Crawford painting are different again, more advanced in style, hinting at Uccello, Baldovinetti, even Filippo Lippi. Both these, in different ways, are superior in execution to the panel to which the Christ Church fragments belong, and to the *larger* one at Balcarres. And yet (as Lord Crawford has pointed out to me) there is enough that is common to all four works – in the details of trees and plants, in the curious method of 'spattering' the paint on the rocky ground, in the subject matter generally and in the composition of the various incidents – to make it possible that all are productions of one workshop, if only two are attributable to one hand. Master A, an established and skilful painter of the old school, might be supposed to be responsible for the earliest, the panel in the Uffizi; B, a promising but as yet unskilful apprentice might then have painted the larger Crawford panel and that which included our fragments; and finally C, influenced by a younger generation of Florentines, and with more talent than B, might have produced the smaller of Lord Crawford's two.

The style of our fragments, and of those which belong to the same panel, is popular, narrative, related to that of the *cassone* painters and the earliest Florentine line-engravers – such as the author of the series of *The Planets* (Hind, *Corpus of early Italian Engraving*, pls. 114–131). There is no reason

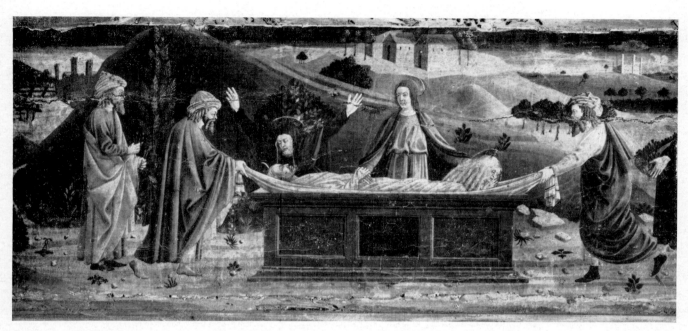

Fig. 8. Tuscan School, about 1450: *The Entombment*. Detail from the predella of Piero della Francesca's Misericordia Altarpiece. Borgo San Sepolcro, Pinacoteca Comunale (*Cf.* Cat. Nos. 21–29)

to suppose that these scenes from the Lives of the Hermits were *cassone* panels, despite their characteristic shape; that was no doubt dictated by the narrative and didactic character of the subject. They were intended to be 'read' by the clergy, for the benefit of illiterate people, and it was important that each little incident should be within range of the eye; they were a sort of *Biblia Pauperum*, like the so-called Blockbooks of the same date in Northern Europe. The treatment of the landscape in the fragments at Christ Church, Zürich and elsewhere, is conventionalized and very characteristic, particularly the rendering of the trees and plants – small trees and bushes with individual branches and leaves painted in light tones within a dark, rounded silhouette (the best examples are among the eight fragments at Zürich, but see Christ Church Cat. nos. 24 and 28); and strange plants distributed among the stones on barren, rocky ground, one particularly – almost a signature – with leaves flat on the earth and two flower stems crossing and curving inwards like pincers (see cat. nos. 23, 24, 25). Often a stone is placed on top of a plant. These identical features catch the eye in the predella of Piero della Francesca's polyptych with the *Madonna della Misericordia* in the Palazzo Comunale at Borgo San Sepolcro (K. Clark, *Piero della Francesca*, 1951, figs. 17–19) (Figure 8). Even the figures, some of the heads particularly, show similarities. The Misericordia Altarpiece was commissioned by Piero's fellow-townsmen in 1445, to be finished by 1448; though it is clear, as Sir Kenneth Clark says, that this date was not adhered to; nor was the proviso in the contract that the whole was to be painted by Piero himself. The predella, at least, is certainly by an inferior hand, whether or not it was supervised by the master. It is tempting to suppose (though this is hardly more than a guess) that to assist him in this extensive work Piero brought from

Florence (or found in Arezzo) the painter of our dismembered panel with scenes from the Lives of the Hermits; and further (following Berenson's clue) that the painter was the young Neri di Bicci, who was born in 1419 and in 1445 would have been already twenty-six years old, though nothing by him of so early a date has so far been recognized (see no. 34 of this cat.). The *ambiance*, at any rate, is plausible; for Neri's father and first master, Bicci di Lorenzo, belonged to that circle of Florentine Gothicizing artists of the early Quattrocento, of which one of the most typical figures was Lorenzo Monaco; and it is to Lorenzo Monaco's school that the Uffizi panel with the Lives of the Hermits, the direct antecedent of ours, undoubtedly belongs. Again, it was Bicci di Lorenzo who painted the vault of the choir in S. Francesco at Arezzo, which contains the famous frescoes of the Legend of the True Cross by Piero della Francesca. That an association with Piero, in the completion of the Misericordia altarpiece, should spur a young painter to a superior performance, would be natural enough; and in fact certain works of Neri di Bicci which must belong to his early years – *e.g.* the predella of his own Misericordia altarpiece in Arezzo (dated 1456) and a predella with the *Nativity* in the Berenson Collection at Settignano – show Piero's influence clearly.

Dr. Federico Zeri, who agrees with me in seeing a close relationship between our *Hermits* panel and the predella of the Misericordia altarpiece at San Sepolcro, has proposed to me a different solution. He believes that the artist concerned is a certain Giuliano Amidei, known only from a signed altarpiece in the Badia at Tifi, near Caprese (where Michelangelo was born), only a dozen miles from San Sepolcro and little farther from Arezzo. This painting presents, in triptych form, the Virgin and Child between two angels, flanked by four saints, two of whom are

Benedictines. I have never seen it, but from the reproduction[1] to which Dr. Zeri kindly drew my attention, I confess I am not entirely convinced by his argument, though I admit the likeness between the Benedictine saints at Tifi and some of the figures in the fragments at Zürich and Christ Church. If we suppose (from a recorded date of the office of Abbot Michele da Volterra)[2] that the Tifi triptych was painted in the 1480's, then the predella of the Misericordia altarpiece at San Sepolcro must have been done between thirty and forty years before, and for the *Hermits* also I should prefer a much earlier date; yet the triptych seems decidedly inferior to both. Admittedly provincial artists do not necessarily improve as they advance in age; they are often less successful on a larger scale; and no suggestion of Dr. Zeri's in this field can be safely disregarded. I am nevertheless unwilling, on this rather slight evidence, to accept his solution without reserve. I may add that Dr. Giuliano Briganti, who saw the Christ Church fragments lately, was inclined to favour the connexion with the young Neri di Bicci, who also worked in the immediate neighbourhood of Caprese.[3]

Exhibited: Liverpool, 1964, no. 47.

Literature: Borenius Cat., 1916, nos. 21–29.
O. Sirén, Catalogue of the Jarves Collection, Yale, 1916, pp. 93–96 and *Addenda*, p. 280; Berenson, Lists, 1932, p. 196 (as Florentine, Unknown, 1420–65, between Carrand Master and Neri di Bicci); Florentine Lists, 1963, p. 219 (as Unidentified Florentine, 1420–65, between Giovanni di Francesco and Neri di Bicci); Ellen Callmann, *A Quattrocento Jig-saw*, in *Burlington Magazine*, vol. 99, May 1957, p. 149 *ss.*; Alice Wolfe, *Thebaid Fragments*, in *Essays in Honor of Hans Tietze* (printed 1958); Fritz Blanke, *Bildinhalte Christlicher Kunst des Mittelalters*, *Zürcher Kunstgesellschaft*, *Neujahrsblatt 1964*, pp. 25–31; St. John Gore, Catalogue of the Exhibition, *Painting in Florence and Siena 1250–1500*, Wildenstein, London, Feb.–April 1965, pp. 24–27.

21. SCENES FROM THE LIFE OF ST. BENEDICT, ABBÂ MACARIUS AND OTHERS Plate 22

The lower corners are cut irregularly.

At top L., a sainted monk, probably Abbâ Nopi (see Budge, 1907, I, 372, from St. Jerome), living in a hollow tree-trunk, is fed by an angel. Centre and upper R., a monk seated, reading to another. L., Abbâ Macarius, carrying

1. P. L. Occhini, *Valle Tiberina (Italia Artistica*, no. 53), Bergamo, 1910, p. 80. The inscription on the base of the frame runs: *Tem(pore) Dni Michaelis De Vulterris Abbatis (Juli)anus Monachus Camaldulensis Ordinis pinxit.* We know from another inscription in the church that Michele da Volterra was Abbot in 1484. I do not know on what grounds the Giuliano of the signature is identified with Giuliano Amidei, whose name is not mentioned in this connexion in Occhini's book; the only Amidei mentioned in Thieme-Becker, *Künstlerlexikon*, as working at Tifi is said to be a XIX century artist.
2. See note 1 above.
3. Altarpiece at Compito, see Occhini, *op. cit.*, p. 81.

palm-leaves from the wood to his cell, is confronted by the devil with a scythe (Budge, 1907, I, 161, from *The Sayings of the Holy Fathers*). Centre below, a monk conversing with another at the window of his cell. R., above, a monk lowering food to St. Benedict in his inaccessible cave; below this, St. Benedict in penitence, lying naked among thorns.

From the top centre of the original panel, no. 3 of Miss Callmann's reconstruction. According to the legend, a bell was attached to the rope on which St. Benedict's food was lowered, to rouse him from his meditations. This was broken by a devil, who appears in fact, flying towards it, on the left of the adjoining fragment, which is now in Zürich (Callmann, no. 4; Wildenstein, 1965, cat. no. 42 and pl. 38).

The two incidents at the top of the Christ Church fragment – the monk in a hollow tree-trunk fed by an angel, and the two monks seated, one reading to the other – are depicted in very similar fashion at the top centre of Lord Crawford's *larger* panel (repr. Callmann, *loc. cit.*, fig. 13, but there described as the *smaller* one). There, too, appears the bear drinking at a pool, as in our fragment (immediately below the monk in the hollow tree-trunk). The same incidents are to be found (at top L. centre) in the Uffizi panel, no. 447, to which I have referred above.

22. SCENES FROM THE LIFE OF ST. ANTHONY ABBOT.
Plate 24

Above, St. Anthony (?) meditating outside his cell, with a vision of angels ascending to Heaven; below, St. Anthony burying St. Paul the Hermit with the help of two lions, who dug the grave (Budge, 1907, I, 202–203, from Palladius).

The top R. corner of the original panel, Callmann, no. 6; it was adjoined on the L. by other scenes from the Lives of St. Anthony and St. Paul the Hermit, in a fragment now at Zürich (Wildenstein, 1965, cat. no. 43 and pl. 39).

The angels on the ladder above are damaged and restored.

23. ABBÂ MOSES THE INDIAN ASSAULTED BY THE DEVIL, AND A SAINTED HERMIT RECEIVING A BEGGAR.
Plate 23

The panel is cut irregularly on the L.

For Moses the Indian (*i.e.* Ethiopian), who was flogged by the devil while drawing water for some of the old hermits, see Budge, 1907, I, 217. I have not identified the other scene.

From the upper centre part of the original panel, Callmann no. 7. In Miss Callmann's reconstruction our fragment is too much cut at the top; as she herself suspected (*op. cit.*, p. 153, footnote 11), the roofs and the rocky ground (with the very characteristic pincer-like plant at top L.) are original, though internal restoration was necessary across the building immediately below the roof, and in the face

of the tall disciple to the R. of the seated hermit. The fragment fits, as suggested, on to the lower R. corner of Christ Church cat. no. 21, where the rest of Abbâ Moses' well is clearly visible. The incident of the Abbâ Moses, composed in almost the same way, occurs towards the R. foreground of Lord Crawford's larger panel; but there the black monk is drawing the water not from a well but from the river.

24. THE DEATH OF THE BARBARIAN SLAVE-OWNER, WHO PURSUED THE MONK MALCHUS; AND OTHER SCENES. Plate 25

Above L., a hyena looking into the entrance to a cave (?); upper R., two monks in conversation with a sainted Hermit in his cell; below this, Malchus and his wife in the cave, watching their barbarian master attacked by a lioness; and further R., the lioness carrying off her cub. The two camels of the barbarian and his companion are tethered to the bushes on L.

No. 8 of Miss Callmann's reconstruction (in which our fragment is too much cut at the top). The scene in the foreground illustrates the end of the story recounted by Palladius of the solitary monk Malchus, of which earlier incidents are shown in other Christ Church fragments, cat. nos. 26 and 28 (see below). Malchus, having been captured and enslaved by the barbarians near Edessa, and having been married by force to a woman who was captured at the same time, escaped with the woman by swimming a river sitting astride inflated goatskins (no. 26); but was pursued by his barbarian master and a companion (no 28), and took refuge in a cave in which were a lioness and her cub. When the barbarian attempted to follow the fugitives into the cave, he was killed by the lioness, who afterwards carried away her cub and left them in peace. Malchus then reverted to his monastic life, and his wife entered a nunnery (Budge, 1907, I, pp. 228–234).

The incident at upper R. may be Palladius (the author of the *Paradise of the Holy Fathers*), accompanied by the interpreter Theodore, interviewing John of Lycus at the window of his closed cell, where he communicated with the outside world only on Saturdays and Sundays (Budge, 1907, I, 170–171); and the hyena at top L. may be the one which led St. Anthony Abbot to the cave where St. Paul the Hermit lived (see Budge, 1907, I, 200, from Palladius). This fragment does in fact fit exactly below the one now at Zürich (see above, no. 21) which contains scenes from the lives of St. Anthony and St. Paul. In the lower R. corner is part of the bridge which is continued in no. 26 below.

25. A SAINTED HERMIT ON HIS DEATH-BED, ATTENDED BY AN ANGEL. Plate 27

The panel is cut irregularly on the R.
The Saint, apparently dying, is attended by an Angel in his closed cell, while two young monks, at the bidding of two older ones, attempt to break down the door.

In the L. foreground, on the river-bank, are two examples of the curious pincer-like plant which is almost a signature of the artist.

I have not identified the scene, which is no. 13 of Miss Callmann's reconstruction and comes from the centre of the original panel, immediately below the Christ Church fragment cat. no. 23. The projecting part at lower R. fits on to the L. side of cat. no. 26; and the rest of the R.-hand side adjoins cat. no. 24.

26. MALCHUS AND HIS WIFE CROSSING THE RIVER; AND ANOTHER SCENE. Plate 29

The panel is cut irregularly.
No. 14 of Miss Callmann's reconstruction.
For the story of Malchus and the woman to whom he was married by force (though both accepted a purely spiritual union), see above, cat. no. 24. Here they are escaping from their barbarian slave-master by crossing the river on inflated goatskins. This fragment fits immediately below cat. no. 24, where the *dénouement* is depicted; and the barbarian pursuers appear in another Christ Church fragment, cat. no. 28, which originally fitted below to the L.

The group on the R. appears to be independent of this story. It probably illustrates the obedience of the man who wished to become a monk, and was ordered by Abbâ Sisoes to throw his only son into the river: when he was preparing to do so, Sisoes, being satisfied by his willingness to obey, sent a messenger to countermand the order (Budge, 1907, II, p. 55, from *The Sayings of the Holy Fathers*, no. 245).

27. ABBÂ PAPHNUTIUS FORCED TO DRINK WINE; AND OTHER INCIDENTS. Plate 26

The story of the scene on the R., which is continued on the L. of the adjoining fragment (also at Christ Church, cat. no. 28), is told in *The Sayings of the Holy Fathers* (Budge, 1907, II, p. 16): Paphnutius, who was unwilling to drink wine, came upon a band of thieves drinking; the captain of the thieves threatened to kill him if he did not drink a cup; whereupon Paphnutius took the cup and drank, and (perhaps rather surprisingly) converted the captain by his submission.

The other leg of the captain, and three other thieves drinking, appear on the extreme L. of cat. no. 28; but there is a narrow strip missing between the two fragments.

Lower L. is a monk fishing; and above, in a boat on the river, is a naked child tortured by two devils, with a third devil propelling the boat. This incident, which I have not been able to identify, occurs also in the L. centre foreground of the Uffizi picture, and the R. centre foreground of Lord Crawford's smaller panel. Langton Douglas, in describing Lord Crawford's panel in his catalogue of the Burlington Fine Arts Club Exhibition, *Pictures of the School of Siena*, 1904, no. 16, calls this child 'the soul of a bishop' –

presumably because it seems to wear a mitre, if nothing else.

This fragment and cat. no. 28 formed the centre of the lower edge of the original panel, nos. 18 and 19 of Miss Callmann's reconstruction.

28. ABBÂ MACARIUS CONVERSING WITH THE SKULL; AND OTHER INCIDENTS. Plate 28

Above, L., three soldiers drinking; further R., two barbarians riding camels; below, centre, Abbâ Macarius conversing with the skull; and lower R., a sainted monk kneeling before a female saint.

The soldiers drinking are part of the incident depicted on the adjoining Christ Church fragment, cat. no. 27 (*q.v.*); the barbarians riding camels are the pursuers of the monk Malchus and his wife (see note to cat. no. 24). For the story of Macarius and the skull, see L. Réau, *Iconographie de l'Art Chrétien*, III, 2, 1958, pp. 844–845. The same incident occurs towards the upper L. of Lord Crawford's smaller panel, and also in the large fresco in the Camposanto at Pisa (E. Carli, *Pittura Pisana del Trecento*, vol. I, pl. 65b). I have not identified the other incident.

No. 19 of Miss Callmann's reconstruction.

29. TWO INCIDENTS IN THE HISTORY OF THE HERMITS. Plate 30

The panel is cut irregularly above.

A sainted monk receiving a message from an angel at the door of his cell; above, a devil tormenting a sainted monk, who is praying. I have not identified either incident, unless the saint with the angel is Abbâ Pachomius. The same incident, so interpreted by Langton Douglas (*op. cit.*, p. 52), occurs in the smaller Crawford panel at upper L.

This panel consists of two fragments, nos. 21 and 15 of Miss Callmann's reconstruction, forming the extreme R. lower corner of the original composition. The fragment with the devil and the praying monk had been wrongly attached to the R.-hand lower edge of the other. Miss Callmann appreciated that this small piece rightly belonged above; the spire of the campanile in the larger fragment is in fact continued at lower L. in the smaller; but the top of the spire in the smaller fragment had been painted out, so that it was not observed that the juncture is exact. This was first noticed by Mr. J. C. Witherop, when he did some further restoration to these fragments at Liverpool in 1964, and corrected the juxtaposition.

GIOVANNI DI PAOLO
1403 (?)–1482/3

Painter and miniaturist in Siena, a pupil of Sassetta. His numerous small panel paintings, 'Byzantine' and archaistic in style, have little of the charm of Sassetta or Sano di Pietro, and his forms are sometimes of surprising angularity and ugliness. His quality varies greatly, but the best of his work is highly original in conception and treatment.

30. CALVARY. Panel, 26·6 × 33 cm. Plate 19

Landor-Duke Gift, 1897.

The armour, and the lake in the background, seem to be in reddish brown underpainting only, with incised hatchings. An iconographical curiosity is the introduction of *two* centurions, both with haloes. The same occurs in another small panel by the same artist in the Aartsbisschoppelijk Museum, Utrecht (cat., 1948, p. 25, repr.), which was exhibited at the Wildenstein Gallery, London in 1965 (*Painting in Florence and Siena 1250–1500*, cat. no. 98 and fig. 85). It also occurs in his *Crucifixion* at Altenburg (Lindenau Museum, no. 77; repr. Brandi, *G. di P.*, 1947, fig. 12), but in modified form, since the head of the bearded horseman on the R. is surrounded by rays, not a nimbus.

Dr. Brandi (*loc. cit.*) must be wrong in identifying this beautiful little panel and the Ashmolean *Baptism of Christ* (cat. 1962, no. 179) with two of four predella panels described by Brogi in his *Inventario degli oggetti d' arte della Provincia di Siena* as then belonging to the Compagnia degli Artisti di Montepulciano. Apart from the fact that the dimensions do not correspond, Brogi wrote this in 1897, thirty-three years after W. S. Landor's death, and twenty-two years after Reddie Anderson acquired the Ashmolean picture (1875).

Mr. Pope-Hennessy relates the Christ Church painting, in style and quality, to the series of scenes from the life of St. Catherine of Siena, of which six were until lately in the Stoclet Collection, Brussels. For these he suggests a date not earlier than 1461, when St. Catherine was canonized. The connexion of style is agreed as plausible, but the date remains in dispute; for both Brandi and Langton Douglas (*Burlington Magazine*, Jan. 1938) consider that Pope-Hennessy's dating of the St. Catherine series is too late. Brandi in fact shows good reason for supposing that these panels formed the predella and side-pieces of the Pizzicaiuoli altarpiece, commissioned in 1447, and dates them 1447–49. St. Catherine would then have been depicted wearing a halo a dozen years before her canonization by the Piccolomini Pope Paul II.

The condition is very good, apart from some old scratches and local abrasions in the sky.

Exhibited: Matthiesen Gallery, London, 1960, no. 8, pl. III; Liverpool, 1964, no. 24.

Literature: Borenius Cat., 1916, no. 73, pl. XXIV. Van Marle, IX (1927), pp. 445–446; Berenson, Lists, 1932, p. 247; J. Pope-Hennessy, *Giovanni di Paolo*, 1937, p. 133; C. Brandi, *Le Arti*, III, 1941, p. 321 and fig. 38; and *Giovanni di Paolo*, Florence, 1947, pp. 40 and 78 and fig. 50.

SANO DI PIETRO
1406–81

Ansano di Pietro di Mencio, pupil of Sassetta; worked all his life in Siena. An extremely prolific miniaturist and painter, repeating many of his small Madonna-pieces with slight variations in detail or in the attendant figures.

31. THE VIRGIN AND CHILD, WITH SIX SAINTS: (L.) SS. Catherine of Siena, Francis and Ambrose, and (R.) Jerome, John the Baptist and Bernardin of Siena. Linen, laid down on canvas, 43 × 52·8 cm. Plate 20

Fox-Strangways Gift, 1828.

Label at back: 'Duccio di Boninsegna'.

Langton Douglas (see below *loc. cit.*), Roger Fry (*The Athenaeum*, June 4, 1904, p. 729) and Van Marle (*loc. cit.*) all refer to this picture as an early work of the master, and so it seems to be; the more delicate type of the Child Christ, particularly, reflecting the influence of Giovanni di Paolo, and contrasting sharply with the rather coarse convention of Sano's innumerable later Madonna-pieces (*e.g.* no. 32 below). Since St. Bernardin, who was canonized only in 1450, here wears a halo, it might be argued that the picture must have been painted after that date; but it may also be observed that his halo is smaller than the others, and is painted over the golden rays which denote a *beato*, not a saint. It seems therefore probable that this halo was added some years later – perhaps immediately after the canonization – and that the painting is considerably earlier than 1450.

Two full-length Madonna-pieces in the Siena Gallery are closely related: no. 252, in which the composition of the Virgin and Child is almost the same; and no. 234, in which the composition, with some variations, is reversed. The Child, however, in the Christ Church painting, is taller, slenderer, more Gothic, and ours is no doubt the earliest of these three.

All previous catalogues (from Borenius onwards) state that the painting has been transferred from panel to canvas. The late Horace Buttery, who cleaned it lightly in February 1958, assured me that this was not the case: it was painted on linen, and he himself re-layed it on another canvas. M. Gaillard remarks that the blue background with gold stars is quite exceptional in Sano's work, and suspects that it may not be original. Certainly the present greenish-blue looks to be of doubtful authenticity, but there is no trace of an earlier gold background beneath the blue. The condition is far from good; the Virgin's dark blue cloak, particularly, is much damaged and restored, and contours have been strengthened throughout.

Exhibited: Manchester, 1857, *Art Treasures*, no. 11 (as Duccio); Burlington Fine Arts Club, 1904, *Sienese Pictures*, no. 26; Royal Academy, 1930, *Italian Art*, no. 42, and 1960, *Italian Art and Britain*, no. 268; Liverpool, 1964, no. 40.

Literature: 1833 Cat., no. 115 (as a Holy Family, by Duccio); Borenius Cat., 1916, no. 71 and pl. XXII.
Langton Douglas, Illustrated Cat. of Burlington Fine Arts Club Exhn., 1904 (published 1905), p. 59; Crowe and Cavalcaselle, *Painting in Italy*, vol. V (ed. Borenius), 1914, p. 174; E. Gaillard, *Sano di Pietro*, 1923, pp. 148 n. and 202; Van Marle, IX (1927), p. 471; Berenson, Lists, 1932, p. 500.

SANO DI PIETRO

32. THE VIRGIN AND CHILD WITH SS. JEROME AND BERNARDIN OF SIENA, AND TWO ANGELS ABOVE. Panel (painted surface), 51 × 33 cm. Plate 21

Landor-Duke Gift, 1897.
Label at back: 'Duccio Sanese'.

In better condition than no. 31, but much less delicate in quality, and certainly later. A comparison of the head of St. Bernardin with that in the earlier picture is enough to point the difference: here the forms are stereotyped and conventional, and the composition is one of which a dozen or more variations exist, by Sano or from his studio.[1] The motive seems to derive from Sano's altarpiece, no. 273 of the Siena Gallery (Van Marle, fig. 319).
The picture was cleaned by H. Buttery in July 1958. There is very little restoration.

Literature: Borenius Cat., 1916, no. 72 and pl. XXIII.
Crowe and Cavalcaselle, *Painting in Italy*, vol. V (ed. Borenius), 1914, p. 174; E. Gaillard, *Sano di Pietro*, 1923, p. 202; Van Marle, IX (1927), p. 530; Berenson, Lists, 1932, p. 500.

SCHOOL OF
PIERO DELLA FRANCESCA
c. 1415–92

Piero della Francesca, probably the pupil of Domenico Veneziano in Florence, whom he was assisting in 1439. His first known commission is the altarpiece of the Madonna della Misericordia in his native town of Borgo San Sepolcro, not far from Arezzo (c. 1445–50); his greatest surviving masterpieces are the frescoes with the *Story of the True Cross* in the choir of San Francesco at Arezzo (c. 1455–60) and the *Resurrection* in the Palazzo Comunale of his birth-place. Worked also in Rimini, Urbino, Bologna, Ferrara and Rome. He had been blind for some time when he died at Borgo San Sepolcro, 1492. He was not only one of the greatest of the early Renaissance painters in Italy, but also renowned in his time as a mathematician and writer on perspective, under the influence of Leon Battista Alberti.

1. *Cf.* Van Marle, IX, figs. 304, 316, 323.

33. The Virgin and Child and three Angels.
Panel, 88 × 58·2 cm. (without slip). Plates 32-33
Fox-Strangways Gift, 1834 (?) (not identifiable in 1833 Cat.).

Since the earlier literature (see Borenius, *loc. cit.*), in which the picture is cited as by Piero himself, this has been generally accepted as by an immediate follower or assistant of the master. Berenson (1926) attributed it, with others at Boston and (formerly) in the Villamarina Collection, Rome, to the young Signorelli. It is true that Vasari insists that Signorelli in his novitiate imitated Piero's manner so closely that his work was mistaken for his master's;[1] it is also true that the head of the angel in three-quarter view to the R. of the Virgin in our picture bears a curious resemblance to the head of St. Paul in a fresco fragment at Città di Castello, which is almost all that remains of a painting once on the exterior wall of the Torre del Vescovo in that city; and that this fresco has been identified with one commissioned to the young Signorelli in 1474.[2] But it would be easier to accept Berenson's suggestion if the three paintings concerned could be compared with anything other than these gravely damaged remains. The fact is, there is very little relationship between them and other paintings by Signorelli which are generally accepted as early works, such as the *Flagellation* and the *Madonna* in the Brera Gallery, Milan.[3]

The connexion, however, between the Christ Church picture and the two others so attributed by Berenson is undeniable. The Villamarina Madonna (now in the collection of Count Cini, Venice) was exhibited beside the Christ Church picture at the Royal Academy in 1930 (no. 127), and seemed to me then certainly by the same artist, and the Boston picture might be a less accomplished (or simply more damaged) work by the same hand again. But in all three the forms are less robust than in Piero's acknowledged works. Certainly they fall short of the massive grandeur of Piero's late *Madonna with two Angels* (*Madonna di Senegallia*) at Urbino.

The panel (which has not been cleaned recently) is much worm-eaten, and a piece seems to have broken away at the right edge, from the top to a point below the waist of the angel. All this part, including the back of the angel's head and body, is false; and this angel may originally have had white wings, like his fellow on the left. In spite of this and other damages, the picture remains one of the most beautiful in the collection.

Exhibited: Royal Academy, 1880, no. 223; Royal Academy, 1892, no. 153; New Gallery, 1893/4, no. 106; Burlington Fine Arts Club, 1909/10, no. 3 (repr.); Royal Academy, 1930, no. 126; Matthiesen Gallery, London, 1960, no. 5, pl. IV; Liverpool, 1964, no. 34.

1. Scarpellini, *op. cit.*, p. 10.
2. Signorelli Exhibition, Cortona and Florence, 1953, cat. no. 1; P. Scarpellini, *op. cit.*, p. 126 and pl. 2.
3. Nor can I see any relationship to the detached fresco fragments now attributed to him in the Pinacoteca at Arezzo.

Literature: Borenius Cat., 1916, no. 75 and pl. XXVI.
Crowe and Cavalcaselle, *Italian Painting*, 2nd ed., V, 1914, p. 32, note 2; Venturi, VII, pt. I, pp. 478, 480, and pt. II, p. 98 (repr.) (as Fra Carnevale); Berenson, *Art in America*, XIV, 1926, p. 105 (as early Signorelli); Van Marle, XI, 1929, p. 93 (3); XVI, 1937, p. 5; Longhi, *Piero della Francesca*, 1930, p. 155; P. Toesca, in *Enciclopedia Italiana*, vol. XXVII, 1935, p. 212 (as at 'Christ Church College di Londra'); Pietro Scarpellini, *Signorelli*, 1964, pp. 11 and 145 (as in the Ashmolean Museum).

NERI DI BICCI
1419-91

The son of the late Gothic painter Bicci di Lorenzo (b. 1373), and the head of a productive studio where many younger artists were trained in Florence, among them Cosimo Rosselli and Botticini. His *Libro di Ricordi*, recording his commissions for the years 1453-75, is in the Uffizi Library, but little is known of his early work. His style is antiquated and popular, and his achievement never above that of the third rank of Florentine artists.

34. The Three Archangels (Gabriel L., Michael centre, Raphael R.) and the Holy Dove above; below, kneeling, L. to R.: SS. Augustine, Paul, Gregory and Jerome. Rectangular panel, painted and framed to an arched top, 86·5 × 48·7 cm. Plate 31

Landor-Duke Gift, 1897.

There are several similar representations by the same artist of St. Raphael leading Tobias by the hand. One rather closely related to the Christ Church picture was sold at the Galerie Fischer at Lucerne, June 1959, lot 1874 (repr. in cat.). Another was exhibited at Wildenstein's, London, in 1962, from the Platt Collection (*Religious Themes in Painting*, cat. no. 11).

Cleaned by Deliss 1963. The condition is by no means bad; there is a vertical crack R., through the L. hand of St. Jerome to the bottom, and through the L. shoulder and hair of Raphael to the top. Most damage was found in the robes of St. Augustine, lower L.

Literature: Borenius Cat., 1916, no. 31 and pl. VII.
Van Marle, X, 1928, p. 543; Berenson, Florentine Lists, 1963, p. 156.

STUDIO OF BOTTICELLI
c. 1445-1510

Alessandro Filipepi, called Botticelli, pupil of Filippo Lippi, worked for the Medici family in Florence, and took part, with other Florentine painters, in the decoration of the

side-walls of the Sistine Chapel in Rome for Pope Sixtus IV in 1481. Towards the end of his life, according to Vasari, he was much affected by the preaching and death of Savonarola. His most famous paintings – the *Birth of Venus* and the *Primavera* in Florence – reveal, not in their content but in their graceful linear rhythms, something of a reversion to late Gothic idiom.

35. FIVE SIBYLS SEATED IN NICHES: the Babylonian, Libyan, Delphic, Cimmerian and Erythraean. Panel, 74·2 × 140·3 cm. Plates 34, 36, 37

Fox-Strangways Gift, 1828.

Until 1948, when both this and no. 36 were cleaned and skilfully restored by the late Horace Buttery, they were so extensively disfigured by coarse repainting that no accurate judgement could be made. When the repaint was removed, it was apparent that the previous restorer had by no means confined his attention to the damaged parts, but had touched up almost every line and surface of the two pictures, including the inscriptions. The main damages revealed, which were subsequently made good by Buttery, were as follows: No 35. (*a*) two horizontal cracks, with consequent loss of paint, through the whole length of the panel – one just above centre, from the R. elbow of the first Sibyl L. (Babylonian) to the L. elbow of the fifth Sibyl R. (Erythraean), the other lower down, cutting the legs of the figures just above the ankles; (*b*) considerable damage to the inscription below and the names of the Sibyls above (the Cimmerian Sibyl, fourth from L., still seems to be named Cumaean, though the Cumaean Sibyl appears in no. 36); (*c*) local damages both to figures and architecture, particularly to the central figure (the Delphic Sibyl), in her face, her L. wrist and hand, and the plinth on which her L. arm is resting; also in the headdress, hair and neck of the Libyan Sibyl, second from L., and the R. hand of the Erythraean Sibyl, extreme R. The best preserved figures in this panel are the Babylonian and Cimmerian, first and fourth from L. No. 36. (*a*) two horizontal cracks, as in no. 35, but at different levels – one passing through the capitals from which the arches spring, and cutting the raised forefinger of the Tiburtine Sibyl R., the other through the laps of all the figures, and cutting the fingers of the R. hand of the Phrygian Sibyl, fourth from L.; (*b*) damage to the inscription below and the Sibyls' names, but less than in no. 35; (*c*) local damages, not so much in the heads, but in the drapery of all except the central Sibyl (Hellespontic), whose drapery is well preserved; also considerable damage to the floor and ledge between the feet of the first and second figures from L. On the whole this panel is in rather better condition than no. 35.

It seems necessary to insist on the salutary transformation which Buttery effected in these two panels, since they were seen by the general public for the first time only in 1960, when they were exhibited in aid of the Christ Church Clubs at the Matthiesen Gallery, London; and it was singu-

larly unfortunate that on that occasion the reproductions in an otherwise excellent catalogue were made from old photographs, showing the two panels still in their coarsely overpainted state. Students and art-historians who have never seen the originals may have misjudged them on this account. Justice was done only in 1964, when the *Burlington Magazine*, on the occasion of the Liverpool exhibition, reproduced both panels from new photographs for the first time.

It is now evident that the paintings are of very high quality, and it seems reasonable to assume that they were produced in Botticelli's studio about 1472–75. That is to say, soon after Botticelli himself, in 1470, had painted the *Fortezza* (Figure 9) to complete the series of Virtues by the Pollaiuolo brothers in the hall of the Mercanzia at Florence. That beautiful figure, now in the Uffizi, though superior in quality and in much better condition, shows a close

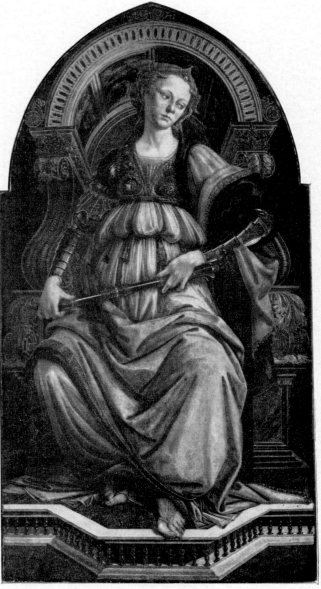

Fig. 9. Botticelli: *Fortezza*. Florence, Uffizi (*Cf*. Cat. No. 35)

relationship to the Sibyls in no. 35, particularly the first, second and fourth from the L. (Babylonian, Libyan and Cimmerian) – in the physical type, the inclination of the head, the headdress, the drapery and the architecture. There, as in the Sibyls, the length of the body, from the waist to the lap, is curiously exaggerated, so that the legs seem too short from the knee downwards; and the delicate lines of the drapery are gathered inwards towards the ankles, and then break outwards in flattened folds over the floor.

In 1472 Filippino Lippi appears in the records of the Guild of St. Luke of Florence as '*dipintore chon Sandro Botticelli*' (Scharf, *op. cit.*, p. 11). Filippino was then only fifteen, but he is already described as a painter, and he had already assisted his father in Spoleto. It is not known how long he remained with Botticelli, who was about thirteen years older than he; but it is to the young Filippino, in the early and mid 1470's, that the group of paintings once distinguished by Berenson under the pseudonym of 'Amico di Sandro' (*i.e.* friend of Botticelli) is now almost universally attributed. This identification was accepted by Berenson himself in his Lists of 1932; though Van Marle (*loc. cit.*, 1931) inexplicably preferred to retain the pseudonym for this group. Berenson then included both the Christ Church panels as the work of the young Filippino, although they were still in their overpainted state when his Lists of 1932 were published; and since the restoration of 1948 it has become evident that the greater part, at least, of no. 36 is by that artist at precisely this stage of his career. In this panel the peculiarities of form, referred to above, are more pronounced than in no. 35: in all the figures the length of the torso, from the waist down, is even more exaggerated, the legs even shorter, the drapery more filmy, with more sharply defined folds – all features immediately recalling the 'Amico di Sandro'. The profile of the Tiburtine Sibyl, on the extreme R., is no longer Botticellian, but exactly in the manner of Filippino. The most comparable example of the 'Amico di Sandro' group, and not only in subject, is the somewhat smaller panel with *Five Allegorical Figures seated on Clouds* in the Corsini Gallery, Florence, which Dr. Scharf (*op. cit.*, fig. 5) attributes convincingly to Filippino c. 1475.

There is, however, as I have suggested, a difference in style between the two Christ Church panels; and I feel some justification in restoring the name of Botticelli himself to this catalogue, proposing that these Sibyls are a production of his studio at this early date, partly executed by him, and partly by his most distinguished disciple. I am gratified that so reliable an authority as Mr. Philip Pouncey is inclined to share my opinion.

For the subject, so typical of the fusion of classical and Christian notions in Renaissance art, see J. J. M. Timmers, *Symboliek en Iconographie der Christelijke Kunst*, 1947, pp. 203–210. Most famous of the Sibyls were the Cumaean, whose prophecies as recorded in the Fourth (the so-called 'Messianic') Eclogue of Virgil were supposed by Christian scholars to refer to the coming of Christ; and the Tiburtine, who, according to a mediaeval legend, showed a vision of the Blessed Virgin to the Emperor Augustus. Their names and number in the Christ Church panels correspond to those given by Lactantius in the second half of the III century, and by St. Isidore; the list of ten was increased in later writers to twelve by the addition of Sibylla Europea and Sibylla Agrippa. Representations by Ghirlandaio (Sta. Trinità, Florence), Pinturicchio (Rome, Appartamenti Borgia), Michelangelo (Sistine Chapel), and Raphael (Sta. Maria della Pace) are familiar enough. More closely related to our panels is the series of twelve engraved in Florence in the so-called Broad Manner, c. 1480–90 (Hind, *Corpus of Early Italian Engraving*, pls. 244–256), since the types and forms of the Sibyls in those prints show unmistakably the influence of Botticelli's style. There is, however, no correspondence of detail, and the engravings are probably a decade or so later than the paintings. The general scheme of the figures, seated in sculptured niches, may originate from the famous frescoes of the Liberal Arts and Sciences in the Spanish chapel of Sta. Maria Novella in Florence, painted by Andrea da Firenze about a hundred years earlier; an arrangement more immediately transmitted to Botticelli through the scheme of decoration of the Hall of the Mercanzia, in which he himself participated in 1470.

Exhibited: London, Matthiesen Gallery, 1960, nos. 1–2 and pls. V–VI; Liverpool, 1964, nos. 5–6.

Literature: 1833 Cat., no. 109 or 110 (as Botticelli); Borenius Cat., 1916, no. 33 and pl. IX (as School of Botticelli). Crowe and Cavalcaselle, *Painting in Italy*, vol. IV (ed. Langton Douglas), 1911, p. 267 ('Sibyls in niches assigned to Botticelli. These are hung very high, and at the distance seem genuine productions'); Van Marle, XII (1931), p. 256 (as 'Amico di Sandro'); Berenson, Lists, 1932, p. 286; Florentine Lists, 1963, p. 110 (in both as Filippino Lippi); A. Scharf, *Filippino Lippi*, 1935, pp. 41, 112, 117 (as *cassone*-panels, by an imitator of Botticelli); B. Nicolson in *Burlington Magazine*, vol. 106, 1964, p. 201 and pl. 1.

STUDIO OF BOTTICELLI
(FILIPPINO LIPPI)

36. FIVE SIBYLS SEATED IN NICHES: the Samian, Cumaean, Hellespontic, Phrygian and Tiburtine. Panel, 74·3 × 141 cm. Plates 35, 38, 39

Fox-Strangways Gift, 1828.

See note to no. 35.
For Exhibitions, see no. 35.

Literature: 1833 Cat., no. 109 or 110 (as Botticelli); Borenius Cat., 1916, no. 34 and pl. X (as School of Botticelli). For other Literature see no. 35.

JACOPO DEL SELLAIO

1442–93

A popular painter of the second rank in Florence, said by Vasari to have been a pupil of Filippo Lippi, but clearly much dependent on Botticelli. Works attributed to him vary greatly in quality; very few are as good as no. 37 at Christ Church.

37. THE VIRGIN ADORING THE CHILD. Panel, 104 × 59 cm. Plate 42

Fox-Strangways Gift, 1828 (?).

An exceptionally good example of the master, in good condition. A weaker version of the same composition, with a different background, in a private collection in New York, is reproduced by Van Marle, XII, p. 380, fig. 248. Cleaned by H. Buttery in 1960.

Exhibited: Manchester, 1857, no. 860; Leeds, 1868, no. 24; Liverpool, 1964, no. 41.

Literature: 1833 Cat., no. 111 (?); Borenius Cat., 1916, no. 32, pl. VIII.

Van Marle, XII, 1931, p. 413; Berenson, Lists, 1932, p. 527; Florentine Lists, 1963, p. 198.

FOLLOWER OF BOTTICELLI

38. CHRIST, NEARLY HALF-LENGTH, HOLDING THE CROWN OF THORNS AND THE NAILS, AND SHOWING THE WOUND IN HIS SIDE. Panel, 39·8 × 29 cm.

Plate 52

Fox-Strangways Gift, 1828.

Horne mentions this as a copy, with a different background, of a picture formerly in Sir George Donaldson's collection, which is itself, he considers, an imitation of Botticelli's picture at Bergamo (repr. Berenson, Florentine Lists, 1963, pl. 1111).
The Donaldson picture, certainly by Sellaio, is now in the Museum of Birmingham, Alabama,[1] and is reproduced by Berenson, Florentine Lists, 1963, pl. 1112, side by side with the Botticelli at Bergamo. The Christ Church picture certainly resembles the Donaldson/Kress Sellaio in general composition, but is far from being an exact copy. The resemblance of both of these to the Bergamo Botticelli is only in the subject.
The Christ Church picture, which was cleaned by J. C. Deliss, 1963, and is in good condition (except that some of the gold ornament of the dress is rubbed), is somewhat in the manner of Sellaio, inferior to the Donaldson/Kress picture, but at the same time more Botticellian.

Literature: 1833 Cat., no. 123 (as Castagno); Borenius Cat., 1916, no. 35.

Horne, *Botticelli*, 1908, p. 119; Van Marle, XII (1931), 271; not listed by Berenson, 1932 or 1963.

1. From the Kress Collection, Cat., 1966, p. 134 and figs. 363, 450.

ATTRIBUTED TO FRANCESCO BOTTICINI

1446–97

Pupil of Neri di Bicci in Florence (from 1459), later influenced by Castagno, Cosimo Rosselli, Verrocchio and Botticelli. The very large Palmieri altarpiece in the National Gallery (no. 1126), though attributed by Vasari to Botticelli, is almost certainly by Botticini, *c.* 1475.

39. ST. NICHOLAS OF TOLENTINO. Panel, arched top, 83 × 37 cm. Plate 41

Landor-Duke Gift, 1897.

There are two seals, apparently export seals of the early XIX century on the back. Also on the back, in a late XVIII-century hand, is an ascription to Davide Ghirlandaio, and this label originally included the words, now destroyed, '*prima maniera*'. This attribution is not unintelligent, but the Botticellian influence seems rather to suggest the hand of the young Botticini. There appears to be no reference to the picture in recent literature.
Cleaned by H. Buttery in 1960; the black robe is much damaged, also the sky and the ground below, especially on the right, but the flesh, book, lily, etc., are in reasonably good condition.

Exhibited: Liverpool, 1964, no. 7.

Literature: Borenius Cat., 1916, no. 44.

FOLLOWER OF GUIDOCCIO COZZARELLI

Guidoccio Cozzarelli (working *c.* 1450–99), painter and miniaturist of Siena, probably a pupil and certainly a close imitator of Matteo di Giovanni, who may, however, have been slightly younger than Guidoccio himself.

40. THE VIRGIN, HALF-LENGTH, ADORING THE CHILD. Panel, 57·3 × 40 cm. Plate 53

Landor-Duke Gift, 1897.

Dr. Federico Zeri rejects, with good reason, the attribution to Cozzarelli himself, though this is accepted by Berenson and Van Marle, as well as Borenius. In fact, his authenticated work is much closer in style to that of his master, Matteo di Giovanni. Dr. Zeri also refers me to a *Virgin and Child with SS. John and James* in the Musée Chéret at Nice, which he believes to be by the same hand as ours. A cruder version of our composition, closely corresponding except that the Child holds a bird instead of the bunch of strawberries and juniper, is in Siena, no. 337 (Van Marle, XVI, p. 384; not exhibited, 1966). The figure of the Child has been

considerably varied, in painting, from the incised preliminary outlines, which are clearly visible. The tooling of the haloes and gold background is coarse, but original.

Cleaned by H. Buttery in 1962. There is damage only at the upper edge L. (in the gold background) and at the lower edge R. centre (L. foot of the Child).

Literature: Borenius Cat., 1916, no. 74, pl. xxv.
Berenson, *Central Italian Painters*, p. 159; Crowe and Cavalcaselle, 2nd ed., v, 185, no. 1; Berenson, Lists, 1932, p. 158; Van Marle, xvi (1937), p. 382.

FILIPPINO LIPPI

c. 1457–1504

Born *c.* 1457 (or earlier) at Prato, followed his father, the painter Filippo Lippi, to Spoleto, and assisted him there 1467–69, when Filippo died. Working with Botticelli in Florence, 1472. Even if the date of his birth is earlier than 1457, he seems to have been extremely precocious; some of his most graceful and delicate work, dating from the 1470's, was formerly published by Berenson under the pseudonym 'Amico di Sandro' (*i.e.* friend of Sandro Botticelli). In Rome 1488–89 (Caraffa Chapel, Sta. Maria sopra Minerva). His late work (Strozzi Chapel, Sta. Maria Novella, Florence, finished 1502) shows a pronounced Mannerist tendency, particularly in the ornament, the drapery and the gesticulation of the figures.

41. THE WOUNDED CENTAUR; *verso*, The Birth of Venus (?). Double-sided panel, 77·5 × 68·5 cm.

Plate 40 and Figure 10

Fox-Strangways Gift, 1834 (?) (not in 1833 Cat.).

The subject of this charming mythology has not been explained. The centaur, examining a quiver full of arrows, has been wounded by an arrow in the foreleg; but Cupid, who might have been held responsible, seems to be fast asleep beside his bow on a ledge of rock in the background. The centaur's wife and family are in a cave further R. It is one of the most delightful of Filippino's smaller works, decidedly reminiscent of the famous mythological compositions of Piero di Cosimo, such as the *Battle of Centaurs and Lapiths* in the National Gallery, and of the contemporary engravings of Cristofano Robetta.

The picture on the *verso* is unfinished, and is virtually a pen drawing on panel, with some colour added. The subject might be *The Birth of Venus*; the figure in the background is apparently female, not a young man as Scharf seems to think, and is not floating in the air, as Borenius describes her, but walking on the sea. *Cf.* the *cassone* panel by Bartolomeo di Giovanni, called *The Triumph of Thetis*, in the Louvre (Berenson, Florentine Lists, 1962, pl. 1123).

Fig. 10. Filippino Lippi: *The Birth of Venus* (?)
(Cat. No. 41 *verso*)

There are already traces of the mannerism of Filippino's later style; Scharf dates the picture *c.* 1500, which may, however, be somewhat too late.

The surface was lightly cleaned by H. Buttery in 1954, but there is still much dirty varnish on the *recto*. The condition of this side is, however, better than that of the *verso*, which is badly damaged and much restored in the background. The three figures in the foreground are better preserved than the rest. The panel is badly warped.

Exhibited: Burlington Fine Arts Club, London, 1920, no. 38; Royal Academy, 1930, *Italian Art*, no. 222; Matthiesen Gallery, London, 1960, no. 7, pl. vii; Liverpool, 1964, no. 27.

Literature: Borenius Cat., 1916, no. 38.
Crowe and Cavalcaselle, *Painting in Italy*, 2nd ed., iv, p. 292; Morelli, *Die Galerien zu München und Dresden*, p. 127, and *Italian Painters*, ii, 97 (wrongly described as a *tondo*); G. Gronau in Thieme-Becker, *Künstlerlexicon*, vol. xxiii, 1929, p. 270; Van Marle, vol. xii, 1931, p. 360; Berenson, Lists, 1932, p. 286; Florentine Lists, 1963, i, p. 110; A. Scharf, *Filippino Lippi*, Vienna, 1935, p. 111, no. 18, figs. 110–111, and *Filippino Lippi*, Schroll, Vienna, 1950, p. 57 and pls. 118, 119.

BARTOLOMMEO DI GIOVANNI (?)
Late XV Century

A document of 1488 identifies this artist as the painter of

the predella to Ghirlandaio's *Adoration of the Magi* in the Innocenti Hospital at Florence; but before that document was discovered Berenson had already assembled a number of his works under the pseudonym of 'Alunno di Domenico' (*i.e.* pupil of Domenico Ghirlandaio), by comparison with the Innocenti predella and the scene of the Massacre of the Innocents, clearly by the same hand, in the background of the altarpiece itself. Bartolommeo di Giovanni seems also to have served in Botticelli's studio, perhaps before he attached himself to Ghirlandaio.

42. THE VIRGIN AND CHILD WITH THE YOUNG ST. JOHN. Panel, arched top, 78 × 49·8 cm. Plate 45

Fox-Strangways Gift, 1834 (?) (not in 1833 Cat.).

The drawing is faulty throughout, particularly in the profile of St. John, the L. hand and R. leg of the Christ Child, and the landscape; and Dr. F. Zeri may well be right in supposing that this is not by Bartolommeo di Giovanni himself, but by an anonymous follower. The types of the Virgin and Child are not quite characteristic. The altarpiece by Bartolommeo now in the St. Louis Art Museum, to which Borenius refers for comparison, is dated 1486, not 1496, as can be clearly seen from Venturi's reproduction in *L'Arte*, XIII, 1910, p. 287 or that in Van Marle, XIII, p. 235; but the comparison is hardly relevant. That painting shows a much closer dependence on Ghirlandaio, whose assistant the artist was in 1488.

Cleaned by S. Isepp, 1945. The condition is good.

Literature: Borenius Cat., 1916, no. 39 and pl. XIV.

Van Marle, XIII (1931), 256; Berenson, Lists, 1932 (under 'Alunno di Domenico'), p. 7; Florentine Lists, 1963, p. 26.

'UTILI' (BIAGIO D'ANTONIO DA FIRENZE?)

For more than sixty years pictures by this master have been referred to as by 'Utili', according to the identification suggested by Corrado Ricci (*Rivista d'Arte*, IV, 1906, pp. 137, *ss.*) with Giovanni Battista Utili of Faenza, where several of his works are to be found. Carlo Grigioni (*La Pittura Faentina*, 1935, pp. 194, *ss.*) has shown that this identification is unwarranted, and proposed instead, with some plausibility, to identify the artist with Biagio d'Antonio da Firenze, who is mentioned in documents as a painter of some importance at Faenza in 1476, 1483 and 1504. That the painter of our pictures was a Florentine, whose modest but attractive art was more appreciated outside his native city, seems likely enough; but no documented picture has yet been found to confirm Grigioni's identification. The influence of Verrocchio and Ghirlandaio is evident; the artist was approximately on the level of Sellaio and Bartolommeo di Giovanni.

43. VIRGIN AND CHILD WITH THE YOUNG ST. JOHN AND AN ANGEL HOLDING THE THREE HOLY NAILS. Panel, 64·8 × 50·2 cm. Plate 43

Fox-Strangways Gift (1834?) (not in 1833 Cat.).

There are three paintings by this easily recognizable hand in the Christ Church collection (see also nos. 44 and 45); and this is certainly one of the best examples. Another excellent and attractive picture, also from the Fox-Strangways Collection, is the *Flight of the Vestal Virgins*, now in the Ashmolean Museum (no. 444).

The picture was cleaned by H. Buttery in 1936. It is in very good condition.

Exhibited: Liverpool, 1964, no. 49.

Literature: Borenius, Cat., 1916, no. 40 and pl. XV.

Van Marle, XIII, 1931, p. 180; Berenson, Lists, 1932, p. 585; Florentine Lists, 1963, p. 211.

'UTILI' (BIAGIO D'ANTONIO DA FIRENZE?)

44. THE VIRGIN ADORING THE CHILD. Panel, 59 × 42·5 cm. Plate 44

Fox-Strangways Gift, 1828.

Not of the same high quality as no. 43, but clearly by the same hand, as was first noticed by Sir Herbert Cook. On the identification of the artist, see note to no. 43.

Cleaned by H. Buttery, 1959. In good condition.

Literature: 1833 Cat., no. 126 (as 'Massolino de Panicale'); Borenius Cat., 1916, no. 41 and pl. XVI.

Van Marle, XIII, 1931, p. 180; Berenson, Lists, 1932, p. 585; Florentine Lists, 1963, p. 211.

'UTILI' (BIAGIO D'ANTONIO DA FIRENZE?)

45. THE CRUCIFIXION; St. John R., two Holy Women supporting the fainting Virgin L., the Magdalen kneeling at the foot of the Cross. Panel, arched top, 80·2 × 51 cm. Plate 46

Landor-Duke Gift, 1897.

Old label at back 'Andrea del Castagno' (with dates).

A good example of the so-called 'Utili' (on whom see note to no. 43), and evidently considered of some importance by Berenson, who gives a full-page illustration.

Cleaned by J. C. Deliss, 1965. Apart from some wormholes and small local damages (in the Virgin's mantle and the black background), the condition is good.

Literature: Borenius Cat., 1916, no. 48 and pl. XVIII (as Florentine School, *c.* 1500).

Berenson, Lists, 1932, p. 585; Florentine Lists, 1963, p. 211 and pl. 1040 (as 'Utili').

FLORENTINE SCHOOL
c. 1500

46. THE TRINITY ADORED BY SS. JEROME AND
NICHOLAS OF TOLENTINO; below: THE NATIVITY.
On canvas (linen?), mounted on wood, arched top, 100 ×
47·5 cm. Plate 47

Fox-Strangways Gift, 1828.

Dr. F. Zeri[1] attributes this modest but rather attractive
little picture to the studio of a Florentine follower of Ghir-
landaio, whom he has named the Marradi Master, from
an altarpiece and other works in the church of Badia del
Borgo, near Marradi, about half-way between Florence
and Faenza (see F. Zeri in *Bollettino d' Arte*, XLVIII, 1963,
pp. 249–250). In a considerable list of paintings which he
attributes to the same master, he includes some previously
ascribed to Sellaio and to Antoniazzo Romano. The late
Dr. W. Suida assembled some of the same paintings, as
works of the same artist, but named him the Master of the
'*Apollini Sacrum*', from the inscription on a *Sacrifice to
Apollo*, one of a pair, in the Kress Collection.[2]
Cleaned by J. C. Deliss in 1962. The condition is fair,
though surface dirt is ingrained in the canvas, and could
not safely be removed. The main damage is at the upper
and R. edges, and at the top R., including the uppermost
cherub's head and wings.

Literature: 1833 Cat., no. 119 (as 'Alissio Bandoretti');
Borenius Cat., 1916, no. 43.

RAFFAELLINO DEL GARBO
1466–1524

Florentine School. Probably a pupil of Botticelli, later
much influenced by Filippino Lippi, Lorenzo di Credi,
Piero di Cosimo, and to some extent by Perugino. Beren-
son, who originally considered the painters known as
Raffaellino del Garbo and Raffaele dei Carli (or dei Cap-
poni) to be different persons, though related in style, after-
wards agreed with other authorities in treating them as the
same (Florentine Lists, 1963).

47. THE MAGDALEN. Canvas, 67 × 53·2 cm. Plate 50

Fox-Strangways Gift, 1834 (?) (not in 1833 Cat.).

1. Letter of Oct. 20 1966.
2. F. R. Shapley, Cat., 1966, p. 128 and figs. 345–346 (both now in
the museum of Atlanta, Georgia).
Mr. Everett Fahy, in reviewing some early Italian pictures in the
Gambier-Parry Collection (*Burlington Magazine*, vol. 109, March
1967) makes independently the same attribution for the Christ
Church picture (p. 134, note 30). The winged cherubs' heads and
clouds surrounding the Trinity closely resemble those in the
Gambier-Parry *Virgin in Glory*, which Fahy reproduces (*loc. cit.*,
fig. 31).

An early work, of the group formerly listed by Berenson
under the name of Garbo, as distinct from those attributed
by him to Carli. Since cleaning by J. C. Deliss in 1962,
when the head (particularly the hair, and the chin) was
discovered to have been considerably altered by restora-
tion, the painting appears even earlier and more linear in
style, reflecting the influence of Botticelli rather than of
Piero di Cosimo, to whom Borenius refers.
A replica mentioned by Berenson as formerly in the col-
lection of the late Sir Otto Beit, Bt., at Tewin Water, was
sold at Christie's, October 25 1945 (lot 18). From the
photograph it appears to be much less good than ours, but
there are variations especially in the landscape, which is
seen through a window behind.
Considerable damages were discovered in neck, cheek and
hand.

Reproduced: Arundel Club, 1908, no. 4 (as Piero di Cosimo).
Literature: Borenius Cat., 1916, no. 42 and pl. XVII.
F. Knapp, *Piero di Cosimo*, 1903, p. 100 (reproduced), as by
Raffaellino del Garbo; Van Marle, XII (1931), 441 and XIII
(1931), 378; Berenson, Lists, 1932, p. 479; Florentine Lists,
1963, p. 188, and pl. 1159 (before restoration); Prussian
Jahrbuch, 1933, LIV, p. 160.

RAFFAELLINO DEL GARBO

48. THE VIRGIN ADORING THE CHILD, with SS. Law-
rence and Mary Magdalen and the Infant St. John. Panel,
round, diameter 72·5 cm. Plate 51

Fox-Strangways Gift, 1834 (?) (not in 1833 Cat.).

A characteristic and attractive work of the master. The
date must be early, but not as early as the very Botticellian
Magdalen, no. 47 of this catalogue. Here the figure of the
Magdalen (which appears to be unfinished in the flesh
parts) is close to Filippino Lippi in type; and the whole
picture illustrates the eclecticism of Raffaellino's style, for
the Virgin recalls Piero di Cosimo, and the Child Christ
Lorenzo di Credi.
A fine drawing by Raffaellino, also in roundel form, of
*The Virgin and Child between SS. Catherine and Mary
Magdalen*, in the Guise Collection at Christ Church, shows
points of connexion, but is probably of rather later date
(exh. London, Matthiesen Gallery, 1960, cat. no. 22 and
pl. XXIII).
Cleaned by J. C. Deliss in 1965/66, and in relatively good
condition.

Exhibited: London, Wildenstein Gallery, 1965, *The Art of
Painting in Florence and Siena*, no. 68.
Literature: Borenius Cat., 1916, no. 36 and pl. XI (as School
of Lorenzo di Credi).
Van Marle, XIII (1931), 316 (as studio of Credi); Berenson,
Lists, 1932, p. 479; Florentine Lists, 1963, p. 187 (as
Raffaellino, early).

RAFFAELLO BOTTICINI
1477–1520

Son and pupil of Francesco Botticini, worked in Florence and Empoli.

49. THE VIRGIN LAMENTING CHRIST, with St. John and St. Mary Magdalen, in a landscape; in the background St. James (L.) and St. Roch (R.) as pilgrims. Roundel, 97·8 cm. diameter. Figure 11

Fox-Strangways Gift, 1828.

Borenius was surely right in doubting the attribution to Piero di Cosimo, though his influence is evident.[1] Mr. Philip Pouncey and Dr. F. Zeri both (independently) suggested the name of the younger Botticini, by whom a few works are known in Empoli, Florence and elsewhere. The types of the Virgin and St. John, the landscape, the formalized plants in the foreground, and, more generally, the combination of primitive and *Cinquecento* elements in the style, all seem characteristic of Raffaello. A painting of the same subject in the Uffizi (reserve, 1966) is more advanced in style, and must be later, but shows points of resemblance. Cleaned by H. Buttery, September 1957; there are local restorations only.

Exhibited: Matthiesen Gallery, London, 1960, no. 3, pl. IX.

Literature: 1833 Cat., no. 112 (as 'Raffalino del Garbo'); Borenius Cat., 1916, no. 56 and pl. XIX (as Florentine, early XVI century).

Van Marle, XIII, 1931, p. 381 (as school of Piero di Cosimo); Berenson, Lists, 1932 (as late Piero di Cosimo); Florentine Lists, 1963, I, p. 176 (as Piero di Cosimo); L. Douglas,

1. A rather similar composition by Piero di Cosimo is at Perugia (Pinacoteca, no. 67D).

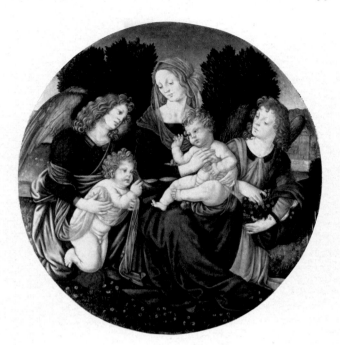

Fig. 12. Imitator of Lorenzo di Credi: *The Virgin and Child with the Infant St. John and two Angels* (Cat. No. 50)

Piero di Cosimo, 1946, p. 122 (as follower of Piero di Cosimo); P. Morselli, *L'Arte*, LVII, 1958, p. 90 (doubtful attribution); Mina Bacci, *Piero di Cosimo*, Milan, 1966, p. 125 (rejecting the attribution to Piero).

IMITATOR OF
LORENZO DI CREDI

Lorenzo di Credi (*c.* 1458–1537), pupil and assistant of Verrocchio in Florence from *c.* 1480 until the latter's death in 1488; associating there with the young Leonardo da Vinci.

50. THE VIRGIN AND CHILD WITH TWO ANGELS, one holding a bunch of flowers, the other (on L.) supporting the Infant St. John. A Town Wall and Tower in background, R. Panel, round, diameter *c.* 75 cm. Figure 12

Fox-Strangways Gift, 1828.

After cleaning by J. C. Deliss in 1964, the painting is in generally good condition; but it is coarse in quality and unpleasantly garish in colour.

The same composition (with some variations) occurs in a roundel in the Uffizi (no. 3244, Van Marle, *loc. cit.*, fig. 217; Dalli Regole, *op. cit.*, cat. no. 199, fig. 248), which is no more than a Credi studio work. Another roundel, of the Virgin and Child in a landscape, with a female Saint and the young St. John, no. 9202 in the Accademia, Florence, is surely by the same hand as ours. An equally crude roundel of Credi's school, of the Virgin and Child with the Infant St. John, which might be by the same painter again, is in the Cremona Gallery (Puerari Cat.,

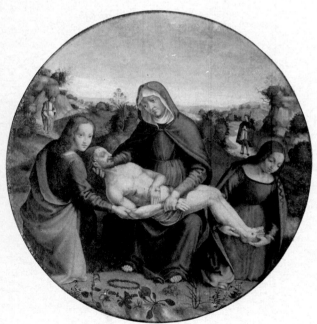

Fig. 11. Raffaello Botticini: *The Lamentation for Christ* (Cat. No. 49)

1951, no. 85 and fig. 74). Dr. F. Zeri (1966) sent me a note of eight other paintings which he ascribes to the same hand, including two *cassone* panels with the *Story of Ulysses* in the collection at Vassar College, Poughkeepsie, U.S.A.; and Mr. Everett Fahy (in a list of May 4 1967) includes some of these and two more. Our picture and that in the Accademia are grouped with four others by G. Dalli Regole (*op. cit.*, 264–269) under the pseudonym of the Master of the Johnson Magdalen; and so far as I can judge from reproductions, the *Assumption of the Magdalen* in the Johnson Collection at Philadelphia is certainly by the same hand as ours.

Literature: Identified by Borenius as 1833 Cat., no. 125 ('Holy Family. Philippino Lippi. 1500') but this seems by no means certain; Borenius Cat., 1916, no. 37.
Van Marle, XIII (1931), 318 (as school of Credi); Gigetta Dalli Regole, *Lorenzo di Credi*, 1966, cat. no. 268 and fig. 288 (as '*Maestro della Maddalena Johnson*').

COPY OF LEONARDO DA VINCI

Leonardo da Vinci, born near Florence 1452, probably a pupil of Verrocchio, remained in Florence until *c.* 1482, then in Milan until 1499/1500. In Florence again until 1506, then returned to Milan until 1513. 1513–16 in Rome and elsewhere in Italy, and finally removed to France, in the service of King Francis I. Died at Cloux, near Amboise, 1517.
Very few pictures by Leonardo's own hand exist; he had many other interests – engineering, natural science, sculpture, *etc.* The best idea of his personality is derived from his drawings, of which the finest collection is at Windsor Castle, and from his notebooks. He exercised a decisive influence on the painters of the Milanese School. Five of his original drawings are in the Guise Collection at Christ Church.

51. HEAD OF ST. ANNE. Canvas, a fragment, laid on panel, 15·8 × 12·7 cm. (the canvas, as cut, 13 cm. high).
Guise Bequest, 1765.
A fragment of a reduced copy of the Louvre picture of the *Virgin and Child with St. Anne* (no. 1598). Coarsely restored.
Literature: L. & E., III, 24; E.C., II, 55; 'A' Cat., 1776, p. 2; 1833 Cat., no. 82 or 83 (always as by Leonardo); Borenius Cat., 1916, no. 52 (as copy of Leonardo).

COPY OF LEONARDO DA VINCI

52. HEAD OF THE INFANT CHRIST. Canvas, a fragment, laid on panel, 16·5 × 13·2 cm. (the canvas, as cut, 12·5 cm. high).
Guise Bequest, 1765.

Another fragment from the same picture as no 51. To judge from this head, which is better preserved than that of St. Anne, the copy from which both are cut may have been by a good Milanese pupil or follower of Leonardo.
Literature: L. & E., III, 24; E.C., II, 55 (as Fra Bartolommeo); 'A' Cat., 1776, p. 2 (as Leonardo); 1833 Cat., no. 82 or 83 (as Leonardo); Borenius Cat., 1916, no. 53 (as copy of Leonardo).

SCHOOL OF
LEONARDO DA VINCI

53. THE VIRGIN AND CHILD ('The Madonna with the Yarn-Winder') with a background of Rocks. Panel, without additions: 89·6 × *c.* 66 cm.; with additions (which are old, and of uncertain extent in the width): 92·8 × 69 cm.
Plate 54

Guise Bequest, 1765.

This is a replica, no doubt of the Milanese School, of a design of Leonardo, the original of which has disappeared. The best-known versions are probably those referred to by Borenius, in the collections of the Duke of Buccleuch and Mr. W. Reford of Montreal (the latter from the collection of Lord Battersea). Dr. Emil Möller (*Burlington Magazine*, vol. 49, 1926, p. 61 *ss.*) published the Buccleuch picture as Leonardo's original, and wished to identify it with a picture described by Fra Pietro da Novellara in a letter to Isabella d' Este, Marchioness of Mantua, written from Florence in 1501, where he had seen Leonardo at work. It is true that there is a connexion here, in the curious motive of the yarn-winder held up by the Christ Child in the semblance of a cross, which Fra Pietro describes. But as W. Suida says (*Leonardo und sein Kreis*, Munich, 1929, pp. 136–137), the rest of the description does not tally with the Buccleuch picture, or with any other known version of the composition. In the picture seen by Fra Pietro on Leonardo's easel, the Child had planted His foot in the Virgin's work-basket, and she was attempting to take the yarn-winder from Him.
The two versions referred to, which correspond fairly closely to one another except for the landscape-background, both differ from the Christ Church picture again in the landscape, and also in the turban-like headdress of the Virgin. Other replicas are in the reverse direction, with the Child leaning out to the L., which Suida considers more natural. One of these, from the collection of Prince Rupprecht of Bavaria (Suida, *op. cit.*, fig. 132) shows the Virgin full-length, but her head, with hair parted in the middle and without the turban, more closely resembles that in the Christ Church picture.
The motive of the yarn-winder seems gradually to have been confused with the reed-cross often carried by the young St. John, with which the Christ Child sometimes plays, as in Raphael's *Madonna Alba* now in Washington;

and it is noticeable that in the early lists and catalogues, as Borenius says, the subject of the present picture is always given as *St. Elizabeth with St. John musing upon a cross made of reeds*. It was always attributed to Leonardo himself, and the magnificent French frame indicates that it was highly valued by General Guise.

The appearance of the Christ Church panel has been greatly improved by cleaning at the hands of J. C. Deliss in 1966. The rocky landscape, particularly, is of good quality, and the rest, though undeniably damaged, is in better state than might have been supposed before Mr. Deliss began his work. An attribution to Leonardo's Milanese follower Marco d'Oggiono, who died c. 1530, may be worth considering. The heavy types, the conventionally curved lines of the drapery, and the form of the rocks are all characteristic of this artist. The dark, jagged silhouette of the rocks with hanging grasses, opening on the sky at upper L. recurs almost exactly in the background of a curious picture of Venus, half-length behind a parapet, pointing to a shell, which was once in the Lederer Collection in Vienna, and was sold at Sotheby's, November 20 1957, lot 80. This has generally been attributed to Marco d'Oggiono (Suida, *op. cit.*, pl. 258).

Literature: L. & E., III, 21 *ss.*; E.C., II, 52; 'A' Cat., 1776, p. 12; 1833 Cat., no. 74 (always as Leonardo); Borenius Cat., 1916, no. 49.

SCHOOL OF
LEONARDO DA VINCI

54. THE VIRGIN WITH THE CHILD SEATED ON A PARAPET, holding a Branch of Cherries, with a Cherry Tree in the Background. Panel, 86 × 65·9 cm. Plate 55

Guise Bequest, 1765.

Borenius describes this as 'a variation of the motive of [his] No. 49, the composition being reversed', but in fact there is no real resemblance. He also adds that the quality here is even lower, whereas in fact that of no. 54, though certainly not worthy of the master himself, is at least as good as that of no. 53.

Another version of the present composition, certainly better preserved, was sold at Christies', June 26, 1964, lot 86 (as by a follower of Leonardo); it was the property of A. G. Fenwick, from the collection of Sir Thomas Phillips, Bt., and bought by the latter at the Northwick Sale in 1859. In that painting the background was of jasmine instead of cherry, but the Virgin's L. hand held one end of a spray of cherries (instead of the book), the other end of which was in the L. hand of the Child. In place of the parapet, the Child was seated on a ledge of rock.

The Christ Church picture is much damaged, especially in the face of the Virgin; but the background is of fair quality. A very similar background of cherries appears in a representation of Flora, nude, half length, more or less in the pose of the *Mona Lisa*, which belonged to Lord Muir Mackenzie (Bodmer, *Leonardo*, 1931, pl. 85). This and the Fenwick picture might be by Leonardo's pupil, Francesco Melzi; but the Christ Church picture is not so characteristic in detail. Dr. John Shearman thought the picture might be by a painter of Mantuan or Veronese origin, and the colouring (reddish hair) and type of the Virgin lend some support to this view.

Cleaned and restored by the Hon. Thomas Lindsay in April–May 1966. The face of the Virgin, particularly, had been transformed by an earlier restoration, and though necessarily restored, is now certainly nearer to the original.

Literature: Probably 'A' Cat., 1776, p. 12; 1833 Cat., no. 73 or 81 ('Madonna and Child, by Leonardo da Vinci'); Borenius Cat., 1916, no. 50.

MATTEO BALDUCCI

Working in Siena in the first quarter of the XVI century, much influenced by Pinturicchio.

55. THE VIRGIN AND CHILD WITH ST. MARY MAGDALEN L., A FEMALE MARTYR R., AND TWO ANGELS. Panel, 28·2 × 25 cm. Plate 48

Fox-Strangways Gift, 1828.

Though this beautiful little picture is not included in Berenson's Lists of 1932, it seems to be the one mentioned, with acknowledgment to Berenson, in Venturi's list of works by Matteo Balducci,[1] and that attribution is surely the right one. Closely related are: (*a*) Siena Gallery, no. 359, *Virgin and Child with a Swallow, St. Bernardin and St. Clare*; and (*b*) Siena Gallery, nos. 377, 379, 381 and 393, four hexagonal panels representing the Cardinal Virtues, especially the *Charity*, no. 377.

This must be one of the best works of Matteo, and though there is some restoration in the drapery near the bottom edge, it is on the whole in very good condition, the gold background being particularly well preserved. It was cleaned by H. Buttery in 1962.

Exhibited: Agnew, Horace Buttery Memorial Exhibition, 1963, no. 11; Liverpool, 1964, no. 48.
Literature: Perhaps 1833 Cat., no. 124 (as Francesco Francia); Borenius Cat., 1916, no. 76 (as Umbrian School, c. 1500).

FORMERLY ATTRIBUTED TO
MATTEO BALDUCCI

56. ST. CHRISTOPHER. Panel, 73·1 × 47·1 cm. Plate 49

Label at back: 'Paolo Uccello'.

Probably Fox-Strangways Gift, 1834.

1. As: 'Oxford, Christ Church College, 21 (*sic*), *Madonna con due Sante e due Angeli*'. See Venturi, IX, 5 (1932).

The attribution to Balducci, which was suggested (verbally) by Charles Loeser in 1905, is by no means certain, though the personality of this Umbro-Sienese artist, who was chiefly influenced by Pinturicchio, remains rather indeterminate. A small painting of a *Bacchanal Procession* in the Pinacoteca at Gubbio, attributed to Matteo, shows various points of resemblance; but the Christ Church *St. Christopher* is more primitive in style, and less accomplished in execution, than the small *Virgin and Child*, no. 55 above, which seems fairly certainly to be by him.

Dr. Zeri denies the attribution, and sees nothing Sienese in the style. He draws attention to no. 746 in the Museum of Verona, an anonymous *Crucifixion*, in which types and forms are identical. The treatment of the gold background, which is punched with groups of short rays radiating outwards like electric sparks, at slightly varying angles from the figure of the Saint, is very unusual, but occurs in the Verona picture to which Dr. Zeri refers (Figure 13). The whole is apparently painted over gold, and in the landscape distance, especially R., the paint has been deliberately scratched away in places to give gold heightening to the trees and rocks.

Cleaned by H. Buttery in the summer of 1961, and in good state. The panel is rectangular, but the original painted surface is arched above, the spandrels having been painted over at a later date.

Literature: Not in 1833 Cat.; Borenius Cat., 1916, no. 77 (as Matteo Balducci).

Crowe and Cavalcaselle, *Italian Painting*, 2nd ed., v, 421, note 2; Berenson, Lists, 1932, p. 38, as Balducci (?).

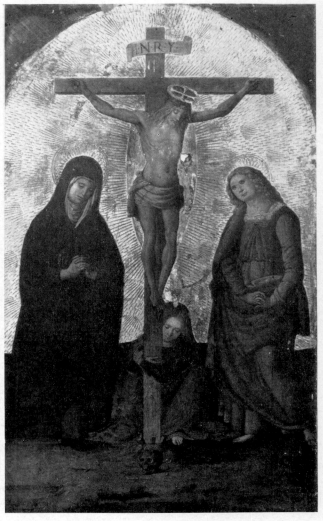

Fig. 13. North Italian School, about 1500:
The Crucifixion, with the Virgin, St. John and St. Mary Magdalen.
Verona, Museo di Castelvecchio. (*Cf.* Cat. No. 56)

FLORENTINE SCHOOL

c. 1510

57. ST. PAUL, three-quarter length. Panel, 31·5 × 16·5 cm.
 Plate 58

Landor-Duke Gift, 1897.

Label at back: 'Balducci sullo stile antico'.

As Borenius remarks, this and no. 58 are clearly fragments from the side of the same altarpiece. Both figures end below in a painted architectural framework, rounded at the corners, and the background of no. 57 is broken upper R. by what appears to be the outline of the original frame. It is possible that the gold backgrounds, though of some age, are not contemporary. The top of St. Nicholas' crozier, and the crudely tooled haloes of both saints, must surely be later additions.

Dr. John Shearman has made (verbally) the interesting suggestion that these two fragments may be very early works of Andrea del Sarto, *c.* 1505 or soon after, at the time of his association with Raffaellino del Garbo. They show undeniable resemblances to the three half-length saints in a predella-piece formerly in the Kaufmann Collection, which Shearman dates *c.* 1507 (*Andrea del Sarto*, 1965, cat. no. 1 and pl. 1b.).

Literature: Borenius Cat., 1916, no. 45 (as Florentine, late XV century).

FLORENTINE SCHOOL

c. 1510

58. ST. NICHOLAS OF BARI, three-quarter length. Panel, 32 × 16·5 cm. Plate 59

Landor-Duke Gift, 1897.

See note to no. 57.

Literature: Borenius Cat., 1916, no. 46.

SCHOOL OF ANDREA DEL SARTO

Andrea d' Agnolo di Francesco, called del Sarto (because

his father was a tailor), 1486–1531, Florentine. Influenced first by Raffaellino del Garbo, later by Fra Bartolommeo and Michelangelo.

59. THE MAGDALEN, half length. Panel 58·3 × 43·2 cm.
Figure 14

Guise Bequest, 1765.

There is a partly erased inscription on the back, giving the subject as the Magdalen, and the attribution to Andrea del Sarto.

The picture was cleaned and restored by S. Isepp (c. 1943?), but is in very poor condition, and is difficult to judge. It must once have been good.

Literature: Possibly 'A' Cat., p. 4 ('The portrait of a Woman, about half length', without attribution); 1833 Cat., no. 194 ('A Female, half length', as Andrea del Sarto); Borenius Cat., 1916, no. 57 (as 'Female Figure, half length', school of Andrea del Sarto).

FRANCESCO GRANACCI
1477–1543

Pupil and assistant of Domenico Ghirlandaio, and a friend of Michelangelo. Later influenced by Fra Bartolommeo and Raphael. Like Franciabigio and Bugiardini, he represents the transition from the early Renaissance to the High Renaissance style in Florence.

60. ST. FRANCIS HOLDING A BOOK, IN A NICHE. Canvas, laid down on panel, rounded above and below, backed, 32·5 × 14·5 cm.
Figure 15

Fox-Strangways Gift, 1828.

Old label on back: 'S. Francesco di Francesco Granacci della Galleria dei Conti Guidi di Firenze'.

Borenius draws attention to two similar panels by Granacci, of *St. Anthony of Padua* and an *Angel*, nos. 181 a and b in the Ashmolean Museum, to which they were presented by

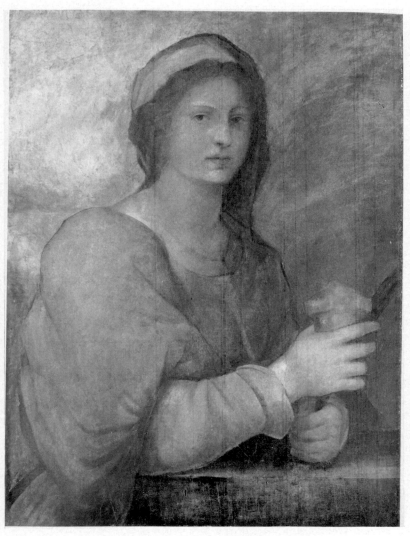

Fig. 14. School of Andrea del Sarto: *The Magdalen* (Cat. No. 59)

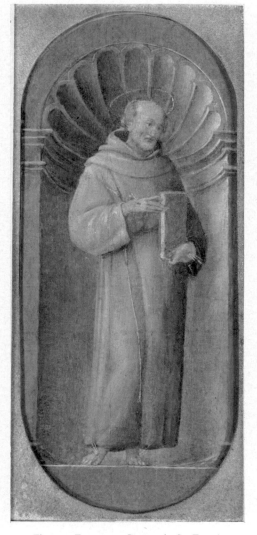

Fig. 15. Francesco Granacci: *St. Francis* (Cat. No. 60)

E

the same donor in 1850. Probably all three are fragments from the sides of a large altarpiece.

Cleaned and backed on another panel by H. Buttery, 1953. The surface is rubbed, and there are small restorations throughout. The Ashmolean pictures, which have been transferred from panel to canvas, and which, though damaged, are only slightly and discreetly restored, are much pleasanter in effect, particularly the Angel.

Literature: 1833 Cat., no. 114 (as Granacci); Borenius Cat., 1916, no. 55.
Crowe and Cavalcaselle, *History of Painting in Italy*, 2nd ed., vol. VI, 1914, p. 159, note 2; Berenson, Lists, 1932, p. 267; Florentine Lists, 1963, p. 100.

FRANCESCO UBERTINI, CALLED BACCHIACCA
1494–1557

Pupil of Perugino, but properly of the Florentine School, influenced by Andrea del Sarto and Michelangelo. Like other Florentines of his time he made frequent use of the earlier engravings of Dürer and Lucas van Leyden as models for individual figures, but the character of his art is highly original.

61. CHRIST APPEARING TO THE MAGDALEN. Panel, 43 × 35·3 cm. Plate 56

On the back, a large M and a *paraphe* incorporating a large L in pen and ink, at least as early as XVIII century.

Guise Bequest, 1765.

This very early work, probably dating from the second decade of the XVI century, is comparable, in its dependence on Perugino and in the delicate charm of the landscape, to Bacchiacca's *Resurrection* at Dijon, which was exhibited in Paris, *Le XVIᵉ Siècle Européen*, 1965, cat. no. 18. A predella-piece of the same subject by Perugino himself, in the Ryerson Collection, Chicago (from the Dudley Sale, 1892), shows the tomb lodged in a rocky hillock behind, in direct frontal view, with ghostly angels visible in the dark interior, exactly as in our picture. This may well have been Bacchiacca's source of inspiration. I can offer no explanation of the lion, apparently devouring his prey, on the R., behind the Magdalen.

Literature: L. & E., III, 29; E.C., II, 60; 'A' Cat., 1776, p. 5; 1833 Cat., no. 148 (always as Perugino); Borenius Cat., 1916, no. 60 and pl. XX.
Morelli, *Italian Painters*, I, 105 (as early Bacchiacca); A. McComb, *Bacchiacca*, in the *Art Bulletin*, VIII, 1926, p. 165; Berenson, Lists, 1932, p. 36; Florentine Lists, 1963, p. 20; Lada Nikolenko, *Il Bacchiacca*, New York, 1966, p. 35 and fig. 2.

FRANCESCO BACCHIACCA

62. CHRIST PREACHING, BEFORE A CLASSICAL TEMPLE
Panel, 88·5 × 61 cm. Plate 57

Guise Bequest, 1765.

An early work of Bacchiacca, but not as early as no. 61. The figures in the background still reflect Perugino's influence, and the architecture, in pure Renaissance style and exact frontal view, is undoubtedly inspired by that master; compare, for example, the building in the background of Perugino's *Presentation in the Temple*, one of the predella-pieces to the great S. Agostino altarpiece at Perugia, which was begun in 1512 but still unfinished at Perugino's death in 1523.[1] The arrangement of the figures in seven compact groups, with the figure of Christ isolated in the centre, is very striking, and this too owes something to Perugino. The little girl kneeling in the R. foreground might be a portrait. In the kneeling women in the foreground, however, something of Sarto's influence appears. Dr. John Shearman[2] would date the picture not later than *c.* 1520, comparing the small panels with the story of Joseph in the Borghese Gallery, Rome, of *c.* 1515–16. It seems to me to be closely related to the *Legend of the dead King* in Dresden (Berenson, Florentine Lists, pl. 1244), which Berenson dates *c.* 1523. There the building in the middle distance is nearly the same as here; on the other hand the Dresden picture already reveals the influence of the Northern engravers (in this case Lucas van Leyden) which is so characteristic of Bacchiacca's later work, and of which there is as yet no trace, so far as I can see, in the picture at Christ Church.

Unfortunately this fine painting is gravely damaged, and when cleaned by Messrs. Holder in 1947 the lower corners were found to be so badly worm-eaten that they were cut off, with a strip about 6 cm. deep at the bottom, and a new frame was adapted accordingly. A large piece of the sky is restored; otherwise the upper part is in better condition than the rest. It may be noted that Morelli (and formerly Berenson) described the subject as *The Raising of Lazarus*, and the attitudes of Christ and the other figures in the foreground would suit this. But old photographs show nothing but a dark mass of restoration at the places where the panel has now been cut, and it is impossible to find any trace of a tomb, or a figure of Lazarus rising from it.

Literature: L. & E., III 31; E.C., II, 61 (as Andrea del Sarto); 'A' Cat., 1776, p. 12 (as Sarto); 1833 Cat., no. 134 (as Perugino); Borenius Cat., 1916, no. 59.
Morelli, *Italian Painters*, I, 105 (as early Bacchiacca); A. McComb, *Bacchiacca*, in *Art Bulletin*, VIII, 1926, p. 165; Berenson, Lists, 1932, p. 35; Florentine Lists, 1963, p. 20; Lada Nikolenko, *Il Bacchiacca*, New York, 1966, p. 35 and fig. 3.

1. Bombe, *Perugino (Klassiker der Kunst)*, 1914, p. 170.
2. Verbally, 1965.

JACOPO CARRUCCI, CALLED IL PONTORMO (?)
1494–1556

Jacopo Carrucci, called Il Pontormo, perhaps the most distinguished of the early Florentine Mannerists. At first a close follower of Andrea del Sarto, and much influenced by the engravings and woodcuts of Dürer; but in his later work, inspired by the forms of Michelangelo, he developed a highly individual style and an exquisite quality of workmanship. The study for one of his finest paintings, the *Deposition* in S. Felicità, Florence, is in the Guise Collection of drawings at Christ Church.

63. A SCHOLAR, HOLDING TWO GILT STATUETTES. Panel (enlarged all round), originally 39·3 × 28·9 cm. (43·7 × 34 cm. including the later enlargement). Plate 60

Probably Guise Bequest, 1765 (but not identifiable in the early catalogues).

Borenius read the sitter's age on the paper on the table 'AN. AE. LVIII', but this has disappeared in cleaning. He also records an observation of Loeser and Berenson, that the statuette of Hope, in the sitter's L. hand, is imitated from Andrea del Sarto's fresco in the Chiostro dello Scalzo at Florence.

The style is near to Pontormo's – cf. the portrait of Alessandro de' Medici in the Johnson collection at Philadelphia (Berenson Cat. no. 83); and the quality in the better preserved parts – the hands and the statuettes – seems good. The small scale is, however, unusual. Dr. John Shearman (verbal opinion 1965) and Mr. P. M. Pouncey (independently) both suggested the name of Pier Francesco Foschi, by whom there are altarpieces, reflecting the style of Fra Bartolommeo and Bacchiacca as well as that of the Florentine Mannerists, in the church of S. Spirito in Florence and at Poggio alla Noce nearby (the last dated 1545; see *Bollettino d' Arte*, 1938, vol. XXXII). The artist's name was formerly misread in a contemporary document as 'Toschi'; and under that name Myril Pouncey convincingly attributed to him a group of drawings, including one in the Christ Church Collection (*Burlington Magazine*, May 1957). Portraits, formerly called Pontormo or Bronzino, in the Thyssen Foundation at Lugano, the Corsini Collection in Florence (dated 1540), the Rijksmuseum, Amsterdam, and the Stirling Collection at Keir (1549; sold at Sotheby's 1963) are attributed to Foschi by Kurt Forster in *Pantheon*, 1965, p. 217 ss.

The hands in the Christ Church portrait seem rather better, less mannered, than in these works, perhaps nearer to Pontormo himself, and allowance must be made for the condition, which is by no means good. But Dr. Shearman is convinced that the portrait is not by Pontormo.

Cleaned by J. C. Deliss, 1964. There are many minor repairs in the face and dress.

Exhibited: Leeds 1868, no. 335.

Literature: Borenius Cat., 1916, no. 61 (as possibly a copy of Pontormo).

Berenson, Lists, 1932, p. 468; Florentine Lists, 1963, p. 181 (as repainted and doubtful).

FLORENTINE SCHOOL
c. 1550

64. PORTRAIT OF A LADY, half length. Panel, 76·5 × 52·5 cm. Plate 61

Guise Bequest, 1765.

The picture was cleaned by S. Isepp in the early 1940's, and now appears to be a straight portrait, the attributes of Judith (head of Holofernes, sword, *etc.*) having disappeared in the process. The additions were certainly made before General Guise's time, since the picture is described as '*Judith holding Holofernes' head*' in the *English Connoisseur* of 1766 and in *London and its Environs* (before 1761).

The surface is much cracked and worn, and the quality is not high. Mr. A. E. Popham expressed the opinion (verbally, 1963) that the picture is nearer in style to Vasari than to F. Salviati; and Dr. John Shearman (verbally, 1965) suggested the name of Poppi (Francesco Morandini, called Il Poppi, 1544–97), who was Vasari's pupil.

Literature: L. & E., III, 22; E.C., II, 52 (as Francesco Salviati); 'A' Cat., 1776, p. 9 ('Salviati'); 1833 Cat., no. 181 ('Salviati'); Borenius Cat., 1916, no. 63 ('attributed to Francesco Salviati').

FLORENTINE SCHOOL, MID XVI CENTURY

65. CLEOPATRA (bust-length). Panel, 63·5 × 49 cm. Figure 16

Fox-Strangways Gift, 1828.

Label at back (late XVIII or early XIX century): '*Cleopatra in mezza figura e nella cornice otto quadretti dipinti a chiaroscuro di Francesco Salviati*'.[1]

The picture, though originally allotted a number (64) by Borenius, was not included in the published catalogue, and has been in store for the last fifty years.

1. It is possible that this frame, the description of which corresponds to that of Bronzino's portrait of Don Garzia de' Medici in the Ashmolean Museum (Cat. 1962, no. 77), was transferred to the Bronzino when both pictures were in the Fox-Strangways Collection. The measurements correspond closely enough (Bronzino, 66 × 53, Christ Church picture, 63·5 × 49 cm., without the surrounding strip; with it: 66·3 × 51·6 cm). Such a frame, however, was not unique (as Sir Karl Parker pointed out to me); another of much the same type surrounds a *Holy Family* by Vasari in the Acton Collection, Florence (*Mostra del Cinquecento Toscano*, Palazzo Strozzi, 1940, Cat. p. 88 and pl. 41).

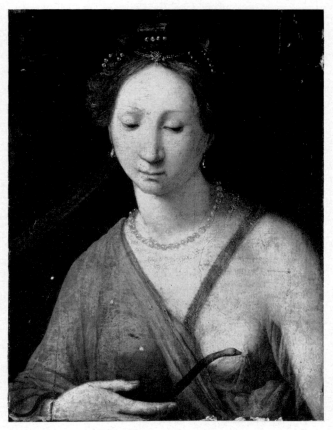

Fig. 16. Florentine School, mid XVI century: *Cleopatra*
(Cat. No. 65)

It is certainly not by Francesco Salviati, and though the thick panel is of a type commonly found in Florentine paintings of the XVI century, the style rather suggests a Netherlandish artist, perhaps working in Italy, *c.* 1550. Partly cleaned by Miss Jacqueline Pouncey in 1965. There are damages in the background, and the pearl-necklace; the snake and other parts are rubbed.

Literature: 1833 Cat., no. 180 (as Salviati).

ATTRIBUTED TO FRANCESCO SALVIATI
1510–63

Francesco de' Rossi, called also Cecchino, a friend and fellow-pupil of Vasari with Bandinelli in Florence; afterwards with Andrea del Sarto. From about 1530 he was in Rome in the service of Cardinal Salviati, whose name he adopted. He visited Venice, and was in France, in the service of the King, 1554–55; but his chief works are in Florence, where he returned more than once, and in Rome, where he died. One of the most important of the Florentine-Roman Mannerists of the mid XVI century.

66. THE VIRGIN KNEELING, WITH THE CHILD IN HER ARMS. Canvas, 66·5 × 49·7 cm. Figure 17

Guise Bequest, 1765. Bought at Dr. Bragge's Sale, 1757 (1st day, lot 43: 'The Virgin Kneeling holding the Child, Sch. of Parmeggiano. Gen. Guise 6–10–0') (Houlditch MS.).

Inscribed on the back of the stretcher '*Original de Salviaty*'. The picture, which was cleaned and restored by S. Isepp, *c.* 1943, is in ruined condition, and impossible to judge.

Literature: L. & E., III, 22; E.C., II, 53 ('Our Lady contemplating her babe. The figure about 2 feet and a half, wonderfully well done after Correggio's manner by Francesco Mazzuoli, commonly called Parmigianino'); 'A' Cat., 1776, p. 12 (as Primaticcio); 1833 Cat., no. 179 (without attribution); Borenius Cat., 1916, no. 65 (as attributed to Salvia.i, possibly after him).

BATTISTA NALDINI
1537–91

Pupil of Pontormo, later assisting Vasari in the decoration of the Palazzo Vecchio in Florence. One of the group of Florentine Mannerists who collaborated in the decoration of the Studiolo of Duke Francesco I. There is an interesting group of drawings by him in the Guise Collection at Christ Church.

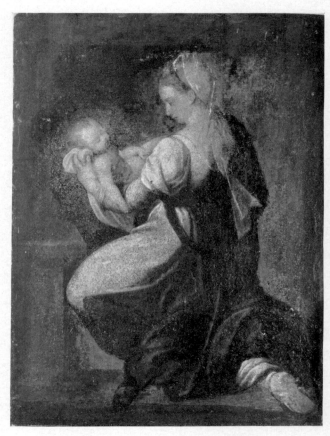

Fig. 17. Attributed to Francesco Salviati:
The Virgin kneeling, with the Child (Cat. No. 66)

67. ECCE HOMO. Panel, 51·7 × 35·5 cm. Plate 62
Guise Bequest, 1765.

Mr. Philip Pouncey, the first to recognize this as a Florentine work of the second half of the XVI century, was inclined to attribute it to Giovanni Balducci, called Cosci, a younger associate of Naldini; but has since suggested to me that it may be by Naldini himself, and Dr. Giuliano Briganti is of the same opinion. The scheme of composition, the architecture, and more particularly the figures in the immediate foreground, are indeed characteristic. This may be a *modello* for a large altarpiece, such as Naldini painted for S. Maria Novella, S. Marco and other churches in Florence. Another small *modello* by him is in the Ashmolean Museum.

Cleaned by J. C. Deliss, 1961, and backed with balsa wood. The poplar panel was badly worm-eaten. The colour is much darkened by the old varnishes and the general condition is not good.

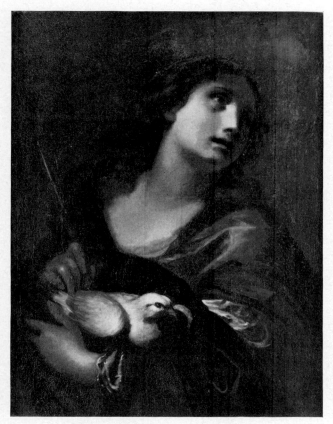

Fig. 18. Attributed to Simone Pignoni:
A female Martyr with a Dove (Cat. No. 69)

Literature: L. & E., III, 29; E.C., II, 60; 'A' Cat., 1776, p. 10; 1833 Cat., no. 7 (in all these as by Barocci); Borenius Cat., 1916, no. 93 (as copy after Barocci?).

TUSCAN SCHOOL,
LATE XVI CENTURY

68. ST. FRANCIS RECEIVING THE STIGMATA; in a feigned oval. Panel, 23·9 × 21·4 cm.

Fox-Strangways Gift, 1834 (?) (not in 1833 Cat.).

Attributed on the back, in an XVIII century hand, to Andrea del Sarto, but certainly much later, and of indifferent quality.

Literature: Borenius Cat., 1916, no. 275 (as Italian, XVII century).

ATTRIBUTED TO
SIMONE PIGNONI
1614–98

The pupil and most gifted follower of Francesco Furini in Florence.

69. A FEMALE MARTYR, WITH A DOVE. Canvas, 74 × 55·8 cm. Figure 18

Guise Bequest, 1765.

The painting has always been attributed to Furini, but the facial type, with the long straight nose and strongly marked nostril, rather suggests the hand of Pignoni, and both Mr. P. M. Pouncey and Dr. G. Briganti prefer this attribution. Another version of our picture, in an English private collection, apparently inferior and perhaps only a copy, was attributed to Pignoni by Dr. Hermann Voss.[1] As to the subject, it was interpreted in the early catalogues as an Allegory of Simplicity; but the woman seems to hold a palm-branch, and may be a Martyr.

Relined and cleaned by J. C. Deliss, 1965. The surface is badly rubbed about the neck and throat, and the hands and dress are restored.

Literature: L. & E., III, 26; E.C., II, 56; 'A' Cat., 1776, p. 3; 1833 Cat., no. 54; Borenius Cat., 1916, no. 67 (as Furini).

1. Photo, Witt Library.

BYZANTINE AND VENETIAN PAINTERS

GRECO-VENETIAN SCHOOL, EARLY XVI CENTURY

70. THE AGONY IN THE GARDEN. Panel, 36·5 × 31 cm.
Plate 63

According to a note on the back (1844), presented by John W. Brett to the Rev. Frederick Barnes, D.D., who is said to have presented it to Christ Church. Dr. Barnes died in 1859. Borenius records an inscription at back: '*Maestro Paolo*' (*i.e.* by the Venetian XIV century artist, Paolo Veneziano); but this is no longer visible.

According to Professor D. Talbot Rice, this is a good example of Greco-Venetian art – by a Greek painter working in Venice, as Borenius supposed – of fairly early date. The iconography is interesting, with all eleven Apostles, most of them sleeping, in the foreground; one is at full length on a sort of bed.

Cleaned by J. C. Deliss, 1964. The olive trees on the pink hill-side in the middle distance had been painted over, certainly before the picture came to Christ Church. There are local damages, especially in the trees which had been painted out, and in the figure of the angel at upper L., but on the whole the condition is not bad.

Literature: Borenius Cat., 1916, no. 2 (as Byzantine, XVI century).

GRECO-VENETIAN SCHOOL, LATER XVI CENTURY

71. ST. GEORGE AND THE DRAGON. Panel, 27·4 × 24·4 cm.
Figure 19

Fox-Strangways Gift, 1828.

The date 1540 on the frame has apparently no more authenticity than that of 1514 mentioned in the 1833 Cat. Professor D. Talbot Rice considers this of later date than no. 70. It is of fairly good quality, and in fair condition.

Exhibited: Manchester, 1857, no. 189.

Literature: 1833 Cat., no. 127 (as 'by a Greek painter, 1514'); Borenius Cat., 1916, no. 1.

GRECO-VENETIAN SCHOOL XVI-XVII CENTURY

72. THE VIRGIN AND CHILD WITH FOUR SAINTS, SS. Lawrence, and Andrew L., Peter and Donato (?) R. Panel, 63·2 × 95·8 cm.

Fox-Strangways Gift, 1834 (?) (not in 1833 Cat.).

A painting of coarse quality, in traditional late Byzantine style, with a lingering influence of the familiar half-length compositions of the school of Giovanni Bellini.

Literature: Borenius Cat., 1916, no. 3.

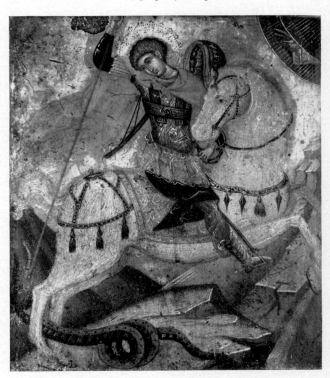

Fig. 19. Greco-Venetian School, later XVI century: *St. George and the Dragon* (Cat. No. 71)

BYZANTINE (RUSSIAN) SCHOOL, XVII/XVIII CENTURY

73. AN IKON, WITH ST. NICHOLAS THE WONDER-WORKER, half length. Small figures of Christ and the

Virgin, half length, in the upper corners. St. John Baptist L. and St. Catherine R., full length, on the borders of the panel. The names are inscribed in Slavonic characters. The centre of the panel is recessed. Panel, 30·5 × 26·1 cm.

Fox-Strangways Gift, 1834 (?) (not in 1833 Cat.).

Borenius refers to a similar ikon, of the Moscow School, reproduced by Muñoz, *L'Art Byzantin*, p. 23. Professor Dimitri Obolensky believes that ours is either Russian or Balkan in origin. The condition is good.

Literature: Borenius Cat., 1916, no. 4.

STUDIO OF ANDREA MANTEGNA
1431–1506

Painter and engraver, adopted at an early age by the painter Francesco Squarcione of Padua, who probably inspired him with a love of classical antiquities. He became the most important artist of the Paduan school. Removed to Mantua 1459/60, and remained there in the service of the Gonzaga family for the rest of his life, except for a stay in Rome 1488–90. He married the sister of Gentile and Giovanni Bellini.

74. CHRIST CARRYING THE CROSS. Canvas, backed with another canvas, 63 × 77·8 cm. Plate 64

Guise Bequest, 1765. From the collection of King Charles I.[1]

The mark of Charles I's collection, CR with a crown above, is on the back of the second canvas, perhaps copied from the earlier one. There is also a number, 162, at least as early as XVIII century.

Crowe and Cavalcaselle suggest that this may be the picture recorded in the Inventory of the Duke of Mantua, Jan. 12, 1627; '*Un quadro con N.S. che porta la croce, mezza figura, oppera di Mantegna con ornamento fregiato d' Oro. L. 90*' (see A. Luzio, *La Galleria dei Gonzaga venduta al-l' Inghilterra*, Milan, 1913, p. 97, no. 118).

The painting, which is mentioned by Fiocco (see below, *loc. cit.*) as '*opera di bottega e scadente*' but ignored in more recent literature (Tietze-Conrat, 1955; Cat. of Mantegna Exhibition, Mantua, 1961), is rather hard and mannered in style, but of good quality and close to the late Mantegna. The head of Christ may be compared to that in the *Imago Pietatis* at Copenhagen (Knapp, *Klassiker der Kunst*, 1910, 105) and to the head of St. Sebastian in the Ca d' Oro painting (*ibid.*, 122), both certainly late works, not much before 1500. Grotesque types of the same sort as the

1. Mr. Oliver Millar informs me that this was valued by the Commonwealth officials in Oct. 1649 (Hampton Court, no. 157) at £40, and sold to 'Jackson and others in a Dividend', Oct. 23 1651. He suggests that it may later have belonged to Cardinal Mazarin (no. 997 of his inventory of 1661).

soldiers and assistants here appear to R. and L. of Christ in the *Ecce Homo* of the Musée Jacquemart-André, Paris (Tietze-Conrat, *Mantegna*, 1955, fig. 18), which is generally considered no more than a studio work; but such types are also to be found in Mantegna himself, as in the famous *Minerva expelling the Vices*, from the *studiolo* of Isabella d' Este, now in the Louvre.

The picture of the same subject at Verona, to which Borenius refers, was exhibited at the Mantegna Exhibition at Mantua in 1961, and is reproduced in the Catalogue, pl. 47. It is clearly much damaged but has been skilfully restored (contrast the reproduction in Tietze-Conrat, *op. cit.*, fig. 17). Fiocco believes it to be autograph; and certainly it offers some interesting points of comparison with the Christ Church picture, in the hands of Christ, the halo, the Cross and the heads in the background.

Cleaned by J. C. Deliss, 1964. The condition is by no means bad; there is a large hole in the L. hand of the Roman soldier R., and a strip about 38 mm. high at the top is false. Otherwise there is only local restoration in the face of Christ (about the nose) and in the draperies, where the surface was rubbed and the red bolus ground was obtrusive.

Exhibited: Manchester, 1857, no. 97.

Literature: L. & E., III, 19; E.C., II, 49; 'A' Cat., 1776, p. 11; 1833 Cat., no. 80 (always as Mantegna); Borenius Cat., 1916, no. 183 and pl. XLI (as School of Mantegna).

Claude Phillips, *The Picture Gallery of Charles I*, 1896, p. 75; Kristeller, *Andrea Mantegna*, 1901, p. 453 (as by a Veronese pupil of Mantegna); Crowe and Cavalcaselle, *History of Painting in North Italy*, 2nd ed., 1912, II, 119, note 2 (as possibly by Francesco Mantegna); Fiocco, *Mantegna*, Milan, 1937, p. 209; Berenson, Lists, 1932, p. 370; Venetian Lists, 1957, p. 119 (as Jacopo da Montagnana) (the Christ Church number is given as 198, but presumably this picture is meant); A. Moschetti, *Jacopo da Montagnana*, Padua, 1940, p. 150 and fig. 77.

VENETIAN (?) SCHOOL,
LATE XV CENTURY

75. BUST PORTRAIT OF A MAN IN A BLACK CAP, three-quarters to R. Panel, 27·5 × 23 cm.

Guise Bequest, 1765.

The painting was exhibited at Manchester in 1857 as 'School of Bellini', but was catalogued as German by Borenius. It does in fact recall portraits by Giovanni Bellini or his school produced in the last two decades of the XV century, though the cut of the coat at the neck is not in Venetian style, and the panel is of oak, suggesting a Northern origin. When partly cleaned at the Courtauld Institute in 1965 the painting was found to be in such deplorable condition that no restoration was undertaken; but there are still traces of high quality in what remains.

Exhibited: Manchester, *Art Treasures*, 1857, no. 899.

Literature: Perhaps 'A' Cat., 1776, p. 11 ('A small head, by Hans Holbein'); 1833 Cat., perhaps no. 247 or no. 249 (both Heads attributed to Holbein); Borenius Cat., 1916, no. 310 (as German School, *c.* 1520).

ATTRIBUTED TO MARCO BELLO
1470–1523

Recorded at Udine in 1511, and resident there until his death (see Crowe and Cavalcaselle, *History of Painting in North Italy*, ed. Borenius, 1912, I, p. 291). He is described in his signature on a painting of *The Circumcision*, in the Rovigo Gallery, as a disciple of Giovanni Bellini.

76. THE VIRGIN AND CHILD WITH THE INFANT ST. JOHN IN A LANDSCAPE. Panel, 36·7 × 54·3 cm. Plate 65

Guise Bequest, 1765.

The composition of the Virgin and Child seems almost certainly to derive from Giovanni Bellini at a fairly late stage in his career (perhaps *c.* 1510), but no original by Bellini seems now to be known. On the other hand, Borenius was clearly right in pointing out a connexion with Catena, in whose works the Virgin and the little St. John appear in almost identical form (see, for example, pictures at Prague and in the collection of Captain Stopford Sackville, reproduced by Giles Robertson, *Catena*, pl. 22). Of the two other versions mentioned by Borenius, that in the Accademia, Venice (cat. vol. I, 1955, no. 111), corresponds more exactly, and seems no better than the Christ Church picture; that formerly in the Benson Collection (repr. Burlington Fine Arts Club, Exh. of Early Venetian Painting, 1912, cat. pl. XXXVIII) may be of rather better quality, but there the landscape and the hands of the Virgin are differently disposed. The Benson picture was sold at auction in New York in 1943 (Parke-Bernet, Oct 1943, lot 497, repr. in cat.).

Besides these, an apparently good version of this composition, but with a view of Venice (Campo S. Polo) in the background, belongs to Mr. E. P. Warren of Lewes (Photo., Witt Library); the same Child Christ, somewhat more Bellinesque in type, appears in a damaged *Virgin and Child* in the National Gallery of Canada, Ottawa, (cat., 1957, I, 316); and the Virgin and Child, with a different infant St. John, are in the Leningrad picture, no. 1655.

All these pictures have been attributed, at one time or another, to the obscure Marco Bello. The Accademia picture was attributed to him at least as early as 1859, though it is now catalogued (1955) as '*Seguace di Vincenzo Catena*'. The Virgin in the Christ Church picture does in fact bear some resemblance to the young woman on the R. of the signed painting by Marco Bello at Rovigo. But since that is a copy of Bellini, the basis of comparison is narrow. The

type of the Child Christ in our picture and the treatment of the most prominent tree in the background, are curiously Düreresque, and it may be that the painter was influenced by Dürer during his stay in Venice 1505–06, as well as by Bellini.

For an article on Marco Bello, see Felton Gibbons in *Arte Veneta*, XVI (1962), p. 42 *et sq.* He makes no reference to the Christ Church picture.

Literature: 1833 Cat., no. 12 (as Giovanni Bellini); Borenius Cat., 1916, no. 184 (as School of Catena). Giles Robertson, *Vincenzo Catena*, 1954, p. 79 (as Follower of Catena); Berenson, Venetian Lists, 1957, I, p. 39 (as Marco Bello); F. Heinemann, *Giovanni Bellini e i Belliniani*, 1960, I, p. 25 and II, fig. 233 (as by Francesco da Santa Croce, after a lost original by Giovanni Bellini of *c.* 1505).

GIOVANNI FRANCESCO CAROTO
c. 1480–1546

School of Verona, a pupil of Liberale da Verona. Much influenced at first by Mantegna and Bellini, later by Raphael and perhaps Titian.

77. THE MARTYRDOM OF ST. CATHERINE. Panel, 15 × 43·8 cm. (without additions). Plate 66

Fox-Strangways Gift, 1828.

Borenius suspected that this predella-piece was of the school of Verona, and Berenson's attribution seems acceptable. An altarpiece by Caroto of the Virgin and Child enthroned between SS. Catherine and Paul, with two donors and their children below, is in the church of Mezzone di Sotto, near Verona (repr. Fiocco, *Paolo Veronese*, 1928, p. 17, fig. 11); and it is conceivable that our small panel was part of the predella of that work. The date must be fairly early in the artist's career, *c.* 1510–15.

Backed on another panel and cleaned by H. Buttery, 1955. Considerable areas of original paint are lost in the foreground and elsewhere, but the condition of the figures is tolerable.

Literature: 1833 Cat., no. 130 (without attribution); Borenius Cat., 1916, no. 250 (as Italian School, *c.* 1500). Berenson, Lists, 1932, p. 131 (as Caroto).

GIOVANNI FRANCESCO CAROTO

78. THE LAMENTATION FOR CHRIST. Linen, mounted on panel, 25·7 × 37·6 cm. Plate 67

Guise Bequest, 1765.

It was Mr. Philip Pouncey who first recognized this interesting little painting as by Caroto, and his attribution is decisively confirmed by comparison with two works by

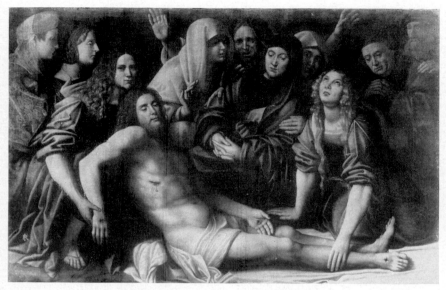

Fig. 20. Giovanni Francesco Caroto: *The Lamentation for Christ*. Turin, Fontana Collection
(*Cf.* Cat. No. 78)

that master in which the same group, with variations, appears: (i) the *Lamentation* in the Fontana Collection at Turin, dated 1515 (Figure 20), and (ii) the upright composition of the same subject, with four figures only, in the Castello at Milan (Schlosser *Festschrift*, 1927, fig. 70). The Fontana picture has portraits of kneeling donors in the background L. and R., and the weeping man who appears immediately above St. John on the L. of our picture is omitted. Otherwise the correspondence is fairly close, though the Fontana picture is different in scale and much more elaborately finished. The correspondence between the Christ Church picture and that in the Castello at Milan is much less close, but the connexion is clear.

Our picture might well be the earliest of the three. As the 1833 catalogue says, it is in an unfinished state: the preliminary pen outlines are visible in all the flesh parts, and some of the drapery – the bright green of St. John, for instance – is in underpainting only. The surface has suffered from rubbing, and much later restoration was removed when the picture was cleaned by J. C. Deliss in 1964.

Literature: Perhaps 'A' Cat., 1776, p. 12 ('A small dead Christ, with several figures, by Albert Dürer'); 1833 Cat., no. 231 (as Andrea del Sarto, 'a very curious unfinished picture'); Borenius Cat., 1916, no. 62 (as Florentine School, *c.* 1550).

TITIAN (?) (TIZIANO VECELLIO)
1477 (?)–1576

The date of Titian's birth is much disputed, and is variously given by early authorities as between 1473 and 1482. His earliest certainly datable works are the frescoes in the Scuola del Santo at Padua of 1511, but some still existing must be earlier than that. Said to have been a pupil of Gentile and Giovanni Bellini, and an associate of Giorgione, he was the most celebrated and influential painter of the High Renaissance in Venice. Created Count Palatine and Knight of the Golden Spur by the Emperor Charles V; worked extensively for him, and for the princely families of Italy, as well as for Venetian patrons. At the end of his life he was almost continuously employed by King Philip II of Spain.

79. THE ADORATION OF THE SHEPHERDS. Panel, 93·7 × 112 cm. Plate 70

Guise Bequest, 1765. From the collection of King Charles I, whose cipher CR and crown are burnt into the back of the panel.

This is almost certainly the painting recorded in the Gonzaga Inventory of 1627 as '*un Presepio di mano di Titiano, con cornice nera fregiata d' oro, stimato scudi 40*' (A. Luzio, *La Galleria dei Gonzaga venduta all' Inghilterra*, Milan, 1913, p. 114, no. 302); and probably also the '*nascita del Salvatore in picciola tela (sic) con i pastori, che si vede in istampa di legno*' mentioned by Ridolfi (*Meraviglie*, 1648, ed. Hadeln, 1914, see below, *loc. cit.*) as among several pictures by Titian acquired for the King of England. Ridolfi's remark refers to the contemporary woodcut, signed with a monogram IB, which reproduces the composition in reverse (Passavant, VI, p. 225, 10; Mauroner, *Le Incisioni di Tiziano*, 1943, p. 48, no. 14 and pl. 28). There are also three corresponding line-engravings: (1) inscribed: *Tytianus pro Luca Berteli* (in reverse)[1]; (2) another, inscribed: *Titianus Vecellius inven. pinxit. Franc. Petrucci delin. Fr. An. Lorenzini Min. Con.*

1. Luca Bertelli, a publisher, worked in Venice and Rome, *c.* 1550–1580.

scul. (Mauroner, *loc. cit.*); and (3) another, by Boel, in the same direction as our painting, in Teniers' *Teatrum Pictorium*. The woodcut and the Bertelli engraving are both in the Christ Church Collection.

Borenius refers to the well-known version of this composition in Palazzo Pitti, Florence (no. 423), and to another (surely inferior) in Palazzo Corsini (no. 399), and says that all three are copies of one of the frescoes executed by pupils of Titian in the church of Pieve di Cadore in 1566–67. The frescoes were in fact completely destroyed by fire in 1813, but from an exact description given by Ticozzi (*Vite dei Pittori Vecelli di Cadore*, 1817) and largely repeated by Crowe and Cavalcaselle (see below, *op. cit.*, 1881), the composition of this one must have been essentially that of the Christ Church and Pitti pictures and of the various related prints. The correspondence with the Cadore fresco is, however, much more easily explained by supposing that Titian's pupils, in painting the fresco, made use of the woodcut referred to above.

In the face of all the evidence ascribing this design to Titian, it seems fantastic to maintain, as Dr. Mary Pittaluga (see below, *op. cit.*) wishes to do, that it is nothing but a plagiarism from a famous picture by Bassano. Here again the correspondence of certain figures is undeniable, but it would be characteristic of Bassano, in painting his *Adoration of the Shepherds* now at Hampton Court (datable 1549), to borrow a figure or two from Titian; and it is noticeable that the IB woodcut, which no doubt provided Bassano with his immediate model, is in the reverse direction to the Titian paintings but in the same direction as the Bassano. In fact, the Christ Church/Pitti composition is in Titian's much earlier style; the Pitti version is generally identified with the *Nativity* painted for the Duchess of Urbino in 1532/33; the Christ Church version may be considerably earlier, if, with due allowance for the condition of the painting, we may trust the rather 'primitive', Giorgionesque type of the Infant Christ.

This Duchess of Urbino, for whom the Pitti version was probably painted, was a Gonzaga, sister to Titian's patron the Marquis Federico of Mantua, and it was his descendant who sold the Christ Church version, about a century later, to King Charles I of England. Thus both these versions can claim a very distinguished pedigree, and the possibility that both are, or once were, from Titian's own hand, the one a replica painted for a close relative of the owner of the other, should not be discarded. Unhappily both are in very bad condition, particularly that at Christ Church. I have seen it freed from all restoration, when the late Sebastian Isepp tried to improve it in 1952, and must admit that very little of the original surface remains; but there are traces of true quality here and there, particularly in the Virgin's head, and the dignity of the design and contour is not entirely lost. Of recent writers, only Berenson, in his Venetian Lists of 1957, seems to imply a not entirely unfavourable opinion – he calls it a studio replica of the repainted original in the Pitti. I should be inclined to

reverse the order of precedence. In view of the present condition of both panels, this is no more than a guess; but to reject the Christ Church version out of hand as a copy, without reference to condition, as Hadeln, Borenius and Suida do, seems both presumptuous and misleading. Tietze (*loc. cit.*, 1950) is more cautious, but though he considers our version to be 'much closer to the original' (the reason for this judgement is not clear), he adds that it is 'probably not by Titian's own hand'.

Exhibited: Manchester, *Art Treasures*, 1857, no. 271.

Reproduced: Arundel Portfolio, 1908, no. 5.

Literature: L. & E., III, 26; E.C., II, 57; 'A' Cat., 1776, p. 10; 1833 Cat., no. 33 (always as Titian); Borenius Cat., 1916, no. 188 and pl. XLIII (as copy after Titian). Crowe and Cavalcaselle, *Titian*, 2nd ed., 1881, vol. II, p. 380 (note); D. von Hadeln, editing Ridolfi, *Meraviglie*, 1914, I, p. 196 (note 6); G. Fiocco, in *L' Arte*, XX, 1917, pp. 360–361 ('*buona copia contemporanea*'); Mary Pittaluga in *Dedalo*, XIII, 1933, pp. 297 *ss.*; W. Suida, *Tizian*, 1933, pp. 159–160; H. Tietze, *Titian*, Phaidon, 1950, p. 371; Berenson, Venetian Lists, 1957, I, p. 189.

COPY OF TITIAN

80. PORTRAIT OF THE DUKE OF ALVA, half length to left. Canvas, 102·3 × 89 cm. Figure 21

Guise Bequest, 1765.

The picture has been re-lined, through Agnew (label), probably at the time of the Manchester *Art Treasures* Exhibition, 1857, and an old inscription, no doubt once on the back, has been copied on to the new canvas: '*Ex: Col: Arund: D. d' Alva. Titian P:*' The original inscription might have been of the XVIII century.

I can find no mention of a portrait of the Duke of Alva, by Titian or any other artist, in the Arundel Inventory of 1655.[1] Dr. John Shearman drew my attention to an entry in the Van der Doort inventory of Charles I's Collection (Walpole Society, XXXVII, p. 25), referring to a portrait of the Duke 'when he was younge', which was in fact presented to the King by Lord Arundel; but this was 'in armoure whereuppon a crucifix', and only 'to ye Should[rs]'.[2]

Ferdinand Alvares de Toledo, Duke of Alva (*b.* 1508–*d.* 1582), Governor-General of the Netherlands 1567–74, is known to have been painted by Titian before 1549, when Pietro Aretino referred to the portrait in a sonnet: it may have been done in Augsburg in 1548, and was perhaps finished in Venice. It was formerly supposed that this was the portrait in the collection of the Duke of Alva, of which

1. Published by Miss M. Cox in *Burlington Magazine*, XIX, 1911, pp. 178 and 322; and by Miss Mary Hervey in her *Life and Correspondence of Thomas Howard, Earl of Arundel*, 1921, p. 473.
2. That description more nearly fits the version reproduced by Mayer, *loc. cit.*, p. 298, fig. 9.

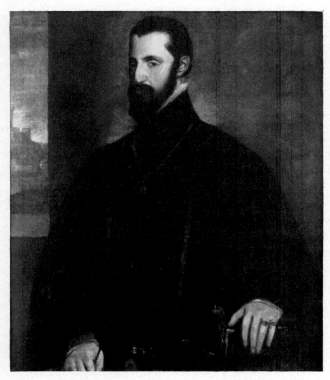

Fig. 21. Copy of Titian: *The Duke of Alva* (Cat. No. 80)

FERDINANDVS ALVARVS A TOLETO DVX D'ALVA
PHILIPPVS. II REGIS HISPANIARVM BELGICARVM GVBERNAT
obyt An.º 158 2. ÆTATIS SVÆ. 74.
Floriano Francie HOPE *P. de Iode excudit.*
PORT. COLLR.

Fig. 22. Pieter de Jode after Titian: *The Duke of Alva.*
Engraving (*Cf.* Cat. No. 80)

that belonging to the Conde de Huescar at Madrid (Fischel, *Klassiker der Kunst, Tizian*, 1906, p. 118), to which Borenius refers, is a replica. W. Suida, however (*Tizian*, 1933, p. 107), showed that the true portrait taken at this time is represented in the engraving by Pieter de Jode (see Figure 22), and, as A. L. Mayer was the first to point out (see below, *loc. cit.*), this engraving corresponds in reverse to the Christ Church painting, except for the arch in the background, which is a characteristic invention of the engraver. The sitter in our portrait might well be forty years old; he is certainly not an old man, as the Duke appears in the Alva/Huescar likeness.[1]

Our picture is therefore of some importance, as the record of a noble work by Titian. Crowe and Cavalcaselle judged the condition too harshly, on the assumption that this was once an autograph by the great master. When cleaned by J. C. Deliss in 1965, it proved to be less repainted than they supposed, but on the other hand certainly not autograph, and hardly contemporary.

Exhibited: Manchester, 1857, no. 272.

Literature: 'A' Cat., 1776, p. 10; 1833 Cat., no. 34; Borenius Cat., 1916, no. 194.
Crowe and Cavalcaselle, *Titian*, II, p. 466 ('utterly ruined by repainting'); Mrs. Lane Poole, *Oxford Portraits*, III, 1925, p. 13, no. 32; A. L. Mayer, in *Gazette des Beaux-Arts*, 1938, pp. 305–307.

1. According to Friedländer and Mayer, the later portrait dates *c.* 1668–70, and is not by Titian but perhaps by Sir A. Mor.

COPY OF TITIAN

81. CHRIST IN PROFILE, half length to L., R. hand across. Canvas, 77·7 × 58·2 cm.

Guise Bequest, 1765.

A bad copy, in very bad condition, of the picture in the Pitti Gallery, Florence, no. 228.

Literature: ? 'A' Cat., 1776, p. 4; 1833 Cat., no. 32; Borenius Cat., 1916, no. 189.
Crowe and Cavalcaselle, *Titian*, II, p. 417.

COPY OF TITIAN

82. THE PESARO ALTARPIECE. Canvas, 85 × 50·4 cm.

Guise Bequest, 1765.

A sketchy, but not very good copy of the celebrated altarpiece in the Frari Church in Venice. There is a very poor drawn copy of the same composition, in pen and wash, among the unmounted Venetian drawings in the Guise Collection at Christ Church.

Literature: L. & E., III, 25 *ss.*; E.C., II, 56; 'A' Cat., 1776, pp. 2–3; 1833 Cat., no. 31 ('This is called a Bolognese copy of Titian's picture of the Pesaro family . . .'); Borenius Cat., 1916, no. 190.

FOLLOWER OF TITIAN

c. 1520–30

83. THE VIRGIN AND CHILD WITH THE INFANT ST. JOHN. Canvas, 93·2 × 79·8 cm. Plate 74

Guise Bequest, 1765.

There is an early (XVII century?) inscription on the back of the old re-lining canvas, which looks like an artist's (?) name, followed by *F*.

The picture, which is attributed to Titian in the early catalogues, was supposed by Berenson to be by Previtali, perhaps after a composition by Titian himself. I am unable to follow his reasoning. It is certainly very Titianesque; but the Bergamasque Andrea Previtali (d. 1528) is always more primitive in style in his early works,[1] while in his later work he is more related in style to Lotto.[2] The Christ Church picture can only be described as an imitation of early Titian. It may once have been of better quality than now appears; the surface is much rubbed and damaged generally.

It was lightly cleaned and re-varnished by J. C. Deliss, 1966.

Exhibited: New Gallery, 1894–95.

Literature: L. & E., III, 35 *ss.*; E.C., II, 66 ('an excellent performance, by Titiano'); 1833 Cat., no. 35 (as Titian); Borenius Cat., 1916, no. 195 and pl. XLIV (as Venetian School, first half of XVI century).

Berenson, Lists, 1932, p. 474, as Previtali (after Titian?); and Venetian Lists, 1957, as Previtali (late).

LORENZO LOTTO

c. 1480–1556

Venetian by birth, in Rome 1509, in Bergamo 1513–35, and in various other cities of the Veneto and the Marches. At the end of his life, in 1554, he dedicated himself and all his goods to the Holy House of Loreto. In spite of various influences that appear in his work, from Giovanni Bellini and Dürer to Titian, Correggio and Raphael, Lotto is one of the most independent, unconventional and distinguished artists of his time.

84. THE SUPPER AT EMMAUS. Canvas, 75·5 × 101·5 cm.
 Plate 73

Guise Bequest, 1765.

Berenson refers this picture to an entry in Lotto's account book (A. Venturi, *Il 'libro dei conti' di Lorenzo Lotto*, in

Gallerie nazionali italiane, I, 1895): '*1546 Aprile. A Alessandro Catanio speziale, un quadretto di Cristo quando andò in emaus*'. He suggests that the innkeeper may be a portrait of Alessandro Cattaneo, a druggist, for whom the picture was painted. To this Anna Banti adds that it is probably the picture which belonged to Michiel Spietra in Venice (C. A. Levi, *Le collezioni veneziane d' arte e d' antichità dal sec. XIV ai nostri giorni*, 2 vol., Venice, 1900).

A late work, painted in Venice in 1546, the picture seems to show the influence of Titian's famous composition, of which the earlier version, painted for Contarini, belongs to Lord Yarborough,[3] and the later is in the Louvre; particularly in the setting, with the severely frontal arrangement of table and table-cloth (in which Titian himself, of course, echoes Leonardo), and also in the head of the disciple L. But the 'frontality' of Lotto's composition is more extreme: the figure of Christ is placed exactly in the centre, and composed with almost Byzantine symmetry on either side of the centre-line. The picture is pleasanter in detail (especially the innkeeper, and the serving boy, R.) than as a whole; and the unpleasant effect is unfortunately increased by the condition, since the most prominent parts, the figure of Christ and the white table-cloth, are the most damaged. The rest is better preserved.

Cleaned by S. Isepp, 1951.

Exhibited: Birmingham, 1955, *Italian Art*, no. 68; Liverpool, 1964, no. 28.

Literature: 'A' Cat., 1776, p. 7 (as 'Lazarini'); 1833 Cat., no. 25 (as 'Lazzarini'); Borenius Cat., 1916, no. 230 (as Venetian School, *c.* 1550).

Berenson, Lists, 1932, p. 58 (as Jacopo Bassano, early?) and again p. 310 (as Lotto, late); Anna Banti and A. Boschetto, *Lorenzo Lotto*, 1955, p. 92, no. 132, pl. 242; Piero Bianconi, *Tutta la Pittura di Lorenzo Lotto*, Rizzoli, Milan, 1955, p. 68, pl. 192; Berenson, *Lorenzo Lotto*, Phaidon, 1956, p. 125 and pl. 349; Berenson, Venetian Lists, 1957, I, p. 104.

BONIFAZIO DE' PITATI

c. 1487–1553

Bonifazio dei Pitati, or Bonifazio Veronese, born at Verona but worked chiefly in Venice. A pupil of Palma Vecchio, to whom many of his best works have been attributed. Older writers tried to distinguish two, or even three painters of this name; there was in fact only one, as G. Ludwig has shown, but Bonifazio's extensive studio practice produced work of greatly varying quality. He was a great popularizer of the type of religious composition known as a *Sacra Conversazione*, of which no. 85 of this catalogue is an example.

1. *E.g.* the picture at Padua, dated 1502 (Berenson, *Venetian Lists*, 1957, pl. 743).
2. *E.g.* the *Sacra Conversazione* at Bergamo (Berenson, *op. cit.*, pl. 753).

3. See K. T. Parker in *Arte Veneta*, 1952, p. 19.

Fig. 23. Bonifazio de' Pitati: *The Holy Family with St. Catherine, the Infant St. John and St. Mark* (Cat. No. 85). From X-ray photographs by the Scientific Department, Courtauld Institute of Art, of the panel partly cleaned

85. THE HOLY FAMILY, with St. Catherine, the Infant St. John and St. Mark. Panel, 84·8 × 134·3 cm.

Plate 69 and Figure 23

Presumably Guise Bequest, 1765.

This painting, though allotted a number (200) by Borenius, was not included in his catalogue, and has been in store for fifty years.[1] Though badly damaged, especially in the draperies of St. Catherine and St. John on the L., it was evidently a fine and characteristic example of a *Sacra Conversazione* by Bonifazio. The head of St. Mark (R) is still very good. The head of the Child Christ is roughly painted, but the painting does not seem to have been rubbed or damaged here, and it may have been left unfinished. An X-ray photograph, made for Mr. Rees-Jones at the Courtauld Institute in 1967, shows that the composition was altered by the artist: the Virgin was originally looking down to R., towards the book held by St. Mark, the heads of St. Catherine and St. Joseph were changed, and another male Saint was included on the L., behind and to L. of St. Catherine (see Figure 23).

A similar composition by the artist is no. 1202 at the National Gallery (exhibited in Reserve Section, 1966); but the rather hard treatment of the foliage, in sharp impasto against a dark green silhouette, somewhat in the manner of Tintoretto, more resembles that in the National Gallery picture no. 3536, described by Mr. Gould as 'style

of Bonifazio'. This may be the work of a studio assistant. The panel was split in two parts horizontally (through the knee of the Child Christ), and a bad crack extended across the face of St. Catherine to the tops of the children's heads. Mended, cleaned and restored by J. C. Deliss, 1966–67. Not identifiable in any of the earlier catalogues.

BONIFAZIO DE' PITATI

86. THE VIRGIN AND CHILD (a fragment). Panel, 21·3 × 17·1 cm.

Guise Bequest, 1765.

Inscribed at back: 'Pordenon', in a XVII or XVIII century hand.

The picture is certainly in Bonifazio's style, and shows Palma's influence clearly, but is so badly damaged that its original quality is impossible to judge.

Literature: 'A' Cat., 1776, p. 6; 1833 Cat., no. 18 (both as Pordenone); Borenius Cat., 1916, no. 199 (as School of Bonifazio).

VENETIAN SCHOOL, FIRST QUARTER OF THE XVI CENTURY

87. THE JUDGEMENT OF MIDAS. Panel, 33 × 50 cm.

Plate 68

Guise Bequest, 1765.

1. This might be the picture recorded by Berenson, Venetian Lists, 1957, p. 43: 'Oxford. Rev. Cook (ex.) *Sacra Conversazione* (p.)'. Some of the Christ Church pictures once hung, or were stored, in the late Canon Cooke's house in Tom Quad.

The picture was cleaned by J. C. Deliss in 1962, but is very badly damaged and much restoration was necessary. In spite of this, it shows traces of high quality in the few parts which are better preserved, particularly in the head and figure of Apollo clasping the tree on the right.

Except in the 1833 Catalogue and in Crowe and Cavalcaselle, the painting has always been attributed to Andrea Meldolla, called Schiavone, but the mood is entirely Giorgionesque, there are none of the characteristic mannerisms of Schiavone, and the date might be a generation before his time. B. Nicolson (Editorial, *Burlington Magazine*, May 1964) tentatively suggested an attribution to Cariani. A panel sold with the Cornbury Park Collection in 1967 (Christie's, June 23, lot 26, 39 × 51 cm.), and included in Berenson's Venetian Lists, 1957, as by Romanino, is in the same style, and illustrates the same story.

Exhibited: Liverpool, 1964, no. 50.

Literature: 'A' Cat., 1776, p. 2 (as Schiavone); 1833 Cat., no. 17 (as Giorgione); Borenius Cat., 1916, no. 219 and pl. XLVI (as Schiavone).
Crowe and Cavalcaselle, *History of Painting in North Italy*, 2nd ed., III, p. 55 (among pictures attributed to Giorgione: 'too much injured to admit of an opinion'); Berenson, Venetian Lists, 1957, p. 161 (as Schiavone).

GIROLAMO DA TREVISO
1497–1544

Perhaps (but not certainly) a member of the Pennacchi family of Treviso. Worked in Venice and in Bologna, and from 1538 in England, as a military engineer in the service of King Henry VIII. He was killed by a cannon-ball at the siege of Boulogne. His later works are much influenced by Raphael.

88. THE ADORATION OF THE SHEPHERDS. Panel, 84·3 × 118·5 cm. Plates 71–72

Guise Bequest, 1765.

The picture is said in the 1833 Catalogue to have been in Charles I's Collection, but there is no mark of his now visible on the back. The back of the panel has, however, been planed and cradled at an early date, and the cipher and crown may have disappeared in the process. There is a seal with a coat-of-arms near the L. edge at the back.

Fiocco (see below, *loc. cit.*, 1917) calls this '*buona replica del noto quadro di Dresda*' and later (*loc. cit.*, 1932) drew attention to the apparent influence of Raphael and Parmigianino. Borenius says that at least three other versions of it exist, of which only one, at Dresden, can now be traced. One version was engraved in reverse by C. Bloemart when it belonged to Giambattista Franceschi of Venice in the second half of the XVII century. There are other engravings

of the composition by Pietro del Pò (1610–92), Antonio Crespi (1704–81), and by an anonymous engraver (published by Vallet in Paris).

Mr. A. E. Popham has drawn my attention to an interesting reference to this picture (or to one of the other versions) in a manuscript of Padre Sebastiano Resta, datable after August 1709, entitled *Correggio a Roma*, which was acquired for the British Museum in 1938 and edited by Mr. Popham in 1958 for the *Deputazione di Storia Patria per le Provincie Parmensi*. On folio 4 r. Resta mentions certain pictures which had been offered to the Marchese del Carpio, Spanish Ambassador in Rome, as the work of Raphael, and on which he was asked his opinion; among them: '*la Natività di Gesù Cristo stampata con la medaglia di Gio. Battista Franceschi Venetiano amico mio*'. He continues: '*Ma poiche magis amica veritas, interrogato, dissi come nell' altro, essere degno d' ogni gran prezzo, ma essere d' un pittore a me cognitissimo, cioè, d' Innocenzo da Imola passato a Raffaele del Francia.*' The engraving of this composition by C. Bloemaert (which is in the Christ Church collection) does indeed show a portrait-medallion of the then owner, Franceschi, and bears the attribution to Raphael. It is possible that it was this very picture that General Guise acquired; if it was once in Charles I's Collection, it may have found its way to Italy again after the dispersal of that collection under the Commonwealth. On the other hand the Dresden version was acquired in Madrid in 1744 (as by Raphael); and if we may suppose that the Spanish Ambassador, despite Resta's advice, bought the picture in Rome *c.* 1710 or so, and took it back to Spain, it might seem more likely that the version referred to by Resta is identical with the one now in the Dresden Gallery. The Dresden picture is reproduced in the illustrated catalogue of 1929, *Die Staatliche Gemäldegalerie zu Dresden*, vol. I, *Die Romanischen Länder*, p. 99 (no. 201b). It measures 86 × 118 cm., almost exactly the same size as ours,[1] and the correspondence seems to be very close. As Popham remarks (*op. cit.*, p. 62), Resta's attribution to Innocenzo da Imola is at least an advance on the attribution to Raphael. Mariette in his *Abecedario*[2] says that he had seen the picture (whether the Dresden version or ours), and describes the owner's pretensions concerning it: he had ordered two engravings of it (those by Bloemaert and Pietro del Pò) to promote the sale of his 'Raphael'. In Mariette's opinion it was by Schiavone – an attribution nearer the mark. The correct attribution was first proposed by G. Ludwig (quoted by Loeser, see below, *loc. cit.*). Venturi dates the picture early, before Girolamo's frescoes in S. Petronio at Bologna (1525); but Berenson is certainly right in considering it a late work. It is probably even later than the frescoes in the Chiesa della Commenda at Faenza (Venturi, *loc. cit.*, figs. 308, 309), which are signed and dated 1533.

1. The catalogue entry is therefore wrong in saying that the Christ Church picture is larger. Nor, I suspect, is there any justification for the remark that ours is inferior to the Dresden version.
2. 1851 ed., I, p. 136, quoted in the Dresden Catalogue, 1929.

Fig. 24. Venetian School, first half of the XVI century:
A Venetian Gentleman (Cat. No. 89)

The picture was lightly cleaned by Holder in 1947. The present varnish is darkened, but the general condition seems to be good.

Exhibited: Manchester, 1857, no. 173; Royal Academy, 1960, *Italian Art and Britain*, no. 74; Liverpool, 1964, no. 25; Manchester, 1965, *European Art 1520–1600*, no. 118.

Literature: 'A' Cat., 1776, p. 10; 1833 Cat., no. 146 (as by Raphael); Borenius Cat., 1916, no. 202 and pl. XLV.
C. Loeser in *Repertorium für Kunstwissenschaft*, XX, 330; G. Fiocco (reviewing Borenius Cat.) in *L' Arte*, XX, 1917, p. 361; and in Thieme-Becker, *Künstlerlexicon*, vol. XXVI (1932), p. 382; A. Venturi, vol. IX, pt. IV (1929), p. 395 and fig. 305; Berenson Lists, 1932, p. 260; and Venetian Lists, 1957, I, p. 90 and II, pl. 901 (wrongly stated to be in the Ashmolean Museum).

VENETIAN SCHOOL, FIRST HALF OF THE XVI CENTURY

89. PORTRAIT OF A BEARDED VENETIAN GENTLEMAN, turned slightly to L. Panel, 45·3 × 38 cm. Figure 24

Probably Guise Bequest, 1765.

This may once have been a fine portrait, and is somewhat in the manner of Paris Bordone. It has been cleaned and restored at some comparatively recent time, but can only be described as in ruined condition.

Literature: Borenius Cat., 1916, no. 251; Borenius suggests an identification with a head attributed to Titian ('in his first manner') in L. & E., III, 18, and E.C., II, 49.

COPY OF JAN STEPHAN VAN CALCAR (GIOVANNI DA CALCA)
1499–1546/50

Painter and designer for woodcut. Born at Calcar in the Duchy of Cleves, but already in Venice 1536/37, where he became a pupil of Titian, and imitated his style as a portrait painter. Later in Naples, where Vasari saw him in 1545, and where presumably he died. He is best known as the author of the woodcut illustrations to Vesalius, *De humani corporis fabrica*, published in Bâle, 1543.

90. PORTRAIT OF MELCHIOR VON BRAUWEILER, BURGOMASTER OF COLOGNE. Canvas, 93·5 × 73·7 cm.

Guise Bequest, 1765.

This is one of numerous replicas and copies of the fine picture in the Louvre, dated 1540 (no. 1185), which used to be considered to be a portrait of Andrea Vesalius, the celebrated anatomist, whose work was illustrated by Calcar. The coat-of-arms on the Louvre portrait has since been identified as that of Brauweiler. There is a woodcut portrait of Vesalius in the 1543 edition of his *De humani corporis fabrica*, which does in fact bear a superficial resemblance to the Louvre portrait, and the many replicas may be due to this mistaken identification. Others are in the Fitzwilliam Museum, Cambridge, and in the Glasgow Gallery (from the Rothermere Collection), as well as in the private collections of Dr. Harvey Cushing at Boston and (in 1930) Dr. Burg in Berlin.
The Christ Church version, which is of indifferent quality and is much restored (especially about the eyes) has been re-lined and cleaned at a comparatively recent date.

Literature: Borenius Cat., 1916, no. 201 (suggesting an identification with 'A' Cat., 1776, p. 10 and 1833 Cat., no. 38, 'portrait of a Venetian nobleman by Titian').

LAMBERT SUSTRIS
before 1520–c. 1595

Worked in Venice and Padua, having arrived in Italy before 1548. Called Lamberto d' Amsterdam, and no doubt Dutch by origin, but justifiably counted with the Venetian School because of his close relationship to Titian (whose pupil he may have been), Bonifazio, Andrea Schiavone and the young Tintoretto. Signed examples of his entirely

Venetian style are in the museums of Lille and Caen.[1]

91. DIANA AND ACTAEON. Canvas, 102·5 × 133·7 cm.
 Plate 81
Guise Bequest, 1765.

This fine picture is much better composed than the variant version at Hampton Court (Berenson, Venetian Lists, pl. 1246), which may have been cut below and above. Despite Borenius, who considered these two 'clearly not from the same hand', I should say they are identical in style, and certainly by Sustris, by comparison with his signed work. The treatment of bushes, trees and foliage is particularly characteristic.

Sustris must have been of the same generation as Tintoretto and Schiavone, and may have been a year or two older than either; we do not know exactly when he arrived in Italy or in Venice, and his relationship to these two artists is not clearly defined. Some of his surviving work, including the Christ Church picture, is practically indistinguishable in general character from that of his Venetian contemporaries; other pictures by him betray their Netherlandish origin more plainly. The date of ours cannot be far from 1550.

Cleaned by H. Buttery in January 1937. There is a good deal of damage and restoration in the figures of the foreground, especially the two nymphs nearest to Actaeon, in the centre foreground. The beautiful Titianesque landscape is better preserved.

Exhibited: Manchester, 1965, *European Art, 1520–1600*, no. 225.

Literature: L. & E., III, 32; E.C., II, 62 (as Tintoretto); 'A' Cat., 1776, p. 3 (no attribution); 1833 Cat., no. 8 (as Titian); Borenius Cat., 1916, no. 220 and pl. XLVII (as Schiavone); Venturi, IX, pt. IV, 1929, p. 737 and fig. 526 (as Schiavone); Berenson, Venetian Lists, 1957, p. 168 (as Lambert Sustris).

JACOPO BASSANO (?)
1510?–1592

The name Bassano, deriving from their birthplace in the Veneto, was adopted as a surname by the family of painters whose proper name was da Ponte only towards the end of the XVI century. The most famous of them, Giacomo or Jacopo da Ponte, called Bassano (1510?–92) conducted a flourishing family studio, which lasted, in Bassano or Venice, under himself or his four sons, well into the first quarter of the XVII century. His sons, Francesco the younger (1549–92), Giambattista (1553–1613), Leandro (1557–1622) and Gerolamo (1566–1621), maintained to the end the characteristic 'Bassano' style, and innumerable repetitions of the familiar compositions occur.

92. CHRIST CROWNED WITH THORNS. Canvas, 107 × 138·5 cm.
 Plate 77
Guise Bequest, 1765. Probably from the Stephen Rougent Sale, 1755, 3rd day, lot 49 ('Our Saviour crowned with Thorns, Bassano. Gen. Guise. 4.0.0.') (Houlditch MS.).

The attribution to Francesco Bassano, proposed by Borenius, is rejected by Arslan without any alternative suggestion. Dr. Alessandro Ballarin, who studied the picture carefully in 1966, is convinced that this is a very late work by Jacopo Bassano himself, of the last years of his life. After 1580 he was generally supposed to have given up painting almost entirely;[2] but the date 1585 has appeared, since cleaning, on the *Susanna and the Elders*, which is signed with Jacopo's initials, in the museum of Nîmes, and Ballarin suggests that other works, such as no. 228 of the National Gallery, *Christ driving the Traders from the Temple*, and our painting at Christ Church, belong to the same period, when Jacopo is said to have been deeply impressed by the late works of Titian. The Christ Church painting, he believes, may be as late as 1590; he compares particularly the *Agony in the Garden*, which was no. 88 in the Bassano Exhibition of 1957, but is not included or reproduced in the first edition of the catalogue.[3] I confess that I have still to be convinced by Dr. Ballarin's argument, so far as our painting is concerned. In both the others referred to, at Nîmes and in the National Gallery, there is a looseness and brilliance of handling that is indeed reminiscent of Titian in his latest manner. I can find nothing of this quality in the Christ Church picture; it strikes me as coarse and heavy-handed in execution, effective from a distance, but entirely without that flickering touch that is so much admired, for instance, in *Susanna and the Elders*. I refer the serious student to Dr. Ballarin's eloquent analysis, to which I have hardly done justice here, since his *Chirurgia Bassanesca* is to be continued in a further number of *Arte Veneta*; but for my part I am still inclined to suspect that our picture, though perhaps representative of Jacopo's latest style, is no more than a product of the Bassano studio. Re-lined and cleaned by J. C. Deliss in 1965. The condition is tolerable, though some of the darker parts, especially to the L. and above, are rubbed.

Literature: L. & E., III, 21; E. C., II, 51; 'A' Cat., 1776, p. 13; 1833 Cat., no. 43; Borenius Cat., 1916, no. 209 (as Francesco Bassano).

E. Arslan, *I Bassano*, 1960, I, p. 359; A. Ballarin, in *Arte Veneta*, XX, 1966, pp. 124–131 and figs. 142–147.

1. Both exhibited Paris, 1965/66, *Le XVI^e Siècle Européen*, cat. nos. 271, 272. For the most important recent research on Sustris see R. A. Peltzer in Vienna *Jahrbuch*, XXXI, 1912/13, p. 221 ss.; J. Wilde, *ibid.*, N.F. VIII, 1934, p. 169 ss.; and A. Ballarin in *Arte Veneta*, XVI, 1962, p. 61 ss.

2. This is implied in a letter written by his son, Francesco Bassano the younger, to Niccolo Gaddi in May 1581. See Arslan, *I Bassano*, 1931 ed., p. 141.

3. This picture, then on the London market, was considered by Pietro Zampetti, who was responsible for the catalogue, as a very late work of the Bassano studio, partly by Jacopo himself. I am greatly indebted to Dr. Ballarin for allowing me to see the proofs of the first part of his essay before it was published.

STUDIO OF BASSANO

93. SOLOMON AND THE QUEEN OF SHEBA. Canvas, 35 × 101·7 cm. Plate 75

Fox-Strangways Gift, 1828.

A typical and respectable production of the Bassano studio, not of high quality but well composed, and in tolerable condition. Cleaned by J. C. Deliss, 1965.

Literature: 1833 Cat., no. 116 ('from the Venetian School'); Borenius Cat., 1916, no. 203 (as School of Bassano).

STUDIO OF BASSANO

94. THE LAST JUDGEMENT. Canvas, 206 × 125 cm.

Guise Bequest, 1765.

A much damaged studio replica of the picture in the Museo Civico at Bassano, but apparently of good quality.

Literature: 'A' Cat., 1776, p. 10; 1833 Cat., no. 195 (in both as Francesco Bassano); Borenius Cat., 1916, no. 206 (as copy of Bassano).
E. Arslan, *I Bassano*, 1960, I, p. 359.

COPY OF JACOPO BASSANO

95. THE ADORATION OF THE SHEPHERDS. Canvas, 104·2 × 219·5 cm.

Guise Bequest, 1765.

A competent copy, in full size, of the beautiful early picture by Jacopo Bassano in the Royal Collection at Hampton Court Palace (no. 467), which was formerly attributed to Palma Vecchio.

Literature: 'A' Cat., 1776, p. 12 (as after 'old Palma'); 1833 Cat., no. 214 (as after 'Younger Palma'); Borenius Cat., 1916, no. 205.
E. Arslan, *I Bassano*, 1960, I, p. 359.

COPY OF BASSANO

96. SS. PETER AND PAUL, whole length. Canvas, 102·1 × 71·9 cm.

Guise Bequest, 1765.

As Borenius points out, this is a copy of a picture in the Modena Gallery (Pallucchini Cat., no. 388). Both the early catalogues attribute the Christ Church picture to Andrea Sacchi, and since he is known to have made a practice of copying earlier masters, and to have been influenced by Bassano, he may possibly have been the copyist. But the condition does not allow a fair judgement.

F

Literature: 'A' Cat., 1776, p. 8; 1833 Cat., no. 211 ('This is esteemed a good study'); Borenius Cat., 1916, no. 207.

SCHOOL OF BASSANO

97. TWO BOYS WITH A DOG, A GOAT AND CHICKEN. Canvas, laid on panel, 28·8 × 23 cm.

Guise Bequest, 1765.

Not of good quality, and probably not from the Bassano studio, though certainly derivative from that source, and perhaps a copy of part of a larger picture.

Literature: 'A' Cat., 1776, p. 9 ('by old Bassano'); 1833 Cat., no. 14 (the same); Borenius Cat., 1916, no. 204.
E. Arslan, *I Bassano*, 1960, I, p. 359 ('opera di modesto bassanesco').

SCHOOL OF BASSANO

98. THE MARRIAGE OF ST. CATHERINE. Canvas, 68 × 49·7 cm.

Guise Bequest, 1765.

There is an inscription in pen and ink, in a sprawling XVIII-century hand, on the back of the stretcher, giving the name of Paolo Veronese and a reference to '*Ridolfi folio 306*'. Another inscription farther R. is only partly legible: '*Verona S^{to} Christofero fuori*' (?).
The style seems Bassanesque rather than that of a follower of Veronese. There is a certain nobility in the composition, but the condition is so bad that it is hard to judge if the painting was ever of any quality.
Tested by J. C. Deliss in 1964.

Literature: 'A' Cat., 1776, p. 1 or p. 7; 1833 Cat., no. 10 or no. 11; Borenius, Cat., 1916, no. 222 (as School of Paolo Veronese).

SCHOOL OF BASSANO

99. THE AGONY IN THE GARDEN. Canvas, 83 × 106 cm.

Guise Bequest, 1765.

Certainly of the Bassano School, but a poor picture and in very bad condition. For the composition, *cf.* the picture formerly with Agnew, London, which was exhibited at the Bassano Exhibition, Venice, 1957, no. 88 (reproduced only in the 2nd edition of the catalogue).

Literature: 'A' Cat., 1776, p. 2 (unattributed); 1833 Cat., no. 23 (as Bassano); Borenius Cat., 1916, no. 237 (as Venetian School).

TINTORETTO
1518–1594

Jacopo Robusti, called Il Tintoretto, born and died in Venice, where he spent his whole career. His master may have been Titian or Bonifazio; his aim was said to be to combine the draughtsmanship of Michelangelo with the colour of Titian. He made numerous drawings from casts of Michelangelo's sculptures, some of them now in the Guise Collection at Christ Church. His early work (before 1545) has only lately been to some extent elucidated, and distinguished from that of such artists as Bonifazio, Sustris and Schiavone. The most famous works in his mature style are the vast canvases decorating the Scuola di San Rocco in Venice, and the *Paradiso* in the Doge's Palace, one of the largest paintings in the world.

100. PORTRAIT OF A GENTLEMAN. Canvas, laid down on panel, 145·5 × 87·5 cm. Plates 78–79

Guise Bequest, 1765.

The picture was cleaned by Horace Buttery in June 1937, and in a letter to *The Times*, dated Nov. 27 1937, Borenius changed the opinion expressed in his catalogue ('perhaps not quite up to the standard of Tintoretto'), and attributed it to the master himself. The attribution is now generally accepted. It is certainly a fine early work by Tintoretto, recalling both Titian and Paris Bordone, nearly related to the portrait of a man at Hampton Court, which is dated 1545 (Berenson, Venetian Lists, 1957, pl. 1274).

Exhibited: Royal Academy, 1872, *Old Masters*, no. 57; Royal Academy, 1960, Italian Art and Britain, no. 85; Agnew, 1963, *Horace Buttery Memorial Exhibition*, no. 24; Liverpool, 1964, no. 44.

Literature: ? 'A' Cat., 1776, p. 10 ('the portrait of Spagnuoletto by Tintoretto'); ?1833 Cat., no. 5 ('Portrait Tintoretto'); Borenius Cat., 1916, no. 212 (as School of Tintoretto).
J. B. Stoughton Holborn, *Tintoretto*, 1903, p. 110; Borenius, in *Burlington Magazine*, vol. 72, 1938, pp. 36, 39; Von der Bercken, *Tintoretto*, 2nd ed., 1942, p. 9, no. 270; R. Pallucchini, *La Giovinezza del Tintoretto*, 1950, pp. 141, 164 and pl. 234; Berenson, Venetian Lists, 1957, I, p. 176.

TINTORETTO

101. THE MARTYRDOM OF ST. LAWRENCE. Canvas, 126 × 191 cm. Plate 80

Guise Bequest, 1765.

Ridolfi (*Meraviglie*, ed. Hadeln, II, p. 52) refers to a *small* picture of this subject painted for the Bonomi chapel in S. Francesco della Vigna, Venice, which in Ridolfi's time (1648) belonged to the Procurator Morosini. A painting of the same subject in the Castle at Prague is mentioned in an inventory of 1718 (Hadeln, *loc. cit.*). Tietze suggests that the composition was inspired by Titian (probably the picture in the Escorial), and the catalogue of the Birmingham Exhibition (1955) points out that the three seated figures in the background are adapted from the celebrated engraving of the same subject by Marcantonio after Baccio Bandinelli (Bartsch XIV, p. 89, no. 104). Hadeln shows good reason for dating the picture in the late 1570's.

Three drawings have been connected with this picture by Hadeln or Tietze: one in the Victoria and Albert Museum, apparently for the man carrying firewood in the R. foreground (Tietze, *Drawings of the Venetian Painters*, New York, 1944, no. 1700 and pl. CXIII, 4); one in Rotterdam (Koenigs Collection, formerly Boehler Collection) for the executioner stoking the fire R. centre (Hadeln, *Handzeichnungen des Giacomo Tintorettos*, Berlin, 1922, pl. 46; Tietze, *op. cit.*, no. 1677); and one in the Hermitage, Leningrad, which Tietze (*ibid.*, no. 1682) supposes to be for the figure of St. Lawrence (repr. *Apollo*, 1932, p. 147, fig. 1). The Rotterdam drawing may have been used again later, as Hadeln shows, for the *Naval Battle* (also called the *Rape of Helen*) in Madrid. Another drawing in the Hermitage at Leningrad has been supposed to be a study for the Christ Church picture (Fondazione Giorgio Cini, Venice, Exhibition, 1964, cat. no. 11; also reproduced in *Apollo*, July 1964, p. 68); but the connexion is not convincing.
Cleaned by H. Buttery, 1951.

Exhibited: Birmingham, 1955, *Italian Art*, cat. no. 103; Royal Academy, 1960, *Italian Art and Britain*, cat. no. 77; Liverpool, 1964, no. 45.

Literature: L. & E., III, 20; E.C. II, 50; 'A' cat., 1776, p. 10; 1833 cat. no. 26; Borenius Cat., no. 213 (as School of Tintoretto).
Osmaston, *The Art and Genius of Tintoretto*, 1915, II, pp. 169, 180; Hadeln, *Burlington Magazine*, vol. 48, March 1926, p. 115 and fig. 13 (as Tintoretto); Tietze, *Tintoretto*, 1948, p. 357 and pl. 169; Berenson, *Venetian Lists*, 1957, I, p. 176 and II, pl. 1311.

COPY OF TINTORETTO

102. THE MIRACLE OF THE SLAVE. Canvas, 99·2 × 135 cm.

Guise Bequest, 1765.

This is a good XVIII century copy of the large picture in the Accademia in Venice of *c.* 1548 (Berenson, Venetian Lists, 1957, pl. 1271) – done after the corners of the original were made up to rectangular form. It is quite clear from the present appearance of the original painting that the corners were once concave, no doubt to fit an elaborate carved frame on the wall in the Scuola Grande di S. Marco, for which it was painted, and indeed the extension of the figure of the donor, in the lower L. corner, to fill the

added canvas, is clumsy and absurd. But the alteration to the present rectangular shape must have been made before the picture was moved in 1791 (see Accademia Cat. II, 1962, p. 222), since the Christ Church copy must be earlier than 1765.

The small version in Lucca (wrongly referred to in the Accademia Cat., II, 1962, as '*una grande tela*') also shows the corners made up, and is almost certainly a copy too, though Campetti, *Art in America*, 1930, p. 94, claims that it is an original replica. Another copy, about the size of those at Christ Church and Lucca, and of fair quality (also with the corners made up) was sold with the collection of Sir Esmond Ovey, Culham Manor, nr. Abingdon, on Dec. 2, 1963. In one respect the Christ Church and Lucca pictures resemble one another, and are different from the original: the kneeling man holding the broken shaft of an axe, just by and over the left shoulder of the slave, wears a black coat, whereas in the original he wears a sort of jerkin and short hose. In the original, again, the vine in the trellis above is very luxuriant, whereas in the Lucca picture it has only a few tendrils, and in the Christ Church picture there appears to be no vine or trellis at all.

Re-lined, cleaned and restored by J. C. Deliss, 1961. The picture had previously suffered throughout from rough cleaning and oil-varnishing at an early date. Considerable restoration was necessary.

Literature: 'A' Cat., 1776, p. 6; 1833 Cat., no. 27; Borenius Cat., 1916, no. 217.

VENETIAN SCHOOL, XVI CENTURY

103. BUST PORTRAIT OF A BEARDED MAN, WITH A WHITE COLLAR, three-quarters to R. Canvas, 45 × 35·5 cm.

Probably Guise Bequest, 1765, but not identifiable in the early catalogues.

Borenius refers to the damaged condition of this picture, and in fact so little of the original paint is visible that no attribution is justified.

Literature: Borenius Cat., 1916, no. 210 (as Tintoretto).

FOLLOWER OF TINTORETTO, LATE XVI CENTURY

104. THE RESURRECTION. Canvas, 114·5 × 177 cm.

Guise Bequest, 1765.

A poor picture, perhaps by some Northern artist in imitation of Tintoretto, and in very bad condition.

Literature: 'A' Cat., 1776, p. 9 ('A large picture of the general Resurrection', without attribution); 1833 Cat., no.

173 ('Called a Venetian Picture of good character'); Borenius Cat., 1916, no. 214 (as School of Tintoretto).

VENETIAN SCHOOL, SECOND HALF OF XVI CENTURY

105. THE LAST SUPPER; a night-piece. Canvas, 94 × 128 cm. Plate 76

Guise Bequest, 1765. Probably bought at the Anthony Cousein Sale, 8/9 Feb. 1749/50 (1750), 1st day, lot 47 ('The Last Supper. Tintoret. Gen. Guise 5–0–0') (Houlditch MS.).

The drapery and hands are coarse, but some of the heads (especially the three on the extreme L.) show quality. The general effect is Bassanesque, but the heads in the Christ Church picture are nearer to Tintoretto. It seems possible, as Dr. Giuliano Briganti has suggested to me, that this might be by Scarsellino (Ippolito Scarsella, called Il Scarsellino, Ferrara 1551–1620), who was much influenced by both artists. A somewhat similar picture is at Modena, described by Pallucchini (Cat., 1945, no. 425, fig. 157) as by a follower of Bassano; and Pallucchini refers to other versions of this in the depôt of the Brera, Milan, and at Hanover (no. 106).[1]

The condition is hard to judge. Some loose paint was repaired by H. Buttery, 1953, and the picture re-varnished; probably it is much damaged.

Literature: L. & E., III, 32; E.C., II, 62; 'A' Cat., 1776, p. 11; 1833 Cat., no. 28 (always as Tintoretto); Borenius Cat., 1916, no. 236 (described as here).

PAOLO VERONESE
1528–88

Paolo Caliari, called Il Veronese, born at Verona, died in Venice. Pupil of Antonio Badile. With Titian and Tintoretto, one of the greatest Venetian painters of the XVI century, and one whose work had a profound influence on the revival of Venetian painting in the XVIII century.

106. THE MARRIAGE OF ST. CATHERINE; a Franciscan Saint on L. Canvas, 65·9 × 87·2 cm. Plates 82–83

Guise Bequest, 1765.

The St. Catherine is clearly the same model as in the painting from the Gerini Collection, which is now in the

1. The Hanover picture was sold by auction at Helbing, Munich, July 2 1931, lot 218. To judge from the reproduction in the catalogue, it might be by the same hand as ours. A version at Munich (reproduced Willumsen, *El Greco*, 1927) is closer to Bassano in style.

Musée Fabre at Montpellier (*Le Seizième Siècle Européen*, Paris, Petit Palais, 1965/66, cat. no. 310), and has been variously dated between 1557 and 1565. The Christ Church picture may be somewhat later, towards 1570. I believe it to be a fine original, though this opinion was questioned by Benedict Nicolson in reviewing the Liverpool Exhibition in the *Burlington Magazine*, May 1964 (Editorial). Otherwise it has remained unnoticed in recent literature. It was cleaned by H. Buttery in 1948, and is on the whole in good condition.

Exhibited: Manchester Art Treasures, 1857, no. 280; Manchester, Art Treasures Centenary, 1957, no. 84; Liverpool, 1964, no. 51.

Literature: 'A' Cat., 1776, p. 1 or p. 7; 1833 Cat., no. 10 or 11; Borenius Cat., 1916, no. 221 (as School of Veronese).

COPIES OF PAOLO VERONESE

107. JUPITER. Canvas, 68 × 54·1 cm. Plate 84

108. JUNO. Canvas, 68·1 × 54 cm. Plate 85

109. NEPTUNE. Canvas, 68·1 × 54·6 cm. Plate 86

110. CYBELE. Canvas, 67·9 × 53·8 cm. Plate 87

Guise Bequest, 1765.

Borenius points out that these are important as copies of frescoes of *c.* 1557 by Paolo Veronese and Zelotti, on a ceiling in the Palazzo Trevisan at Murano, which no longer exist (see Hadeln in Prussian *Jahrbuch*, XXXV, 177, and XXXVI, 116). *Juno* and *Cybele* were engraved by Zanetti, *Varie pitture a fresco . . .*, Venice, 1760, pls. 23 and 24. These engravings correspond to nos. 108 and 110 at Christ Church, and it may therefore be presumed that nos. 107 and 109 also reproduce figures from the same series of frescoes, in which according to Ridolfi both Jupiter and Neptune were included.

A drawing from the J. C. Robinson collection in *grisaille* on grey paper, 16 × 13 cm., purporting to be Veronese's original study for the *Cybele*, was exhibited at the Perugia University Gallery in 1955, afterwards sold at Christie's, May 24 1963 (lot 87), and again at Sotheby's, July 8 1964 (lot 33). It was, however, clearly not by his own hand, and may have been a considerably later copy from the fresco, though of fairly good quality.

The painted copies are of fair quality, though much damaged. They are surely of the XVII century, and perhaps by some artist of the Venetian mainland such as Maffei.

All cleaned by H. Buttery 1954–55. There is a good deal of restoration (Juno's L. arm, Neptune's head and R. arm, *etc.*).

Literature: 'A' Cat., 1776, pp. 2–3; 1833 Cat., nos. 136–139 (in both cases as Giulio Romano); Borenius Cat., 1916, nos. 223–226 (as after Veronese).

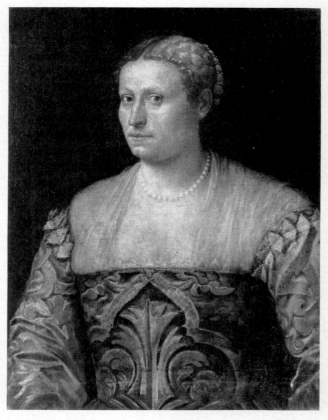

Fig. 25. Venetian School, second half of the XVI century: *A Venetian Lady* (Cat. No. 112)

COPY OF PAOLO VERONESE

111. VENUS AND ADONIS. Oak panel, 26·7 × 38·6 cm.

Guise Bequest, 1765.

A good and apparently early copy of the upright picture in the Prado at Madrid, showing more to right and left, and less above and below.

Cleaned by J. C. Deliss, 1960. The surface glazes are gone, and there is some restoration (in the face of Venus, *etc.*).

Literature: 'A' Cat., 1776, p. 4; 1833 Cat., no. 15; Borenius Cat., 1916, no. 227.

VENETIAN SCHOOL, SECOND HALF OF XVI CENTURY

112. PORTRAIT OF A LADY, three-quarters to L., in a red brocade dress. Canvas, 75 × 58·5 cm. Figure 25

Guise Bequest, 1765.

The style is between that of Titian and Paolo Veronese, but the picture is so damaged and repainted that its original quality is impossible to judge.

Tested by J. C. Deliss, 1964.

Literature: Identified by Borenius as 1833 Cat., no. 236 ('Portrait of a Lady'); Borenius Cat., 1916, no. 239.

PALMA GIOVANE
1544–1628

Giacomo (Jacopo) Palma Negretti, called Palma Giovane (to distinguish him from his great-uncle Palma Vecchio), an extremely prolific painter and draughtsman. In Urbino and in Rome at an early age, but spent most of his career in Venice, carrying on the traditions of Titian and Tintoretto well into the XVII century. Good examples of his drawings are in the Guise Collection at Christ Church.

113. THE LAMENTATION FOR CHRIST. Canvas, 108·3 × 86·3 cm. Plate 88

Guise Bequest, 1765.

A typical late work of Palma Giovane.
Cleaned by J. C. Deliss, 1965, and in fair condition.

Literature: 'A' Cat., 1776, p. 10 ('A dead Christ'); 1833 Cat., no. 213 ('The Taking Down from the Cross') (in both cases as 'Old Palma'); Borenius Cat., 1916, no. 242 (as Palma Giovane).

PALMA GIOVANE (?)

114. HERCULES AND OMPHALE. Canvas, 54 × 99·8 cm.

Guise Bequest, 1765.

The picture has not been cleaned lately, and is much obscured by dirty varnish, but it appears to be of fair quality and is close to Palma Giovane in style. The treatment of the subject, and more particularly the dress of Hercules, is unusual.

Literature: 'A' Cat., 1776, p. 7; 1833 Cat., no. 51 (in both as 'from the Venetian School'); Borenius Cat., 1916, no. 215 (as school of Tintoretto).

FOLLOWER OF PALMA GIOVANE

115. THE GENERAL RESURRECTION. Canvas, 86 × 59·2 cm. Figure 26

Guise Bequest, 1765.

A sketchy, but feeble picture, in very bad condition; somewhat in Palma Giovane's style, but probably by a Northern artist.

Literature: 'A' Cat., 1776, p. 2 ('by young Palma'); 1833 Cat., no. 199 (the same); Borenius Cat., 1916, no. 255 (as Italian School, second half of XVI century).

VENETIAN (?) SCHOOL
c. 1550

116. THE VIRGIN ADORING THE CHILD, who lies on a

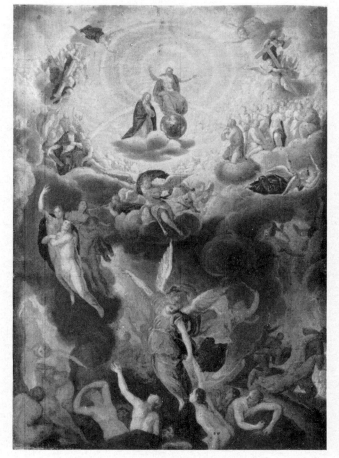

Fig. 26. Follower of Palma Giovane: *The General Resurrection*
(Cat. No. 115)

Pallet of Straw; two Angels' Heads in a Glory above. Canvas, 36·4 × 24·9 cm.

Guise Bequest, 1765.

In ruined condition.

Literature: Possibly 'A' Cat., 1776, p. 4 ('a small Madonna and Child'); 1833 Cat., no. 49 or 62 (the same); Borenius Cat., 1916, no. 232.

VENETIAN SCHOOL,
LATE XVI CENTURY

117. PORTRAIT OF A SENATOR, three-quarter length. Canvas, 126·5 × 105 cm.

Guise Bequest, 1765.

The face and hands are better than the rest, and might be by a Flemish artist of the time of Rubens, copying a Venetian portrait; but the painting of the robes is extremely crude. There may be extensive over-painting.

Literature: L. & E., III, 28; E.C., II, 58; 'A' Cat., 1776, p. 2; 1833 Cat., no. 235 (always as Francesco Torbido); Borenius Cat., 1916, no. 229.

MARCANTONIO BASSETTI
1588–1630

Born and died at Verona. Influenced by the work of Tintoretto and Palma Giovane in Venice. In Rome *c.* 1615–20 where he worked with Carlo Saraceni, at the same time as his countryman Alessandro Turchi (l' Orbetto); both Veronese artists show the influence of the Caravaggesques.

118. THE GOOD SAMARITAN. Canvas, 45·9 × 56·4 cm.
Plate 91

Guise Bequest, 1765.

There is nothing here to recall the style of Sisto Badalocchio, the favourite pupil of Annibale Carracci, to whom this much damaged picture has always been attributed. From a small photograph, both Professor Hermann Voss and Professor Ellis Waterhouse independently suggested to me the name of Bassetti. The clumsy forms, the facial types, the drapery are indeed characteristic of Bassetti's rare paintings, some of which were exhibited in the Venetian *Seicento* exhibition at Venice, 1959. Comparison may also be made with the series of drawings in the Royal Collection at Windsor Castle, first attributed to Bassetti by A. E. Popham (Blunt and Croft-Murray, *Venetian Drawings*, 1957, nos. 1–24; particularly no. 7 and pl. 8).

Literature: L. & E., III, 26; E.C., II, 57; 'A' Cat., 1776, p. 12; 1833 Cat., no. 266; Borenius Cat., 1916, no. 129 (always as Sisto Badalocchio).

PIETRO DELLA VECCHIA
1605–78

Pietro Muttoni, called Pietro della Vecchia, a pupil of Alessandro Varotari (Il Padovanino), famous for his imitations of Giorgone more than a hundred years after the death of that artist.

119. FAITH ARMING A GENERAL. Canvas, 110·9 × 110·5 cm. (excluding additions; the canvas has been enlarged slightly on all sides to fit the frame, probably during re-lining).
Plate 89

Guise Bequest, 1765.

Typical of Pietro della Vecchia's 'Giorgionesque' style. Rubbed and flattened by re-lining, with some restorations throughout, especially on the white dress of Faith.

Literature: L. & E., III, 20; E.C., II, 51 (as Pietro della Vecchia); 'A' Cat., 1776, p. 5 (without attribution); 1833 Cat., no. 232 (as Pierino del Vaga); Borenius Cat., 1916, no. 245 (as Pietro della Vecchia).

PIETRO DELLA VECCHIA

120. THE PHILOSOPHERS (Ptolemy and Euclid with their Pupils). Panel, 33·5 × 51·9 cm. Plate 90

Guise Bequest, 1765.

Inscribed on the back in an XVIII century hand '*Tolmée*' and '*Euchlide*', with what is apparently a note of the sale price in Italian *lire*.

Another version of the same size, one of a pair belonging to Mr. Francis Stonor in London, was sold at Christie's, July 1 1966 (lot 3). The correspondence is almost exact, but both are clearly by the master. Both Stonor pictures are reproduced by L. Fröhlich-Bume in *Paragone*, July 1952 (no. 31), figs. 13 and 14, and also in Christie's catalogue. A much larger version of the same composition as ours, with some variations, was in the Pisko Sale, Vienna, Nov. 17 1906, no. 35 (repr. in cat.), and was sold again at Christie's in the Sternberg Sale, Feb. 24 1928, lot 157; this was attributed to Luca Giordano, but was certainly by Pietro, as Borenius suggested at the time.

The painting is coarse, but there is not much damage. Cleaned by J. C. Deliss in 1962.

Literature: 'A' Cat., 1776, p. 5; 1833 Cat., no. 165 ('Philosophers with a Globe; a Sketch') (both as 'Old Palma'); Borenius Cat., 1916, no. 246 (as Pietro della Vecchia).

COPY OF
PIETRO DELLA VECCHIA

121. THE LOVERS. Canvas, 74·4 × 55·9 cm.

Guise Bequest, 1765.

An undistinguished version of a popular romantic subject by this late imitator of Giorgione. Borenius refers to other versions at Edinburgh, National Gallery of Scotland, no. 96 (reproduced *Paragone*, 1952, no. 31, fig. 11), Berlin (no. 445a), and Bassano (no. 177).

Literature: Perhaps 'A' Cat., 1776, p. 3 ('Two Heads in one Picture, by a Spanish Master') and 1833 Cat., no. 201 ('Two Spanish Heads. Morelio'); Borenius Cat., 1916, no. 244, and pl. LII (as Pietro della Vecchia).

SEBASTIANO RICCI
1659–1734

Sebastiano Ricci, the most celebrated Venetian painter of the XVIII century before the time of Tiepolo. Much in demand in other cities of Italy (especially Florence) and in various capitals of Europe (Paris, London, The Hague). *The*

Resurrection was painted by him in the apse of the chapel of Chelsea Hospital. He is said to have left London in disgust when Sir James Thornhill was commissioned to decorate the cupola of St. Paul's.

122. THE JUDGEMENT OF MIDAS. Canvas, 134 × 155 cm.
Plate 92

Guise Bequest, 1765.

A good picture, finely composed and surely by the master, soon after 1700, but very badly damaged.

There are at least two other pictures of this subject by Sebastiano Ricci: (1) in the collection of Walter Chrysler, Jr. (exhibited Portland Art Museum, U.S.A., 1956, Cat. no. 43, reproduced), once in the Collection of Sir R. Colthurst, Bt., Blarney Castle, Co. Cork; with a more crowded, less successful composition, but evidently better preserved; this represents a later moment in the contest of Apollo and Marsyas, when Apollo, having finished his own performance, and Midas the judge turn to listen to the satyr Marsyas playing his pipe; (2) one of a set of four upright mythologies sold at Christie's, May 1959, lot 67 (reproduced in catalogue), and afterwards exhibited R.A., *Italian Art and Britain*, 1960, cat. no. 423.

A *grisaille* by G. B. Tiepolo in a private collection in Milan (Morassi, *Tiepolo*, II, 1962, fig. 240) seems to show some connexion with the Christ Church picture in general arrangement.

Cleaned and restored by J. C. Deliss 1964–66. An extensive damage, about a foot deep, runs across the canvas above the heads of the figures L. and centre, just above the head of Apollo, and through the faces of the two nymphs R. Apart from this, there are local damages throughout. The old restoration was extremely coarse.

Literature: L. & E., III, 21; E.C., II, 51 (as Sebastiano Ricci); 'A' Cat., 1776, p. 4 (without attribution); probably 1833 Cat., no. 210 (as Andrea Schiavone); Borenius Cat., 1916, no. 284 (as Italian School, XVII century).

SEBASTIANO AND
MARCO(?) RICCI

For Sebastiano Ricci, see no 122. His nephew, Marco (1676–1729), often accompanied Sebastiano on his travels, and was in England before him, working at Castle Howard. His small landscapes, often with classical ruins, painted in *gouache* on thin kid-skin, were particularly popular in England; the finest collection is in the Royal Library at Windsor. He collaborated very frequently with his uncle.

123. THE BUILDING OF A CLASSICAL TEMPLE IN A LANDSCAPE. Canvas, 136·6 × 174·8 cm. (including additional strips).
Plates 93–94

Guise Bequest, 1765.

The figures are typical of Sebastiano Ricci, and that part of the old attribution can hardly be disputed. 'Viviani', however, must mean Viviano Codazzi, who died when Sebastiano was still a boy, and whose architectural fantasies bear only a superficial resemblance to this picture (see no. 147 of this catalogue for a characteristic work by him). The most likely assumption is that Sebastiano here, as so often elsewhere, collaborated with his nephew Marco. The crisp painting of the architecture, with strong cast shadows, and of the foliage over the walls, accords with the style of Marco's popular *gouaches* at Windsor Castle and elsewhere, though in them the architectural theme consists commonly of a classical temple in decay, rather than in the course of construction.

Such collaborations are frequent in Italian painting from the XVII century onwards. Sebastiano and Marco Ricci between them produced at least two of the so-called *Tombeaux des Princes*, the series of 24 architectural allegories ordered by the Irishman Owen McSwiny in the 1720's, ten of which found their way into the collection of the Duke of Richmond at Goodwood.[1] Several of those, as we know from the inscribed engravings, were the joint work of three or even four different Venetian or Bolognese artists.

One other possibility suggests itself: that Sebastiano Ricci's collaborator was the architect-painter Antonio Visentini (1688–1782), who drew the frontispiece to the volume of Ricci's drawings now in the Windsor Library. When Marco Ricci died in 1729, and his uncle might have looked for a new *prospettivista* to help him in this fashionable sort of painting, Visentini was already over forty. It was not until 1746 that he painted the famous houses of England in collaboration with Zuccarelli (the series now at Windsor Castle); but he clearly modelled himself on Marco Ricci, and that, and his neat unobtrusive brushwork, would no doubt have recommended him as an assistant to Sebastiano. The old attribution to 'Viviani' is not surprising, for his is one of the commonest names attached to 'pieces of architecture' in the sale catalogues of the XVIII century.

The picture was cleaned by J. C. Deliss in 1966. A strip about 14 cm. deep was found to have been added to the canvas at the top, and narrower strips R. and L.; but it is very unlikely that these additions were made since General Guise's time, and they may have been made by the artist. There is some damage in the sky; but generally the painting is in fair condition.

Literature: L. & E., III, 18; E.C., II, 49; 'A' Cat., 1776, p. 8; 1833 Cat., no. 252 (in all these as by 'Viviani', with figures by Sebastiano Ricci); Borenius Cat., 1916, no. 303 (as Italian School, XVIII century).

1. The *Tomb of the Duke of Devonshire* is now in the Barber Institute at Birmingham (exh. R.A., 1960, cat. no. 434); that of Admiral Sir Cloudesley Shovell in the Kress Collection at the National Gallery of Art in Washington. Both are signed by both artists. See F. J. B. Watson in *Burlington Magazine*, 1953, p. 362 *ss.*

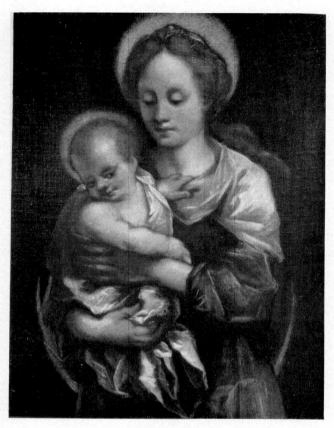

Fig. 27. Formerly attributed to Sebastiano Ricci:
The Virgin and Child (Cat. No. 124)

FORMERLY ATTRIBUTED TO SEBASTIANO RICCI

124. THE VIRGIN AND CHILD, half length, with a crescent Moon behind. Canvas, laid on panel, 52 × 40·5 cm.

Figure 27

Guise Bequest, 1765.

This rather attractive picture, catalogued by Borenius (following the earlier records) as by Sebastiano Ricci, is retained here for want of a better attribution. It can hardly be by Ricci, although that artist was in all probability still alive when General Guise acquired it; and it is doubtful, to say the least, whether it is of the Venetian school. There is something Florentine, of the early XVII century, in the type of the Virgin. A name, unfortunately illegible, seems to be written in ink on the back of the panel.
Cleaned by J. C. Deliss, 1960. There is a good deal of restoration in the background.

Literature: Probably L. & E., III, 26; E.C. II, 57 ('Our Lady with her Babe, about 2 feet high, painted much after Correggio's manner, by Sebastian Ricci'); 'A' Cat., 1776, p. 7 ('A Madona, after Correggio's manner, by Sebastian Ricci'); Borenius Cat., 1916, no. 247.

FRANCESCO ZUCCARELLI
1702–88

Born in Tuscany and trained in Rome, but spent most of his working life either in Venice (from *c.* 1732) or in England, where he lived for long periods between 1742 and 1773. He was a Foundation member of the Royal Academy in London, and became President of the Venetian Academy in 1772. He lived his last years in Florence, but continued to exhibit in London.

125. ROMANTIC LANDSCAPE, with Figures by a River, a Citadel in the middle Distance. Canvas, 27·2 × 47·9 cm.

Plate 95

Nosworthy Bequest, 1966. Sold at Christie's, March 5 1954, lot 165, as by Orizonte. Bought from Colnaghi by Sir Richard Nosworthy, April 1954.

An attractive and unusual early landscape by Zuccarelli, still in the taste of Gaspar Dughet and Andrea Locatelli in the treatment of foreground and foliage, but already characteristic of Zuccarelli in the distance and also in the figures. The condition is good.

FRANCESCO ZUCCARELLI

126. THE ADORATION OF THE SHEPHERDS. Canvas, 82 × 104 cm.

Plates 96–97

Guise Bequest, 1765.

Religious subjects by Zuccarelli are much less common than his landscapes with pastoral or mythological subjects, and this night-piece, lit in the foreground by the glory surrounding the Infant Christ, and in the background by a mysterious ray from heaven, is a beautiful example. The scene in the background R., with the shepherds and their flocks terrified by the celestial light, and one angel turning to comfort them, is charmingly realized. Zuccarelli was General Guise's younger contemporary by twenty years, and the picture was already in Guise's collection before 1761 (when it is mentioned in *London and its Environs described*); this may be a fairly early work, perhaps *c.* 1740. It was cleaned by S. Isepp in 1943, and is in good condition, having no doubt (as a comparatively 'modern' work) escaped the attention of the Oxford restorer Bonus when it arrived at Christ Church after Guise's death. Some minor repairs and re-varnishing were done by J. C. Witherop in Liverpool in 1965.

Exhibited: Liverpool, 1964, no. 52.

Literature: 'A' Cat., 1776, p. 7; 1833 Cat., no. 212; Borenius Cat., 1916, no. 248 and pl. LIII.

III

PAINTERS IN ROME

COPY OF RAPHAEL

Raffaello Santi (1483–1520), the most celebrated and influential artist in the history of European art. Probably the pupil of his father Giovanni Santi at Urbino until he was twelve years old, when Giovanni died; then of Perugino at Perugia. In Florence 1504–7. Removed to Rome, and remained there for the rest of his life, increasing in favour with the Pope, first with Julius II and then with Leo X. Began work in fresco in the *Stanze* of the Vatican in Rome 1509 (*Stanza della Segnatura* 1509–11, *dell' Eliodoro* 1511–14, *dell' Incendio* 1514–17). *The Transfiguration*, now in the Vatican (see no. 130 of this catalogue), commissioned in 1517, was apparently finished just before Raphael's death at the age of thirty-seven. There are two original drawings by Raphael in the Guise Collection at Christ Church.

127. THE VIRGIN AND CHILD. Panel, 60 × 41·5 cm.

Guise Bequest, 1765.

A copy, apparently of early date (XVI century), of the Madonna formerly belonging to the Earl of Northbrook, now in the Museum of Worcester, Massachusetts (*Klassiker der Kunst, Raphael*, 1909, 210, 58 × 43 cm.); other versions belong to the Alte Pinakothek at Munich and to Sir Alec Douglas-Home. Mr. Martin Davies of the National Gallery, who is responsible for the catalogue of Italian pictures at Worcester, tells me that there are signs of later alterations in the original picture, particularly in the Virgin's head and veil; and in the shape of the Virgin's head the Christ Church copy might be considered more Raphaelesque. The whole composition is extended in the Christ Church picture in all directions, especially above; and there are some considerable variations in the landscape and elsewhere. The Child wears a narrow scarf crossed over his breast.

The authenticity of the Worcester picture has frequently been doubted; but with some reservations as to its present condition, Mr. Davies is inclined to accept it as an original by Raphael's own hand. The picture at Christ Church is an interesting old copy of some quality; the least good parts are the Virgin's red dress and sleeve, and the Child's head.

Parts of the picture, including the landscape, are in fair condition; there is much damage and restoration in the head of the Virgin.

Literature: Possibly 'A' Cat. 1776, p. 11 ('Madonna in the first manner of Raphael'), and 1833 Cat. no. 154; Borenius Cat., 1916, no. 82.

COPY OF RAPHAEL

128. THE VIRGIN AND CHILD. Panel (oak), 35 × 23 cm.

Guise Bequest, 1765.

A reduced copy, of very poor quality, from the 'Bridgewater Madonna' in the Collection of the Duke of Sutherland (formerly Earl of Ellesmere). Morelli considered it to be by a Flemish artist. It can hardly be earlier than the XVIII century.

Literature: Perhaps 'A' Cat., 1776, p. 11 ('A Madona, after Raphael's manner'); 1833 Cat., no. 150 ('Madonna and Child, from Raphael') (not 152, as given by Borenius); Borenius Cat., 1916, no. 83.
Morelli, *Die Galerien zu München und Dresden*, p. 361, and *Italian Painters*, II, 279.

COPY OF RAPHAEL

129. PORTRAIT OF BALDASSARE CASTIGLIONE. Canvas, 78 × 63·5 cm.

Guise Bequest, 1765.

A poor copy of the celebrated painting in the Louvre (no. 1505).

Literature: 1833 Cat., no. 143 (as after Raphael); Borenius Cat., 1916, no. 84.

COPY OF RAPHAEL

130. THE TRANSFIGURATION. Canvas, 55·9 × 43·6 cm.

Guise Bequest, 1765.

A much reduced and undistinguished copy of Raphael's famous painting now in the Vatican Gallery in Rome.

Literature: 'A' Cat., 1776, p. 5; 1833 Cat., no. 155; Borenius Cat., 1916, no. 85.

FOLLOWER OF RAPHAEL

131. JUPITER AND JUNO, STANDING IN THE CLOUDS. Panel, 42·3 × 36·5 cm. (including gilt border). Plate 101

Guise Bequest, 1765.

Clearly Raphaelesque, perhaps Ferrarese, by some follower of Girolamo da Carpi, as Mr. P. M. Pouncey suggested; but necessarily much restored after cleaning by J. C. Deliss in 1964, and not of much quality in its present state.

Literature: 'A' Cat., 1776, p. 5; 1833 Cat., no. 149 ('from Raphael'); Borenius Cat., 1916, no. 87 (as School or Copy of Raphael).

GIULIO ROMANO
1499 (?)–1546

Giulio Pippi, called Romano, painter and architect, was born in Rome, became a pupil of Raphael, and (with Luca Penni) was one of Raphael's legal heirs at his death in 1520. In 1524 Giulio went into the service of the Gonzaga family at Mantua, and remained there until his death. He is mentioned as a sculptor (which he was not) in Shakespeare (*A Winter's Tale*, Act v, Scene 2).

132. A ROMAN EMPEROR ON HORSEBACK. Panel, 86 × 55·5 cm. Plate 98

Guise Bequest, 1765.

The picture has always been attributed to Giulio, and comes from the collection of Charles I, whose cipher and crown are burnt into the panel at the back. As Borenius points out, it is one of a series of ten Emperors on horseback described in the Mantuan Inventory of January 12 1627 (Luzio, *La Galleria dei Gonzaga venduta all' Inghilterra*, Milan, 1913, p. 92, no. 13). Seven of the series are described in A. van der Doort's inventory of the Collections of Charles I (Walpole Society, XXXVII, pp. 226–227) as hanging (with seven of Titian's *Emperors*, now lost) 'In the Gallerie att St. Jameses'. The whole series was sold from the King's collection by the Commonwealth, but two pieces were recovered after the Restoration and are now at Hampton Court (E. Law, Cat., 1898, and Collins Baker, Cat., 1929, nos. 257 and 290). Mr. Oliver Millar (Walpole Society, *loc. cit.*) records another now at Narford Hall; and Dr. John Shearman drew my attention to three more, united in one frame, in the museum of Marseilles, said to have been given by Cardinal Mazarin to the King of France.[1] There is no reference to any of this series in F. Hartt's exhaustive monograph on the artist (1958).

The Christ Church picture was partially cleaned and restored by H. Buttery in 1950. It is very badly damaged, and reveals little of the quality of the master.

Literature: L. & E., III, 36; E.C., II, 66; 'A' Cat., 1776, p. 1; 1883 Cat., no. 144; Borenius Cat., 1916, no. 89.

1. Gibert, *Le Musée des Beaux-Arts de Marseille*, 1932, p. 16. Presumably Mazarin bought them at the Commonwealth Sale.

COPY OF
DANIELE DA VOLTERRA

Daniele da Volterra, *c.* 1509–66, follower of Michelangelo, born at Volterra, died in Rome.

133. THE DESCENT FROM THE CROSS. Canvas, 72 × 50·5 cm.

Guise Bequest, 1765. Bought from the Earl of Oxford's Sale, 1748 (2nd day, lot 12) for £6 10s.[2]

This is a good small copy of the celebrated (and now much damaged) fresco by Daniele da Volterra in the church of the Trinità de' Monti at Rome. It is apparently of the XVII century, and somewhat Poussinesque in style and colour. It is worth noting that Nicolas Poussin is said to have declared that Raphael's *Transfiguration*, Domenichino's *Last Communion of St. Jerome*, and this *Deposition* by Daniele da Volterra were the three greatest masterpieces of painting (see the note in the 1833 Cat., under no. 103, quoting *Œuvres des peintres les plus célèbres*. Paris, 1803). Copies of all three are in the Guise Collection at Christ Church.

Literature: L. & E., III, 22; E.C., II, 53; 'A' Cat., 1776, p. 12; 1833 Cat., no. 79; Borenius Cat., 1916, no. 91.

ROMAN OR BOLOGNESE (?)
SCHOOL, LATE XVI CENTURY

134. THE CIRCUMCISION. Brown monochrome on paper, laid on panel, 30·4 × 25·7 cm.

Guise Bequest, 1765.

A feeble little painting, possibly by some follower of Polidoro.

Literature: L. & E., III, 23; E.C., II, 54 (as Polidoro da Caravaggio); 'A' Cat., 1776, p. 3 ('a small sketch of the Circumcision, by Correggio'); 1833 Cat., no. 48 (as Correggio); Borenius Cat., 1916, no. 256 (as Italian School, second half of XVI century).

GIUSEPPE CESARI, CALLED
IL CAVALIERE D' ARPINO
1568–1640

Giuseppe Cesari, known as the Cavaliere d' Arpino, born probably in Rome. Introduced early to the patronage of Pope Gregory XIII, and created Cavaliere di Cristo by Clement VIII in 1600. Painted extensive works in fresco in Roman churches, and supervised the other artists in the decoration of the Lateran. Visited Paris and was created Chevalier de Saint Michel by Louis XIII of France. In the

2. Mr. Frank Simpson kindly drew my attention to this.

first two decades of the XVII century he enjoyed a great reputation, and his small cabinet-pieces, on wood or copper, were as famous as his frescoes.

135. THE EXPULSION FROM PARADISE. Copper, 46·5 × 35·5 cm. Plate 99

Guise Bequest, 1765.

Borenius dismisses this as a copy from the large picture in the Louvre; but it is in fact a characteristic cabinet-piece by the Cavaliere himself, of high quality, repeating the same composition with variations in the landscape. A similar cabinet-piece, also on copper, with differences particularly in the hands, is in the Wellington Museum at Apsley House. The drawing in the Morgan Library (Fairfax Murray publication, IV, 161) shows considerable variations, and has the composition of the figures reversed. Cleaned by J. C. Deliss in 1960. There are small restorations above and below the hands and forearms of Eve.

Exhibited: Liverpool, 1964, no. 11.

Literature: 'A' Cat., 1776, p. 7; 1833 Cat., no. 278; Borenius Cat., 1916, no. 94 (as copy of Cavaliere d' Arpino).

FOLLOWER OF FEDERICO ZUCCARO (?)

136. THE NATIVITY. Oak panel, 37·7 × 30 cm. Plate 100

Guise Bequest, 1765.

As Borenius remarks, the painting bears little resemblance to the work of Perino del Vaga, in spite of the XVIII century inscription on the back ('Paint par Perino dell Vago pour les College des Domenecins a Florence 1541') (*sic*). In fact the composition and the forms suggest the influence of Federico Zuccaro, but the painting is probably by a Northern artist.

Cleaned by L. Freeman in 1963. There is some rubbing and restoration on the head of the angel in the centre and on the hands of the kneeling shepherd.

Literature: 'A' Cat., 1776, p. 9; 1833 Cat., no. 228; Borenius Cat., 1916, no. 90 ('copy after Perino del Vaga?').

COPY OF CARAVAGGIO

Michelangelo Merisi, called Il Caravaggio, born Sept. 28 1573 at Caravaggio, between Milan and Brescia. In Rome *c.* 1591, the pupil of Cavaliere d' Arpino (see no. 135 of this catalogue). Worked in the churches of S. Luigi de' Francesi, Sta. Maria del Popolo, and for various other patrons in Rome, 1598–1606. Fled from Rome, after killing a man in a brawl, May 1606, and settled in Naples. In Malta 1607–1608, in Sicily 1608–9. Died on his way back to Rome, where he hoped to receive a pardon from the Pope, July 18 1609.

The great founder of the Realist school, who though he was not yet thirty-six when he died, exercised enormous influence, directly or indirectly, on painters of Italy, the Netherlands, France and Spain.

137. MARTHA REPROVING MARY MAGDALEN FOR HER VANITY. Canvas, 97·7 × 135·8 cm. Plate 103

Guise Bequest, 1765.

The painting was not included in the Caravaggio Exhibition at Milan in 1951, and is not referred to in the catalogue. Various attributions have been suggested for it in print, and in letters in the Christ Church file: Fiocco (1917) confidently named Orazio Gentileschi as the author; Voss (1924), who was the first to explain the subject correctly, considered it might be one of the earliest Caravaggesque works of Simon Vouet; and the name of Nicolas Regnier (Renieri) has also been put forward.

Longhi (1943), Berenson (1951), Mahon and Hinks were surely right in supposing that the design at least must be Caravaggio's own. Longhi (*loc. cit.*, pl. 12) illustrates another good version in the Manzella Collection, Rome, and mentions one more, which he describes as mediocre, on the Roman art market. Dates suggested for the composition vary between *c.* 1595 (Longhi) to *c.* 1597–98 (Hinks). It is generally recognized that the model of the Magdalen must have been the same as for the kneeling St. Catherine in the Thyssen Collection at Lugano (Hinks, *op. cit.*, pl. 17) – a point first noticed by Fiocco (1917).[1]

Two other versions, in the same direction as ours, but noticeably different from it in the type of the Magdalen, have been published by Nicola Ivanov (*Arte Veneta*, XVIII, 1964, p. 179), one as of the studio of Carlo Saraceni, the other as a copy after that master; and yet another, near to the Saraceni type in detail, was exhibited as a copy of a lost Caravaggio at the Ringling Museum, Sarasota, in Spring 1960, the property of Mr. and Mrs. Julius Weitzner, New York.[2] The ex stence of so many replicas and imitations by various followers of Caravaggio supports the view that there was an original by the master himself.

The Christ Church picture is by a good hand, and something might be said for supposing that it is a copy of a lost Caravaggio by the young Vouet, who then developed the composition (in reverse), with a much more characteristic Magdalen, in the picture in Vienna to which Voss first drew attention.[3]

The Manzella picture (which I have not seen) seems from the reproduction to be slightly better than ours in the

1. It was this connexion in fact which induced Fiocco to attribute our picture to Gentileschi, since Longhi had previously attributed the Thyssen (ex-Barberini) Magdalen to that artist, though he afterwards changed his opinion.
2. *Ringling Museum Bulletin*, vol. 1, no. 1, Feb. 1960, reproduced.
3. *Op cit.*, 1924. The attribution of the Vienna picture to Vouet himself is doubted by Georgette Dargent and Jacques Thuillier in their article *Simon Vouet en Italie* in *Saggi e Memorie di Storia dell' Arte*, vol. 4, 1965, p. 57 and fig. 78.

painting of parts of the dress (the Magdalen's R. sleeve, and the drapery over her L. arm); but the underlying drawing in the Christ Church picture is very good, especially of the hands. The whole surface, however, is flattened and rubbed, so that the the original quality is hard to judge – see, for example, the ivory comb on the table, the detail of which has almost disappeared. There were some disfiguring retouches, which had discoloured, in the face of the Magdalen, but the appearance of the painting is improved after cleaning by J. C. Deliss in 1966.

Literature: L. & E., III, 31; E.C., II, 61–62 (as Domenichino); 'A' Cat., 1776, p. 11 ('two female figures, half length, by Mutiano'); 1833 Cat., no. 182 ('Two Female Figures, a Lady and her Servant, by Mutiano'); Borenius Cat., 1916, no. 96 and pl. XXXII (as 'A Lady with her Servant' of the school of Caravaggio).
G. Fiocco in *L' Arte*, vol. XX, 1917, p. 361 (review of Borenius Cat.); H. Voss in *Zeitschrift für bildende Kunst*, vol. 58, 1924, pp. 66–67; R. Longhi, *Ultimi Studi sul Caravaggio*, in *Proporzioni*, I, 1943, p. 11 and pl. 13; Berenson, *Del Caravaggio*, Florence, 1951, p. 17 and pl. 13; D. Mahon in *Burlington Magazine*, 1951, p. 228, note 55, and *ibid.*, 1952, p. 19; R. Hinks, *Caravaggio*, 1953, p. 101, no. 18 and pl. 19; B. Joffroy, *Le Dossier Caravage*, Paris, 1959, p. 255 and pl. CXXI; G. Dargent and J. Thuillier, *Simon Vouet en Italie*, in *Saggi e Memorie di Storia dell' Arte*, vol. 4, 1965, pp. 57 and 58.

COPY OF CARAVAGGIO (?)

138. CHRIST CROWNED WITH THORNS. Canvas, 88·5 × 108·1 cm. Plate 102

Guise Bequest, 1765.

Pietro Bellori (1672) records that Caravaggio painted this subject for the Marchese Vincenzo Giustiniani, but no known picture is accepted as the original. Longhi (*Ultimi Studi sul Caravaggio*, in *Proporzioni*, I, 1943) considers both the painting in Vienna (*op. cit.*, pl. 27) and that in the Cecconi Collection, Florence (*ibid.*, pl. 21), to be old copies of Caravaggio. The Christ Church picture, which is of different composition from either of these, is also close to the master in style, but is of poor quality and certainly not by his hand; it may be a copy after a work of one of his followers, perhaps Manfredi.[1] It has not been noticed, so far as I am aware, in any of the recent literature.

Literature: Identified by Borenius with 'A' Cat., 1776, p. 4 ('Our Saviour crowned with Thorns'), but perhaps rather p. 3 ('in the manner of Guercino'); 1833 Cat., no. 185 ('Guercino') (probably this, and not no. 50 as Borenius supposed); Borenius Cat., 1916, no. 95 (as Caravaggio?).

1. Prof. E. K. Waterhouse, independently, has made the same suggestion.

ROMAN OR BOLOGNESE SCHOOL, FIRST HALF OF XVII CENTURY

139. BUST PORTRAIT OF A MAN. Canvas, 51·2 × 38·5 cm.

Guise Bequest, 1765.

In scale and character, this bears a superficial resemblance to Bernini's painted and drawn self-portraits; but very little of the original painting is preserved.

Literature: Borenius Cat., 1916, no. 299. Borenius suggests that this may be identical with 'the head of Vandyke', 'A' Cat., 1776, p. 13, and 1833 Cat., no. 239 ('Portrait of Vandyke – Sketch by himself').

PIER FRANCESCO MOLA
1612–66

Born at Coldrerio near Como, the son of an architect who removed to Rome soon after Pier Francesco's birth. Pupil in Rome of the Cavaliere d' Arpino, then in Bologna, and also in Venice and at his birthplace near Como; otherwise chiefly in Rome.

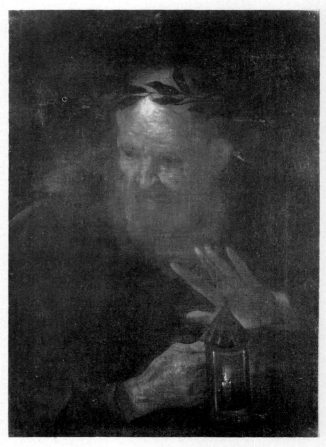

Fig. 28. Pier Francesco Mola: *Diogenes* (Cat. No. 140)

140. DIOGENES, half length. Canvas, 77 × 56 cm.

Figure 28

Guise Bequest, 1765.

Typical of Mola, but so badly damaged that the quality of the painting is destroyed.

Literature: L. & E., III, 36; E.C., II, 66 (as Spagnoletto); 'A' Cat., 1776, p. 1 (as 'Spagnuoletto'); 1833 Cat., no. 217 (as Mola); Borenius Cat., 1916, no. 162.

ATTRIBUTED TO MOLA

141. PORTRAIT OF A MAN, supposed to be the self-portrait of the artist. Canvas, 46·2 × 36·5 cm.

Guise Bequest, 1765.

Inscribed: MOLA in gold upper L. (not contemporary). Of very coarse quality, and apparently entirely repainted.

Literature: L. & E., III, 19; E.C., II, 50; 'A' Cat., 1776, p. 2; 1833 Cat., no. 238 (always as a self-portrait of Mola); Borenius Cat., 1916, no. 163.

COPY OF P. F. MOLA (?)

142. THE ANGEL APPEARING TO HAGAR IN THE DESERT. Canvas, 47·5 × 64 cm.

Guise Bequest, 1765.

Borenius refers to two engravings from pictures of this composition by Mola, one in the *Galerie Napoléon* and one in the Orléans Gallery (in reverse). The present picture seems to be an early copy of fairly good quality, but in very bad condition.

Literature: 'A' Cat., 1776, p. 7 (without attribution); 1833 Cat., no. 64 (as Mola); Borenius Cat., 1916, no. 167 (as copy of Mola).

PIETER VAN LAER, CALLED BAMBOCCIO
1592 or 1595–1642

Pieter Boddink van Laer, called Bamboccio, born at Haarlem and died there, began his career as a follower of Esaias van der Velde, but spent the best part of his working life (1625–38) in Rome, where he was a prominent member of the Dutch artists' *Bent* (or club). His small pictures of low life in Rome had a great vogue, despite the ridicule of the academic painters of the time.

143. LANDSCAPE WITH A HUNTSMAN IN THE ROMAN CAMPAGNA. Octagonal panel, 30·6 × 44·6 cm.

Guise Bequest, 1765.

What appears to be an almost contemporary label in Dutch on the back gives the attribution and the date 1630. It is unfortunate that this and no. 144, which seem from the old labels to be well accredited examples of Pieter van Laer, are so damaged and darkened as to provide no clear evidence of the artist's style at this period. The octagonal shape is characteristic; *cf.* a series of somewhat larger dimensions in the Spada Gallery, Rome (Zeri Cat., 1953, pls. 110–113).

Partly cleaned by J. C. Deliss in 1964, but found to be in irretrievably bad condition.

Literature: 'A' Cat., 1776, pp. 7–8; 1833 Cat., no. 226; Borenius Cat., 1916, no. 332.

PIETER VAN LAER

144. LANDSCAPE WITH PEASANTS DANCING, NEAR A TOWER IN THE CAMPAGNA. Octagonal panel, 30·4 × 45 cm.

Guise Bequest, 1765.

A companion picture to no. 143, with a similar inscription giving the attribution and date 1630 in a contemporary Dutch hand on a label at the back. The condition is equally bad.

Partly cleaned by J. C. Deliss, 1964.

Literature: 'A' Cat., 1776, pp. 7–8; 1833 Cat., no. 227; Borenius Cat., 1916, no. 333.

FORMERLY ATTRIBUTED TO MICHELANGELO CERQUOZZI
1602–60

Cerquozzi, who was born and died in Rome, was much influenced in his early work by Pieter van Laer (see nos. 143, 144 of this catalogue), from the Dutch artist's arrival in Rome in 1625 to his departure in 1638. Cerquozzi collaborated later with the architectural painters, particularly Codazzi (see no. 147 of this catalogue). How nearly he approached the style of his Dutch friend and master in the later 1620's and 1630's is by no means certain.

145. THE QUACK DENTIST. Canvas, laid on panel, 38·5 × 49·9 cm.

Plate III

Guise Bequest, 1765.

In spite of the old attribution to Cerquozzi, this and its companion-piece, no. 146, seem hardly distinguishable in style from a considerable number of pictures attributed to

Pieter van Laer by recent authority[1] and I should prefer that name, if the confusion between van Laer's own work and that of his friend and imitator, in his younger days, had been more conclusively cleared away. A picture in the Dresden Gallery of men playing bowls (Cat. 1920, no. 1365, photo Bruckmann) is very close to no. 146 in subject matter, architecture and types – here again are the man bowling, in a sheepskin coat, the man pointing, and the man standing on one leg in his excitement over the game. This and our picture can hardly be by different hands, though the Dresden picture was attributed to van Laer, and ours to Cerquozzi, as early as the middle of the XVIII century. There are very few authentic signatures by van Laer, and the dark tone of such paintings makes them difficult to judge from photographs.

Both Christ Church pictures, though rubbed and restored in places, are of very good quality, and certainly original. The choice of attribution is surely between the two artists already referred to, and in spite of Borenius' suggestion that they are by a Dutch imitator of van Laer, the work of the other Dutch painters of this *genre* in Rome – Jan Miel, Michel Sweerts, Lingelbach, Helmbreker and Thomas Wyck – is much less relevant to the problem.

Literature: L. & E., III, 28; E.C., II, 59; 'A' Cat., 1776, p. 12; 1833 Cat., no. 230 (always attributed to Cerquozzi); Borenius Cat., 1916, no. 102 ('probably, like the following picture, by a Dutch imitator of Pieter van Laer').

1. See especially Giuliano Briganti in *Proporzioni*, III, 1950, p. 185 *ss.* and in the catalogue of the *Mostra dei Bamboccianti*, Rome, in the same year.

FORMERLY ATTRIBUTED TO MICHELANGELO CERQUOZZI

146. A GAME OF BOWLS IN A ROMAN RUIN. Canvas laid on panel, 38·6 × 50 cm. Plate 112

Guise Bequest, 1765.

See note to no. 145 above.

Literature: L. & E., III, 28; E.C., II, 59; 'A' Cat., 1776, p. 12; 1833 Cat., no. 229 (always attributed to Cerquozzi); Borenius Cat., 1916, no. 103 (as probably by a Dutch imitator of Pieter van Laer).

VIVIANO CODAZZI
1603/4–1670

Sometimes called Codagora, born at Bergamo, arrived in Rome *c.* 1620. In Naples early 1634, but again in Rome from 1648. Died in Rome 1670. He was much in demand as a painter of architectural perspectives, either as backgrounds to figure subjects by more important artists, such as Lanfranco or Stanzioni (in Naples), or as independent pieces to which small figures were added by various collaborators.

147. AN ARCHITECTURAL FANTASY, WITH A FOUNTAIN AND FIGURES. Canvas, 156 × 193 cm. Plate 108

Guise Bequest, 1765.

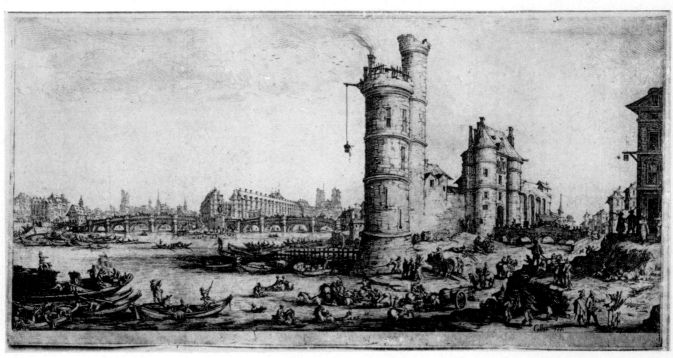

Fig. 29. Jacques Callot: *View of Paris with the Tour de Nesle.* Etching, Lieure 668 (*Cf.* Cat. No. 147)

The painting is not by Ghisolfi, but typical of the rather earlier Codazzi, whose work has only recently been studied (see Estella Brunetti in *Paragone*, 1956, no. 79, p. 48 *ss.*). A painting at Colnaghi's 1966, signed with Codazzi's monogram (and also by Micco Spadaro his collaborator, who painted the figures) and dated 1647, is very like, so far as the architecture and landscape are concerned – the perspective accentuated by the sharp lighting, the fluted columns chipped and cracked in places, the tree protruding from the terrace in the middle distance, the distant buildings and the sky; but the figures in our picture are certainly not by Micco Spadaro, who became Codazzi's favourite collaborator after his visit to Naples in 1634. They are rather French in style, and resemble those in an early architecture-piece by Codazzi in the Pallavicini Collection in Rome,[1] which are supposed by Estella Brunetti to be by the Frenchman François Perrier (1590–1650). It is interesting that the view in the background of our picture is clearly derived from one of Jacques Callot's two famous etchings of Paris, Lieure 668, showing the Tour de Nesle on the R., and the Pont-Neuf, with the statue of Henri IV, in the distance (Figure 29). Callot was in Paris 1628–30, and Lieure supposes that these views were etched on his return to Nancy in the latter year. Perrier was in Rome before 1630, but in that year was back in France. He was in Rome again 1635–c. 1645, but by that time Codazzi was in Naples, where he remained perhaps until 1648. If therefore we are to suppose that Perrier was the collaborator in our picture, we must probably assume that Perrier also went to Naples. The date of the Christ Church painting must be after 1630, but not much later than 1635.

Cleaned by J. C. Deliss, 1964. The condition is reasonably good.

Literature: L. & E., III, 20; E.C., II, 51 ('in his first manner, by Nicol. Poussin'); 'A' Cat., 1776, p. 11 ('by Ghisolfo'); 1833 Cat., no. 183 (the same); Borenius Cat., 1916, no. 182 (as Ghisolfi, attributed to).

ATTRIBUTED TO FRANCESCO COZZA
1605–82

Born in Calabria, became a pupil of Domenichino in Rome, and followed him to Naples 1631–34. Afterwards worked chiefly in Rome.

148. The Flight into Egypt. Canvas, 110 × 149 cm.
Plate 104

Guise Bequest, 1765.

The types, and the very characteristic colour – the Virgin's 'Cambridge' blue cloak, St. Joseph's white and gold – lend plausibility to Mr. Philip Pouncey's suggestion, supported by Dr. Zeri, that this good picture may be by Francesco

Cozza. It may be compared, for instance, with the *Hagar in the Desert* in the collection of Mr. Brinsley Ford in London, or the *Nativity of the Virgin* in the Colonna Gallery in Rome. There is a painting of the same subject by Cozza, with full-length figures, in the church of S. Bernardino at Molfetta, which was exhibited at Bari in 1964 (*Arte in Puglia*, cat. no. 164, reproduced); and in the same exhibition was a *Madonna del Cucito* from the same church, also by Cozza (cat. no. 165).[2]

Cleaned by H. Buttery, January 1957, and again by Miss J. Pouncey, 1965. The surface is rubbed and the ground shows through in places (especially in the angel's L. arm); but the general condition is not bad, and there is little restoration.

Literature: L. & E., III, 21; E.C., II, 52 (in both as Guido Reni); 'A' Cat., 1776, p. 9; 1833 Cat., no. 256; Borenius Cat., 1916, no. 148 (always as Lanfranco).

GASPAR DUGHET
1615–75

Often called Gaspard Poussin, the son of a Frenchman and the brother-in-law of Nicolas Poussin, who married Dughet's eldest sister in 1630; but since he was born in Rome and spent most of his life there, he may be counted with the Roman School. After Nicolas Poussin, his master (who was twenty-one years his senior), and Claude, he was the third great landscape-painter of French origin to draw his inspiration from Rome. His landscapes were highly prized by English collectors, and contributed much to the development of English landscape painting in the XVIII century.

149. Landscape with Boats on a Lake. Canvas, 50·7 × 66 cm. Plate 107

Nosworthy Bequest, 1966. From the Ashburnham Collection. Probably bought by the 2nd Earl of Ashburnham from Humphrey Morice, Esq., The Grove, Chiswick, in 1786; bought in at the Ashburnham sale, July 20 1850, lot 72; sold by the Executors of Lady Catherine Ashburnham, June 24 1953, lot 76 (bought Leggatt); bought from Leggatt Brothers by Sir Richard Nosworthy, November 1953.

A good and characteristic example of Dughet's style in his middle years, 1650–55, and in good condition.

FILIPPO LAURI
1623–1694

Born in Rome, the son of an Antwerp painter Balthasar Lauwers who had settled in Italy. Pupil first of his elder

1. Zeri Cat., 1959, no. 142.

2. For an article on Cozza, see Luisa Mortari in *Paragone*, 1956, no. 73, pp. 17–21. A replica of the Molfetta *Flight into Egypt* in the Cappellina di S. Maria in S. Marco (Palazzo Venezia), Rome, is there reproduced.

brother Francesco, who died young, then of Angelo Caroselli. His small pictures, generally of mythological subjects, were extremely popular with the Roman nobility and the foreign collectors in Rome.

150. THE RAPE OF EUROPA: a Design for a Fan. Gouache on paper, laid on wood, 23 × 45·5 cm. Plates 109–110
Signed and dated indistinctly on the gilt scroll below: F. LAVRI 166 . . . (?).
Guise Bequest, 1765.

The signature, which Borenius could not decipher, on this charming and beautifully finished design, is certainly that of Lauri, though the date is hard to read. The exquisitely carved frame, picking up motives from the border, is no doubt contemporary with the painting. Apart from a little rubbing and flaking, the condition is good; there is no restoration.

Literature: 'A' Cat., 1776, p. 2 (without attribution); 1833 Cat., no. 61 (as Guido); Borenius Cat., 1916, no. 288 (as Italian School, XVII century).

ROMAN SCHOOL, SECOND HALF OF XVII CENTURY

151. ST. BRUNO PRAYING BEFORE A CRUCIFIX. Canvas, 60·8 × 77·4 cm. Plate 106
Nosworthy Bequest, 1966. From the collection of Gen. R. O'Hara Livesay, and from the Hope Collection. Sold by order of the Executrix of Dr. Seymour, M.D., of London, Christie's, January 29 1954 (lot 70). Bought by Colnaghi on behalf of Sir Richard Nosworthy.
This good picture was attributed to Andrea Sacchi, but seems unlikely to be by him. The elegant hands are suggestive of Maratti, who was Sacchi's pupil, and it may be worth considering whether this could be an early work by him.
Cleaned by J. C. Deliss, 1954, and in good condition.

STUDIO OF CARLO MARATTI
1625–1713

Born in the Marches, but in Rome from 1636, and a pupil of Andrea Sacchi. Following the principles of the Carracci rather than the High Baroque decorative style of Pietro Cortona, Maratti became the most representative and celebrated painter of the late Baroque period in Rome.

152. DIANA AND ACTAEON. Canvas, 110 × 154 cm. Plate 105
Guise Bequest, 1765.[1]

1. There were two paintings of this subject attributed to Carlo Maratti in the Earl of Halifax's sale, March 6–10 1739/40 (1740 N.S.): 1st day, lot 80, and 3rd day, lot 74 (Houlditch MS., in this case without buyers' names).

The author of the 1833 Catalogue states that this is 'an imitation of the Picture by Domenichino in the Borghese Palace at Rome', and Borenius (1916) appears to follow him. Only one figure, however – the nymph sitting in the water in the centre foreground – derives (in the reverse direction) from the Borghese Domenichino, which has a different subject (*Diana hunting*). Other figures derive from Albani's picture in the Louvre (of which a replica in reverse is at Dresden): certainly the nymph R. centre, sitting partly in the water with her hands between her legs; possibly also the one on extreme R., and Diana herself (in reverse).[2] Mr. Michael Levey has drawn my attention to a picture at Chatsworth of nearly the same composition, but upright in shape and with a different background, which is attributed to Maratti and Gaspar Dughet in collaboration. It is reproduced by Dottoressa A. Mezzetti[3] in a valuable article, *Contributi a Carlo Maratta*, where she identifies the Chatsworth picture with one described by Bellori (d. 1696) in his life of Maratti. It was painted, says Bellori, for Lorenzo Onofrio Colonna by Maratti and Dughet; and since Dughet, who was responsible for the *'bellissimo paese'*, died in 1675, it was presumably painted before that date. In Bellori's time it had already passed into the collection of the Marchese Niccolò Pallavicini. Several of the figures correspond to those in the Christ Church version, but they are differently disposed, and there are other variations – for example, in the R. arm and drapery of Diana. Two other variations on the same composition from Maratti's studio, one octagonal, one rectangular and upright, are in the Duke of Beaufort's collection at Badminton.[4]
The Christ Church picture is in tolerable condition, but not of sufficiently high quality to justify an attribution to Maratti's own hand. The two dogs in the lower R. corner are more meticulously painted than the rest, and might be the contribution of a Flemish artist in the studio.
Literature: 'A' Cat., 1776, p. 9 (as Maratta); 1833 Cat., no 191 (the same); Borenius Cat., 1916, no. 153 (as a copy after Domenichino).

GIROLAMO TROPPA
c. 1636–after 1706

Cavaliere Girolamo Troppa, born at Rocchette in Sabina, said to have been a pupil of Carlo Maratti, and according to others of Sacchi and Lazzaro Baldi (whose influence he seems to show). A few altarpieces by him are in churches in Rome, where he was working 1656–69; and several paintings are in the Royal Museum at Copenhagen. See Thieme-Becker, *Künstlerlexicon,* XXXIII, 1939, p. 439; and

2. See catalogue of the Bologna Exhibition, 1962, *L' Ideale classico nel Seicento,* p. 146 and pl. 49.
3. *Rivista dell' Instituto Nazionale d' Archaeolgia e Storia dell' Arte,* 1955, p. 290.
4. Photos., Witt Library.

for a more recent account, Cesare Verani in *L' Arte*, XL, 1961, pp. 300–301.

153. ALLEGORY OF PAINTING. Canvas, 133·7 × 98·3 cm.
Plate 113

Signed *G^{mo} Troppa* lower L., below the child's R. foot.

Guise Bequest, 1765.

In the background L. appears a representation of Time unveiling Truth, which may be inspired by Bernini's famous group in the Borghese Collection, Rome.
Mr. J. C. Deliss, when cleaning the picture in 1962, discovered the signature of this rare artist. By comparison with an altarpiece in the church of S. Maria del Popolo at Cittaducale, which is similarly signed and dated 1692 (repr. Verani, 1961, *loc. cit.*), our painting may be dated about the same period. It is much damaged and darkened, and the surface quality is lost. Only a few words of the long inscription on the tablet lower R. are now legible.

Literature: 'A' Cat., 1776, p. 5 (no attribution); 1833 Cat., no. 223 ('Spagnuoletto'); Borenius Cat., 1916, no. 294 (as Italian XVII century).

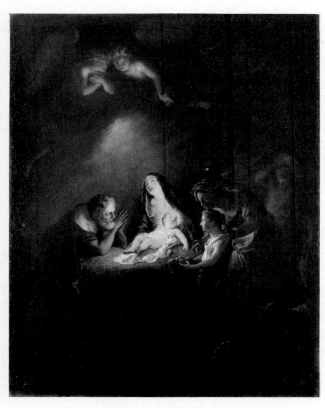

Fig. 30. Roman or Bolognese School, early XVIII century: *The Nativity* (Cat. No. 154)

ROMAN OR BOLOGNESE SCHOOL, EARLY XVIII CENTURY

154. THE NATIVITY: a Night-piece. Canvas, 97 × 77 cm.
Figure 30

Guise Bequest, 1765.

The picture is by no means bad, and is not in bad condition, but I cannot suggest a more exact attribution. It is surely of later date than Cavedone, to whom it is attributed in the early catalogues. Mr. P. M. Pouncey has suggested the name of the Bolognese Giuseppe Marchesi, called Il Sansone (1699–1771).
Re-lined and cleaned by L. Freeman in 1963.

Literature: L. & E., III, 28; E.C., II, 59 ('A Nativity of Our Saviour. The figures about one foot high. The effect of light that shines out of the babe, and irradiates the whole picture, is astonishing. This is a celebrated piece, by Cavalier Cavedone'); 1833 Cat., no. 200 (Cavedone); Borenius Cat., 1916, no. 264 (as Italian School, XVII century).

ROMAN (?) SCHOOL, XVIII CENTURY

155. AN ASSEMBLY OF THE GODS: Sketch for an oblong Ceiling; Jupiter, Juno in a Chariot of Lions, Venus with Cupid and Doves, Mars, Mercury and other Deities in the Clouds. Paper, laid on canvas, 27·5 × 63·5 cm.

Guise Bequest, 1765.

Identified by Borenius with L. & E., III, 35, E.C., II, 65 ('The original sketch of one of the ceilings painted in the Barberini Palace at Rome by Pietro da Cortona'), and 'A' Cat., 1776, p. 2. The picture referred to in these sources was probably from Dr. Bragge's sale, 1748/49, 1st day, no. 34 ('The Barberini Hall', £6 10s.).[1] But the present painting might also be 'An Assembly of the Gods – A small picture, painted upon paper' mentioned on p. 3 of the 'A' Catalogue of 1776, in which case, the references to L. & E., E.C. and 'A' Catalogue, p. 2, would apply to another picture, untraced. In any case, the present painting seems to have no connexion with Pietro da Cortona, or any ceiling in the Barberini Palace. It is much damaged, especially about the figure of Venus, and is at best of indifferent quality.

Literature: Borenius Cat., 1916, no. 97 ('Attributed to Pietro da Cortona; probably a copy?').

1. My attention was drawn to this by Mr. F. Simpson.

G

LOMBARD AND EMILIAN PAINTERS

(INCLUDING BOLOGNESE)

LOMBARD SCHOOL, LATE XV CENTURY

156. PORTRAIT OF BEATRICE D' ESTE, DUCHESS OF MILAN, in profile to L. Panel, 51 × 34·5 cm. Plate 114

Guise Bequest, 1765.

In General Guise's time, when the painting was described (in the old accounts of the collection) as a St. Catherine (by Carpaccio), the sitter appeared with the attributes of that saint; her R. hand held a palm-branch and the top of her wheel of martyrdom showed at the lower edge. It is so reproduced by Borenius. When the painting was cleaned by J. C. Deliss in 1965 these attributes and the hand disappeared, and false strips of wood were removed from R. and L. There is rubbing in the flesh parts, about the nose and cheek, and much damage in the black background; but the dress and the jewels are better preserved and of good quality.

Borenius describes our picture as a copy of one in the Palazzo Pitti (no. 371) 'which is faithfully reproduced' (except for the attributes of St. Catherine). The picture in Florence (see Figure 31) is illustrated in F. Malaguzzi-Valeri, *La Corte di Lodovico il Moro*, Milan, vol. I (1913), p. 51, as a portrait of Beatrice d' Este, with a tentative attribution to Lorenzo Costa. Since then it has been transferred from the Pitti Palace to the Uffizi (no. 8383); it is now called a portrait of Barbara Pallavicini, and attributed to Alessandro Araldi of Parma. Whoever the sitter may have been, whoever the painter, and whatever the relative merits of the versions at Christ Church and in Florence,[1] there can be no doubt that these two versions are very closely related; probably they derive from the same drawing, and were painted in the same studio. The correspondence is, however, not quite exact: our version shows jewels on the sleeve, catching together the slashed velvet over the linen beneath, where in the Uffizi version there are fastenings of a black feathery substance; on the other hand the Uffizi picture, unlike ours, shows some loose hair pulled down the cheek from the side of the *coiffure*, in the fashion that

was common, but not invariable, with Milanese ladies of the end of the XV century.[2]

The existence of more than one version is easily explained if it is accepted that this is the likeness of Beatrice d 'Este (1475–97), daughter of Duke Ercole I of Ferrara and sister of Isabella d' Este, Marchioness of Mantua. Beatrice married Lodovico Sforza, called Il Moro, in January 1491; he was then regent for his nephew, and himself became Duke of

2. This is evident, for example, in two profile portraits now generally attributed to Ambrogio de' Predis, that of Bianca Maria Sforza at Washington (from the Widener collection) and that of an unknown lady in the Ambrosiana (Bodmer, *Leonardo, Klassiker der Kunst*, 1931, p. 46); but not, so far as I can see, in 'La Belle Ferronnière', probably by Boltraffio, in the Louvre. The last two portraits have both been supposed, wrongly, to represent Beatrice d' Este.

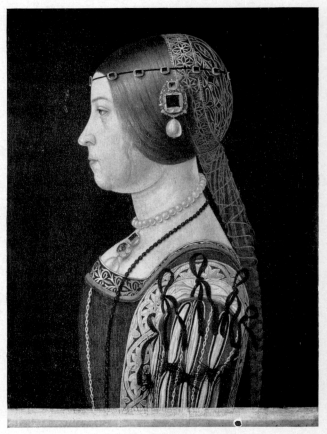

Fig. 31. Lombard School, late XV century: *Beatrice d' Este*. Florence, Uffizi (*Cf.* Cat. No. 156)

1. The other supposed version referred to by Borenius, in the Musée Jacquemart-André, Paris, is unconnected. It is a profile portrait of another lady by another painter, probably by Boltraffio.

Milan in 1494. She was one of the most celebrated princesses of her time, and her portrait was no doubt much in demand. And in fact, in spite of the re-naming of the Uffizi portrait (the reason for which I have been unable to discover), it seems certain that both this and the Christ Church version are portraits of Beatrice. Malaguzzi-Valeri (*op. cit.*, III, 1917, pp. 26–30) has a long note on her iconography. The best authenticated likenesses are: (*a*) the marble bust by Gian Cristoforo Romano now in the Louvre (before 1491; Malaguzzi-Valeri, I, pp. 46, 47); (*b*) in the so-called *Pala Sforzesca*, an altarpiece now in the Brera Gallery, where she appears kneeling opposite her husband, with her two children, at the Virgin's throne (1494/95; *ibid.*, I, frontispiece); and (*c*) in the richly illuminated Diploma of Lodovico il Moro, now in the British Museum, which has medallion portraits of Lodovico and Beatrice, dated Jan. 28, 1494 (*ibid.*, I, opposite p. 408). In all these the features are the same. One more point may be noted in this connexion: in August 1490, six months before his marriage, Lodovico sent a gentleman to her father's court with a present for Beatrice, '*una bella collana cum perle grosse ligate in fiori d'oro et uno bello zoglielo da atachare a dicta collana, nel quale è uno bellissimo smiraldo de grande persona, et uno balasso et una perla in forma de un pero*'.[1] Except for the stringing of the pearls '*in fiori d'oro*', which is not evident, this is an exact description of the necklace and pendant worn by the sitter in our picture: here are the great pearls; and the attached jewel (*zoglielo*) consists of an emerald, a ruby (*balasso*) and a pear-shaped pearl in that order from the top. Similar jewels and pendants may be found in other Milanese portraits; but I have not found one so closely corresponding to the contemporary description of Lodovico's present to his betrothed.

As for the authorship of our painting, it would be rash to pronounce, since the attribution of the Uffizi version is equally uncertain. I can find no evidence to support the suggestion[2] that the painter was Alessandro Araldi (d. 1528), a minor artist of Parma, who at some time must have been greatly influenced by Pinturicchio, and who had no known connexion with the courts of Ferrara or Milan. The old attribution to Lorenzo Costa was perhaps prompted by the tradition that a betrothal portrait of Beatrice by that artist was sent to Lodovico;[3] but Costa never seems to have favoured this type of profile portrait; even in one of his earliest works, the Bentivoglio altarpiece of 1488, which contains so many family portraits, he avoids the profile entirely. In fact, this type, in the last decade of the XV century, is characteristically Milanese. There is something primitive in the stiffness and *naïveté* of our portrait. There is no trace of Leonardo's influence; it is too primitive for Ambrogio de' Predis. Sir Herbert Cook's suggestion

(*Burlington Magazine*, 1904, *loc. cit.*) that the artist concerned was Bernardino Zenale (1436–1526), is to my mind the most worthy of consideration, though Cook, in my view, was wrong in condemning the Christ Church version as a copy.

The Christ Church and Uffizi portraits, or their immediate prototype, must be dated within the years 1490–97, that is if the jewellery here is really the present sent to Beatrice by Lodovico in August 1490. She was then fifteen years old; one would hardly suppose her less in our painting; and if this is not the betrothal portrait (and in fact when the betrothal took place she was only four years old), it may as well have been painted after her marriage. When she died in 1497 she was not yet twenty-two.

As to the relative merits of the two versions, my impression is that the better preserved parts of the Christ Church picture (the jewels, hair and dress) reveal a rather better hand than that now in the Uffizi, but that the latter is in much better condition in the flesh parts. Dottoressa Luisa Becherucci, Director of the Uffizi Gallery, to whom I am indebted for a photograph, was good enough to tell me that she agrees with this opinion; also that the attribution of the Uffizi version to Araldi, and its identification as the portrait of Barbara Pallavicini, have no other authority than the surmise of Corrado Ricci.

Literature: L. & E., III, 30; E.C., II, 60 (as 'Vettori Carpacio'); 'A' Cat., 1776, p. 2 (as Carpaccio); 1833 Cat., no 21 (as 'Pietro della Vite'); Borenius Cat., 1916, no. 181 and pl. XL (as a copy of the painting in Florence).
A. Venturi, *La Galleria Crespi*, 1900, p. 256 (as the original of the Pitti picture); H. F. Cook, in *Burlington Magazine*, vol. V, 1904, p. 200 (note 10) (as a copy of the Pitti picture).

LUDOVICO MAZZOLINO
c. 1478–*c.* 1528

School of Ferrara. His earliest recorded works are of the first decade of the XVI century; they are mostly small and highly finished, often repeating the same subject, and very individual in style. Many are in the Borghese and Capitoline Galleries in Rome.

157. THE TRIBUTE MONEY. Canvas, 30 × 20·5 cm. (the painted surface arched above). Plate 115

Nosworthy Bequest, 1966. From the collections of the Marquis of Exeter; Dr. Ludwig Mond; Sir Robert Mond (bought by Colnaghi from Mr. Basil Austin, his grandson). Sold by Colnaghi to Sir Richard Nosworthy, 1957.

Richter draws attention to the fact that Alfonso I d'Este, Duke of Ferrara, used the text illustrated in this beautiful little painting ('Render unto Caesar . . ., etc.') as a Latin inscription on his coinage; and that Titian's painting of the same subject, now at Dresden, was commissioned by him.

1. Quoted in Malaguzzi-Valeri, *op. cit.*, I, p. 37.
2. According to Malaguzzi-Valeri, *op. cit.*, III, p. 28, this (and the re-naming of the sitter) was due to Corrado Ricci.
3. Mentioned by Malaguzzi-Valeri, *op. cit.*, III, p. 28. I cannot find his authority.

The *Christ and the Woman taken in Adultery*, which came from the Aldobrandini Collection to the Borghese Gallery in Rome (Paola della Pergola, Cat., I, 1956, no. 91) is so similar in general scheme of composition, and so nearly of the same dimensions (29 × 17 cm.), that it might be considered a companion-piece to ours. The Borghese picture, however, is painted on panel.

Literature: J. P. Richter, *The Mond Collection*, 1910, II, p. 556.

COPY (?) OF BENVENUTO TISI, CALLED IL GAROFALO
1481–1559

Benvenuto Tisi, called Il Garofalo, one of the leading artists of Ferrara, perhaps a pupil of Boccaccio Boccaccino in Cremona. Influenced by Raphael. Many of his pictures, highly finished and very characteristic in colour, are in the public collections of Rome, and he is well represented in the National Gallery in London.

158. ST. CATHERINE. Panel, 53·8 × 39·3 cm. Figure 32

Guise Bequest, 1765.

Why the attribution to Garofalo, recorded in the earliest lists (see below), was entirely abandoned in all subsequent catalogues, including that of Borenius, is difficult to understand, for it seems certain that the picture is either by or after that master, though it could no longer be described as a 'well preserved performance'. Its condition, which involved a good deal of retouching, particularly in the flesh parts, after cleaning by J. C. Deliss in 1964, makes it difficult to judge, but I am inclined to think that the picture is an old copy of a lost original by Garofalo. It has a certain charm, for instance in the landscape and the distant scene of St. Catherine's martyrdom, and in the colour generally. The clumsiness in the form of the R. hand is partly due to damage and restoration.

Literature: L. & E., III, 24; E.C., II, 55 ('St. Catharine, a foot and a half high. A celebrated and well preserved performance by Benvenuto da Garofalo'); 'A' Cat., 1776, p. 4 (as Salviati); 1833 Cat., no. 177 (the same); Borenius Cat., 1916, no. 252 (as Italian School, XVI century).

COPY OF CORREGGIO

Antonio Allegri, called Correggio from his birthplace in the Emilia, *c.* 1494–1534. Probably a pupil of Francesco Bianchi Ferrari, influenced in his youth by the work of Mantegna, and also Leonardo da Vinci. The evident influence of Michelangelo's Sistine ceiling suggests the pos-

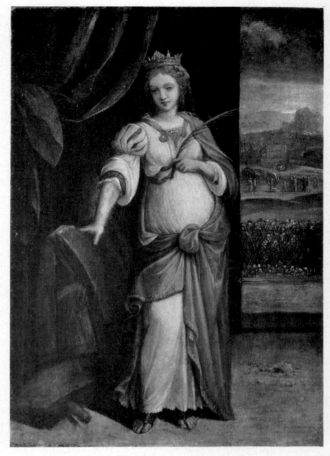

Fig. 32. Copy (?) of Garofalo: *St. Catherine* (Cat. No. 158)

sibility that Correggio visited Rome, otherwise he worked chiefly in Correggio and Parma. One of the most admired masters of the High Renaissance. His decorative schemes in the cupolas of S. Giovanni Evangelista and of the Cathedral at Parma anticipated the Baroque of the XVII century. An important drawing by him is in the Guise Collection at Christ Church.

159. THE VIRGIN AND CHILD, with a white Rabbit, an Angel above. Canvas, 57 × 46·1 cm.

Guise Bequest, 1765.

As the 1833 Cat. already noted, this is a copy of the well-known Madonna of Correggio called *La Zingarella* in the Naples Gallery. It is damaged and restored.

Literature: 1833 Cat., no. 93; Borenius Cat., 1916, no. 112.

COPY OF CORREGGIO

160. THE NATIVITY. Canvas, 98·5 × 74 cm.

Guise Bequest, 1765.

This good copy of the famous Correggio known as '*La Notte*', now in the Dresden Gallery, is attributed in all the

earlier lists and catalogues to Carlo Cignani of Bologna (1628–1719). It is in good condition.

Literature: L. & E., III, 32; E.C., II, 62; 'A' Cat., 1776, p. 6; 1833 Cat., no. 97; Borenius Cat., 1916, no. 113.

COPY OF CORREGGIO

161. THE VIRGIN. Canvas, 43·1 × 27 cm.

See note to no. 163.

COPY OF CORREGGIO

162. THE INFANT CHRIST. Canvas, 42·6 × 26·7 cm.

See note to no. 163.

COPY OF CORREGGIO

163. ST JOSEPH. Canvas, 42·2 × 26·7 cm.

Nos. 161–163 all Guise Bequest, 1765.

All three are fragments of a full-size copy of Correggio's *Madonna della Scodella*, the original of which is in the Parma Gallery (no. 350).

Literature: 'A' Cat., 1776, p. 6; 1833 Cat., nos. 94, 95, 96 (as by Annibale Carracci after Correggio); Borenius Cat., 1916, nos. 114, 115, 116.

IMITATOR OF CORREGGIO

164. HERCULES INTRODUCED TO OLYMPUS. Grisaille sketch on panel (oak, according to Borenius), 29·6 × 22 cm. Figure 33

In spite of an attempt by F. Bologna (*loc. cit.*) to re-establish this spirited little sketch as a study for a ceiling by Correggio himself, the attribution can hardly be maintained. An oil-sketch of this kind by the master would be most unusual, and a mannerist tendency is evident in the style. Mr. A. E. Popham has suggested that it may be by some Northern imitator, such as Bartolomeus Spranger, who in fact worked with Bernardino Gatti on the frescoes of the Steccata at Parma early in 1566, and was no doubt impressed by Correggio's example. Tonino Ferrari (*loc. cit.*) also discounts the attribution to Correggio himself, and is inclined to support Popham's suggestion that the painting may be by Spranger.

On the other hand it may be noted that among the thirteen paintings listed by H. W. Singer (*Mittheilungen der Gesellschaft für vervielfältigende Kunst*, 1901, p. 6), which are stated by contemporary authority to be by Jakob Chris-

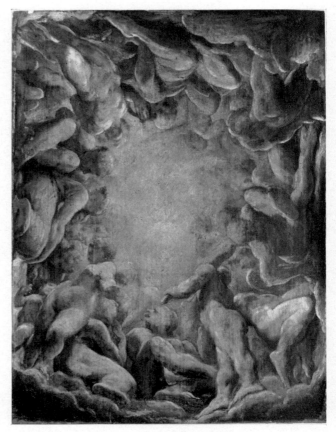

Fig. 33. Imitator of Correggio:
Hercules introduced to Olympus (Cat. No. 164)

toffel Le Blon, is a 'Hercules received by the Gods, a small oil painting' (Gool, *De Nieuwe Schouberg*, The Hague, pt. 1, p. 344); and in view of Le Blon's close connexion with General Guise, as well as the comparative rarity of the subject, the small size, and the fact that it is painted upon oak, it seems at least possible that this is the painting referred to (see *Excursus*, p. 25).

Exhibited: Manchester, 1965, no. 75.

Literature: L. & E., III, 24; E.C., II, 54 (as Correggio); 1833 Cat., no. 47 (as after Correggio); Borenius Cat., 1916, no. 109 (as an imitation of Correggio).

F. Bologna, *Paragone*, 1957, no. 91, pp. 19–21 and figs. 9–11; *Arte antica e moderna*, 1958, III, 305; Tonino Ferrari, *Parma per l'Arte*, 1965, XV, iii, pp. 196–198 (repr.).

COPY OF PARMIGIANINO

Girolamo Francesco Maria Mazzola, called Il Parmigianino, 1503–1540, perhaps the greatest of the Italian Mannerists, whose style was enormously influential, not only in the local school, but also among Venetian painters of the XVI century (Bassano, Tintoretto, Schiavone), and in France in the schools of Fontainebleau. Some of his exquisite small figure-drawings are in the Guise Collection at Christ Church.

165. THE VIRGIN AND CHILD with St. Jerome, the Magdalen and the Infant St. John. Panel, 75 × 59 cm.

Guise Bequest, 1765. According to a note given to me by Mr. Frank Simpson, this may be the picture bought by the General at the Henry Furnese Sale, Feb. 4, 1758, lot 42 ('A Holy Family, Permeggiano').

An early and fairly good copy, though much restored in parts, of Parmigianino's picture in the Uffizi (no. 1006).

Literature: L. & E., III, 31; E.C., II, 62; 'A' Cat., 1776, p. 11 (Parmigiano); 1833 Cat., no. 91 (the same); Borenius Cat., 1916, no. 123 (copy of P.).

ATTRIBUTED TO
NICCOLÒ DELL' ABBATE
1509/12–1571

Born in Modena; Bologna, 1547; removed to France, *c.* 1551; Fontainebleau, assistant to Primaticcio. Much influenced by the work of Correggio and Parmigianino.

166. A CONCERT: three Ladies singing from a Book of Music, a Gentleman on the L. Panel, 109·3 × 111·7 cm.

Figure 34

Guise Bequest, 1765.

The style is that of Niccolò dell' Abbate's fresco decorations on the façade of the Beccherie at Modena, and in one of the rooms of the Rocca dei Boiardo at Scandiano – both series now transferred to canvas and in the Modena Gallery (Pallucchini Cat., 1945, pp. 47–60). The latter series consists of half-length figures of men and women playing various musical instruments. There are drawings in the British Museum, one of them from the Fenwick Collection (Popham Cat., 1935, p. 23 and pl. xx), which also show considerable resemblances to our picture. These works of Niccolò are of relatively early date, at least twenty years earlier than the *Venus*, no. 167 of the present catalogue, which may have been painted in France during the last decade of the artist's life.

The Christ Church panel is very roughly painted; it may have been part of the decoration of a high room and intended to be seen from a distance. The heads are over life-size; that of the man is surely a portrait, bearing in fact a considerable resemblance to the self-portrait of Primaticcio in the Louvre. The whole is, however, in very bad condition, and extensive restoration was necessary after the panel was flattened and mended, and the painting cleaned, by J. C. Deliss in 1965.

For the frescoes formerly in the Palace of Scandiano, see W. Bombe in *Bollettino d' Arte*, 1931, p. 529 *ss.* A long study of the artist's activity in Bologna by H. Bodmer was published in *Commune di Bologna*, 1934.

Literature: L. & E., III, 25; E.C., II, 56 (as Titian); 'A' Cat.,

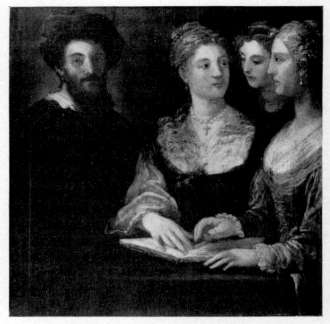

Fig. 34. Attributed to Niccolò dell' Abbate: *A Concert* (Cat. No. 166)

1776, p. 3 (as Venetian School); 1833 Cat., no. 30 (as Titian); Borenius Cat., 1916, no. 233 (as Venetian School, second half of XVI century).

ATTRIBUTED TO
NICCOLÒ DELL' ABBATE

167. VENUS SEATED, HOLDING A GOLDEN APPLE, with two Doves. Panel, 112 × 70 cm.

Plate 124

Guise Bequest, 1765.

Inscribed on the apple: DATELE A LE PIU BELLA [*sic*].

The picture is not included in Borenius' catalogue, though a number (110) was allotted to it. It remained in store until June 1965, when it was partly cleaned by Miss Jacqueline Pouncey. It then became apparent that it is a mannerist picture of considerable charm and good quality; and in spite of damage from flaking blisters above and below the R. hand and under the L. armpit, and serious abrasions in the face and neck, the general condition is by no means bad.

The style and quality seem close enough to those of Niccolò dell' Abbate in his later manner, when he was in the service of the French Court, to justify an attribution to him. Compare especially the heads and headdresses, and the form of the hands, in Niccolò's *Finding of Moses* in the Louvre, datable *c.* 1560 (Briganti, *La Maniera Italiana*, 1961, pl. 43). The method of modelling the flesh in delicate white hatching (still visible here in the better preserved parts, *e.g.* at the throat of Venus) is very characteristic of the best of Niccolò's drawings.

The cleaning was completed, the panel re-backed and necessary restoration made by J. C. Deliss in 1966.

Literature: Possibly 'A' Cat., 1776, p. 10 ('A Venus, by Bronzino'); not in 1833 Cat., unless it is no. 295, unattributed, 'A Figure representing Ceres'.

JACOPO BERTOIA
1544–74

Employed by the Farnese family at Parma, in Rome and at Caprarola from 1568 until his early death. After Parmigianino, by whose work he was profoundly influenced, Bertoia is the most charming of the North Italian mannerists.

168. MARS. Hexagonal panel, 71 × 32·7 cm. Plate 116

Guise Bequest, 1765.

A seal on the back of the panel can be identified as that of Ranuccio Farnese II, Duke of Parma 1646–94. All four panels (nos. 168–171) have this seal, also the number 6 in the same sealing-wax.

This and the three companion-pieces were evidently painted for a decorative purpose, and in spite of some damages, and some repainting in the red backgrounds, are of high quality. The attribution to Jacopo Bertoia, suggested to me by Mr. A. E. Popham, is obviously the right one. For the youthful figure of Mars *cf.* the *Mars and Venus at the Forge of Vulcan* in the Parma Gallery (A. G. Quintavalle, *Il Bertoia*, 1963, pl. XLIb), and the warriors and cavaliers of the *Sala del Bacio* in the Palazzo del Giardino at Parma (*ibid.*, pls. XXVIII–XXXIX).[1]

I cannot identify these panels in the Farnese inventories of 1680 or 1708,[2] but the seal, with the name *Ranutius Far. Princ.* surrounding the Farnese arms, makes it certain that they came from that famous collection; and in the list of lost pictures by Bertoia extracted by Dottoressa Quintavalle from the inventory of 1708 (*op. cit.*, p. 57) there appear several pictures of very similar description: *e.g.* a set of four with *Hercules, Apollo and Daphne, Bacchus* and *Mars and Venus*, 'con cornice dorata, con quattro angoli intagliati e dorati'. These, however, were oblong in shape. The description of their frames makes it almost certain that the frames on our four pictures are original, and of the same pattern.

Exhibited: Liverpool, 1964, no. 1.

Literature: 'A' Cat., 1776, pp. 1, 3; 1833 Cat., nos. 85–89

1. Dr F. Bologna attributed two of the Christ Church panels, nos. 168 and 170 (without reference to the other two) to Perino del Vaga, by comparison with a *Nativity* formerly at Wilton House (*Paragone*, 1956, no. 73, pls. 6 and 7). The relationship is undeniable, but the Wilton House picture is surely also by Bertoia, as Mr. P. M. Pouncey has already pointed out.

2. Carboni, *Cataloghi ed inventari inediti*, 1870.

(as Parmigianino); Borenius Cat., 1916, no. 118 (as School of Parmigianino).

JACOPO BERTOIA

169. HERCULES. Hexagonal panel, 70·5 × 32·6 cm.
 Plate 117

Guise Bequest, 1765.

See note to no. 168.

For the type and dress of Hercules, *cf.* the figure of a General in the historical frescoes at Castello S. Secondo (Quintavalle, *op. cit.*, pl. XXVIIa).

Exhibited: Liverpool, 1964, no. 2.

Literature: as for no. 168; Borenius Cat., 1916, no. 119.

JACOPO BERTOIA

170. BACCHUS, WITH A BABY SATYR. Hexagonal panel, 70·6 × 33 cm. Plate 118

Guise Bequest, 1765.

See note to no. 168.

Exhibited: Liverpool, 1964, no. 3.

Literature: as for no. 168; Borenius Cat., 1916, no. 120.

JACOPO BERTOIA

171. A BEARDED GOD (Jupiter?). Hexagonal panel, 71 × 32·5 cm. Plate 119

Guise Bequest, 1765.

See note to no. 168.

Exhibited: Liverpool, 1964, no. 4.

Literature: as for no. 168; Borenius Cat., 1916, no. 121.

GIULIO CESARE AMIDANO
1566–1630

Of the school of Parma, sometimes very close in style to the Modenese Schedoni, who was a few years his junior but may have exercised some influence upon him.

172. THE ENTOMBMENT OF CHRIST. Canvas, 41·7 × 31·3 cm. Plate 122

Guise Bequest, 1765.

This is a reduced version of a painting acquired by the Parma Gallery in 1919, measuring 136 × 99 cm. (Quintavalle Cat., 1939, p. 62, no. 1120). The correspondence is

exact, but the Christ Church painting seems not inferior to the larger one in quality, and may well be from the artist's own hand.

It was cleaned by Miss Jacqueline Pouncey in 1965, and is in fair condition.

Literature: 'A' Cat., 1776, p. 2 (without attribution); 1833 Cat., no. 98 (as Correggio); Borenius Cat., 1916, no. 108 (as Imitator of Correggio).

BARTOLOMEO SCHEDONI
c. 1570–1615

Born near Modena, but worked chiefly in Parma, in the service of the Duke (from 1597), and died there. Much influenced by the work of Correggio, and later by the Carracci. His best pictures came with the Farnese Collections to Naples, and are now in the Naples Gallery.

173. THE HOLY FAMILY. Panel, 75 × 55·2 cm.

Plate 121

Guise Bequest, 1765.

A good and characteristic example, in fair condition, apart from a vertical crack (running the whole length of the panel through the face of the Virgin, just to L. of her nose, and through the edge of the L. hand and the R. wrist of the Child), from which paint had broken away.
Cleaned by J. C. Deliss, 1966.

Literature: 'A' Cat., 1776, p. 2; 1833 Cat., no. 283; Borenius Cat., 1916, no. 127.

FORMERLY ATTRIBUTED TO BARTOLOMEO SCHEDONI

174. THE HOLY FAMILY WITH ST. CATHERINE. Panel, 22·8 × 19·7 cm.

Plate 120

Guise Bequest, 1765.

Though rather hard in drawing and in chiaroscuro, the picture has quality, and seems to be original. The types of the Virgin and Child, however, are not characteristic of Schedoni himself, and Dr. G. Briganti has suggested that this may be an early work by Sisto Badalocchio (1581–1647), who was born in Parma and became one of Annibale Carracci's favourite pupils in Rome 1606–9. It is less developed, less *Seicento* in style, than Badalocchio's more familiar work, but the head of St. Joseph, particularly, is in his manner.
Cleaned by J. C. Deliss, 1964. There is hardly any restoration.

Literature: L. & E., III, 29; E.C., II, 59; 'A' Cat., p. 9; 1833 Cat., no. 284; Borenius Cat., 1916, no. 126 (always as Schedoni).

SCHOOL OF PARMA (?), MID XVI CENTURY

175. THE LAMENTATION, BY TORCHLIGHT. Panel (oak), 106·9 × 76 cm.

Plate 123

Guise Bequest, 1765.

Another version of this picture, apparently somewhat inferior to ours in quality but closely corresponding, was sold at Sotheby's, Nov. 16 1966, lot 138 (104 × 73·5 cm.), attributed to Andrea Schiavone. Mr. Philip Pouncey is inclined to favour this attribution for the Christ Church picture, which was formerly attributed to Schedoni. It seems to me to lack Schiavone's characteristic mannerism, the drooping, tapering forms, the graceful linear rhythms, and the Titianesque types.[1] There is indeed something Venetian in the figure of the angel supporting Christ; but the head of the Virgin, and the *chiaroscuro*, are more suggestive of the influence of Correggio.

The painting is by a good hand, and the condition is tolerably good. It was cleaned by J. C. Deliss in 1966.

Literature: 'A' Cat., 1776, p. 9; 1833 Cat., no. 285 (in both as Schedoni); Borenius Cat., 1916, no. 128 (as Schedoni?).

SCHOOL OF PARMA, LATER XVI CENTURY

176. THE VIRGIN AND CHILD. Canvas, laid on panel, 46·8 × 34·7 cm.

Figure 35

Probably Guise Bequest, 1765.

Mr. A. E. Popham has pointed out to me that this composition was engraved at least three times as by Correggio; one of the prints (in reverse), closely corresponding, but showing a landscape background through an arch behind, being by N. Edelinck; another, in outline only, also in reverse, by Normand fils (with inscription in French, perhaps *c.* 1840). The Christ Church picture is nearer in date to Schedoni, but can hardly be by him.
Lightly cleaned and restored by L. Freeman in 1963.

Literature: Borenius Cat., 1916, no. 261 (as Italian School, XVII century).

GIULIO CESARE PROCACCINI
c. 1570–1625

One of a family of artists of Bolognese origin, which removed to Milan, where Giulio Cesare died. Son of Ercole Procaccini the elder, brother of Camillo and Carl-

1. Contrast Schiavone's picture of the same subject formerly in the Donà delle Rose Collection (Berenson, Venetian Lists, pl. 1163).

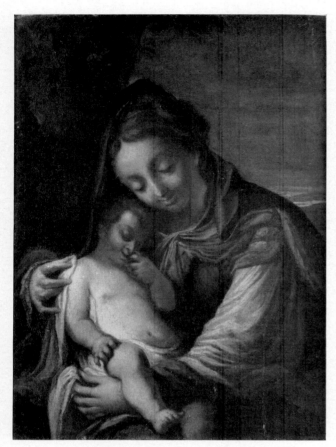

Fig. 35. School of Parma, later XVI century:
The Virgin and Child (Cat. No. 176)

antonio, and uncle of Ercole the younger. Worked as a
sculptor before turning chiefly to painting *c.* 1600.

177. SUSANNA AND THE ELDERS. Canvas, 200 × 125·5
cm. (after removal of additional strips). Plate 125
Guise Bequest, 1765.

Borenius rightly doubted the old attribution to Agostino
Carracci; the picture is clearly by G. C. Procaccini, and
an important work, probably fairly early in date. It is not
far removed in style from the large painting of *The
Emperor Constantine receiving the Instruments of the Passion*,
which was commissioned to decorate the Cappella del
Broletto in Milan in 1605.[1] A small canvas of the same
subject by the same artist, related in style but of different
composition, is in the Bergamo Gallery (Carrara Collec-
tion, no. 250).

Strips had been added on all sides, but these were removed
(not quite completely at R. and L.) when the picture was
cleaned by J. C. Deliss in 1962.

Literature: L. & E., III, 27; E.C. II, 58 (as Agostino Car-
racci); 'A' Cat., 1776, p. 6 or p. 12 (no attribution, *cf.* no.
203 of this catalogue); 1833 Cat., no. 276 (as Agostino
Carracci); Borenius Cat., 1916, no. 133 (as Agostino Car-
racci, attributed to).

1. Now Castello Sforzesco; repr. N. Pevsner in *Rivista d' Arte*, vol.
XI, 1929, p. 325.

LUDOVICO CARRACCI (?)
1555–1619

Ludovico was the eldest of the three Carracci who founded
a teaching Academy in Bologna in the 1580's, but outlived
both his cousins, Agostino and Annibale; after their
departure to Rome, he remained head of the Bologna
School.

178. THE SUPPER AT EMMAUS. Canvas, 144 × 177·5 cm.
Plate 127

Guise Bequest, 1765.

Much damaged and restored throughout. The heads are
over life-size, and coarsely painted, but that of the disciple
on the L. is better preserved, and seems close to Ludovico
Carracci in style. The gigantic proportions are also
characteristic. Dr. Giuliano Briganti is inclined to accept
the old attribution, with due allowance for the condition
of the picture. A picture of the same subject attributed to
Ludovico, but of quite different composition and upright
in shape, is in the Provinzialmuseum at Hanover (no. 61).

Literature: L. & E., III, 21; E.C. II, 52; 'A' Cat., 1776, p. 10;
1833 Cat., no. 257 (always as Lodovico Carracci); Borenius
Cat., 1916, no. 131 (as attributed to Lodovico Carracci).

ATTRIBUTED TO
LUDOVICO CARRACCI

179. THE DEAD CHRIST. Canvas, 76·1 × 104 cm.

Guise Bequest, 1765.

The picture must originally have shown the body of Christ
lying on a flat surface, in sharp foreshortening, as in the
picture in the Spada Gallery, Rome, formerly attributed to
Annibale Carracci but engraved as by Orazio Borgianni
(Voss, *Malerei des Barock in Rom*, 124; F. Zeri, Cat. of the
Spada Gallery, p. 44, no. 286).
In the Christ Church picture the figure is seen at an angle,
and no attendant figures are visible. But the condition
is such, that the painting is impossible to judge, and
apparently worthless.

Literature: L. & E., III, 20; E.C., II, 51; 'A' Cat., 1776, p. 3;
1833 Cat., no. 261 (always as Lodovico Carracci); Borenius
Cat., 1916, no. 132 (as attributed to Lodovico Carracci).

ANNIBALE CARRACCI
1560–1609

Born in Bologna, died in Rome. At first the pupil of his
cousin Ludovico Carracci. Deeply influenced by Cor-
reggio's work in Parma, which he visited first in 1580.

From the mid 1580's until 1595, he was a partner, with Ludovico and with his own elder brother Agostino, in a flourishing studio at Bologna, with many pupils. In 1595 he was called by Cardinal Odoardo Farnese to Rome, where he painted his most celebrated works in fresco, the Camerino Farnese and the great Galleria of the Farnese Palace. Commonly described by earlier critics as the leader of the Eclectic School, because of the various influences – Correggio in Parma, the Venetians, Michelangelo and Raphael and the Antique in Rome – which contributed to his style, in contrast to the naturalism of Caravaggio. He was undoubtedly the most influential Italian master of his time. All the accepted pictures by him in the Christ Church Collection are of his pre-Roman period; the *Man Drinking* and the *Butcher's Shop* are among his earliest and most original.

180. A MAN DRINKING. Canvas, 75·5 × 64 cm.

Plate 126

Guise Bequest, 1765.

The catalogue of the Carracci Exhibition at Bologna, 1956, refers to this picture in connexion with one of the same subject, very similar in conception though different in composition and in much better state, in the collection of Dr. Robert Emmons, which was there exhibited as no. 50. The Emmons picture was identified by Mr. Denis Mahon as having been once in the Borghese Collection.

The Christ Church picture must surely once have been a very early original by Annibale, a rapidly painted *jeu d'esprit*, related in style and subject not only to the Emmons *Drinker*, and the *Smiling Youth* in the Villa Borghese (Carracci Exhibition, no. 54), but also to the much more ambitious *Butcher's Shop* at Christ Church (no. 181 below); but it had been spoilt by rough cleaning at an early date, and almost entirely repainted. The repaint was removed and the damage repaired by Thomas Lindsay in 1966. His restorations were chiefly confined to the face – eyes, nose, mouth and jaw, which he has reconstructed with great skill and care.

Literature: L. & E., III, 28; E.C., II, 58; 'A' Cat., 1776, p. 2; 1833 Cat., no. 260 (always as Annibale Carracci); Borenius Cat., 1916, no. 174 (as Neapolitan, XVII century).

ANNIBALE CARRACCI

181. THE BUTCHER'S SHOP. Canvas, 190 × 271 cm.

Plates 129–131

Guise Bequest, 1765; probably from the collections: Gonzaga, 1627; Charles I; and Countess of Bristol.

Probably identical with '*una beccaria opera del Caratio*' in the Gonzaga Inventory of 1627, and with 'an Italian bocher selling meate . . . £30' (Public Records Office, L.R. 124,

f. 117 *v*.) sold from Hampton Court in the Commonwealth sale of 1651. It would then be identical with 'A butcher in his shambles selling meat to a Swiss' seen by John Evelyn (Diary, Jan. 15, 1678/79) in the possession of the Dowager Countess of Bristol.[1] This would invalidate Dallaway's statement that the picture was acquired (for £1000 sterling) by General Guise in Naples, 'where it was removed with the Farnese Collection'. There is no trace of it in the Farnese Inventories of *c*. 1680 and 1708. A red chalk drawing for the man weighing meat is at Windsor, attributed by Wittkower (*loc. cit.*, 1952) to Agostino, but by Denis Mahon (Bologna Exhibition Catalogue, *Disegni*, no. 84) to Annibale. A small painting of the same subject, of different composition and with two figures only, belongs to Major David Gordon, and was exhibited at Newcastle in 1961, no. 196 (see *Burlington Magazine*, vol. 104, Jan. 1962, p. 26, fig. 30).

After many attempts in recent times to re-attribute this celebrated painting (to Bartolommeo Passerotti, to Ludovico or to Agostino Carracci), the general consensus of opinion, since the Bologna Exhibition of 1956, seems to favour the original attribution to Annibale at a very early date (Mr. Mahon thinks even before 1583), when he was strongly influenced by Bartolommeo Passerotti. It seems certain that Passerotti's paintings, such as *The Fish Market* (no. 80) and more particularly *The Butcher's Shop* (no. 81) in the Barberini Gallery in Rome, must to some extent have inspired Annibale here. On the other hand a painting of such a subject on so vast a scale must have seemed a very remarkable innovation in Italian art of that date.

Ludovico's father is known to have been a butcher, and the author of *London and its Environs* (before 1760) seems to be the first to record a story that the picture represents various members of the Carracci family – Annibale weighing the meat, Agostino leaning through the window to try a nail, Ludovico kneeling, *etc.* Dallaway (1800) adds that Annibale painted it 'to mortify the pride of Lodovico . . . who affected to conceal the meanness of his origin'. Mr. J. R. Martin, in the course of an admirable essay (*loc. cit.*) considers that there may be some foundation of fact in the tradition that family portraits are included in the picture, though he makes no final pronouncement on the individual identifications. The earlier writers differ as to these; indeed, the iconography of the various members of the Carracci family is by no means simple, and even if it were clearer, one man will see a likeness where another sees none. For my own part, I am convinced (in opposition to all previous suggestions) that the man kneeling in the centre foreground of the Christ Church picture is Annibale himself; the growth of the hair is very characteristic, and the features accord, to my mind, with the generally accepted self-portraits at Milan, in the Uffizi, and at Parma,[2] though all these are of progressively later date than our picture,

1. All these references are due to the 2nd ed. of the Royal Academy Catalogue, 1960.
2. Carracci Exhibition, Bologna, 1956, nos. 64, 75 and 83.

whereas the self-portrait drawing at Windsor,[1] also quite compatible, must be a year or two earlier. One other person represented in our painting is I think certainly recognizable in other works by Annibale: the sharp-featured youth with the protruding jaw, on the extreme right, hooking up a carcass of venison; he is surely the same that appears in profile in the Milan self-portrait, seated low down beside the master in an attentive attitude, and again in profile in a drawing belonging to the Duke of Sutherland (formerly Earl of Ellesmere), trying his own hand with the paintbrush.[2] This youth is, however, certainly not Antonio Carracci, Agostino's illegitimate son, as Dallaway says, since he was born only in 1583, or according to other sources, in 1589;[3] nor can it be the so-called Gobbo dei Carracci, Pietro Paolo Bonzi, as stated in *London and its Environs*, since his birth-date is *c.* 1575, and he would have been no more than about seven or eight years old when the Christ Church picture was painted. Perhaps he might be Paolo, the younger brother of Ludovico (as Martin suggests), or else Giovanni Antonio, younger brother of Agostino and Annibale. As to the others, I suspect that the man weighing meat is Agostino, by reference to the Uffizi portrait;[4] for though that is clearly of later date, and the beard and moustaches are fuller and differently cut, the growth of the hair, thick and dark and lower at the temples than Annibale's, is again very characteristic. So far as I know, no authenticated portrait of Ludovico has survived, but by a process of elimination he would then be identified as the figure behind the counter, 'trying a nail'.

Mr. Martin also rightly draws attention to the relationship between the Christ Church painting and the engraving *Straordinario della Carne*, one of the series *Le Arti di Bologna*, by Guillain after Annibale's drawings. His theory that the picture is a composite derivation from Michelangelo's *Sacrifice of Noah* on the Sistine ceiling, and Raphael's fresco of the same subject in the Vatican *Loggie*, may at first seem far-fetched, but on closer examination gains probability. Annibale cannot of course at the time have seen either work, but may have used engravings and drawn copies.

The picture was superficially cleaned for the Bologna Exhibition, 1956; then strip-lined and wax-ironed in spring 1961, and on that occasion more judiciously cleaned by J. C. Deliss. The condition is by no means bad; there is some 'darning' in places to repair loss of paint, owing to the very coarse texture of the canvas, especially along the joins in the canvas (two horizontal and one vertical, at the L. edge).

1. Wittkower, Cat., 1952, pl. 43.
2. Carracci Exhibition, Newcastle-upon-Tyne, 1961, cat. no. 72 and pl. XVII; Tomory, Cat. of Leicester Exhibition, 1954, no. 86.
3. Another drawing in the Sutherland (Ellesmere) Collection (Tomory, cat. no. 31 and pl. x), inscribed as a portrait of Antonio by his father Agostino, is certainly not of the youth of our painting.
4. Goldscheider, *Fünfhundert Selbstporträts*, Phaidon, 1936, pl. 153.

Exhibited: Manchester, 1857, no. 342; Royal Academy, 1950/51, *Holbein and other Masters*, no. 309 (as Bolognese School); Bologna, 1956, *Mostra dei Carracci*, no. 49 (as Annibale, *c.* 1585); Royal Academy, 1960, *Italian Art and Britain*, no. 43 (as Annibale); Kings College, Newcastle-upon-Tyne, Nov. 1961, no. 197; Liverpool, 1964, no. 8.

Literature: 'A' Cat., p. 12; 1833 Cat., no. 259; Borenius, 1916, no. 136 and pl. XXXV (always as Annibale). Dallaway, *Anecdotes*, 1800, p. 483 *ss.*; Waagen, *Treasures of Art in Great Britain*, 1854–57, III, p. 47; H. Bodmer, *Belvedere*, XIII, 1938, p. 69 (as Passerotti); R. Wittkower, *Carracci Drawings at Windsor*, 1952, p. 111, no. 93 (as Agostino); G. C. Cavalli, Catalogue of Carracci Exhibition, Bologna, 1956, no. 49; D. Mahon, Bologna Catalogue, *Disegni*, 1956, 2nd ed., 1963, pp. 70–71, no. 84 (as Annibale); M. Jaffé, *Burlington Magazine*, vol. 98, Nov. 1956; D. Mahon, *Gazette des Beaux-Arts*, May–June 1957, pp. 267–268; R. Wittkower, *Art and Architecture in Italy, 1600–1750* (Pelican History of Art), 1958, p. 40; E. K. Waterhouse, *Italian Baroque Painting*, 1962, p. 85 and fig. 75; J. R. Martin, *Art Bulletin*, XLV, 1963, pp. 263 *ss.*

ANNIBALE CARRACCI

182. PORTRAIT OF GIACOMO FILIPPO TURRINI. Canvas, 85·8 × 66·8 cm. Plate 128
Inscribed upper L.: *Iacobus Philippus Turrinus aetatis suae anno LI.*

Guise Bequest, 1765.

The portrait was first identified in the catalogue of the Bologna Exhibition, 1956, as the one described by Malvasia (1678) in the house of the Turrini family, and as the work of Annibale. Giacomo Filippo Turrini, a banker of Bologna, died in 1606 at the age of seventy-two; since his age is recorded as fifty-one in the inscription on this portrait, it must therefore have been painted in 1585, when Annibale Carracci was twenty-five. Malvasia describes it as '*un ritratto . . . d' uno di quella casa, sul primo buon gusto, che assolutamente è di viva carne*'.

The picture is much damaged, but was cleaned and skilfully restored by Horace Buttery in June 1956, before the Bologna Exhibition.

Exhibited: Magnasco Society, London, 1925, no. 15 (as Ludovico); *Mostra dei Carracci*, Bologna, 1956, no. 55 (as Annibale); Liverpool, 1964, no. 10; Manchester, 1965, *European Art 1520–1600*, no. 60.

Literature: L. & E., III, 35; E.C., II, 65 (both as Ludovico Carracci); 'A' Cat., 1776, p. 10 (no attribution); 1833 Cat., no. 224 (as 'Spagnuoletto'); Borenius Cat., 1916, no. 130 (as Ludovico).
C. C. Malvasia, *Felsina pittrice*, Bologna, 1678, ed. 1841, p. 357; G. C. Cavalli, Catalogue of the Bologna Exhibition, 1956, no. 55.

ANNIBALE CARRACCI

183. THE VIRGIN AND CHILD IN THE CLOUDS, with a view of Bologna. Canvas, 150·5 × 109·5 cm. Plate 134

Guise Bequest, 1765; from the Caprara family, and the collection of Sir James Thornhill.

The picture is recorded by Bellori (1672) as having been painted for the chapel of the Palazzo Caprara at Bologna. It next appears in the sale catalogue of Sir James Thornhill's Collection, Feb. 24–25, 1734/35 (Lot 97, first day), when it was bought for General Guise for 51 guineas. Dallaway (1800) says that it was brought from France by Thornhill, 'at whose sale it was purchased, but has since suffered much from cleaning'. The painting is in fact badly damaged, but was restored by H. Buttery for the Bologna Exhibition in 1956. It is dated by Cavalli and by Mahon c. 1593–94. Four drawings for this composition were exhibited at Bologna in 1956, two from Chatsworth and two from the Albertina (Bologna Catalogue, *Disegni*, nos. 98–101, and pl. 52). Of these one of the Albertina drawings (100) and one at Chatsworth (101) are nearest to the painting.

Exhibited: Bologna, *Mostra dei Carracci*, 1956, no. 74; Liverpool, 1964, no. 9.

Literature: 'A' Cat., p. 9; 1833 Cat., no. 258; Borenius Cat., 1916, no. 134 (always as Annibale Carracci).

Bellori, *Vite de 'pittori*, Rome, 1672, p. 27; Dallaway, *Anec-* *dotes of the Arts in England*, 1800, p. 491; Borenius, *Sir James Thornhill's Collection, Burlington Magazine*, vol. 82, 1943, p. 133; G. C. Cavalli, Catalogue of Carracci Exhibition, Bologna, 1956, no. 74; D. Mahon, Catalogue of Carracci Exhibition, Bologna, 1956, *Disegni*, nos. 98–101.

ANNIBALE CARRACCI (?)

184. ST. FRANCIS IN A SWOON, SUPPORTED BY ANGELS. Panel, 48·5 × 35 cm. Figure 36

Guise Bequest, 1765.

This is not a companion to no. 185, as stated by Borenius, though it is similar in size and scale. At least two other versions of our composition exist: (1) Graves Art Gallery, Sheffield (exh. R.A. *'Primitives to Picasso'*, 1962, cat. no. 87); (2) Dresden Gallery, no. 315, attributed (cat. 1929) to Schedoni. The Sheffield picture (presented by Mrs. Carter in 1956) came from the Miles Collection at Leigh Court (Cat. Young, 1822, no. 33, attributed to Correggio); it is slightly smaller than ours, but may have been cut on the L. (across the R. hand of the angel above). Mr. Denis Mahon considers the Sheffield picture (Figure 37) much superior to that at Dresden, but prefers an attribution to Ludovico Carracci. Waagen (*Treasures of Art in Great Britain*, vol. III, 1854, p. 184) was the first to attribute the Sheffield

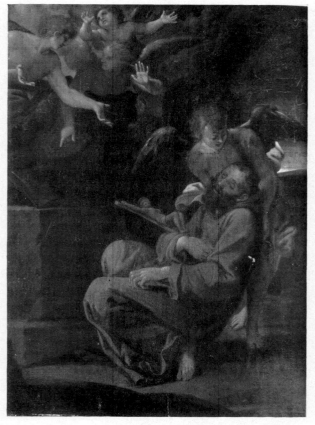

Fig. 36. Annibale Carracci (?): *St. Francis in a Swoon*
(Cat. No. 184)

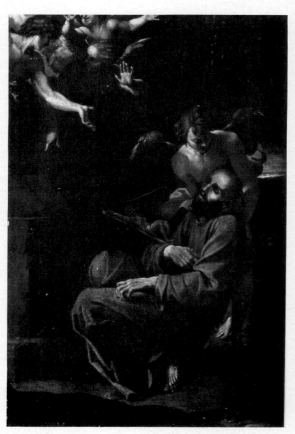

Fig. 37. Annibale Carracci (?): *St. Francis in a Swoon*.
Sheffield, Graves Art Gallery (*Cf.* Cat. No. 184)

picture to Annibale Carracci. The problem is confused by the fact that the Miles Collection contained yet another version of the same composition (Young no. 31, said to be a copy of Correggio by Agostino Carracci).

The Christ Church picture, in spite of its deplorable condition, shows traces of high quality, and in some respects – the head of St. Francis, the hands of the flying angels – seems superior to that at Sheffield. The head and the drapery of the Saint seem nearer in style to Annibale, at an early date, than to Ludovico; cf. *The Vision of St. Francis*, only slightly smaller, which belongs to Mr. Denis Mahon (R. A., *Italian Art and Great Britain*, 1960, cat. no. 399). If that picture were not on copper, it might have been the companion-piece to ours.

The surface of the Christ Church picture is badly rubbed, and the red ground shows in many places.

Literature: L. & E., III, 34; E.C., II, 64; 'A' Cat., 1776, p. 10; 1833 Cat., no. 262 (always as Annibale Carracci); Borenius Cat., 1916, no. 138 (as copy of Annibale Carracci).

COPY OF
ANNIBALE CARRACCI (?)

185. THE ENTOMBMENT OF CHRIST. Panel, 47·2 × 34·8 cm. Figure 38

Guise Bequest, 1765.

I know of at least five other versions of this composition, more or less exactly corresponding: (*a*) Cremona Gallery, Cat. A. Puerari, 1951, no. 195 and fig. 169 (panel, 40 × 30 cm.) (attributed to Sisto Badalocchio by Roberto Longhi); (*b*) Dulwich Gallery (small canvas) (attributed to Badalocchio by M. V. Brugnoli in *Bollettino d' Arte*, 1956, p. 359, fig. 4); (*c*) formerly in the Leuchtenberg Collection, Munich (copper, dimensions given as 16 × 13 ins.) (reproduced in outline etching, as by Annibale Carracci, in the Leuchtenberg publication of 1852); (*d*) formerly in the Ashburton Collection at Bath House, London (old photograph in British Museum); and (*e*) a red chalk drawing in the Hermitage, Leningrad (Cat. of Italian Drawings of the XVII and XVIII Centuries, 1961, no. 18 and pl. IV) (attributed to Badalocchio with reference to (*a*) and (*b*) above). Besides these, Mr. Michael Levey has kindly drawn my attention to a different, but related composition of the same subject of which versions exist in the National Gallery, London (no. 86, convincingly attributed by Mr. Levey to Badalocchio), in the Villa d'Este at Tivoli, and in the Palazzo Patrizi, Rome (Exh. *Pittura del '600 Emiliano*, Bologna, 1959, no. 122).

In two particulars the Christ Church picture is closer to (*a*) and (*b*) than to the others: (i) the head of the turbaned man on the R. is nearly upright, whereas in (*c*) and (*d*) it is inclined to the R. and looking down at the Magdalen; (ii) there is drapery over the L. forearm of Christ.

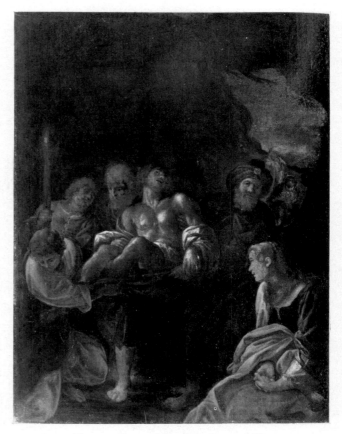

Fig. 38. Copy of Annibale Carracci (?): *The Entombment of Christ* (Cat. No. 185)

The condition of the Christ Church picture is so bad that it is impossible to decide whether it could once have been better than the Cremona or Dulwich versions, which it most closely resembles. The Cremona picture appears to be equally damaged. The Dulwich picture, though generally darker in tone, is in a much better state, and of good quality. Brugnoli's attribution of that to Badalocchio is plausible; but the fact that so many versions of the composition exist suggests that the prototype may have been by a more important artist; and our picture may be no more than an anonymous copy of a lost Annibale Carracci, which Sisto Badalocchio, his favourite pupil, repeated more than once.

Literature: L. & E., III, 34 and E.C., II, 64 (as Ludovico Carracci); 'A' Cat., 1776, p. 10 (as Agostino Carracci); 1833 Cat., no. 267 (no attribution); Borenius Cat., 1916, no. 137 (as copy after Annibale Carracci).

COPY OF ANNIBALE CARRACCI

186. THE HOLY FAMILY, WITH THE INFANT ST. JOHN. Canvas, 36 × 27·8 cm. Figure 39

Guise Bequest, 1765.

Borenius refers to two other versions, in the Hermitage at Leningrad (no. 170) and in the Uffizi (no. 1007), and there

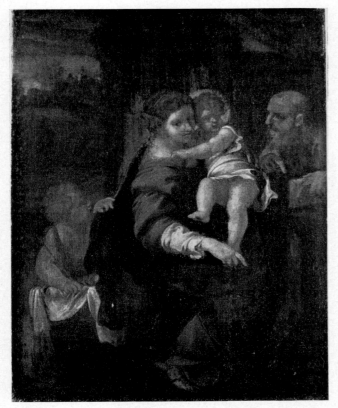

Fig. 39. Copy of Annibale Carracci: *The Holy Family*
(Cat. No. 186)

are various engravings of the same composition. Among the earlier engravings is one (in the same direction) by J. A. Stefanonius, dated 1632, and one (in reverse) by Cornelis Bloemaert from the version then belonging to the Cardinal Montalto.

The composition is certainly Annibale's, resembling, for example, the *Virgin and Child with the Infant St. John* of c. 1595, in the Pitti Gallery at Florence (Carracci Exh., Bologna, 1956, cat. no. 93). This was perhaps a cabinet-piece of considerable charm; but in its present damaged state the quality is impossible to judge.

Literature: L. & E., III, 23; E.C., II, 53; 'A' Cat., 1776, p. 13; 1833 Cat., no. 263 (always as Annibale Carracci); Borenius Cat., 1916, no. 139 (as copy after Annibale Carracci).

SCHOOL OF
ANNIBALE CARRACCI

187. LANDSCAPE WITH THE DEATH OF ST. PETER MARTYR. Canvas, 115·5 × 98·5 cm. Plates 132–133

Guise Bequest, 1765.

Professor Giuseppe Fiocco, reviewing Borenius' lately published catalogue half a century ago, suggested that this good picture might be by Pietro Testa (1611–50); but neither this nor any other attribution so far proposed is satisfactory, and it seems best to leave it for the present under Carracci's name. The figures are very well designed and painted, and are close to Annibale in style; the landscape, however, though it has considerable dramatic effect, is not like anything in Annibale's own work. It may be, as the early catalogues suggest (see below), that figures and landscape are by different hands. The landscape part is there attributed to 'Gobbo dei Carracci' – *i.e.* Pietro Paolo Bonzi (see below, no. 191), who is generally supposed to have started his career in the Carracci studio, chiefly as a painter of still life. Later he is said to have taken to land-scape-painting; but I know of no authenticated examples. It is, however, worth noting that the landscape in the *St. Peter Martyr* has features which immediately recall that in three other pictures in the Christ Church Collection, all un-doubtedly of the Carracci School: nos. 189 and 190, two small oblong landscapes formerly attributed to Mola, and no. 191, a much damaged *Landscape with St. John preaching*, again attributed to the mysterious 'Gobbo'. The tall poplar-trees in the middle-ground, the effect of fitful light in the distance, with clear blues and greens and sharp highlights in white, are characteristic of these as well as of the present picture.

Lightly cleaned by J. Hell, 1951, and again by J. C. Deliss, 1967. Sky and landscape are rubbed, and the red bolus ground shows through.

Exhibited: Liverpool, 1964, no. 39.

Literature: L. & E., III, 20; E.C. II, 50 ('The figures, by Agostino Carracci. The landscape, by Gobbo de Carracci'); 'A' Cat., 1776, p. 5 (as 'Gobbo de Carracci'); 1833 Cat., no. 203 ('Figures by Annibal Carracci. Landscape by Gobbo Carracci'); Borenius Cat., 1916, no. 135 and plate XXXIV (as Annibale); G. Fiocco, in *L' Arte*, XX, 1917, p. 361.

FOLLOWER OF
ANNIBALE CARRACCI

188. THE ASSUMPTION OF THE VIRGIN. Canvas, 32 × 24 cm.

Probably Guise Bequest, 1765.

This little picture has some relationship to Annibale Carracci's later altarpiece in Sta. Maria del Popolo in Rome; but the condition is such that no further opinion as to its authorship or quality could be more than speculative.

Literature: Borenius Cat., 1916, no. 274 (as Italian School, XVII century).[1]

1. The references to L. & E. and E.C., suggested by Borenius, must apply rather to Borenius no. 257, a small coloured drawing of the same subject on paper mounted on canvas, probably by the Floren-tine Giovanni de' Vecchi, which has now been mounted as a drawing and will be included in the appropriate catalogue.

FOLLOWER OF
ANNIBALE CARRACCI
c. 1630

189. LANDSCAPE WITH FIGURES BY THE BANK OF A RIVER. Canvas, 31·2 × 49·3 cm.

Guise Bequest, 1765.

What may have been a charming landscape, in the manner of Domenichino but fresher and lighter in colour, has been ruined by cleaning at an early date, and was extensively repainted with the addition of large trees to R. and L. Apparently a companion-piece to no. 190 below. See note to that picture.
Partly cleaned by J. C. Deliss in 1964, but not restored.

Literature: 1833 Cat., no. 273 or 275 (both landscapes by Mola); Borenius Cat., 1916, no. 165 (as attributed to Mola).

FOLLOWER OF
ANNIBALE CARRACCI
c. 1630

190. LANDSCAPE WITH A STAG-HUNT. Canvas, 32·8 × 49·2 cm. Plate 136

Guise Bequest, 1765.

Cleaned by J. C. Deliss in 1964, and in better state than the companion-piece, no. 189, though there is considerable damage in the dark foreground. The distant landscape is light and clear in colour, and in character resembles the landscape in the *Death of St. Peter Martyr* (no. 187), and the better preserved parts of no. 191 (attributed to 'Gobbo dei Carracci'). It seems improbable that nos. 189 and 190 are by Mola, but if there is any justification for the old attribution of no. 191 to the so-called 'Gobbo dei Carracci', this pair may be further examples of his style. In any case they show dependence on the landscape-style of Annibale Carracci.

Literature: 1833 Cat., no. 273 or 275; Borenius Cat., 1916, no. 166.

ATTRIBUTED TO
PIETRO PAOLO BONZI, CALLED
IL GOBBO DEI CARRACCI

Born at Cortona *c.* 1575, died in Rome between 1633 and 1644. Pupil of the Carracci, a landscape-painter, but particularly noted for his fruit- and flower-pieces.

191. LANDSCAPE WITH ST. JOHN BAPTIST PREACHING. Canvas, 53·2 × 69·8 cm.

Guise Bequest, 1765.

An original etching of this subject by Bonzi is described by Nagler, *Die Monogrammisten,* I, 2299.
The landscape, so far as it can be judged from its present condition, is close in style to that of nos. 189 and 190, with its effect of fitful light, clear blue and green and reddish brown, and whitish highlights painted with a small brush in the rounded tops of trees and bushes. See also the note to no. 187, the *Landscape with the Death of St. Peter Martyr.* When the picture was cleaned, however, by J. C. Deliss in 1964, it was found to be so badly damaged, particularly in the trees on the L., and the group of figures in the L. foreground, that restoration was abandoned.

Literature: L. & E., III, 32; E.C., II, 62; 'A' Cat., 1776, p. 9; 1833 Cat., no. 208; Borenius Cat., 1916, no. 140 (always as 'Gobbo dei Carracci').

GUIDO RENI (?)
1575–1642

Painter and etcher, and an accomplished musician, entered the studio of the Carracci in Bologna, *c.* 1595. In Rome 1600–3, and again from 1605. On his return to Bologna in 1622, after the death of Ludovico Carracci, he was the leading artist of the Bolognese School.

192. THE YOUNG ST. JOHN THE BAPTIST, bust length. Canvas, oval, 61·7 × 45 cm.

Guise Bequest, 1765.

This may have been a good early original by Guido, but is so damaged by flaking that it is practically worthless.

Literature: 'A' Cat., 1776, p. 9; 1833 Cat., no. 57 (in both as Guido Reni); Borenius Cat., 1916, no. 142 (as School of Reni).

COPY OF GUIDO RENI

193. A CHOIR OF ANGELS singing and playing Musical Instruments, with God the Father above. Canvas, 96 × 137·5 cm.

Guise Bequest, 1765.

A copy, perhaps nearly contemporary, but of indifferent quality, from the fresco by Guido Reni in the apse of the Cappella di S. Silvestro in S. Gregorio Magno, Rome.

Literature: L. & E., III, 34; E.C., II, 64 *ss.*; 'A' Cat., 1776, p. 8 ('the sketch of a large picture in the Church of St. Gregorio at Rome, by Guido'); 1833 Cat., no. 20 ('supposed to be the original sketch . . .'); Borenius Cat., 1916, no. 144.

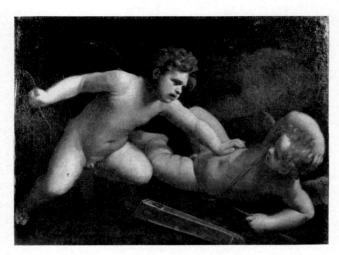

Fig. 40. Formerly attributed to Guido Reni:
The Combat of Sacred and Profane Love (Cat. No. 194)

FORMERLY ATTRIBUTED TO GUIDO RENI

194. THE COMBAT OF SACRED AND PROFANE LOVE.
Canvas, 92·7 × 127·1 cm. Figure 40

Guise Bequest, 1765.

The picture is not by Guido, but is almost certainly
Bolognese, rather nearer to Albani in style. The better
preserved parts – the heads and the hands (except the R.
hand of the *putto* L.) – are enough to show that it was once
of good quality. It was badly damaged by damp, but was
skilfully cleaned and restored by J. C. Deliss in 1960. The
dark background, particularly, had been much repainted
at an early date, and the cleaning was restricted here for
fear of revealing extensive damage.

Literature: L. & E., III, 28; E.C., II, 58 ('one of the best
performances in his first manner'); 'A' Cat., 1776, p. 11;
1833 Cat., no. 60 ('said to be one of the best specimens of
his first manner') (always as Guido Reni); Borenius Cat.,
1916, no. 141 (as School of Guido).

FRANCESCO ALBANI
1578–1660

Pupil of the Mannerist Dionys Calvaert in Bologna, then
(with Guido Reni and Domenichino) of the Carracci.
Joined Annibale Carracci in Rome 1601/2, and worked
partly there and partly in Bologna until 1625, when he
returned finally to Bologna.

195. AN ALLEGORY OF THE PASSION. Canvas, rect-
angular, 62·2 × 62·2 cm. (painted surface diameter 60·2
cm.). Plate 135

Guise Bequest, 1765.

The same subject, with the same somewhat tasteless motive
of the cherubs playing with the Instruments of the Passion,

occurs in an altarpiece in Sta. Maria di Galliera at Bologna
(reproduced *Proporzioni*, II, 1948, fig. 165); but there the
Child Christ is standing at the top of a flight of steps, and
St. Joseph and the Virgin are introduced standing and
kneeling below him. The attitude, hands and drapery of
the Child are nearly identical, but the figure is less elongated
and the face younger. The *putti* with the Instruments of the
Passion are not on the ground, as here, but in the clouds
below God the Father. The same figure of the youthful
Christ, in proportions more resembling that in the Bologna
painting, recurs in the large altarpiece by Albani, *The Holy
Family with SS. Andrew and Thomas Aquinas*, now in the
Brera Gallery (no. 549) (from the Dominican Church at
Forlì).

The construction of the Cagnoli chapel in Sta. Maria di
Galliera was probably completed in 1630.[1]

There is much damage generally, especially in the flesh
parts. However, it is clear that the picture was of high
quality, and it is no doubt an autograph work of Albani.
There is a *pentimento* in the L. foot of the cherub with the
crown of thorns, flying over the head of Christ.

Cleaned (so far as was possible) by J. C. Deliss in 1961.
The surface was not only very dirty, but had been covered
with linseed oil at an early date, which proved extremely
difficult to remove. Traces are still visible, and the whole is
certainly darker than it was originally.

Literature: 'A' Cat., 1776, p. 10; 1833 Cat., no. 56; Borenius
Cat., 1916, no. 147 (always as Albano).

DOMENICO ZAMPIERI, CALLED DOMENICHINO
1581–1641

Born in Bologna, slightly younger than Guido Reni and
Albani. Followed them to Rome 1602–3, and attached
himself to Annibale Carracci, then working in the Palazzo
Farnese. Important work in fresco at Grottaferrata (1608–
1610) and at S. Luigi dei Francesi, Rome (1611–14). *The Last
Communion of St. Jerome*, 1614, in the Vatican, and the
Hunt of Diana in the Borghese Gallery (*c.* 1620), are among
his most famous pictures; a fine series of landscapes is in
the Louvre. He left Rome for Naples 1631, and died there
ten years later.

196. LANDSCAPE WITH THE DAUGHTERS OF RAGUEL
AT THE WELL, delivered by Moses from the Shepherds.
Canvas, 69 × 81 cm. Plate 137

Guise Bequest, 1765.

A fine original by Domenichino, of relatively early date;
Evelina Borea dates this, like the *St. George* in the National
Gallery, *c.* 1615. The painting was much darkened, but was

1. Antonio Boschetto in *Proporzioni, loc. cit.*

successfully cleaned and restored by J. C. Deliss in 1967. There is some damage in the lake in the middle distance.

Literature: L. & E., III, 33; E.C. II, 63; 'A' Cat., 1776, p. 12; 1833 Cat., no. 207 (always as Domenichino); Borenius Cat., 1916, no. 149 and pl. XXXVI.

Evelina Borea in *Paragone*, no. 123, March 1960, fig. 16, and *Domenichino*, 1965, pp. 61, 174 and fig. 58.

DOMENICHINO

197. RIVER LANDSCAPE WITH FISHERMEN AND WASHERWOMEN. Canvas, 59 × 82 cm. Plate 138

Evelina Borea (*loc. cit.*) gives another painting of the same composition, formerly in the Stafford Gallery, then Ellesmere Collection (sold Christies, Oct. 1946, bought by Colnaghi), as the prime version, and the Christ Church picture as a replica. The Ellesmere picture (reproduced in *Paragone*, *loc. cit.*, fig. 8b and in Borea, *op. cit.*, fig. 11b) was exhibited at the Heim Gallery, London, in summer 1966 (cat. no. 3, repr.). The figures in the foreground do not exactly correspond. Both versions are in poor condition, but both may be genuine; that at Christ Church is particularly badly damaged in the landscape. For the fishermen hauling at their nets in the middle-distance, *cf.* the large *Landscape with the Flight into Egypt* in the Louvre, which Evelina Borea (p. 153 and pl. XVII) dates *c.* 1616.

Cleaned by H. Buttery in December 1937 (noted by him as in very bad condition); and again by J. C. Deliss in 1967.

Literature: L. & E., III, 33; E.C., II, 63; 'A' Cat., 1776, p. 12; 1833 Cat., no. 209 (always as Domenichino); Borenius Cat., 1916, no. 150 and pl. XXXVII; Evelina Borea in *Paragone*, no. 123, March 1960, p. 9, and *Domenichino*, 1965, p. 164.

ATTRIBUTED TO DOMENICHINO

198. THREE STUDIES OF THE HEAD OF AN OLD MAN. Canvas, 50·2 × 66·3 cm. Plate 139

Guise Bequest, 1765.

Borenius says that the study on the L. is clearly for St. Petronius in Domenichino's *Madonna and Saints* in the Brera: and compares the other with the head of St. Jerome in the *Last Communion of St. Jerome* in the Vatican (in reverse). The connexion is plausible, but the correspondence is not exact.

A very good, free sketch, no doubt painted from the life, like those of Rubens and Van Dyck. Mr. Denis Mahon doubts the attribution to Domenichino, and in fact such a sketch would be unusual in Domenichino's work; but the same model certainly occurs in various paintings by the master, not only as the Brera St. Petronius and the Vatican

St. Jerome, but elsewhere: as a half-length St. Jerome in Dijon (no. 74), and as a kneeling bishop (Petronius again?) in the extreme R. foreground of the *Madonna del Rosario* at Bologna. In the famous *Last Communion* now in the Vatican Gallery (of which a good reduced copy is at Christ Church, cat. no. 199 below), the heavy impasto in the head of St. Jerome is certainly comparable. For the handling of paint, however, Domenichino's frescoes are perhaps more comparable than the easel pictures; see, for example, the head of the old man watching the death of St. Cecilia in the series at S. Luigi dei Francesi (repr. in detail, Borea, *op. cit.*, fig. 38).

Re-lined and superficially cleaned by Knight at Ryman's, Oxford, 1942. Thoroughly cleaned by Miss Jacqueline Pouncey in July 1965, when the third head, smaller than the others but presumably of the same model, appeared under thick repaint lower L. centre. It is now evident that the artist used a canvas which he had already used for an unfinished portrait of a lady, in upright *format*. Her hair and a little of her forehead are visible to the R. of the old man's head on the R. (the part of her forehead might be mistaken for the back of the old man's neck); her chest and red bodice show between the two larger heads; the full R. sleeve appears (in underpainting only) above and round the old man's head on the L.; and her L. elbow in the lower corner of the canvas, with the fingers of her L. hand to the L. of the old man's beard, near the centre of the L. edge. There is a strong *pentimento* in the contour of the foreshortened head, immediately above the forehead. All three heads, as they now appear, but especially the foreshortened one on the L., are executed with great brilliance and spontaneity.

Since the picture is already described in *London and its Environs* as of two heads only, the third head must have been painted out before 1760 (for the date of *London and its Environs* see Borenius Catalogue, Introduction, p. 13, footnote, and p. 14 of the present catalogue) and probably before it was acquired by General Guise. The old title, *The Heads of St. Andrew and St. Paul*, and the attribution, in all the early lists and catalogues, to Andrea Sacchi, is also interesting, since there were until lately in the possession of Princess Henriette Barberini in Rome two paintings of similar size and shape, each with the heads of two Saints, one (St. Thomas and St. Andrew) by Bernini, the other (St. Anthony Abbot and St. Francis) by Sacchi, and a painting of this description was included in the inventory of Sacchi's possessions made after his death in June 1661. I do not suggest that there is any real connexion between the Christ Church picture and those formerly in the Barberini Collection, and the attribution to Sacchi for our no. 198 can hardly be maintained; but there was certainly some superficial resemblance between them before the recent cleaning (when the third head appeared), and it seems to me possible that the picture was deliberately altered, before General Guise bought it, to emphasize this resemblance and to bolster the attribution by someone,

H

perhaps a Roman dealer, who was familiar with the Barberini pictures.[1]

Apart from some loss of paint through flaking, and some flattening of the impasto from re-lining, the condition is reasonably good.

Literature: L. & E., III, 21; E.C., II, 52; 'A' Cat., 1776, p. 3; 1833 Cat., no. 251 (always as Andrea Sacchi); Borenius Cat., 1916, no. 151 and pl. XXXVIII (as Domenichino).

COPY OF DOMENICHINO

199. THE LAST COMMUNION OF ST. JEROME. Canvas, 140·3 × 90·8 cm.

Guise Bequest, 1765.

A good reduced copy, perhaps not much later than the original, of the celebrated picture, now in the Vatican Gallery, which Domenichino painted in 1614 for the high altar of S. Girolamo della Carità in Rome. This, with Raphael's *Transfiguration* and Daniele da Volterra's *Descent from the Cross*, is said to have been reckoned by Poussin one of the three greatest masterpieces of painting. General Guise had copies of all three; but the present picture is better than the others. The author of the 1833 Catalogue seems to suggest that this may be a preliminary sketch, or perhaps rather a *modello*; but in fact the only noticeable differences between it and the great altarpiece are one or two omissions: no tall candlestick with lighted candle on the L., no candles on the altar R., and no small figures in the background. The painting is finished, and though of good quality can hardly be by Domenichino's hand.

Literature: 'A' Cat., 1776, p. 9; 1833 Cat., no. 103; Borenius Cat., 1916, no. 152.

COPY OF DOMENICHINO

200. THE MEETING OF ST. NILUS AND THE EMPEROR OTTO III. Canvas, 47 × 65·5 cm.

Guise Bequest, 1765.

This and no. 201 correspond in composition to two frescoes by Domenichino in the Cappella di S. Nilo in the monas-

tery church of Grottaferrata. They have the character of sketches, do not correspond to the frescoes in detail, and are of good quality (where not restored). But it seems unlikely that they were preliminary sketches by the master himself; they may be free interpretations by some rather younger artist, perhaps of the Neapolitan School.[2] A drawing of the composition of no. 200, from Jonathan Richardson's collection and with a note in his handwriting on the back of the mount, is in the Guise Collection at Christ Church (inv. no. 1824). It has the look of a preliminary sketch, but is of poor quality, and can hardly be by Domenichino's own hand.

Both paintings were cleaned and restored by L. Freeman in 1963. No. 200 is in tolerably good condition, no. 201 much damaged.

Literature: 'A' Cat., 1776, p. 6 (as by Domenichino); 1833 Cat., no. 104 (with no. 105 as 'Copies of the sketches of Domenichino for his work at Grotta Ferrata near Rome'); Borenius Cat., 1916, no. 155 (as copy of Domenichino).

COPY OF DOMENICHINO

201. THE BUILDING OF THE CHURCH AT GROTTA-FERRATA. Canvas, 48 × 65·5 cm.

Guise Bequest, 1765.

See note to no. 200.

Literature: 'A' Cat., 1776, p. 8 (as by Domenichino); 1833 Cat., no. 105 (with no. 104 as 'Copies of the sketches of Domenichino for his work at Grotta Ferrata near Rome'); Borenius Cat., 1916, no. 154 (as copy of Domenichino).

STUDIO OF DOMENICHINO, AND MARIO DE' FIORI (?)

Mario Nuzzi, called Mario de' Fiori (1604–73), Roman School, to whom innumerable flower paintings are attributed. Very few are documented as his. Flower garlands of the kind represented here were probably inspired by the work of the Antwerp Jesuit, Daniel Seghers (1590–1661), who was in Rome 1625–27.

202. CUPID IN A CHARIOT, with two attendant *Putti*, surrounded by a Wreath of Flowers. Canvas, octagonal, 71·7 × 56 cm.

Guise Bequest, 1765.

As noted already in the 1833 Catalogue, this picture is related to one in the Louvre, which was engraved in *Galerie du Musée Napoléon*, 1813, no. 591. The Louvre picture is, however, rectangular and much larger (130 × 110

1. Miss Ann Sutherland, now Mrs. Harris, kindly supplied notes on the Barberini pictures from her work on Andrea Sacchi, quoting Incisa della Rochetta in *L'Arte*, 1924, p. 63, and Martinelli in *Commentarii*, I, 1950, p. 96. The Bernini is listed in the Barberini Inventory of June 1, 1627. Sacchi was paid by the Barberini for a picture of 'Two Apostles' on June 21, 1627, but since this would be an erroneous description of the *St. Anthony Abbot and St. Francis*, Martinelli and Miss Sutherland believe that this entry must refer to another similar picture, now lost, and that the *St. Anthony and St. Francis* must have been acquired later, perhaps after Sacchi's death in 1661.

The two Barberini pictures were acquired from Colnaghi by the National Gallery in June 1967.

2. Mr. Jacob Bean suggested to me the possibility that they might be by Micco Spadaro, and this attribution seems plausible.

cm.), and the correspondence is confined to the central part, Cupid and his attendants; the wreath of flowers is quite different, and there is an inner wreath immediately surrounding the *putti*, so that these are relatively smaller in scale. The Louvre picture, which was exhibited at Naples in 1964 (*La Natura morta italiana*, cat. no. 124, fig. 59a,) is attributed to Domenichino and Daniel Seghers, and is no doubt the one described by Bellori in his life of Domenichino (1672, p. 353) as painted for the Cardinal Ludovisi: the painting of the garland only had been presented to the Cardinal, and Domenichino, says Bellori, inserted the three figures.

In all respects the Louvre painting seems to be superior to ours: the *putti* and the chariot, which correspond, are more exactly drawn, and the flowers are by a better hand, no doubt that of the Jesuit Seghers, who rivalled his own master, Jan Brueghel, in this art. But those in the Christ Church version are of respectable quality, and might well be by Mario de' Fiori, by whom there are good flower-pieces in the Pallavicini Collection in Rome (Zeri cat., 1959, nos. 331–334).

The flowers are identified as follows by Mrs. J. C. Deliss: (from the top, clockwise) a lily, lily of the valley, iris, tulip, daffodils and narcissi, cyclamen, convolvulus, anemone, daisy, forget-me-not, ranunculus, wild hyacinth, aconite, orange-blossom, jasmine, carnation, scylla, dogrose and rose.

The painting was re-lined and cleaned by J. C. Deliss in 1964. The flowers are on the whole in good condition, and the *putti* are tolerably well preserved. Repairs were chiefly confined to the black background.

Literature: 'A' Cat., 1776, p. 13 (as Domenichino); 1833 Cat., no. 13; Borenius Cat., 1916, no. 156 (as a copy after Domenichino).

BOLOGNESE SCHOOL, MID XVII CENTURY

203. SUSANNA AND THE ELDERS. Canvas, 38·8 × 29·2 cm. Figure 41

Guise Bequest, 1765.

The picture is not of high quality, but is not necessarily a copy. The relationship to Domenichino is not clear, though the types and dress of the Elders have some resemblance to those in his picture of the same subject at Munich (Voss, *Malerei des Barock in Rom*, 1924, pl. 189). On the other hand, as Mr. Pouncey has pointed out to me, there seems to be an indisputable connexion, so far as composition is concerned, with the much larger picture of the same subject by Ludovico Carracci in the National Gallery (no. 28. Bodmer, *Lodovico Carracci*, 1939, pl. 89). The Christ

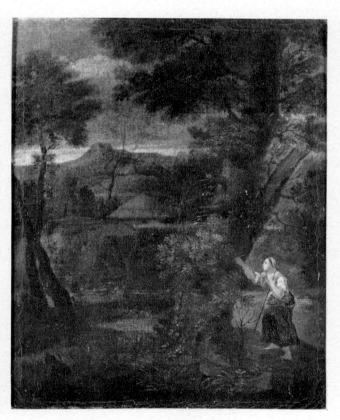

Fig. 41. Bolognese School, mid XVII century:
Susanna and the Elders (Cat. No. 203)

Fig. 42. Bolognese or Roman School, mid XVII century:
Landscape with a Peasant Woman cutting a Name on a Tree
(Cat. No. 204)

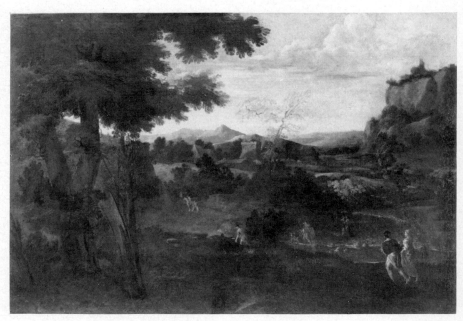

Fig. 43. Bolognese School, XVII century: *Landscape with Figures by a River* (Cat. No. 205)

Church picture is surely of a generation later than Ludovico himself. Its condition, though not very good, is better than that of most of the small XVII century Italian paintings in the collection.

Literature: 'A' Cat., 1776, p. 6 or p. 12 (no attribution; *cf.* no. 177 of this catalogue); 1833 Cat., no. 106 (as after Domenichino); Borenius Cat., 1916, no. 157 (as copy after Domenichino?).

BOLOGNESE OR ROMAN SCHOOL, MID XVII CENTURY

204. LANDSCAPE WITH A PEASANT WOMAN cutting a Name on a Tree. Canvas, 39·5 × 32·2 cm. Figure 42

Guise Bequest, 1765.

Borenius suggests a relationship to P. F. Mola. The style is perhaps nearer to that of the so-called 'Silver Birch Master', who is now generally identified with Gaspar Dughet in his early Poussinesque phase. The little picture may once have had considerable charm; but the present condition is deplorable.

Literature: Not identifiable in the earlier catalogues; Borenius Cat., 1916, no. 168.

BOLOGNESE SCHOOL, XVII CENTURY

205. LANDSCAPE WITH FIGURES BY A RIVER. Canvas, 112·5 × 163 cm. Figure 43

Guise Bequest, 1765.

A typical Bolognese landscape of the mid XVII century, perhaps by Grimaldi, but much damaged and repainted throughout.

Literature: L. & E., III, 26; E.C., II, 56 (both as Domenichino); 'A' Cat., 1776, p. 11 (as Grimaldi, called Il Bolognese); 1833 Cat. no. 202 (the same); Borenius Cat., 1916, no. 169 (as Bolognese School, XVII century).

GUERCINO (?)
1591–1666

Giovanni Francesco Barbieri, called *Il Guercino* (because of his squint), born at Cento in the Duchy of Ferrara, but Bolognese by study of the example of the Carracci, and much influenced by an early visit to Venice in 1618. Working in Rome for Pope Gregory XV (Ludovisi) 1621–23. He returned to Cento, but by that time enjoyed a wide reputation, and refused invitations to the courts of London and Paris. A gradual change, influenced by the work of Guido Reni, is noticeable in his style during the 1640's, when he returned to Bologna (1642) for the rest of his life. A splendid colourist, and one of the great draughtsmen of the XVII century.

206. ST. JOHN THE BAPTIST, half-length, with a Lamb. Canvas, 56·6 × 43·3 cm. Plate 140

Guise Bequest, 1765. Probably Lot 50 from the 1st day of the John van Spangen Sale, Cock and Langford, London, Feb. 10 1747/8 (1748): 'Saint John's Head. Guercino. Gen. Guise 3–10–0'. (Houlditch MS.)

The date must be fairly early, in the mid 1620's. Mr. Denis

Mahon believes the picture to be no more than a studio or school work, though he knows no other example of this composition. I suspect that it may be autograph. Some lack of precision is certainly due to condition, for it is badly damaged throughout. It was re-lined, cleaned and skilfully restored by H. Buttery in November 1960.

Literature: L. & E., III, 33; E.C., II, 63 ('in his best manner, by Guercino da Cento'); 'A' Cat., 1776, p. 5; 1833 Cat., no. 186; Borenius Cat., 1916, no. 159 (always as Guercino).

COPY OF GUERCINO

207. THE VIRGIN AND CHILD WITH THE INFANT ST. JOHN. Canvas, 73·8 × 58·3 cm.

Guise Bequest, 1765.

Mr. Denis Mahon points out that the Hampton Court picture, attributed to Cignani, of which this is a crude and much repainted replica, is a copy of an early Guercino of *c.* 1616 (see *Burlington Magazine*, vol. 70, 1937, p. 189, note 38). A picture in the Pallavicini Collection in Rome (Zeri Cat., 1959, no. 14) has been claimed as the best existing version, and perhaps autograph; Longhi (as quoted by Zeri) considered it one of Guercino's earliest works; but according to Mahon this is itself only a copy of a lost original. Another copy was sold at Sotheby's, May 20, 1953, lot 122, as by Bartolommeo Schedoni.

Literature: 'A' Cat., 1776, p. 1 (by 'Paduanino'); 1833 Cat., no. 140 (the same); Borenius Cat., 1916, no. 170 (as a 'replica of a picture by Cignani at Hampton Court, no. 117').

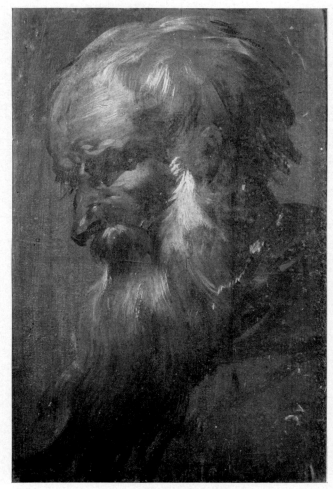

Fig. 44. Bolognese (?) School, XVII century: *Head of an old Man* (Cat. No. 208)

BOLOGNESE (?) SCHOOL, XVII CENTURY

208. HEAD OF AN OLD MAN, in profile to L. On paper, mounted on panel, in brown monochrome, heightened with white, 28·3 × 18·5 cm. Figure 44

Guise Bequest, 1765.

Inscribed 'Tiziano' on the back of the panel.

The sketch is of good quality, but has no apparent connexion with Titian. Mr. A. E. Popham (verbally, 1963) suggested that it might be by Cavedone, and it may well be Bolognese of that period. It is in good condition.

On the back of the frame is written: '*Pagato 15 silini a di 9 Giuno 1764*'. As Borenius remarks, if this refers to General Guise's purchase it must have been one of his last, since he died almost exactly a year later.

Literature: Probably 1833 Cat., no. 39 ('A Head. Titian'); Borenius Cat., 1916, no. 185 (as school of Titian).

MARCANTONIO FRANCESCHINI
1648–1729

Pupil and collaborator for more than ten years with Carlo Cignani at Bologna. One of the most celebrated decorative painters in Italy at the end of the XVII and beginning of the XVIII centuries, much in demand in Genoa, Rome and other cities besides Bologna. His account book for the years 1684–1729 is in the Communal Library at Bologna. His brother-in-law Luigi Quaini (d. 1717) often collaborated in his larger works, especially in the landscape parts.

209. ARMIDA ABANDONED BY RINALDO (from Tasso, *Gerusalemme Liberata*). Canvas, 34 × 45 cm. Plate 142

Nosworthy Bequest, 1966. Bought by Sir Richard Nosworthy from Colnaghi, Nov. 1957.

This very good example of Franceschini's graceful style and delicate colour was identified by Dr. Carlo Volpe (Cat. of the Bologna Exhibition, 1959) as '*un quadro figure piccole esprimenti Rinaldo che abbandona Armida svenuta*', recorded

in the artist's *libro dei conti*, painted for 'Sig.ʳ Gen.ᵉ Baron Martini' and paid for on March 12 1709.

Exhibited: Bologna, 1959, *Pittura del '600 Emiliana*, no. 91.

NORTH (?) ITALIAN SCHOOL, XVII CENTURY

210. SOLDIERS WITH WOMEN PRISONERS. Canvas, 28·3 × 37·2 cm.

Guise Bequest, 1765.

The picture may have had some merit, but is badly damaged by damp, and very difficult to judge. The subject is obscure.

Literature: 'A' Cat., 1776, p. 13; 1833 Cat., no. 169 ('A small Picture of Soldiers and Women', without attribution); Borenius Cat., 1916, no. 297 ('Soldiers and Women dancing', Italian School XVII century).

NORTH ITALIAN SCHOOL, XVII CENTURY

211. HEAD OF A MAN, contorted in Pain (St. Sebastian?). Canvas, 29 × 25·6 cm.

Probably Guise Bequest, 1765 (not identifiable in the early catalogues).
A rather coarse sketch, of no apparent quality in its present condition, and impossible to attribute more exactly.

Literature: Borenius Cat., 1916, no. 211 (as Tintoretto?).

LOMBARD (?) SCHOOL

212. HEAD OF A BEARDED MAN looking up to L.: a Sketch. Canvas, 45·8 × 36·8 cm. Plate 141

Probably Guise Bequest, 1765.

Borenius suggests an identification with the picture described in *London and its Environs*, III, 35, and *The English Connoisseur*, II, 66, as 'a head with part of the shoulders, representing a Greek merchant, as big as the life, by Michael Angelo da Caravaggio'.
The style of this excellent sketch, with the heavy impasto, seems to suggest the Lombard or Genoese School of the first half of the *Seicento*.
Re-lined and cleaned by J. C. Deliss, 1962. There is practically no restoration.

Literature: Borenius Cat., 1916, no. 298 (as Italian School, XVII century).

LOMBARD (?) SCHOOL, XVII CENTURY

213. CHRIST CROWNED WITH THORNS, by Torchlight. Canvas, 56·5 × 45 cm.

Guise Bequest, 1765.

In damaged condition, but apparently of poor quality and perhaps a copy.

Literature: L. & E., III, 23; E.C., II, 53 (as Correggio); 'A' Cat., 1776, p. 4 (?) (without attribution); 1833 Cat., no. 50 (?) (the same); Borenius Cat., 1916, no 267 (as Italian School, XVII century).

GENOESE, NEAPOLITAN AND SPANISH PAINTERS

LUCA CAMBIASO
1527–85

Called Luchetto, the most celebrated Mannerist painter of the Genoese School. Beginning as a pupil and assistant of his father Giovanni Cambiaso, he was the author of extensive works in fresco, often on a gigantic scale, in the Genoese palaces. Called to Spain in 1583 by Philip II to work in the Escorial and at Madrid, where he died. A prolific draughtsman in a highly individual style, much copied and imitated in his time. A good collection of his original drawings, and many copies, are in the Guise Collection at Christ Church.

214. ST. CHRISTOPHER. Panel (pine), 145 × 103 cm. (painted surface 136 × 89·5 cm.). Plate 143
Guise Bequest, 1765.

This and no. 215 were described by Borenius as cartoons on paper mounted on wood, which is not the case: they are in fact painted in brown monochrome (with a little red in the cloak of St. Christopher, and green drapery under the body of Goliath lower L.) on a gesso ground. In 1961, when they were examined by Mr. Buttery and Mr. Hookins, they were found to be in very dangerous condition, the paint flaking extensively, especially at the sides, owing to a heavy and very primitive form of cradling, which was perfectly rigid, built into the frames at the back. This must have dated at least from General Guise's time. Mr. Stephen Rees-Jones, Director of the Scientific Department at the Courtauld Institute of Art, generously undertook the very difficult task of removing the frames and cradling, treating the original panels, and restoring the paintings, with the assistance of his students. The work was completed in 1966, and considering the condition of the panels when it was begun, the result is remarkably successful. It is interesting that the two paintings were executed on panels of different woods: the pine panel (*St. Christopher*) was found to be intact, and not worm-eaten; the poplar[1] panel (*David and Goliath*) was badly worm-eaten, and made up with cross-battens at top and bottom. Perhaps because of the less satisfactory material, the latter painting was in much worse condition than the former; it seems also to have been less well finished.

1. But see below, p. 114, note 3.

Borenius, following a suggestion of C. F. Bell, attributed the paintings to Pordenone. The present attribution seems unquestionable, especially since in the course of cleaning there emerged a small but unmistakable self-portrait head of the artist on the stone which St. Christopher is grasping with his right hand (see Figures 45–46). The introduction of such a portrait in such a place is capricious enough; it is inconceivable that it could be intended for the portrait of a patron, or indeed anyone but the painter himself; and in fact the features, and what appears of the dress (the small ruff), correspond closely with those in the familiar self-portraits of Cambiaso. Most of these, including that in the Uffizi (no. 1181),[2] must be later than ours, and even that in the Mayer Collection at Mexico City,[3] though nearer in date, must also be later. But in all these, though the head is balder, it is of the same round bullet shape, and the short nose, the moustaches and beard, are the same.

The head on the stone in the *St. Christopher* is placed on an escutcheon, and there is a similar shield close beside it to the R., with an indecipherable coat of arms, perhaps that of the artist's family. In the R. lower corner of the *David and Goliath* there are faint traces of a similar shield with a head imposed upon it, rather smaller in scale.

Apart from all this, the Christ Church paintings show the closest relationship to the earliest independent works of Cambiaso in Genoa, after he had moved out of the shadow of his father. They seem more mature than the frescoes of the Deeds of Hercules, the Trojan War, *etc.*, in the Palazzo della Prefettura (formerly Palazzo Antonio Doria), where he was working (with his father) as early as 1544, at the age of seventeen;[4] but they illustrate perfectly what Soprani[5] called Luca's '*prima maniera di gigantesco disegno*'. This 'gigantic' style was modified about the year 1550 (so Soprani tells us) by the influence of the Perugian architect

2. Suida-Manning, *Luca Cambiaso*, 1958, p. 136 and fig. 1. There is a variant replica of this in the Guala Collection at Genoa (*ibid.*, p. 101 and fig. 351). Suida-Manning date this *c.* 1570, when Luca was about forty-three (Giovanni Cambiaso, who also appears in the picture, lived until 1579).
3. Suida-Manning, *op. cit.*, p. 157 and fig. 350.
4. See Suida-Manning, *op. cit.*, figs. 2–12; also Pasquale Rotondi in *Bollettino d' Arte* XLIII, serie IV, 1958, p. 165, figs. 1–3.
5. Raffaelle Soprani, *Le vite de' pittori . . . genovesi*, Genoa, 1674; quoted in Suida-Manning, *op. cit.*, p. 266 ss.

 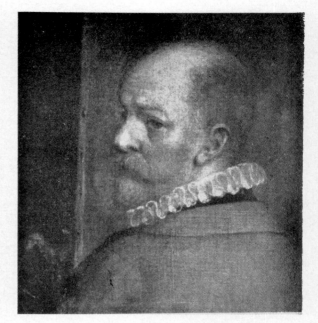

Figs. 45–46. Cambiaso: *Self-portraits*. Fig. 45: Detail from Cat. No. 214. Fig. 46: Uffizi, Florence (detail)

Galeazzo Alessi, who arrived in Genoa at that time and became Cambiaso's friend. Our paintings therefore may date from the late 1540's. It may be observed that the spandrels of the Salone in the Prefettura show very similar compositions, of two figures (*Jupiter and Io, Mercury and Argus, etc.*) of heroic proportions, ingeniously packed by foreshortening into relatively small spaces;[1] and incidentally, that a small portrait-head, again perhaps a self-portrait of the artist, seems to appear very unobtrusively in the border-decoration of the main ceiling in the same palace in Genoa.[2]

Literature: 'A' Cat., 1776, p. 11; 1833 Cat., no. 253 (in both as Michelangelo); Borenius Cat., 1916, no. 196 (as Pordenone).

LUCA CAMBIASO

215. DAVID AND GOLIATH. Panel (poplar),[3] 145 × 99 cm.
Plate 144

Guise Bequest, 1765.

See note to no. 214, to which this is a companion-piece.

Literature: 'A' Cat., 1776, p. 13; 1833 Cat., no. 288; Borenius Cat., 1916, no. 197.

1. Suida-Manning, *op. cit.*, figs. 6–8 and 11–12.
2. See the top R. corner of the reproduction of Suida-Manning, *op. cit.*, fig. 3.
3. According to Mr. Rees-Jones. But Mr. E. Wiggins, who has wide experience of old wood, believes this panel to be Italian walnut.
4. The heavy frame in which this picture was formerly enclosed, apparently of the XIX century, with a recurring thistle device, does not suggest that it was one of General Guise's bequest; and it is not at all in the taste either of W. H. Fox-Strangways or W. S. Landor.

GENOESE (?) SCHOOL, FIRST HALF OF XVII CENTURY

216. AN ASSASSINATION: A SCENE FROM ANCIENT HISTORY. Canvas, 87·2 × 108·4 cm. Figure 47

Provenance unknown.[4]

Mr. P. M. Pouncey may be right in suggesting that the picture is Genoese of the early XVII century, in style between that of Bernardo Castelli (1557–1629) and that of his son Valerio (1624–59). The subject might be *The Assassination of Amulius*, which is among those represented by Ludovico Carracci in the famous frieze in Palazzo Magnani, Bologna (Bodmer, *Lodovico Carracci*, 1939, pl. 12). According to the ancient legend, Romulus and Remus, before the foundation of Rome, discovered that they were the sons of the Vestal Virgin Rhea Silvia by the god Mars, and that their grandfather Numitor, descendant of Aeneas and King at Alba Longa, had been deposed by his younger brother Amulius. They therefore assassinated Amulius and reinstated Numitor on the throne. Mars appears prominently on the R. in our picture, among the statues of gods and goddesses in the throne-room.

Re-lined and cleaned by J. C. Deliss in 1966. The condition is tolerable, in spite of local damages.

BERNARDO STROZZI
1581–1644

Called *Il Capuccino* or *Il Prete Genovese*, since he became a Capuchin monk at the age of seventeen. Pupil of the Sienese Pietro Sorri, who was in Genoa 1595–97. Difficulties with his religious order caused him to remove to

Fig. 47. Genoese (?) School, first half of XVII century: *The Assassination of Amulius* (?) (Cat. No. 216)

Venice in 1630; there he lived the rest of his life. He was nominated Monsignore in 1635, but seems to have devoted himself entirely to painting. The most original and dominant figure in the Genoese School of the earlier XVII century, and one who had much influence on the development of Baroque painting in Venice.

217. JUDITH WITH THE HEAD OF HOLOFERNES, attended by her Servant. Canvas, 138 × 98·2 cm.

Plate 145

Guise Bequest, 1765. Perhaps from Lady Sunderland's sale 1749/50 (1750), 6th day, Lot 21 ('Judith with Holofernes' Head. Italian. Gen. Guise 5–0–0'). (Houlditch MS.)

A fine example of Strozzi's mature (Venetian) style. Borenius refers to a picture by him of the same subject, but of different composition, in the Berlin Gallery, but this is described by Luisa Mortari (*Bernardo Strozzi*, 1966, pl. 409) as *Salome with the Head of the Baptist*. She does not mention the Christ Church painting.

Cleaned by J. C. Deliss in 1961, and generally in fair condition.

Exhibited: Liverpool, 1964, no. 43.

Literature: 'A' Cat., 1776, p. 9; 1833 Cat., no. 192 (wrongly identifying 'Il Prete Genovese' as Hippolito Galantini); Borenius Cat., 1916, no. 178 and pl. XXXIX.

STUDIO OF G. B. CASTIGLIONE
c. 1600 (?)–1670

Painter and etcher, one of the most important artists of the Genoese School. Pupil of G. B. Paggi, much influenced by van Dyck's visit to Genoa 1621–27. In Rome by 1634, and stayed there, with occasional visits to Genoa and elsewhere, till *c.* 1648, associating with Poussin, Mola and Testa. Afterwards at Mantua at the court of the Gonzaga. A large collection of magnificent drawings by Castiglione, in oil

on paper, is at Windsor Castle. One good example is in the Guise Collection at Christ Church.

218. CHRIST DRIVING THE TRADERS FROM THE TEMPLE. Paper laid on canvas, 40·3 × 56·5 cm.

Guise Bequest, 1765.

A studio replica of a better picture now at Bowdoin College, Brunswick, U.S.A. (from the Kress Collection). The Christ Church picture shows the composition somewhat reduced on all sides except at the top. It is not of good quality, and hardly by Castiglione himself. The figure on the extreme L. has the air of a self-portrait, and it is not incompatible with the engraved portrait of the artist in Soprani (*Vite de' pittori . . . Genovesi*, 2nd ed., 1768, p. 308), if we may suppose that he grew more beard in later life. Re-lined by J. C. Deliss in 1960.

Literature: 'A' Cat., 1776, p. 8; 1833 Cat., no. 293; Borenius Cat., 1916, no. 179 (all as Castiglione).

STUDIO OF G. B. CASTIGLIONE

219. AN OLD TESTAMENT SUBJECT: Shepherds and Flocks, with a City on Fire in the Distance. Paper laid on canvas, 40·3 × 56·7 cm.

Guise Bequest, 1765.

Not of good quality, and hardly by Castiglione himself; perhaps only a school copy. Pair to no. 218.
Re-lined by J. C. Deliss in 1960.

Literature: 1833 Cat., no. 291; Borenius Cat., 1916, no. 180 (as Castiglione).

SALVATOR ROSA
1615–73

Painter, etcher, poet, play-actor and musician, born in Naples. Pupil of his mother's brother Antonio Domenico Greco. In Rome 1635, and again from 1639, painting battle-pieces, marines and romantic landscapes. In Florence 1640–1649, but returned to Rome in 1649, and died there. One of the most original and influential personalities among Italian painters of the mid XVII century.

220. A HERMIT CONTEMPLATING A SKULL. Canvas, 105·3 × 78·3 cm. Plate 146

Fox-Strangways Gift, 1828.

The picture, which is particularly praised by Borenius (Introduction, p. 12) as one of the few later Italian pictures included in the Fox-Strangways Gift, is certainly a fine original, but has never been reproduced. Borenius records that it was inscribed on the back: '*Un Filosofo di Salvator Rosa fatto per la Casa Maffei della (dalla?) Galleria dei Conti*

Guidi di Firenze' and '*Del Fideicommisso Primogeniale Maffei di Salvador Rosa*'; but unfortunately at some date between the publication of Borenius' Catalogue (1916) and 1964, when the picture was cleaned by J. C. Deliss, it had been re-lined and re-stretched and the record of this interesting provenance was destroyed. The 'Casa Maffei' referred to was no doubt one of the palaces in Florence or Volterra of the Counts Ugo and Giulio Maffei, who were among the greatest friends of the artist during the 1640's, and with whom he stayed at Volterra before his return to Rome in 1649. It seems likely therefore that the picture belongs to this period.

It is related in style and subject to the *S. Onofrio* now in the Minneapolis Institute of Arts (L. Salerno, *op. cit.*, pl. 92; M. Mahoney in Minneapolis Bulletin, vol. LIII, no. 3, Sept. 1964, p. 55 *ss.*). The condition is good.

For another picture that Fox-Strangways acquired from the collection of Count Guidi at Florence, see no. 60 (Granacci).

Literature: 1833 Cat., no. 216; Borenius Cat., 1916, no. 172.

L. Salerno, *Salvator Rosa*, Milan, 1963, p. 145.

SALVATOR ROSA

221. ROCKY LANDSCAPE WITH THREE FIGURES. Canvas, 75·2 × 61 cm. Plate 147

Nosworthy Bequest, 1966. From the collection of the 5th Earl Cowper, who is said to have bought this and no. 222 in Italy in 1800; from him by descent to Lady Desborough. Sold at Christie's, Oct. 16 1953 (bought Agnew). Bought from Agnew by Sir Richard Nosworthy, 1954.

This and no. 222 are excellent examples of Salvator Rosa's wild romantic landscape, which was so much imitated in the XVIII century in Italy (Marco Ricci), in Germany (C. W. E. Dietrich) and in England (J. H. Mortimer). This pair, which is in very good condition, was admired ('remarkably spirited') by Waagen, when he visited Lord Cowper's collection in July 1835. I can find no reference to them in recent literature on Salvator Rosa.

Literature: Waagen, *Treasures of Art in Great Britain*, III, 1854, p. 15; Lady Morgan, *The Life and Times of Salvator Rosa*, 1855, p. 295.

SALVATOR ROSA

222. A ROCKY COAST, WITH SOLDIERS STUDYING A PLAN. Canvas, 75·2 × 61 cm. Plate 148

Signed with SR in monogram on the plan which the soldiers are studying, lower L.

Nosworthy Bequest, 1966. Provenance and Literature as for no. 221. Pair to no. 221.

SALVATOR ROSA

223. THE INFANT ERICHTHONIUS DELIVERED TO THE DAUGHTERS OF CECROPS TO BE EDUCATED. Canvas, 184 × 127 cm. Plate 149

Guise Bequest, 1765.

The subject is from Ovid, *Metamorphoses*, II, 553 *ss*.

Once undoubtedly a fine and important picture, dramatic in composition and lighting, and closely related in style to the *Moses saved from the Water*, in the Giovanelli Collection, of *c.* 1660 (*Bollettino d' Arte*, July 1925, p. 33, fig. 4). But it is now in sadly damaged condition. All the flesh parts – especially the hands, which play so important a part in the design – are abraded and restored. This is the case in fact with all parts which were more thinly painted (such as the inside of the basket-cradle, and most of the shadows); only the heavier impasto of the highlights – in drapery and hair – and of the foreground and trees have survived better. The damage was no doubt done at least as early as the time of 'Old Bonus' (see Introduction, p. 12); an unsuccessful restoration carried out during the war was greatly improved by J. C. Deliss in 1963.

Literature: L. & E., III, 32 *ss.*; E.C., II, 63; 'A' Cat., 1776, p. 10; 1833 Cat., no. 218; Borenius Cat., 1916, no. 171. L. Ozzola, in *Burlington Magazine*, vol. 16 (1909–10), p. 150 (with the title *Hercules leaving the Cradle*); H. Voss, *Barockmalerei in Rom*, 1924, p. 571; H. Voss, in Thieme-Becker, *Künstlerlexicon*, vol. XXIX (1935), p. 2; L. Salerno, *Salvator Rosa*, 1963, p. 129 and pl. 64.

NEAPOLITAN SCHOOL, XVII CENTURY

224. BUST OF A BEARDED ORIENTAL, full face. Canvas, 60·3 × 49·5 cm.

Probably Guise Bequest, 1765, but not identifiable in the early catalogues.

The picture seems to show the influence of Rembrandt's etchings of men in Oriental dress, and is somewhat in the manner of Salvator Rosa, but of coarse quality.

Literature: Borenius Cat., 1916, no. 176.

NEAPOLITAN OR SPANISH SCHOOL, XVII CENTURY

225. A YOUNG MAN PLAYING THE LUTE, a Boy behind him. Canvas, 96·5 × 74 cm. Figure 48

Guise Bequest, 1765.

The head of the boy is well painted, and the picture may originally have been of some charm. But in the process of cleaning in 1965 by J. C. Deliss it became clear that the

figure of the lute-player had either been introduced at a considerably later date, or completely repainted, and in view of the general condition it was thought inadvisable to continue cleaning.

The attribution given in the earliest catalogues (see below), to a Spanish disciple of Titian (probably, as Borenius says, Fernández Navarrete, called El Mudo, is meant) certainly implies too early a date. That of the 1833 Catalogue, to Antonio Arias Fernández, who was working in Madrid and Buen Retiro about the middle of the XVII century, is at least more acceptable so far as date is concerned.

Literature: L. & E., III, 33; E.C., II, 63 ('A youth little less than life, that plays upon the Guitar, with a boy behind that listens with pleasure to him. By the celebrated Spanish disciple of Titian, Fernandos'); 'A' Cat., 1776, p. 10 (as by 'Fernandez'); 1833 Cat., no. 188 (as Antonio Arias Fernández); Borenius Cat., 1916, no. 306 (as Spanish School, XVII century).

NEAPOLITAN (?) SCHOOL, XVII CENTURY

226. TWO GROTESQUE HEADS. Canvas, 48·6 × 65·1 cm.

Guise Bequest, 1765.

Much darkened by dirt and varnish, and evidently much

Fig. 48. Neapolitan or Spanish School, XVII century: *A Man playing the Lute, with a Boy behind* (Cat. No. 225)

rubbed. The subject is curious, rather reminiscent of Pietro della Vecchia, but the quality seems hardly to justify the expense of cleaning and restoration. Some tests were made by J. C. Deliss in 1964.

Literature: L. & E., III, 18; E.C., II, 49; 'A' Cat., 1776, p. 7; 1833 Cat., no. 234 (always attributed to Ribera); Borenius Cat., 1916, no. 177 (as Neapolitan).

GIACOMO DEL PÒ
1652–1725

Born in Rome, but settled in Naples in 1683 where he worked for most of his life. One of the most successful decorative artists of his time.

227. ST. CATHERINE REFUSING TO SACRIFICE TO AN IDOL. Canvas, 75·8 × 50 cm. Plate 153
Guise Bequest, 1765.

There can be little doubt that Borenius is right in suggesting that this and no. 228 are identical with 'two small pictures, exhibiting two different martyrdoms of two Saints, by Giacomo del Pò', described in *London and its Environs* and *The English Connoisseur*, though he does not adopt the attribution (which is surely correct) in his own catalogue. Much more uncertain are his suggested identifications in the 'A' Catalogue of 1776 and the 1833 Catalogue with two sketches attributed to Valerio Castelli in the former (p. 7) and with two of three sketches called Volterrano in the latter (nos. 161–163).
De Dominici describes in some detail the work done by Giacomo del Pò for the chapel of St. Catherine in the Dominican church of Sta. Caterina a Formello at Naples: it consisted of decorative frescoes on the walls, an altarpiece depicting the martyrdom of the Saint, and two wings ('*laterali*'), showing on one side *St. Catherine before the Emperor Maxentius*, and on the other *St. Catherine converting the Elders* and their subsequent punishment by the Emperor.[1] It seems likely that the two paintings at Christ Church are sketches for these two wings, though one of the subjects does not exactly correspond to this description. Cleaned by J. C. Deliss in 1963. The dark ground on which the picture is painted has become obtrusive in the course of time; but there is little damage or restoration.

Literature: L. & E., III, 26; E.C., II, 57; Borenius Cat., 1916, no. 278 (as Italian School, XVII century).

GIACOMO DEL PÒ

228. A FEMALE MARTYR (ST. CATHERINE?) AND OTHER

1. Bernardo de Dominici, *Vite dei pittori . . . Napoletani*, 1742–45, 1848 ed., vol. IV, p. 290.

VICTIMS BEFORE A ROMAN EMPEROR. Canvas, 75·8 × 50 cm. Plate 154
Guise Bequest, 1765.

See note to no. 227.
Cleaned by J. C. Deliss in 1964. The condition is similar to that of no. 227, but there is damage from damp in the lower L. centre.

Literature: L. & E., III, 26; E.C., II, 57; Borenius Cat., 1916, no. 279 (as Italian School, XVII century).

CORRADO GIAQUINTO
1699–1765

Pupil of M. Rossi and Francesco Solimena in Naples from 1719; from 1723 in Rome as pupil of Sebastiano Conca, whom he accompanied as his assistant to Turin *c.* 1730. In Rome again 1734–53; then in service of the King of Spain (Ferdinand VI) in Madrid. Returned to Naples 1762, and died there.
One of the most charming of Neapolitan decorative artists of the XVIII century, a brilliant colourist and designer in typical Rococo taste.

229. THE BIRTH OF THE VIRGIN. Canvas, 54 × 98·5 cm.
 Plates 150–152
Probably Guise Bequest, 1765 (not identifiable in any of the early catalogues).

The correct attribution for this beautiful painting, which had been supposed by Borenius to be of the Venetian School, was first given by Professor Giuseppe Fiocco in reviewing the Borenius Catalogue in 1917. It is described by Mario d' Orsi (*op. cit.*, p. 84) as one of six '*bozzetti*' or sketches for the great canvas painted by Giaquinto in 1751–1752 for the Cathedral of Pisa, where it still hangs in the chapel between the N. transept and the choir (see Figure 49). Four of these – in the museums of Palermo and Montefortino (d' Orsi, fig. 92), and two in the Villafalletto Collection in Rome – seem to have the character of preliminary sketches, and the canvas in the Uffizi (d' Orsi, fig. 93) may be the final *modello*, corresponding as it does rather nearly in proportions, and in all but occasional details, to the great painting at Pisa. I am inclined to think, however, that the Christ Church picture may well have been painted for a private client after the great picture was finished. The proportions of the canvas are notably different, the composition being much reduced above and below, and the Turkey carpet and the little girl sitting on the floor are omitted. In certain respects – particularly the balustrade and buildings in the background R. – our picture is nearer to that in the Uffizi than to the great picture; and it may be that this was used as the *modello* for ours. But ours seems to

Fig. 49. Corrado Giaquinto: *The Birth of the Virgin*. Pisa, Duomo (*Cf.* Cat. No. 229)

me to be of finer quality, and more brilliant in colour; and it is in very good condition.

A red chalk drawing (27·3 × 32·7 cm.) of St. Joachim standing beside St. Anne in bed, while a woman and a girl attend to her, was recognized by its owner, Mr. H. N. Squire in London, as a preliminary study for the L. background of this composition. It corresponds to the Christ Church painting with only slight variations (see Plate 152-a).

Some flaking of the paint seemed likely to occur while the picture was exhibited at Liverpool in 1964. This was corrected, and the whole re-varnished by Mr. J. C. Witherop.

Exhibited: Royal Academy, 1954/55, no. 293; Liverpool, 1964, no. 23.

Literature: Borenius Cat., 1916, no. 249 and pl. LIV.

G. Fiocco in *L'Arte*, XX, 1917, p. 361; G. Castelfranco in *Miscellanee di storia dell' arte in onore di I. S. Supino*, Florence, 1934; Mario d'Orsi, *Corrado Giaquinto*, 1958, p. 84.

SPANISH SCHOOL, XVI CENTURY

230. CHRIST BEARING THE CROSS. Panel, 114·3 × 87 cm.

Guise Bequest, 1765.

Dottoressa A. Griseri has pointed out to me that this picture is a close copy of one in the sacristy of Toledo Cathedral, which she believes to be by Luis de Vargas. The Toledo picture seems to be of better quality. Another copy of poor quality was sold at Sotheby's, Nov. 17 1965 (Lot 110).

Borenius compares the picture in the Corsini Gallery in Florence, no. 212, a variant of the same composition, by an imitator of Sebastiano del Piombo. The figure of Christ derives from Sebastiano's picture in the Prado (no. 348).

Literature: 'A' Cat., 1776, p. 8; 1833 Cat., no. 215 (both as F. Vanni); Borenius Cat., 1916, no. 198.[1]

1. Berenson's 1932 Lists give this no. as 'Jacopo da Montagnana', but surely in mistake for Borenius no. 183, no. 74 of the present catalogue.

VI

NETHERLANDISH, GERMAN, FRENCH AND ENGLISH PAINTERS

HUGO VAN DER GOES
c. 1440–82

Became a Master in Ghent 1467, and worked chiefly in that city. He entered the Roode Monastery near Brussels in 1475, and died there. His most important and only documented surviving work is the magnificent altarpiece now in the Uffizi in Florence, painted for the Florentine Tommaso Portinari, the representative of the Medici in Bruges (*c.* 1475). All other paintings by him are attributed by comparison with this. His most important drawing, *The Meeting of Jacob and Rachel*, is in the Guise Collection at Christ Church.

231. THE VIRGIN AND ST. JOHN, and part of the figure of Christ (fragment of *The Lamentation for Christ*). Tempera on linen, varnished, 42 × 46·1 cm. Plate 155

Fox-Strangways Gift, 1828.

The 1833 Catalogue, attributing the picture to Mantegna, states that this is 'the fragment of a picture saved from a fire in the Durazzo Palace at Genoa'. It is certainly part of a much repeated composition of *The Lamentation for Christ* (see Figure 50), of which more than thirty copies exist;[1] it is surely the earliest of the known versions, and in spite of the adverse judgments of Friedländer and Winkler, I still believe, with Destrée and Arndt,[2] that it has a good claim to be considered a fragment of the original. It is admittedly much rubbed throughout, gravely damaged especially at the upper L. and lower R. corners and through the fingers of the Virgin, and much darkened by varnish.

Otto Benesch was the first to draw attention to the pen drawing of the whole composition in the Albertina, Vienna (Cat. II, *Niederländische Schulen*, 1928, no. 18) (Plate 155[a]), which he supposes was done directly from a lost original. Winkler (see below, 1964, p. 130), accepting this (and adding the ingenious suggestion that the drawn copy may be the work of Pieter Bruegel the Elder), is inclined to condemn the Christ Church fragment by comparison with the drawing, pointing to various details which seem in the drawing, though it is so much smaller, to be better under-

stood: particularly the folds in the headdress of the Virgin, and her hands. There exist, however, photographs of the painting taken during and after restoration in 1946; and these show that precisely in these parts the painting was either rubbed (the Virgin's headdress) or badly damaged (her hands), and has in the latter case been wrongly restored. It is unlikely that Arndt had access to these photographs, but he no doubt saw the painting, after restoration, at Bruges in 1956 or at the Matthiesen Gallery in London in 1960; and in any case his observations on its condition are entirely correct. The restoration was carefully and skilfully carried out by the late Horace Buttery, and had his attention been drawn at the time to the Albertina drawing, he might have avoided those misinterpretations which Winkler so acutely observed. As to Winkler's preference for the face of the Virgin in the drawing, with her turned-down mouth, I can only protest the contrary opinion: the rendering of the mouth, and indeed of the features generally, seems to me infinitely more dignified and expressive in our painting.

Exhibited: Manchester, 1857, *Art Treasures*, no. 408; Bruges,

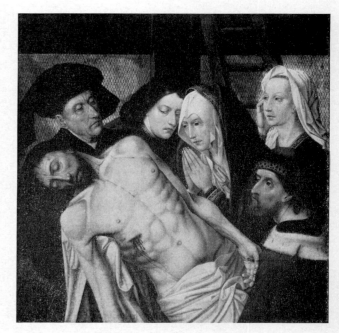

Fig. 50. Copy of Hugo van der Goes: *The Lamentation for Christ*. Hartford, Conn., Wadsworth Atheneum (*Cf.* Cat. No. 231)

1. Besides those mentioned by Destrée and Friedländer, Winkler cites six more paintings.
2. Dr. Otto Pächt has recently expressed the same opinion.

1956, *Flemish Art from British Collections*, no. 13; Matthiesen Gallery, London, 1960, no. 6, pl. x; Agnew, 1963, *Horace Buttery Memorial Exhibition*, no. 29; Liverpool, 1964, no. 26.

Literature: 1833 Cat., no. 129 (as by Mantegna); Borenius Cat., 1916, no. 313 and pl. LVI.

M. J. Friedländer, Berlin *Jahrbuch*, xxv, 1904, p. 108; C. J. Holmes, *Burlington Magazine*, vol. 11, 1907, p. 328 (quoting Weale) (as Rogier van der Weyden); Durand-Greville, *Bulletin de l'Art*, Oct. 5 1907 (see also *Chronique de l'Art*, 1908, p. 20) (as Hugo van der Goes); J. Destrée, *L'Art flamand*, VIII, 1907, pp. 168–175 (as H. van der Goes), and *Hugo van der Goes*, Brussels, 1914, pp. 46 *ss.*; M. J. Friedländer, *Altniederländische Malerei*, vol. IV (1926), p. 130, 23C ('*irrtümlich als Fragment des Originals betrachtet*'); F. Winkler, *Hugo van der Goes*, Berlin, 1964, pp. 129–130 and fig. 96; K. Arndt, *Münchner Jahrbuch*, XV, 1964, pp. 63 *ss.*

THE MASTER OF DELFT
Dutch School, early XVI Century

232. THE DEPOSITION OF CHRIST; in the middle distance L., Christ carried to the Tomb; in the background L., two Maries approaching the Tomb; and background centre, Christ appearing to the Magdalen. Panel (oak), 117 × 101·8 cm. Plates 156–157

Presented to Christ Church by the Rev. William Vansittart, 1833.

Friedländer's attribution of this panel to the Dutch artist whom he names the Master of Delft seems certainly the right one. The name derives from an altarpiece in which Dirck van Beest, Burgomaster of Delft, appears as donor; the painter's best surviving work is perhaps the triptych in the National Gallery (no. 2922).

Cleaned by H. Buttery in 1946 and again by J. C. Witherop in 1965. The panel consists of three planks, and there is restoration along all the joints, particularly in the centre and at lower R. (the two children). Other parts are in excellent condition.

Exhibited: Royal Academy, 1952–53, no. 45; Liverpool, 1964, no. 30.

Literature: Borenius Cat., 1916, no. 330 and pl. LXI (as Dutch School, *c.* 1500).

M. J. Friedländer, *Altniederländische Malerei*, vol. X (1932), p. 127, no. 64.

DUTCH SCHOOL
c. 1520

233. A FATHER AND TWO SONS PRAYING. Panel, 42 × 46·1 cm. Plate 158

Guise Bequest, 1765.

The figures recall in some respects those of the donors in various altarpieces by the Haarlem painter Jan Mostaert (*c.* 1475–1555/6); on whom see Friedländer, *Altniederländische Malerei*, vol. x, 1932. The painting is of good quality, though the faces are rubbed and there is damage generally. This might be the L. wing of a small altarpiece. The frame, however, which is of exquisite workmanship, appears to be nearly contemporary. A strip of wood about 4 cm. deep has been added at the top, perhaps later than the original painting; and the frame may have been made then.

Exhibited: Liverpool, 1964, no. 31.

Literature: 'A' Cat., 1776, p. 6; 1833 Cat., no. 248 (as Holbein); Borenius Cat., 1916, no. 331, pl. LXII (as Dutch School, first half of XVI century).

NETHERLANDISH SCHOOL
c. 1540

234. BUST PORTRAIT OF A MAN. Panel (oak), circular, diameter 45·5 cm. Plate 159

Guise Bequest, 1765.

Cleaned by J. C. Deliss in 1964 and found to be badly damaged, though evidently once of good quality. There is restoration throughout.

Literature: Borenius Cat., 1916, no. 317. Borenius' suggestion that this might be identified with 'A' Cat., 1776, p. 6: 'Another (head), in an oval frame, by Titian' seems unlikely; it might, however, be one of the two heads 'by Holbein' mentioned on pp. 5 and 8 of that catalogue.

JAN VAN SCOREL (?)
1495–1562

Born at Schoorl, became the pupil of Jacob Cornelisz van Oostsanen at Amsterdam, and later of Jan Gossaert (Mabuse) at Utrecht. 1519–21 he travelled to Germany (Nuremberg), Switzerland, Carinthia, Venice and the Holy Land, and was in Rome 1522–24, where he was appointed Director of the Belvedere by the Dutch Pope Hadrian VI. Returned to Holland 1524, and remained in the Netherlands, chiefly at Utrecht, for the rest of his life. He was the illegitimate son of a priest, and became a priest himself and Canon of Sainte-Marie at Utrecht. In 1550 (with Lancelot Blondeel) he restored Van Eyck's *Adoration of the Lamb* at Ghent.

235. A YOUNG MAN, HALF LENGTH, CARRYING GLOVES. Panel, 61·1 × 52·2 cm. Plate 161

Bequeathed to Christ Church by Dr. William Stratford (d. 1729).

Marked on the back in pen and ink with a monogram HR and no. 25. Pair to no. 236.

Walpole, in a letter to General Montagu of July 19, 1760, says that he discovered this and the companion-piece (no. 236) in an old buttery in Christ Church, and supposed (from the monogram on the back) that they belonged to Henry VII. They are, however, as Borenius remarks, certainly of later date, and in fact Walpole himself called them 'two of the most glorious portraits by Holbein in the world'. They were cleaned by H. Buttery in 1938, when the landscape backgrounds, which had been painted over, were revealed, and they were exhibited at the Royal Academy 1952–53 under the name of Jan van Scorel. In a composite review of this exhibition by various authorities (*Burlington Magazine, loc. cit.*) Professor J. G. van Gelder remarks that they are more likely to be by his contemporary, Dirk Jacobsz (Amsterdam, *c.* 1497–1567). Various group portraits (Guild-pieces) by Dirk Jacobsz exist, the earliest of 1529, the latest of 1563 (both at Amsterdam; Friedländer, *Altniederländische Malerei*, vol. XIII, p. 177, pls. LXXVIII and LXXIX). I know of none with such a background as those in the Christ Church pictures; on the other hand these backgrounds with their Roman ruins are very close in style to those both of Scorel and of Marten van Heemskerk. It was the opinion of Mr. A. E. Popham (given to me verbally, 1964) that our paintings are probably by Scorel; and certainly their resemblance to such portraits as the *Bare-headed Man* in Berlin (no. 644B) or the *Man with a sleeping Dog* which was in the Chiesa Sale, New York, in 1925 (Friedländer, *op. cit.*, vol. XII, no. 370) is striking. No. 235 is badly rubbed and to some extent restored throughout.

Exhibited: Manchester, 1857, no. 506 (as Joos van Cleve); Royal Academy, 1952/53, no. 10; Liverpool, 1964, no. 14; Manchester, 1965, no. 83.

Literature: E.C. II, 44–45; 'A' Cat., 1776, p. 17; 1833 Cat., no. 244; Borenius Cat., 1916, no. 315 and pl. LVII. Walpole, *Letters*, IV, 409; *Anecdotes*, ed. Wornum, I, 63, no. 4; *Burlington Magazine*, vol. 95, February 1953, p. 33; G. J. Hoogewerff, *Jan Scorel*, 1923, p. 134 (quoting Friedländer, *Von Eyck bis Brueghel*, 2nd ed., 1921, p. 201) (there is no mention of these portraits in the English ed., Phaidon, 1956); M. J. Friedländer, *Altniederländische Malerei*, XII, 1924, p. 206, nos. 371, 372 ('*Ich konnte diese Gegenstücke nicht genau prüfen, anscheinend von Scorel*').

JAN VAN SCOREL (?)

236. A YOUNG MAN GESTICULATING WITH HIS R. HAND, nearly full face. Panel, 60 × 50·7 cm. Plate 162

Bequeathed to Christ Church by Dr. William Stratford (d. 1729).

Marked on the back in pen and ink with a monogram HR

and no. 22. Pair to no. 235. See note to no. 235. The condition of this panel is rather better.

Exhibited: Manchester, 1857, no. 507, as Joos van Cleve; Royal Academy, 1952/53, no. 18; Liverpool, 1964, no. 15.

Literature: E.C., II, 44–45; 'A' Cat., 1776, p. 17; 1833 Cat., no. 245; Borenius Cat., 1916, no. 316 and pl. LVIII. For later literature see note to no. 235.

NETHERLANDISH SCHOOL

c. 1550

237. A BOY LEARNING TO READ. Panel, 31·4 × 23·6 cm.

Guise Bequest, 1765.

This curious little picture, unusual in subject, but of poor quality in its present damaged state, is not described in any of the published catalogues.[1] It is probably the one bought by General Guise as lot 46 of the Menageot Sale, May 2 1755: 'A Boy learning to read. Titian, G¹ Guise' (no price given) (Houlditch MS.).

Not catalogued by Borenius, but allocated a number, 335.

FRANS FLORIS

1516–1570

Frans de Vriendt, called Floris, born and died in Antwerp; but visited Italy and was much influenced by Michelangelo and his followers. Pupil of Lambert Lombard, and master of Martin de Vos, Frans Pourbus and Frans Francken I.

238. DIANA AND ACTAEON. Brown monochrome, heightened with white, on parchment mounted on wood, 41·5 × 58·5 cm. Plate 166

Guise Bequest, 1765.

The large picture (Figure 51, 65 × 98 ins.) formerly in Lord Middleton's Collection, which Borenius considered to be the original of this, is reproduced by Friedländer, *Altniederländische Malerei*, vol. XIII, pl. XXXIII, as by Frans Floris, and that attribution is clearly correct.[2] The Christ Church monochrome is, however, by no means merely a copy of the larger picture; it is of very good quality, in some respects more graceful than the other, and differs considerably in detail: for instance, in the legs of the figures extreme R. and L., in the figures in the background, the form of the well, and the landscape.

Despite the attribution to Niccolò dell' Abbate, which persists throughout the old catalogues, and the un-Flemish elegance of the forms which are indeed reminiscent of that master, the simple explanation seems to be that this is

1. Unless it is 'A' Cat., 1776, p. 13, and 1833 Cat., no. 272 ('A Master and his Scholar, Gerhard Douw').

2. The picture was sold by Lord Middleton at Christie's, May 15 1925 (Lot 156, as Primaticcio), bought by Durlacher; and sold again at Christie's July 8 1938 (Lot 69, as Floris), bought by Howard.

Fig. 51. Frans Floris: *Diana and Actaeon*. Formerly in the collection of Lord Middleton. (*Cf*. Cat. No. 238)

Floris' preliminary sketch for the Middleton picture. Certain chiaroscuro woodcuts after Floris are comparable; also a drawing by him in chiaroscuro technique, now in the British Museum, of *Mercury and a Nymph*, which was exhibited in the Flemish Exhibition at the Royal Academy, 1927, cat. no. 555. Another painting of similar composition, attributed to the 'circle of Frans Floris', was with the firm of Benedict in Paris 1958 (photo, Netherlands Arts Institute, no. 17805).

The panel was mended and the painting lightly cleaned by J. C. Deliss in 1960. There is very little restoration.

Exhibited: Manchester, 1965, *European Art 1520–1600*, cat. no. 303.

Literature: L. & E., III, 23; E.C., II, 54; 'A' Cat., 1776, p. 2; 1833 Cat., no. 280 (always as Niccolò dell' Abbate); Borenius Cat., 1916, no. 125 (as copy of Niccolò).

ATTRIBUTED TO CORNELIS VAN CLEVE
1520–after 1554

239. THE ADORATION OF THE SHEPHERDS. Panel (oak), 85 × 64·5 cm. Plate 163

On the back of the panel is a seal, and the signature (in pen

and ink) of CROZAT (Pierre Crozat, the celebrated French collector, 1661–1740) with a cross.

Guise Bequest, 1765.

The composition of the lower part of the picture is freely derived (as Borenius pointed out) from one of the 'Raphael' tapestries of the Scuola Nuova in the Vatican. Mr. P. M. Pouncey suggests a near relationship to Giulio Romano, who was probably largely responsible for the cartoons of the Scuola Nuova tapestries; and in fact the forms, of the upper part particularly, are close to his. The effect of light is remarkable, and the picture is clearly by a good hand. But the painting is on oak, and Borenius was surely right in thinking that it is by a Netherlandish follower of Raphael. The same figures, including those of the upper part, but with different architecture, appear in a narrow upright panel (one of a pair of altar-wings) by Lambert Lombard in the Bob Jones University, Greenville, S.C. (Cat., vol. II, 1962, no. 142, reproduced). The types, however, in the Christ Church picture are noticeably different, and it seems unlikely to be by Lombard, though he was in Rome 1537–38 at the age of thirty-two. Georges Marlier (*Érasme et la peinture flamande de son temps*, Damme, 1954) refers to other contemporary versions of the composition by the Master of the Prodigal Son.

Dr. Vitale Bloch suggested to me in July 1966 that the

I

painter was Cornelis van Cleve (1520–after 1554), the son of the celebrated Antwerp master Joos van Cleve. Earlier authorities, including Van Mander, confused his history with his father's, and Carl Justi (Berlin *Jahrbuch*, xvi, 1896, p. 13 *ss.*) distinguished a group of paintings which he attributed to a supposed Joos van Cleve the younger, in which the influence of Raphael is predominant. It is this group, considerably enlarged, which Friedländer (*Altniederländische Malerei*, xiv, 1937, pp. 115–118) gave to Cornelis, who visited England in 1554, and went mad in this country.[1] Friedländer (*loc. cit.*) gives a list of twenty-eight paintings which he believes to be by him; several of these – particularly the *Adoration* at Dresden (Friedländer, no. 1) and the later version of the same composition at Sarasota (*ibid.*, no. 24) – seem to support Dr. Bloch's attribution of the Christ Church picture, so far as can be judged from reproductions; and another *Adoration of the Shepherds*, in the Royal Collection, at present exhibited at Hampton Court,[2] might well be by the same hand.

Cleaned by J. C. Deliss, 1960. There is not much restoration.

Literature: 'A' Cat., 1776, p. 10; 1833 Cat., no. 189 (both as B. Peruzzi); Borenius Cat., 1916, no. 88 (as by an imitator of Raphael).

ATTRIBUTED TO BARTOLOMEUS SPRANGER
1546–after 1625

Bartolomeus Spranger, born at Antwerp, visited France and Italy early in his career, and was much influenced by the Florentine and Roman Mannerists. He was in Parma in 1566. Called to Vienna 1575, as Court Painter to the Emperor Maximilian II, and from then onwards worked for him and for Rudolf II, at Vienna and Prague, where he died.

240. FAITH, HOPE AND CHARITY. Panel, 48·8 × 36·4 cm.
Plate 164

Probably Guise Bequest, 1765 (not identified in the early catalogues).

Borenius describes the subject as *The Virgin and Child with the Infant St. John, two other Saints and an Angel*, but the figure on the L., holding an anchor, is certainly Hope, the centre figure (though apparently male) is surely intended for Faith (with the chalice, and a vision overhead), and Charity, on the R., is represented as usual with three children.

The facial types, the hands, the draperies, are all in the style of Spranger at an early date, before he was called to Vienna

in 1575 at the age of twenty-nine. The hint of Florentine influence (Pontormo, Rosso) in the figure of Hope, the stiff-legged pose of Faith, and the Herculean proportions of the infant reclining in the foreground, are characteristic. Cleaned by J. C. Deliss in 1959, and found to be much damaged by rubbing.

Literature: Borenius Cat., 1916, no. 254 (as Italian School, second half of XVI century).

NETHERLANDISH SCHOOL, LATE XVI CENTURY

241. THE TRIUMPH OF SILENUS. Monochrome, on panel, 34·2 × 46·8 cm.
Plate 165

Guise Bequest, 1765(?)

Omitted by Borenius in his printed catalogue, 1916, though provisionally numbered 286.

An extremely mannered sketch *en grisaille*, almost certainly by a Netherlandish artist working in Italy, and much influenced by Parmigianino. It may be recalled that Bartolomeus Spranger was in Parma, working in the church of the Steccata under Bernardino Gatti early in 1566; but his style during his Italian period was hardly as mannered as this (*cf.* no. 240).

The panel was much damaged and split in two parts horizontally, but was mended and restored by J. C. Deliss in 1965/66.

NETHERLANDISH SCHOOL
c. 1580–1600

242. A PANORAMA OF VENICE FROM THE LAGOON. Canvas, 66 × 193 cm.
Plate 167

Provenance unknown.[3]

The picture, which has hung in the Deanery for some years, is a good early example of a kind of view-painting produced by Northern artists in Venice from the late XVI century onwards, which contributed to the development of the typical Venetian *Veduta* at the beginning of the XVIII century (see W. G. Constable, *Canaletto*, 1962, vol. I, ch. II). The engraving of the Molo and the Piazzetta seen from the Bacino di San Marco, signed and dated 1585 (as after his own design) by the Antwerp artist Lodewyk Toeput, called Pozzoserrato, who settled in Treviso and achieved some distinction as a landscape painter and draughtsman, is an example of about the same date. Later

1. According to E. P. Richardson (*Detroit Bulletin*, xviii, 1938) he returned to Antwerp in 1560 and died only in 1567.
2. Formerly at Windsor Castle, Collins Baker Cat., 1937, p. 57, attributed to Cornelis van Cleve, repr. Friedländer, *op. cit.*, xiv, pl. xxviii.

3. Lot 21 in the Earl of Halifax's sale March 6–10 1739/40 (1740 N.S.), 2nd day, was 'Two long Views', and lot 22 was 'One ditto, of Venice' (Houlditch MS., in this case without buyers' names). If this last was our picture, as seems possible, no. 242 came almost certainly from the Guise Bequest, 1765.

examples in painting by Giuseppe Heintz the younger, dated towards the middle of the XVII century, are cited by Constable.

The scene is taken from the waterfront of the island of S. Clemente, that is, approximately below the imaginary viewpoint of the famous woodcut plan of Venice by Jacopo dei Barbari, dated 1500 (see G. Mazzariol and Terisio Pignatti, *La pianta prospettiva di Veneiva del 1500*, 1963, p. 10, note 13, and pl. 18). Our painter seems, however, not to have made use of that source, and his topography is much less exact. The island of S. Giorgio Maggiore, compressed to smaller dimensions, is in the foreground just R. of centre, and the Giudecca, divided by canals, to the L. The Piazzetta, the Campanile of S. Marco, the Clock Tower and the Doges' Palace are more or less accurately recorded in the centre, but the buildings along the waterfront to R. and L. must be to some extent fanciful – for instance, those immediately to the L. of the Piazzetta, which do not correspond either to those in Barbari's woodcut or to the present Library and Mint, which were finished in 1588, about the time when the Christ Church picture must have been painted. To the R. are many gondolas, accompanying the Bucintoro, the Doge's state barge, apparently on its way to the Lido.

The picture was cleaned and restored by H. Buttery about 1954. It is badly damaged throughout, and much darkened by the old varnishes, but is still of considerable charm and interest.

NETHERLANDISH SCHOOL, LATE XVI CENTURY

243. THE ADORATION OF THE SHEPHERDS. Canvas, 116 × 127 cm. Figure 52

Guise Bequest, 1765.

Catalogued as Venetian by Borenius, and certainly showing Venetian influence, but surely by a Northern artist. The little girl pointing on the R., and looking straight out of the picture, must be a portrait, perhaps of the artist's daughter.

Re-lined and cleaned by J. C. Deliss, 1965. In spite of much local damage from flaking, the general condition is now tolerably good.

Literature: Borenius Cat., 1916, no. 218 (as Venetian School, *c.* 1550). Not identifiable in the earlier catalogues.

NETHERLANDISH SCHOOL

c. 1600

244. SOLOMON RECEIVING THE QUEEN OF SHEBA. Monochrome on parchment, laid on wood, 28·5 × 41·9 cm.

Fig. 52. Netherlandish School, late XVI century: *The Adoration of the Shepherds* (Cat. No. 243)

Guise Bequest, 1765.

A *grisaille* sketch somewhat in the manner of Otto van Veen (1556–1629), who was Rubens' master in Antwerp from 1596 to 1600. The Italian influence is evident.

The panel was so damaged by damp that a section about 11 cm. wide had to be cut from the R. hand side. The rest was restored by J. C. Deliss in 1966.

Literature: 'A' Cat., 1776, p. 2; 1833 Cat., no. 46 (both as Paul Veronese); Borenius Cat., 1916, no. 235 (as Venetian, second half of the XVI century).

SIR ANTHONY VAN DYCK

1599–1641

Born at Antwerp, by far the most gifted pupil of Rubens. In London in the service of King James I by November 1620, perhaps by the recommendation of the Earl of Arundel. Permitted by the King to travel for eight months from February 1621, he stayed in Italy, chiefly in Genoa, until 1627, and then returned for five years to Antwerp; but in 1632 he returned to London, and became the favourite painter of Charles I. Knighted July 5 1632. Died in London, buried in St. Paul's. The cool, formal style of his English portraits is far removed from that of his brilliant early work in Antwerp and Genoa.

245. THE CONTINENCE OF SCIPIO. Canvas, 183 × 232·5 cm. (since removal of later additions in 1949). Plate 168

Bequest of Lord Frederick Campbell, 1809. Perhaps from the collection of George Villiers, 1st Duke of Buckingham. Engraved in mezzotint by T. Miller after a drawing by

R. Earlom, 1766, when in possession of the 4th Duke of Argyll.

Gustav Glück was the first to point out that an entry in the inventory of the 1st Duke of Buckingham's pictures at York House in 1635[1] may refer to this picture ('one Great Piece being Scipio'). Mr. Oliver Millar remarks (see below, *loc. cit.*) that if it was painted for the Duke, who died in 1628, it may have been done during van Dyck's first visit to England, 1620–21. Although rejected by Smith, and catalogued by Borenius as School of Rubens, it was previously attributed to van Dyck, and it can hardly be doubted that it is an important original of very early date, perhaps earlier than suggested by Glück, who placed it in van Dyck's Italian period (1622–27). The splendid figure of the nude man, stooping to lift a gold vase at lower R., is certainly very reminiscent of Rubens, but so far as I can see is not a direct derivation from that master. Dr. Horst Vey notes a general connexion with Rubens' painting of the same subject, destroyed in 1836, but engraved by Bolswert (Rooses, *Œuvre de P. P. Rubens*, 1890, vol. 4, no. 809 and pl. 257); and that the composition is inspired by Rubens can hardly be doubted.[2] The drawing of the hands – which make great play in the centre of the composition – is the least satisfactory part of the picture in its present state; but there are passages of great brilliance throughout. Mr. R. M. D. Thesiger observes that the head of the husband has the look of a portrait.

Ludwig Burchard (quoted by O. Millar) drew attention to another version with some variations formerly in the collection of Prince Dietrichstein; and Glück to related drawings in Paris and in Bremen (Vey, *op. cit.*, 1962, nos. 106, 107 and pls. 141, 142). Neither of these corresponds at all closely to our painting, but both must be of the same early date.

The picture was cleaned by H. Buttery, and false strips were removed from the top and R. side, in 1949. The condition is tolerably good, though the impasto is flattened by re-lining.

Exhibited: Royal Academy, 1953/4, no. 227; Liverpool, 1964, no. 16.

Literature: 1833 Cat., no. 164 (as van Dyck); Borenius Cat., 1916, no. 321 and pl. LIX (as School of Rubens). J. Smith, *Catalogue raisonné*, III, 1831, p. 112, no. 404 ('improperly ascribed to van Dyck'); G. Glück, in *Zeitschrift für bildende Kunst*, Beilage, Oct. 1927, *Heft* 7, pp. 72–73, and *Van Dyck* (*Klassiker der Kunst*), 1931, 140; O. Millar, in *Burlington Magazine*, vol. 93, 1951, pp. 125–126; H. Gerson and E. H. Ter Kuile, *Art and Architecture in Belgium, 1600–1800* (Pelican History of Art), 1960, p. 113 and pl. 97[a]; Horst Vey, *Die Zeichnungen Anton van Dycks*, 1962, I, pp. 177–178.

1. See Randall Davies in *Burlington Magazine*, vol. 10, 1906–7, pp. 376–382.

2. Compare especially Rubens' drawing of the same subject at Bayonne, and other related material, published by Agnes Czobor in *Burlington Magazine*, vol. 109, June 1967, p. 351 *ss*.

SIR ANTHONY VAN DYCK

246. A SOLDIER ON HORSEBACK. Nearly monochrome, on canvas, 91 × 55 cm. Plate 171

Guise Bequest, 1765.

Glück (*loc. cit.*) considers this brilliant sketch, which is of exceptional size, to be a study for the horseman on the extreme R. of one of van Dyck's earliest works, *The Martyrdom of St. Sebastian* in the Louvre (Glück, *Klassiker der Kunst*, 1931, 5), which he dates *c.* 1615–16. The horse's head does in fact correspond.

The late W. G. Hiscock drew my attention to a replica, nearly of the same dimensions, belonging to Sir Evelyn de la Rue at Cookham-on-Thames.

There are some scratches and abrasions, but on the whole the condition is good.

Exhibited: Manchester, 1857, no. 585; Antwerp and Rotterdam, 1960, *Antoon van Dyck, Tekeningen en Olieverfschetsen*, no. 123; Liverpool, 1964, no. 17.

Literature: 'A' Cat., 1776, p. 3; 1833 Cat., no. 160; Borenius Cat., 1916, no. 323 and pl. LX. Glück, *Klassiker der Kunst, Van Dyck*, 1931, 4; H. Vey, *Bulletin Brussel*, 1956, pp. 168–169, fig. 2; R. d'Hulst and H. Vey, Cat. of Antwerp/Rotterdam Exhibition, no. 123 and pl. LXXIII.

SIR ANTHONY VAN DYCK

247. THE MARTYRDOM OF ST. GEORGE. Monochrome on panel, 44·6 × 36·3 cm. Plate 170

Guise Bequest, 1765.

D'Hulst and Vey (*loc. cit.*) date the sketch to the beginning of van Dyck's second Antwerp period. They refer to another of the same subject in Bayonne (*Klassiker der Kunst*, 253), and to one in Detroit (*ibid.*, 252) which they consider to be by an imitator.

Cleaned by H. Buttery, 1938. There is some loss of paint, and small restorations are noticeable throughout.

Exhibited: Royal Academy, 1953/54, no. 493; Antwerp and Rotterdam, *Antoon van Dyck, Tekeningen en Olieverfschetsen*, 1960, no. 128; Liverpool, 1964, no. 18.

Literature: 'A' Cat., 1776, p. 4; 1833 Cat., no. 279; Borenius Cat., 1916, no. 324. Glück, *Klassiker der Kunst, Van Dyck*, 1931, 252; H. Vey, *Bulletin Brussel*, 1956, pp. 194–197 (pl. 19); R. d'Hulst, and H. Vey, Cat. of Antwerp/Rotterdam Exhibition, 1960, no. 128 and pl. LXXVII.

SIR ANTHONY VAN DYCK

248. MARS GOING TO WAR. Monochrome on panel, 30 × 43·5 cm. Plate 169

Inscribed in pen, in a contemporary hand, lower L.: .. *n van Dycke*.

Presumably Guise Bequest, 1765.

The catalogue of the Antwerp/Rotterdam Exhibition relates this sketch to the much larger picture at Vienna, *Venus at the Forge of Vulcan* (Klassiker der Kunst, 1931 ed., 263), to which the composition seems to form a sort of *pendant*. The date may be soon after 1630.

The subject of the present sketch was formerly interpreted as *Venus disarming Mars*, but d'Hulst and Vey (*loc. cit.*) suppose that the god is here departing for war and that the attendant cupids are helping to arm him. They seem to

Fig. 53. Follower of Van Dyck: *Mars returning from War*. Black chalk, heightened with white. Berlin, Print Room (*Cf.* Cat. No. 248)

suggest that a drawing in the Berlin Print Room (Bock-Rosenberg, Cat. I, p. 127, no. 1333) (see Figure 53), though it can hardly be by van Dyck himself, is a reminiscence of a lost *pendant* to our composition, representing the god's return. It is true that in our painting the cupids on the L. might be supposed to be leading the horse forward, whereas in the Berlin drawing they are clearly leading him away; but the actions of the winged genius and the other cupid in the painting might equally well be interpreted in the opposite sense – as disarming rather than arming – a more congenial task, it might be thought, for the servants of Venus. It seems to me not impossible that the older interpretation of the subject was the right one, and that both the Christ Church sketch and the Berlin drawing represent variations on the same theme – *Mars returning from War*.

The sketch is of very good quality, and in better condition than no. 247. It was probably cleaned at the same time (by H. Buttery, 1938).

Exhibited: Antwerp and Rotterdam, 1960, *Antoon van Dyck, Tekeningen en Olieverfschetsen*, no. 130; Liverpool, 1964, no. 19.

Literature: Borenius Cat., 1916, no. 325.

 H. Vey, *Bulletin Brussel*, 1956, p. 197, pl. 22; R. A. d'Hulst and H. Vey, Catalogue of Antwerp/Rotterdam Exhibition, 1960, no. 130 and pl. LXXVIII.

FLEMISH SCHOOL, EARLY XVII CENTURY

249. BUST OF A YOUTH WITH SHORT HAIR. Panel, 36·7 × 33·4 cm.

Guise Bequest, 1765.

The painting may once have had some quality, and seems to show traces of Rubens' influence, but was largely repainted and found to be in ruined condition when tested by J. C. Deliss, 1964. The ruff and background are entirely false, but only the pinkish-grey ground was revealed underneath.

There are inscriptions on the back, possibly of the XVII century: 'Gerrit van C——', with another illegible name below (possibly the name of the sitter); and (upside down) 'Marini fe' (?).

Literature: Borenius Cat., 1916, no. 328. Identified by Borenius with 'A' Cat., 1776, p. 13 ('An head, by Abraham Johnson'), and 1833 Cat., no. 241 ('Head, Abraham Jansens'); but this seems uncertain.

NETHERLANDISH (?) SCHOOL, MID XVII CENTURY

250. PORTRAIT OF A GENERAL, half length. Canvas, 118·7 × 92·2 cm. Figure 54

Guise Bequest, 1765.

A portrait of indifferent quality, difficult to attribute more exactly. The orange scarf and plume no doubt suggested the identification of the sitter, in the 'A' Catalogue of 1776 and the 1833 Catalogue, as 'the first Prince of Orange', but he does not resemble any of the princes of that house portrayed by Miereveld and his school.

Literature: Perhaps L. & E., III, 20; E.C., II, 51 ('a General half-length') (these entries are referred by Borenius to no. 80 of the present catalogue); 'A' Cat., 1776, p. 11; 1833 Cat., no. 243; Borenius Cat., 1916, no. 327 (as Flemish School, XVII century).

Mrs. Lane Poole, *Oxford Portraits*, III, 1925, pp. 13–14, no. 33 (as ? William of Orange).

DUTCH SCHOOL, XVII CENTURY

251. BUST PORTRAIT OF A BEARDED MAN, in a falling white collar, nearly full face. Panel (oak), 43·5 × 29·1 cm.

Probably Guise Bequest, 1765, but not identifiable in the early catalogues.

Much damaged, and of poor quality. On the back is an XVIII century label: 'Within one foot and pays no duty' – apparently a certificate for customs purposes.

Literature: Borenius Cat., 1916, no. 334.

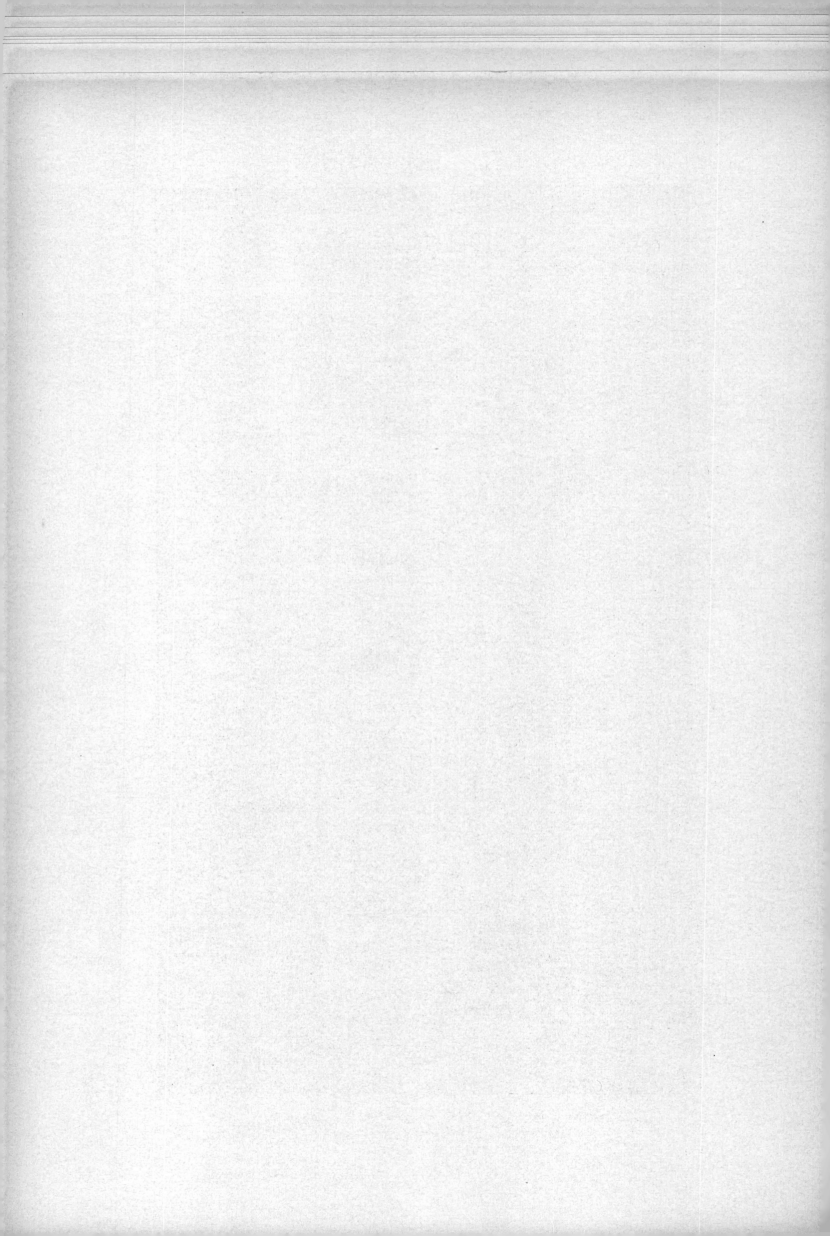

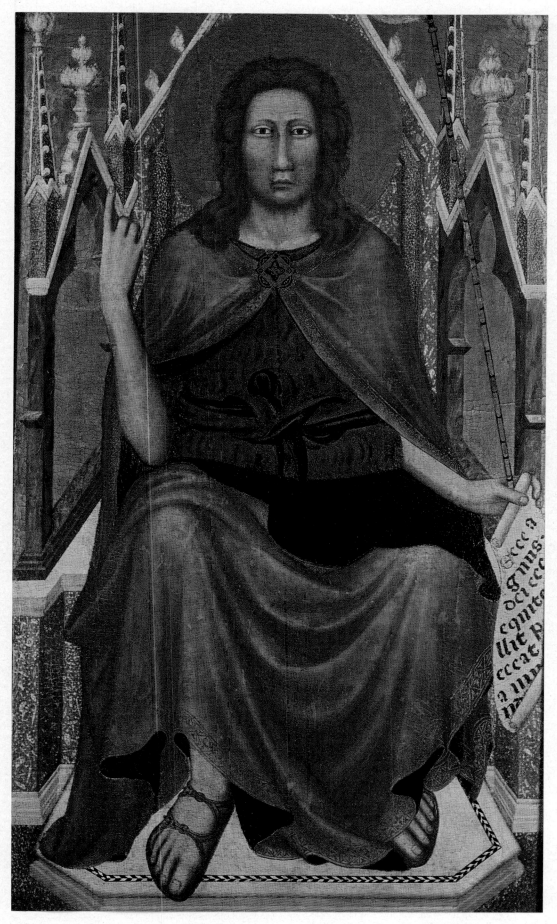

1. Florentine School, first years of the XIV century: *St. John the Baptist enthroned* (Cat. No. 4)

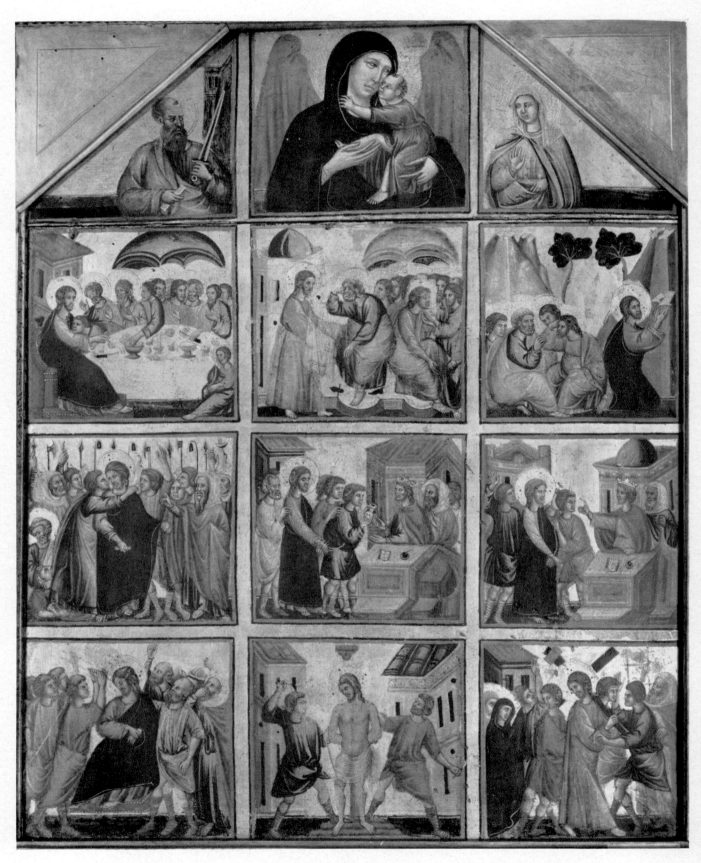

2. Tuscan School, early XIV century: *Small Altarpiece with nine Scenes from the Passion* (Cat. No. 2)

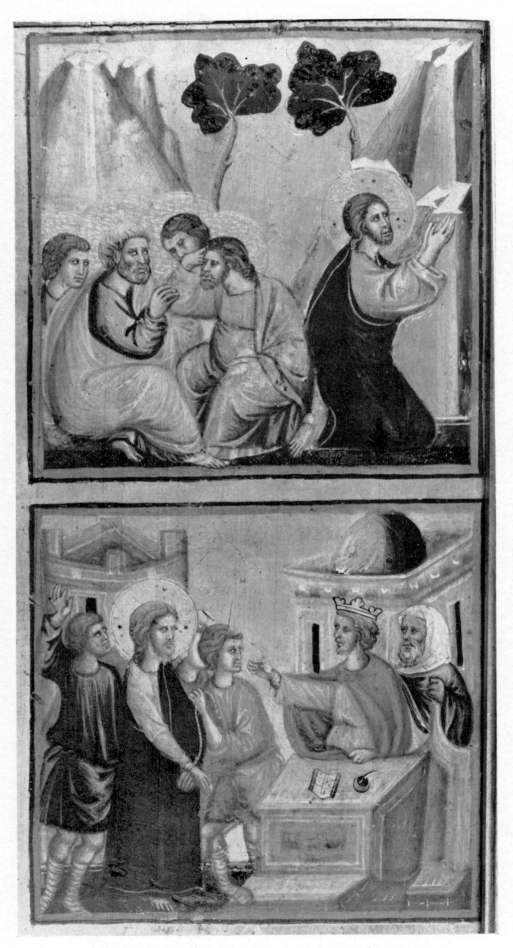

3. *The Agony in the Garden; Christ before Pilate.* Detail from plate 2

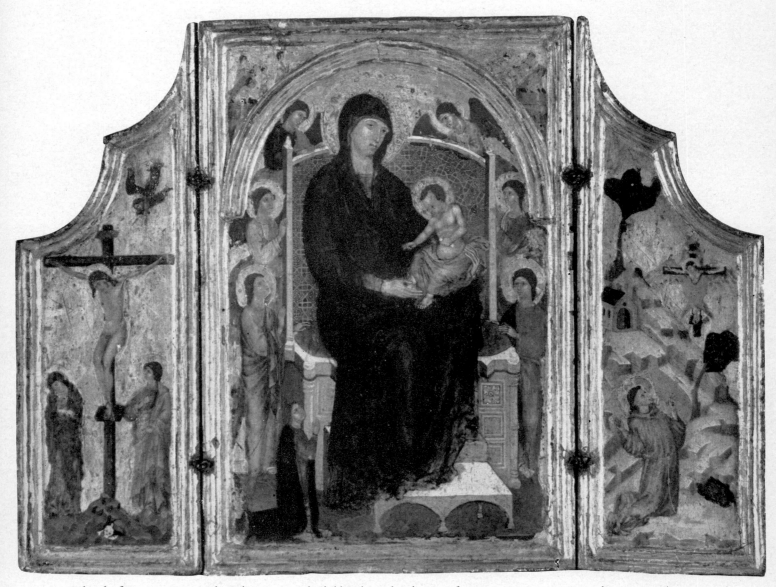

4. School of Duccio: Triptych: *The Virgin and Child enthroned; The Crucifixion; St. Francis receiving the Stigmata* (Cat. No. 3)

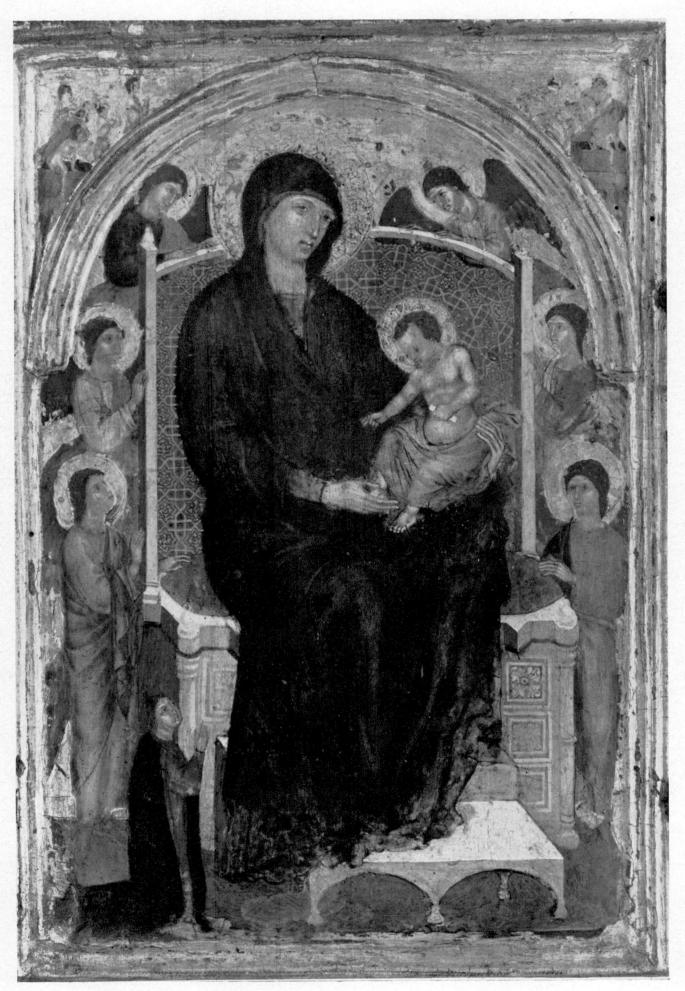

5. *The Virgin and Child enthroned with six Angels and a Donor.* Detail from plate 4

6. Detail from plate 7

7. Florentine School, c. 1340-1350: *Four musical Angels at the Foot of a Throne* (Cat. No. 5)

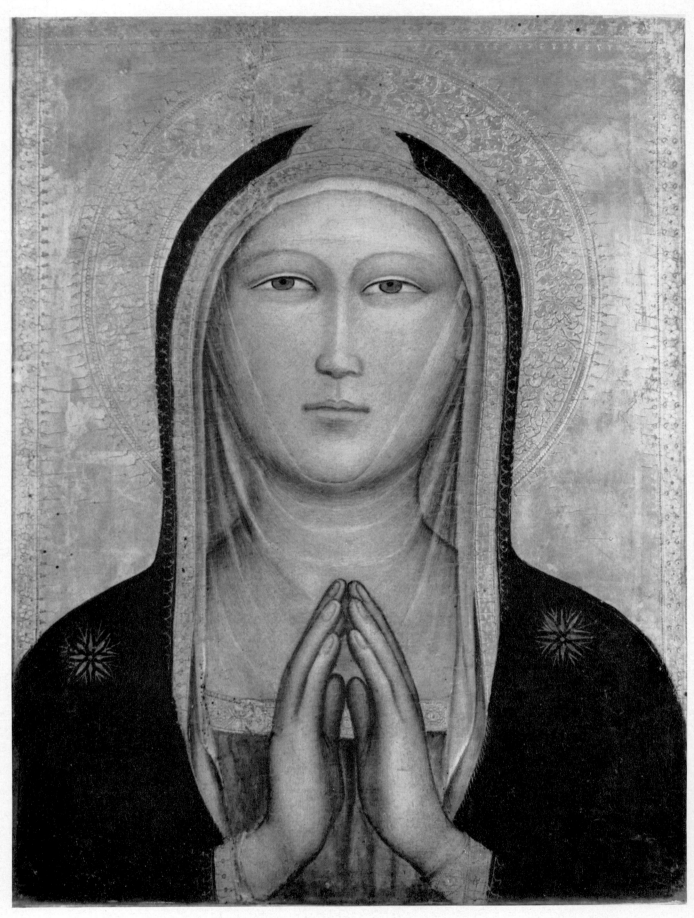

10. Niccolò di Pietro Gerini: *The Virgin with Hands joined in Prayer* (Cat. No. 8)

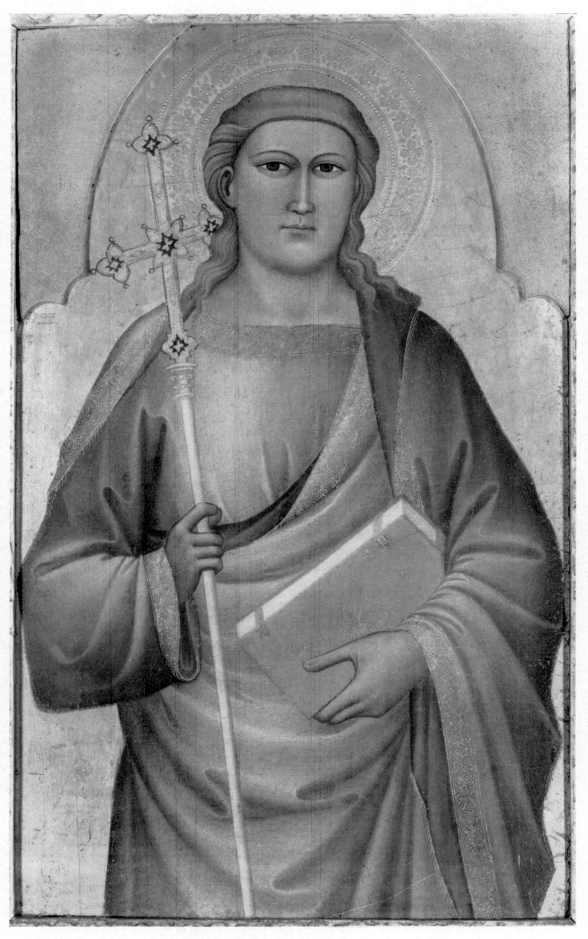

11. Niccolò di Pietro Gerini: *St. Philip with Cross and Book* (Cat. No. 9)

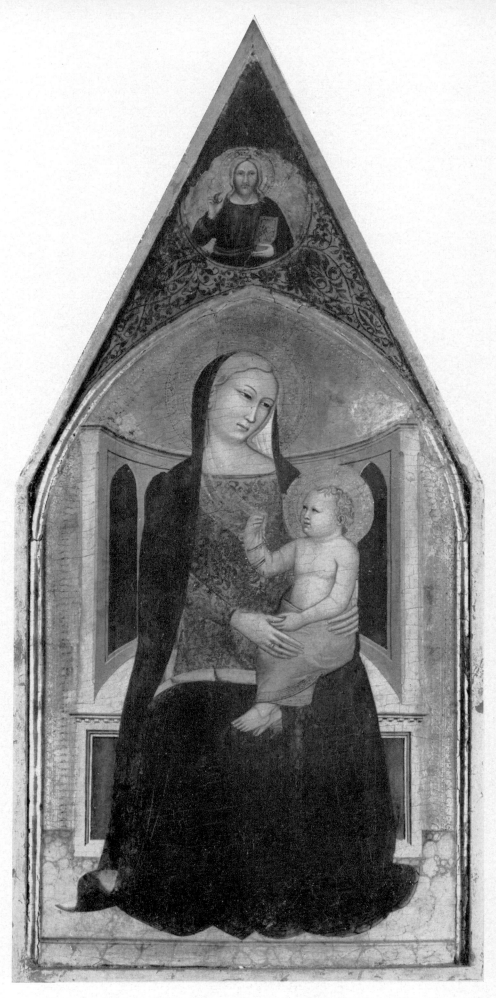

12. Tuscan School, late XIV century: *The Virgin and Child enthroned* (Cat. No. 11)

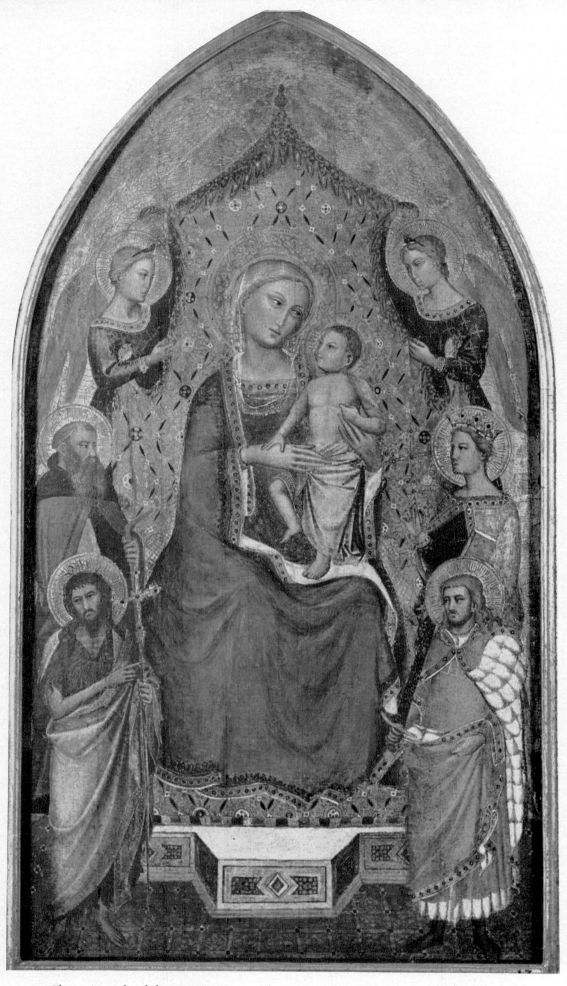

13. Florentine School, late XIV century: *The Virgin and Child enthroned with St. Margaret(?),*
St. Julian, St. Anthony Abbot and St. John Baptist (Cat. No. 16)

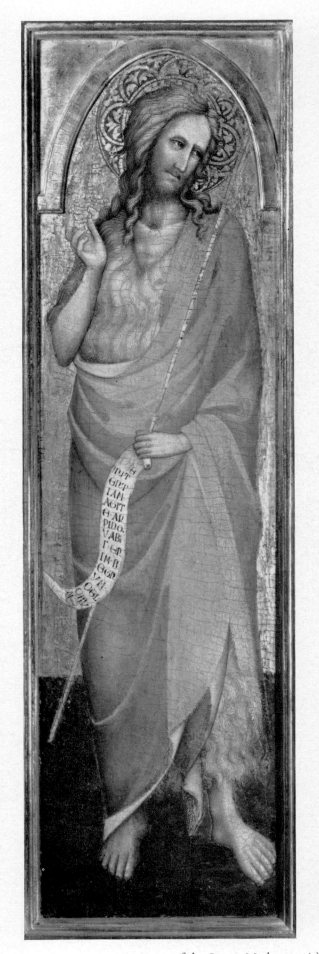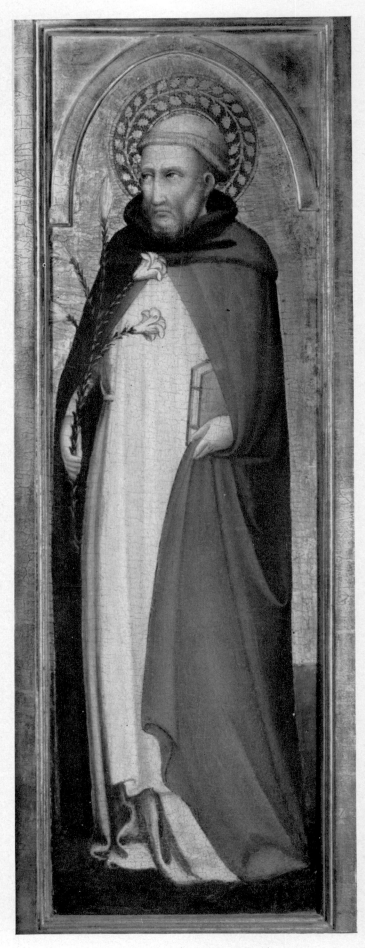

14. Master of the Straus Madonna: (a) *St. John Baptist;* (b) *St. Dominic* (Cat. Nos. 14-15)

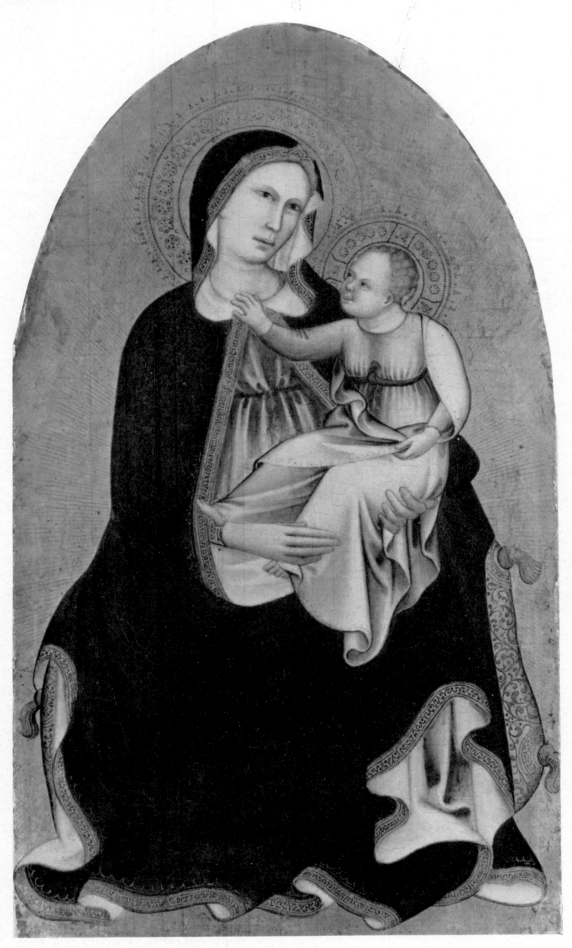

15. Tuscan School, early XV century: *Madonna of Humility* (Cat. No. 17)

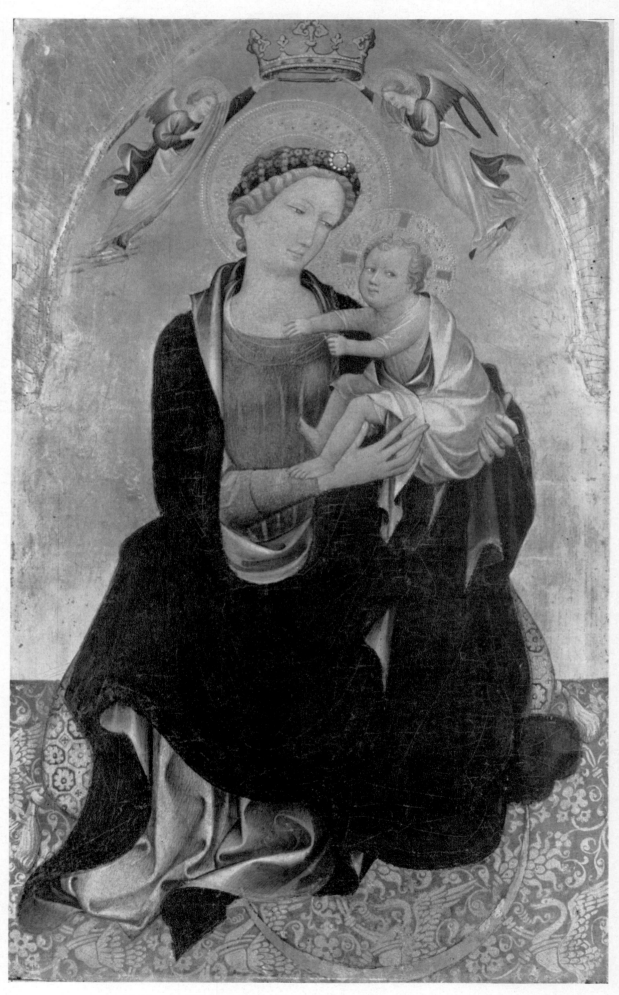

16. Master of the Bambino Vispo: *Madonna of Humility* (Cat. No. 18)

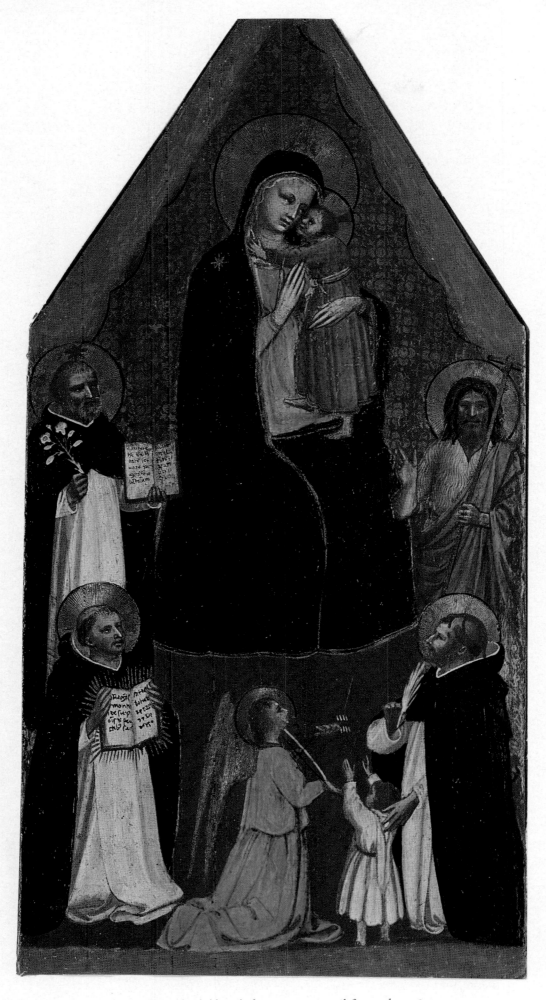

17. *The Virgin and Child with four Saints*. Detail from plate 18

18. Studio of Fra Angelico: Small Triptych: *The Virgin and Child with four Saints; Christ carrying the Cross; Christ crucified with the Magdalen and a Dominican Beata* (Cat. No. 20)

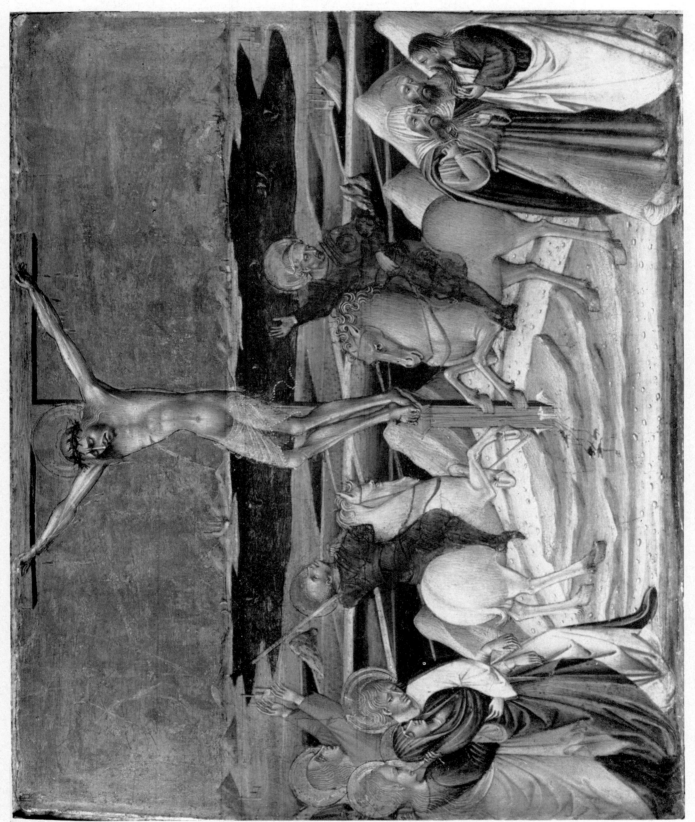

19. Giovanni di Paolo: *Calvary* (Cat. No. 30)

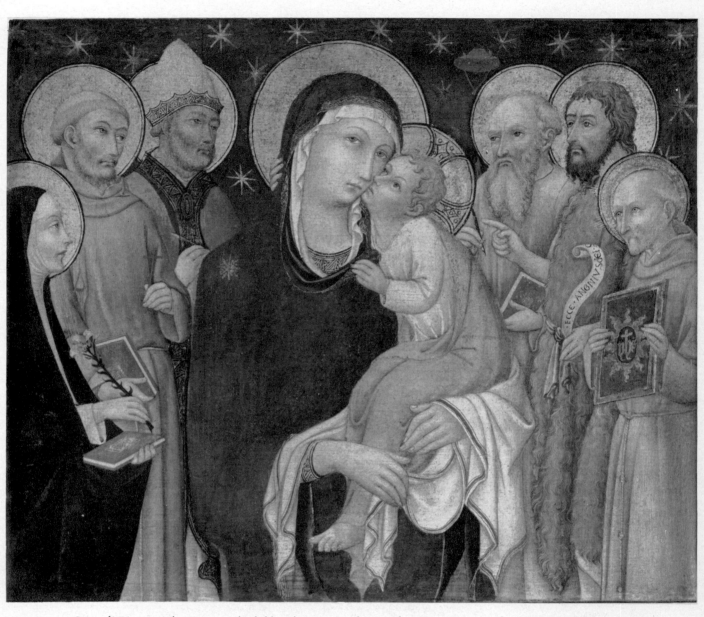

20. Sano di Pietro: *The Virgin and Child with Saints Catherine of Siena, Francis, Ambrose, Jerome, John the Baptist and Bernardin of Siena* (Cat. No. 31)

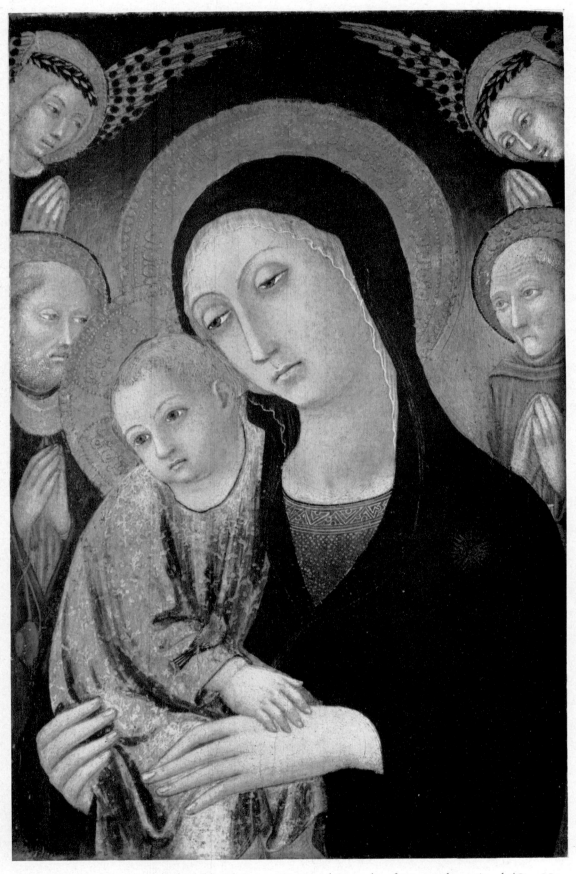

21. Sano di Pietro: *The Virgin and Child with Saints Jerome and Bernardin of Siena and two Angels* (Cat. No. 32)

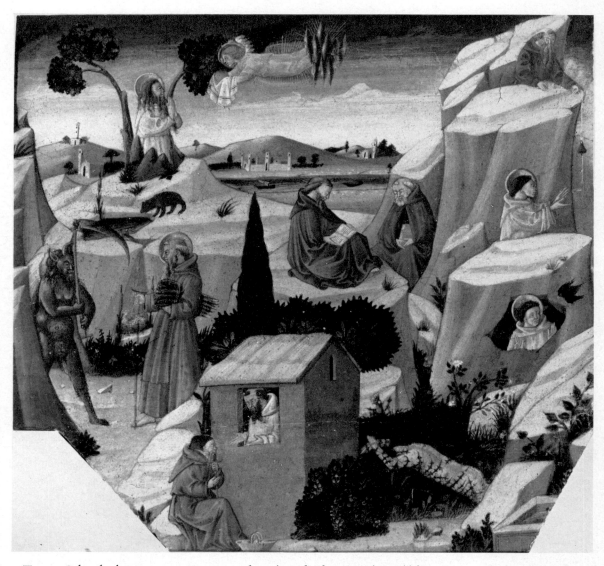

22. Tuscan School, about 1440–1450: *Scenes from the Life of St. Benedict, Abbâ Macarius and others* (Cat. No. 21)

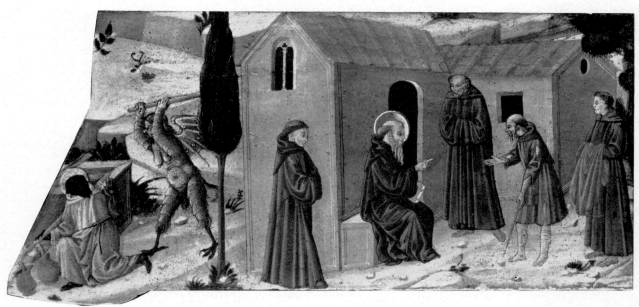

23. Tuscan School, about 1440–1450: *Abbâ Moses the Indian assaulted by the Devil, and a sainted Hermit receiving a Beggar* (Cat. No. 23)

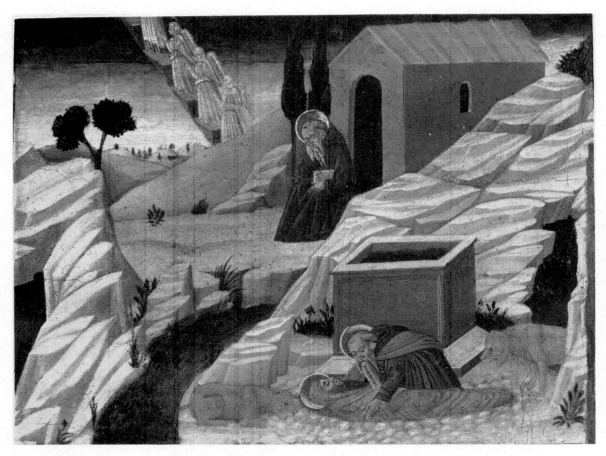

24. Tuscan School, about 1440-1450: *Scenes from the Life of St. Anthony Abbot* (Cat. No. 22)

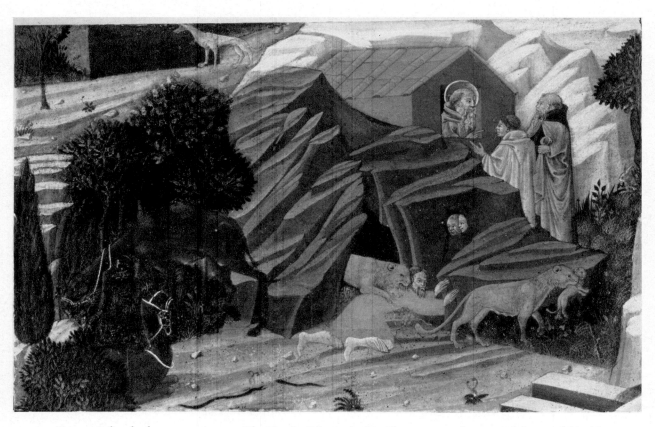

25. Tuscan School, about 1440-1450: *The Death of the Barbarian Slave-owner who pursued the Monk Malchus, and other Scenes* (Cat. No. 24)

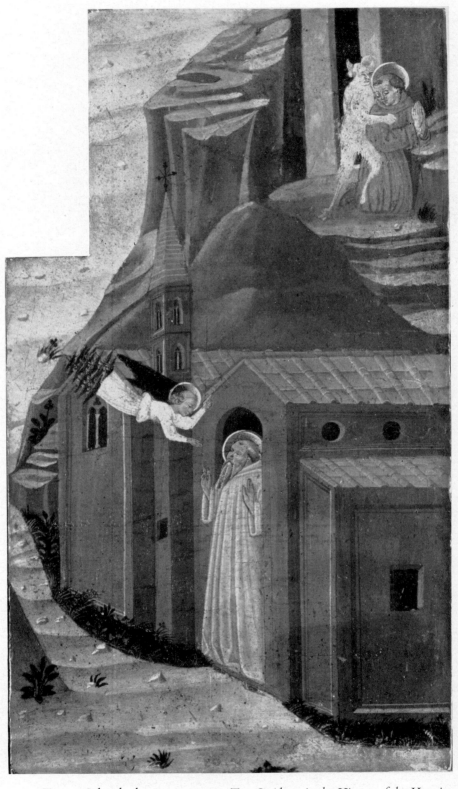

30. Tuscan School, about 1440–1450: *Two Incidents in the History of the Hermits*
(Cat. No. 29)

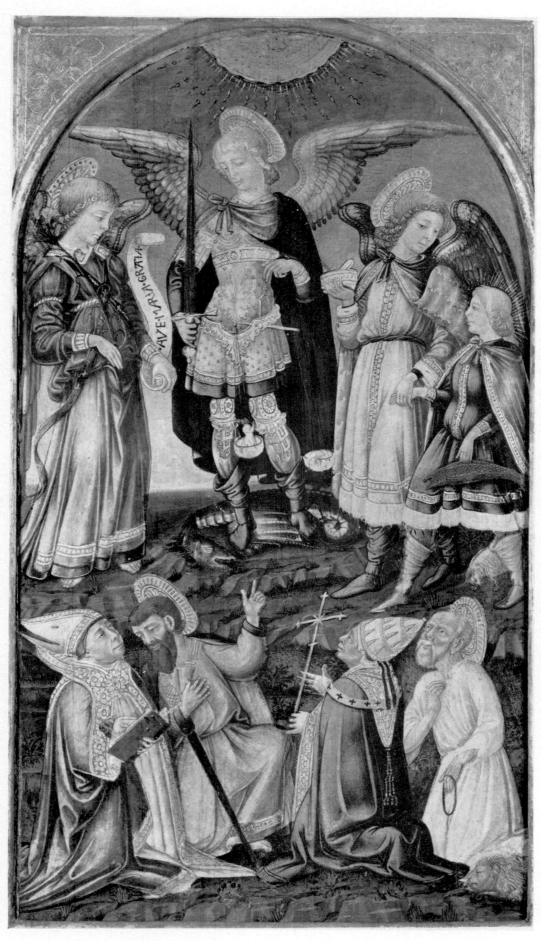

31. Neri di Bicci: *The Archangels Gabriel, Michael and Raphael, and the Holy Dove;*
below, *Saints Augustine, Paul, Gregory and Jerome* (Cat. No. 34)

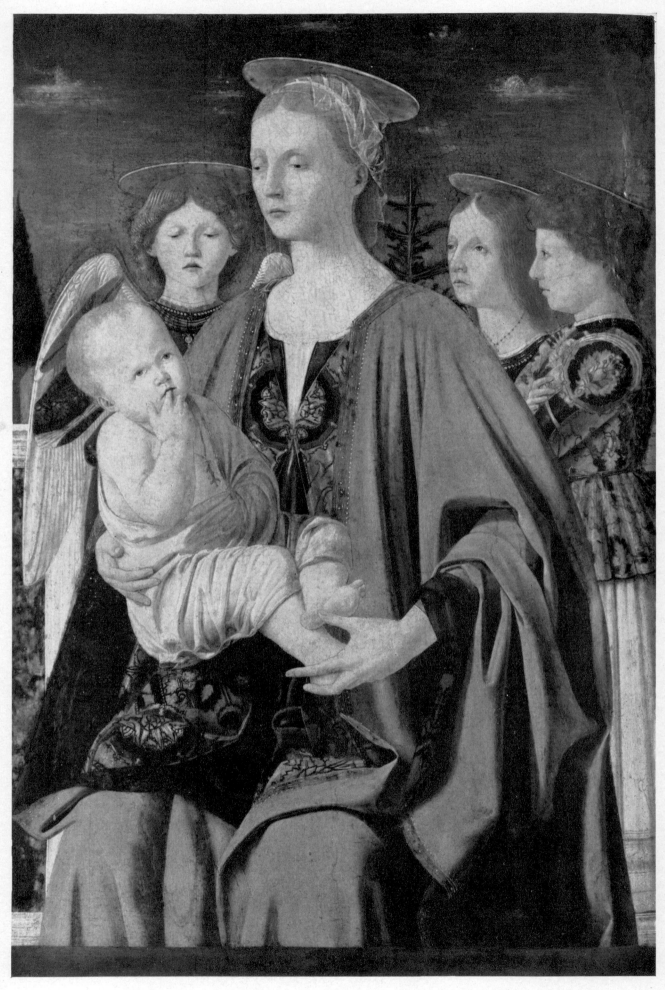

32. School of Piero della Francesca: *The Virgin and Child with three Angels* (Cat. No. 33)

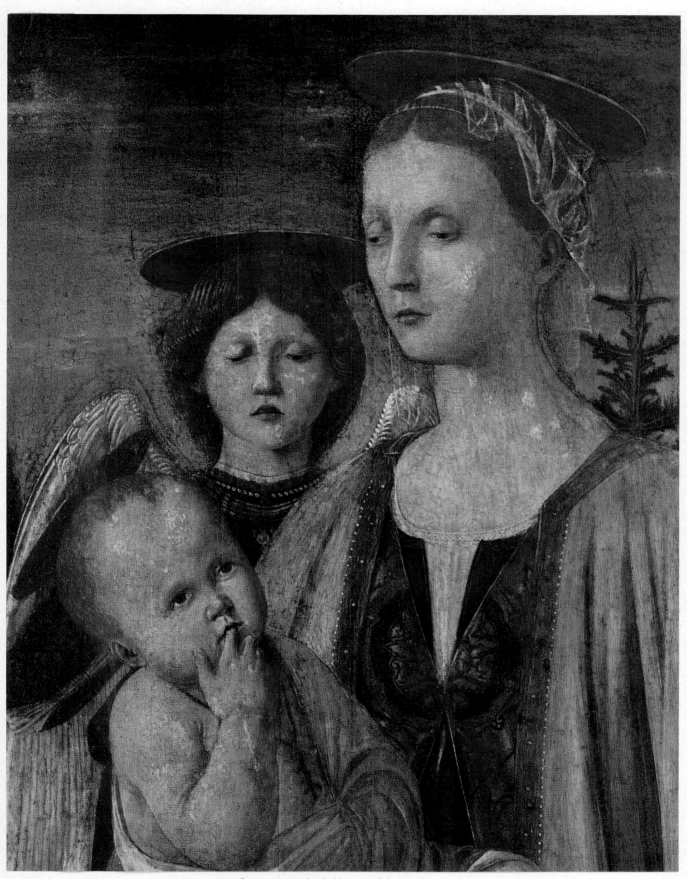

33. *The Virgin and Child*. Detail from plate 32

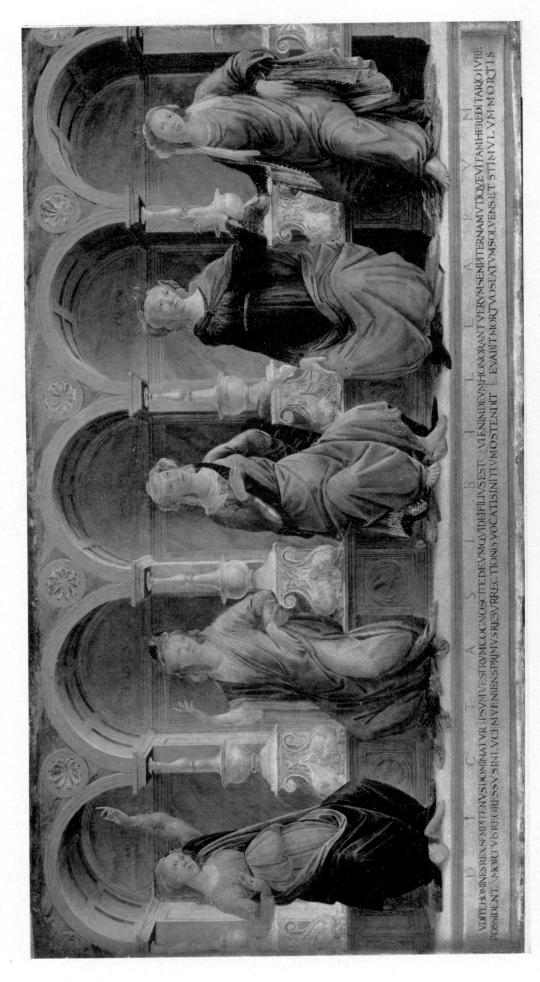

34. Studio of Botticelli: *Five Sibyls seated in Niches* (Cat. No. 35)

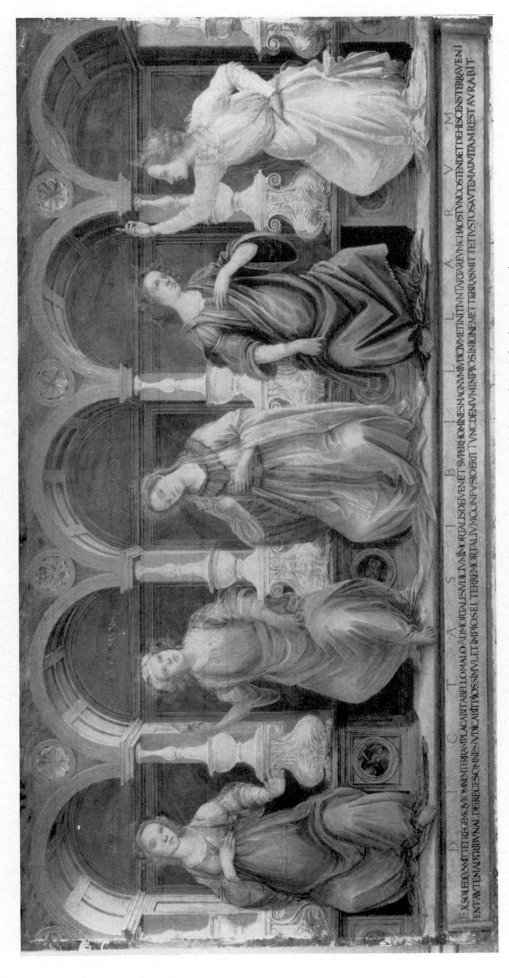

35. Studio of Botticelli (Filippino Lippi) : *Five Sibyls seated in Niches* (Cat. No. 36)

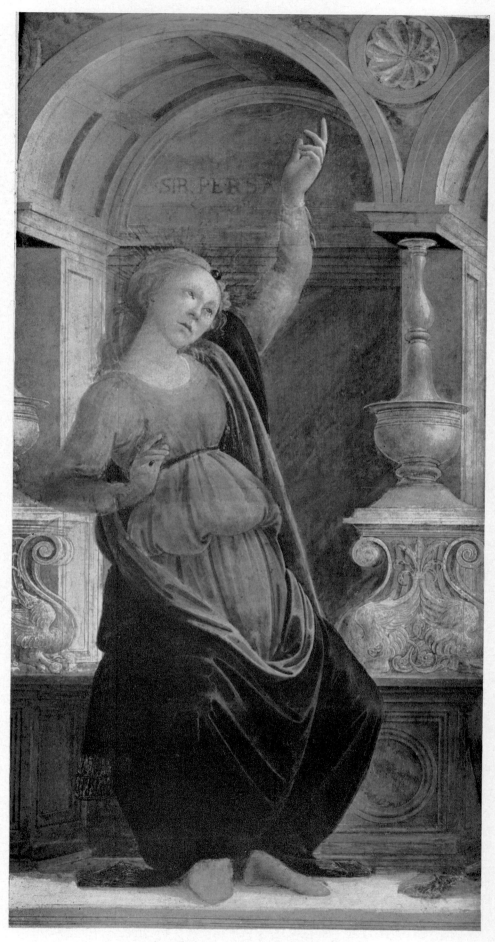

36. *The Babylonian Sibyl*. Detail from plate 34

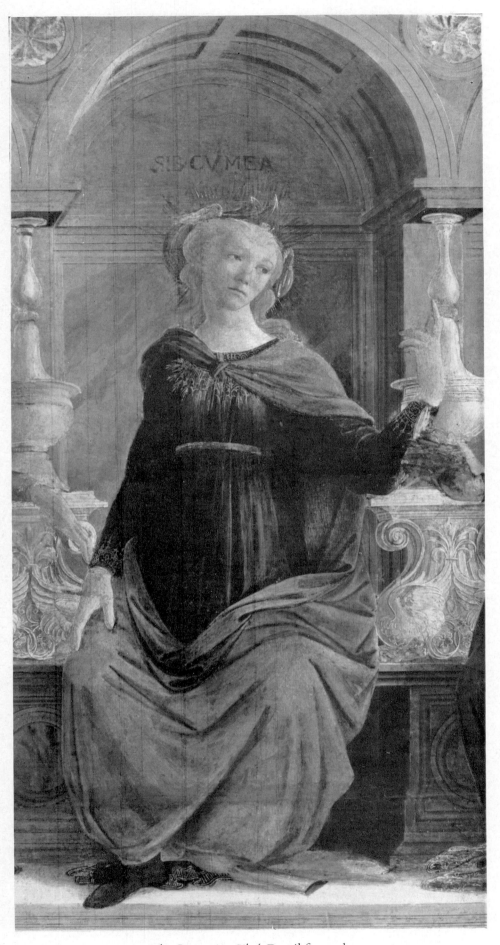

37. *The Cimmerian Sibyl*. Detail from plate 34

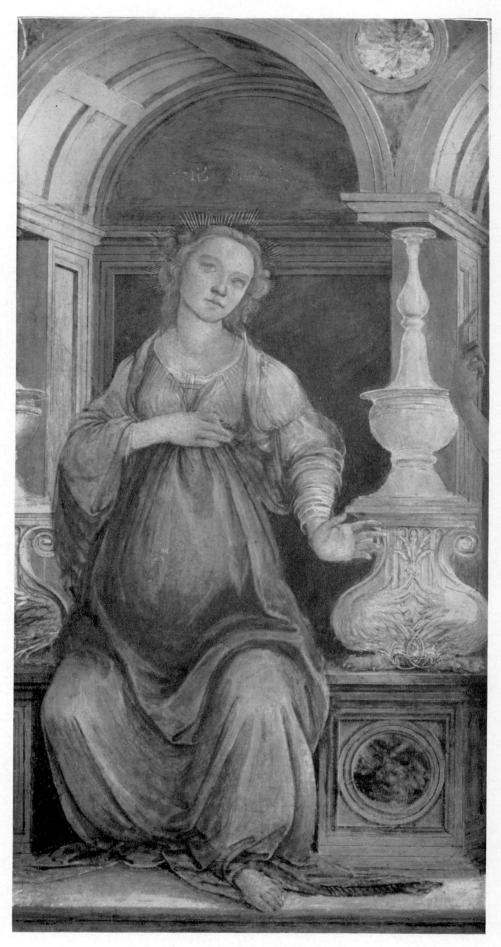

38. *The Samian Sibyl*. Detail from plate 35

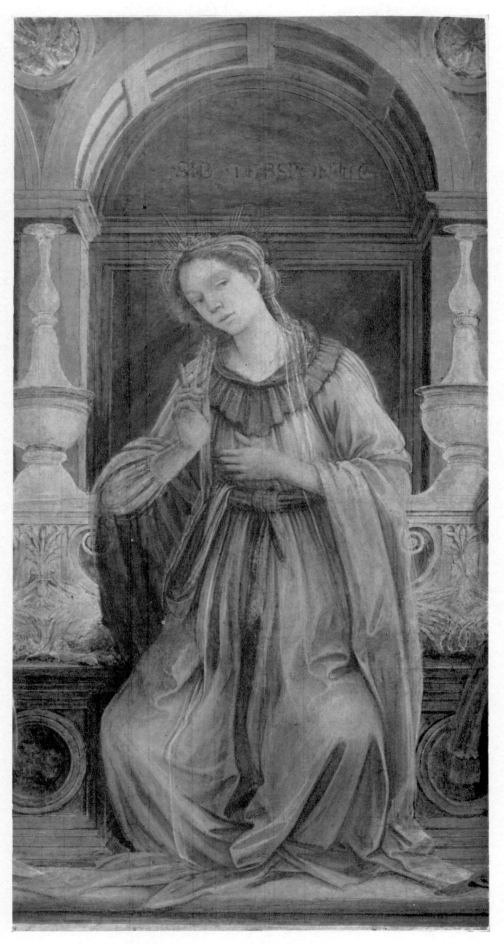

39. *The H llespontic Sibyl.* Detail from plate 35

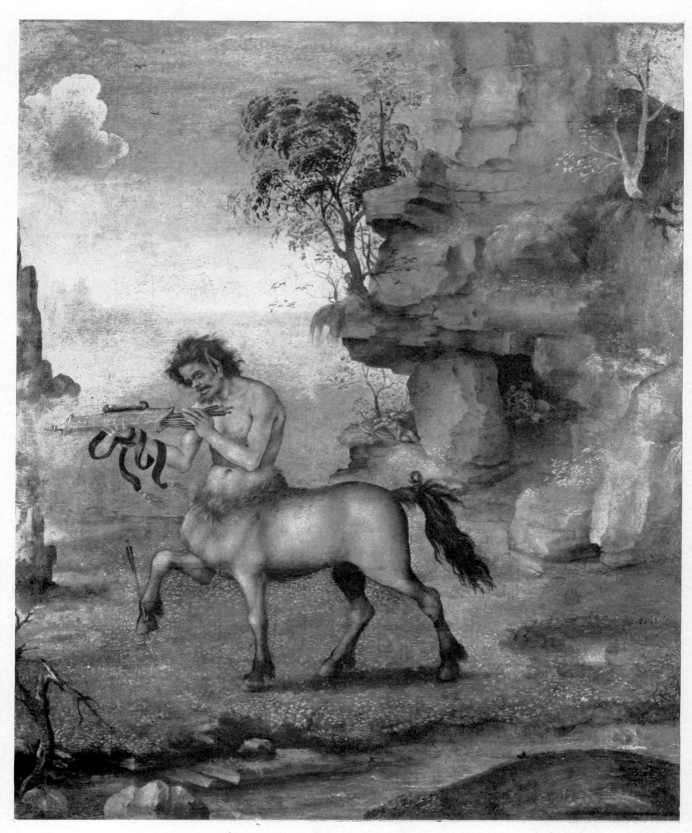

40. Filippino Lippi: *The wounded Centaur* (Cat. No. 41)

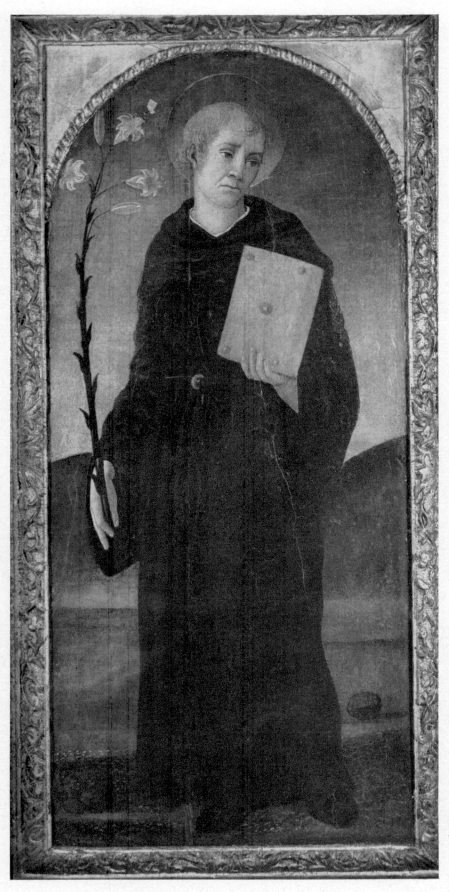

41. Attributed to Francesco Botticini: *St. Nicholas of Tolentino* (Cat. No. 39)

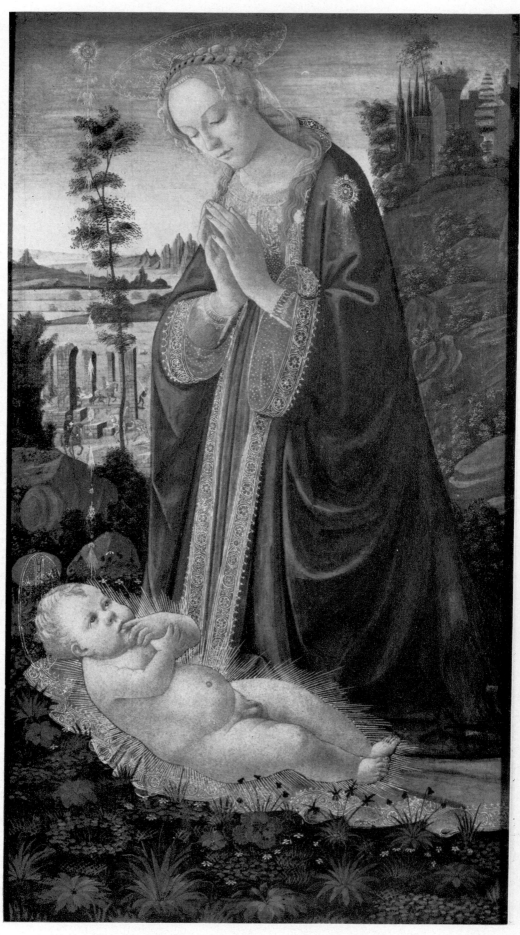

42. Jacopo del Sellaio: *The Virgin adoring the Child* (Cat. No. 37)

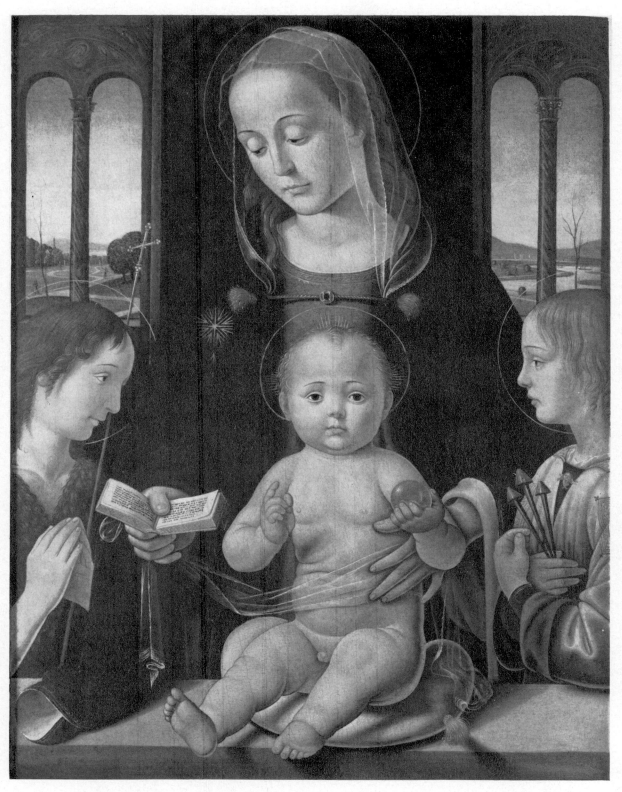

43. 'Utili': *The Virgin and Child, with St. John and an Angel* (Cat. No. 43)

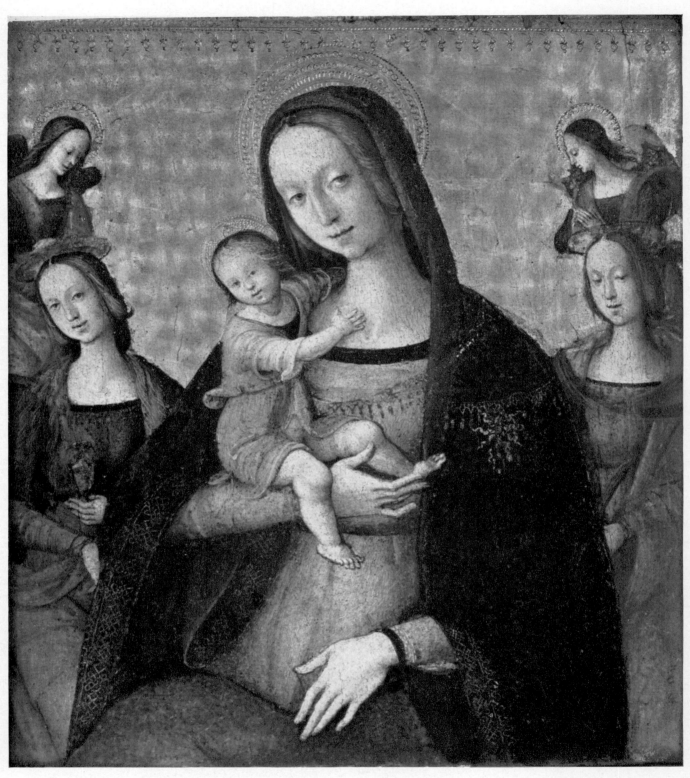

48. Matteo Balducci: *The Virgin and Child, with St. Mary Magdalen, a female Martyr and two Angels* (Cat. No. 55)

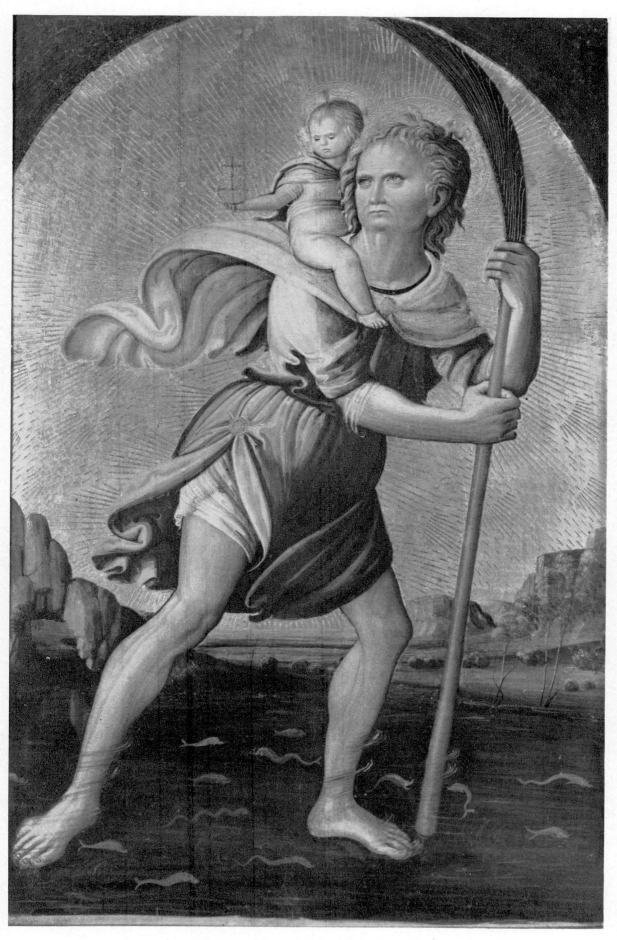

49. Formerly attributed to Matteo Balducci: *St. Christopher* (Cat. No. 56)

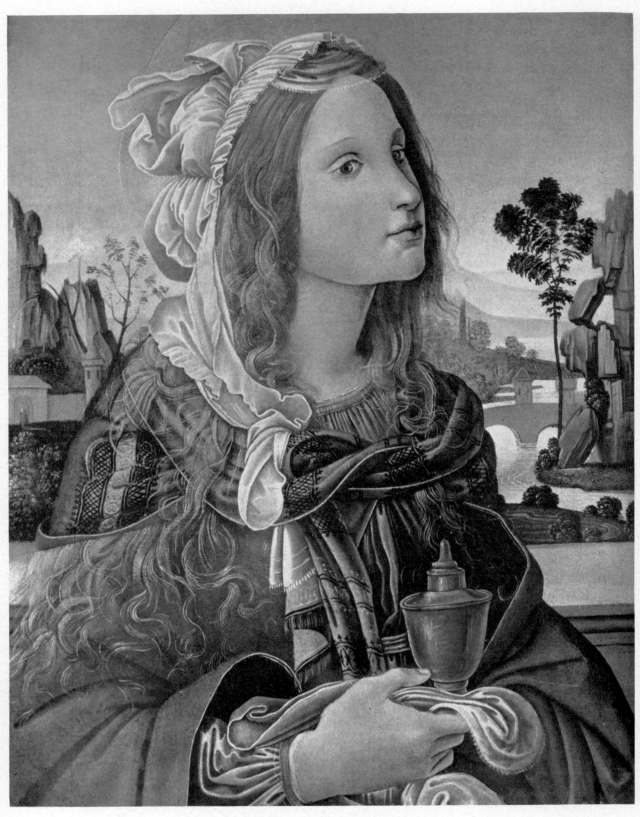

50. Raffaellino del Garbo: *The Magdalen* (Cat. No. 47)

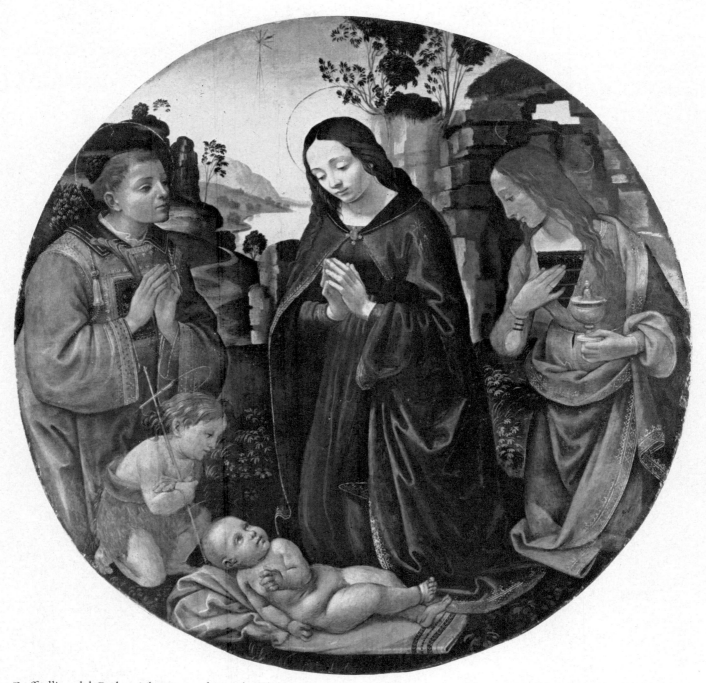

51. Raffaellino del Garbo: *The Virgin adoring the Child, with Saints Lawrence, Mary Magdalen and the Infant John Baptist* (Cat. No. 48)

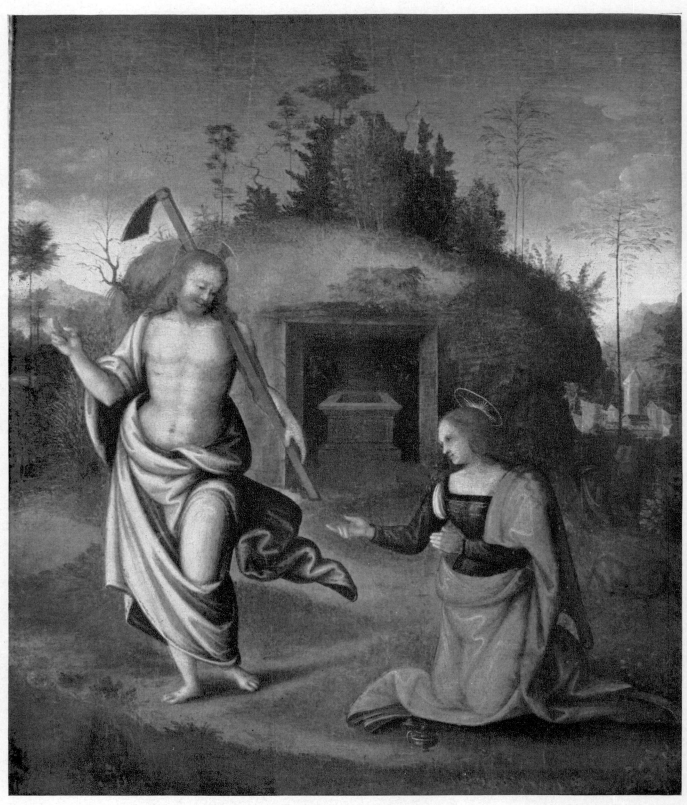

56. Bacchiacca: *Christ appearing to the Magdalen* (Cat. No. 61)

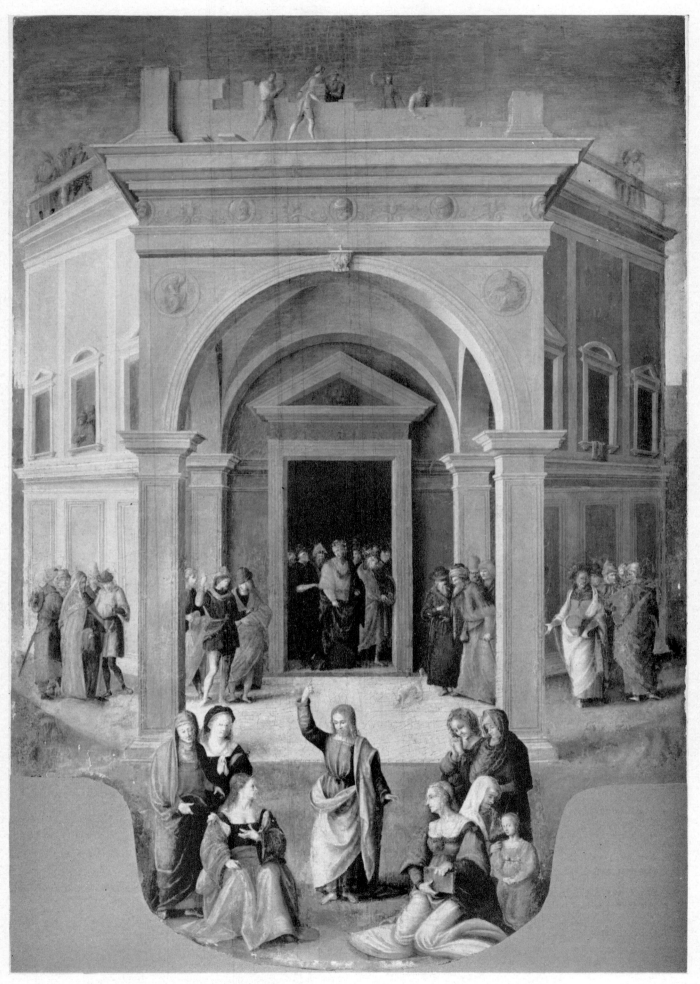

57. Bacchiacca: *Christ preaching before a classical Temple* (Cat. No. 62)

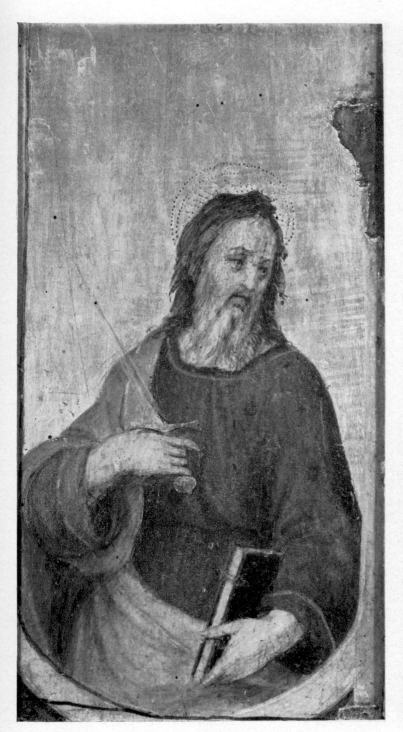 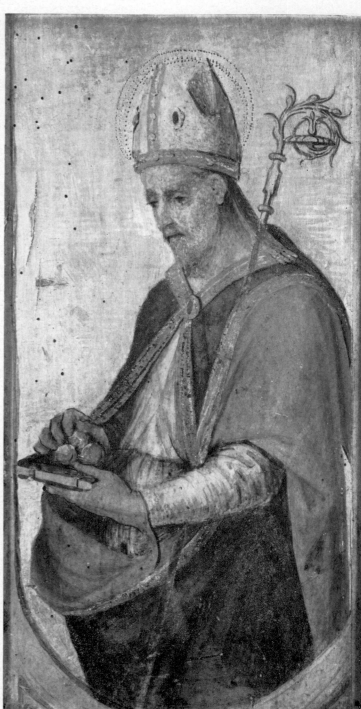

58-59. Florentine School, about 1510: *St. Paul; St. Nicholas of Bari* (Cat. Nos. 57-58)

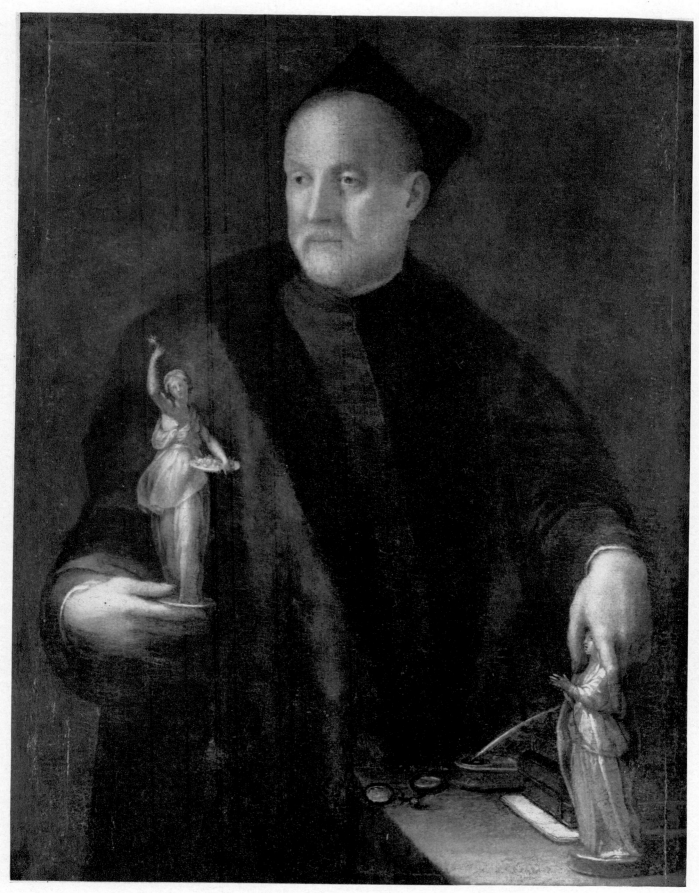

60. Pontormo(?): *A Scholar holding two gilt Statuettes* (Cat. No. 63)

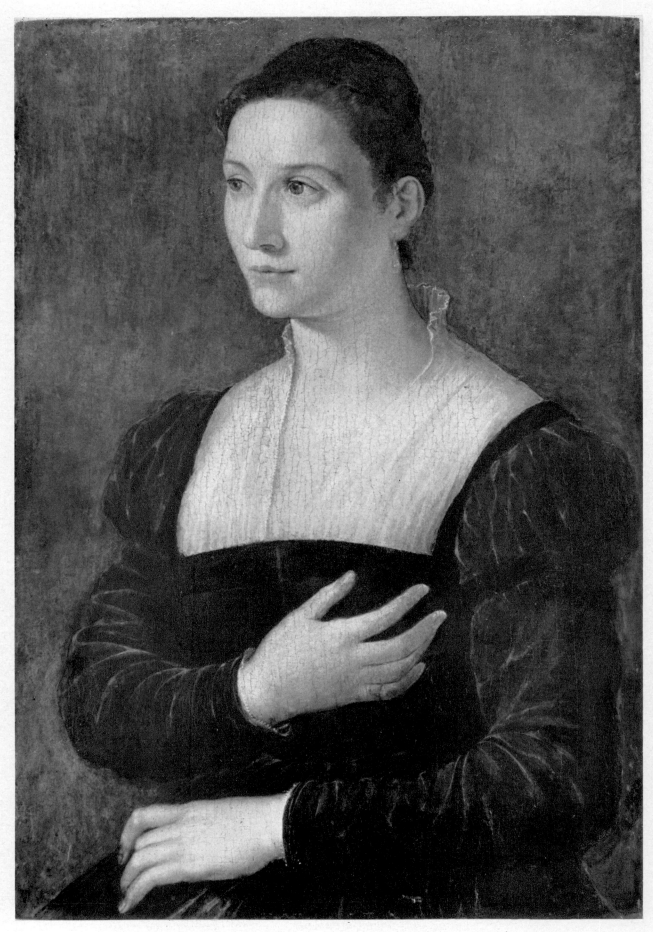

61. Florentine School, about 1550: *Portrait of a Lady* (Cat. No. 64)

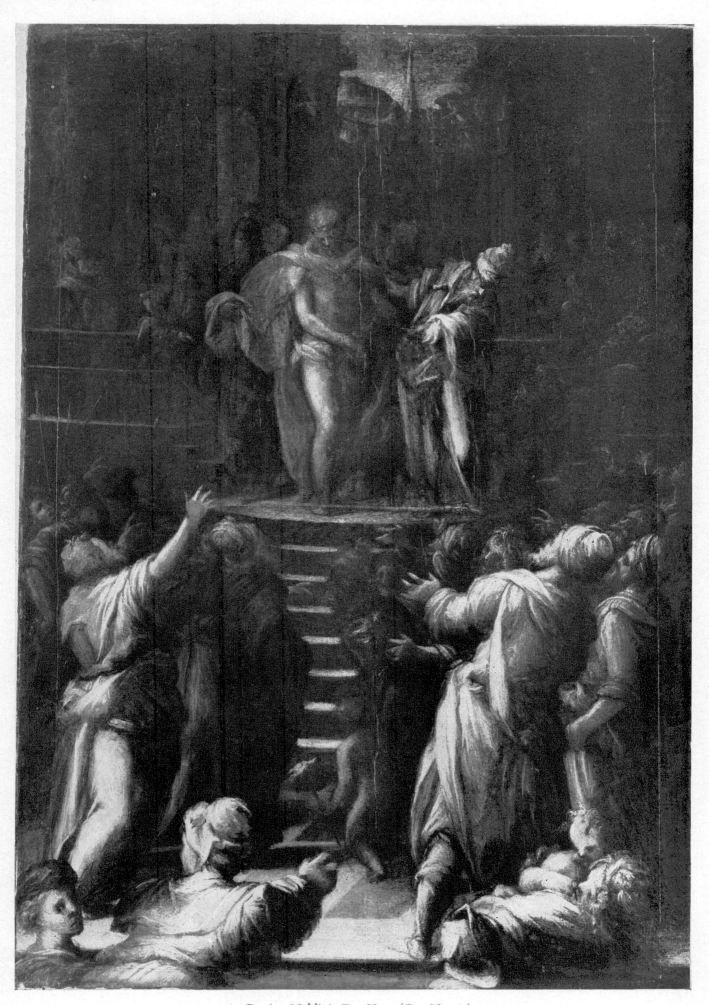

62. Battista Naldini: *Ecce Homo* (Cat. No. 67)

BYZANTINE AND VENETIAN PAINTERS

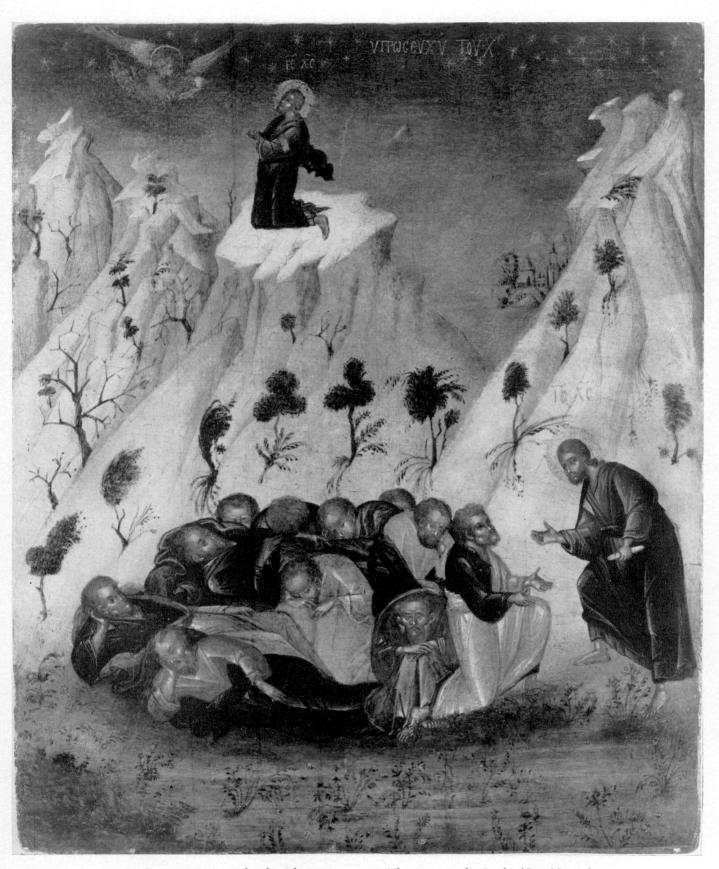

63. Greco-Venetian School, early XVI century: *The Agony in the Garden* (Cat. No. 70)

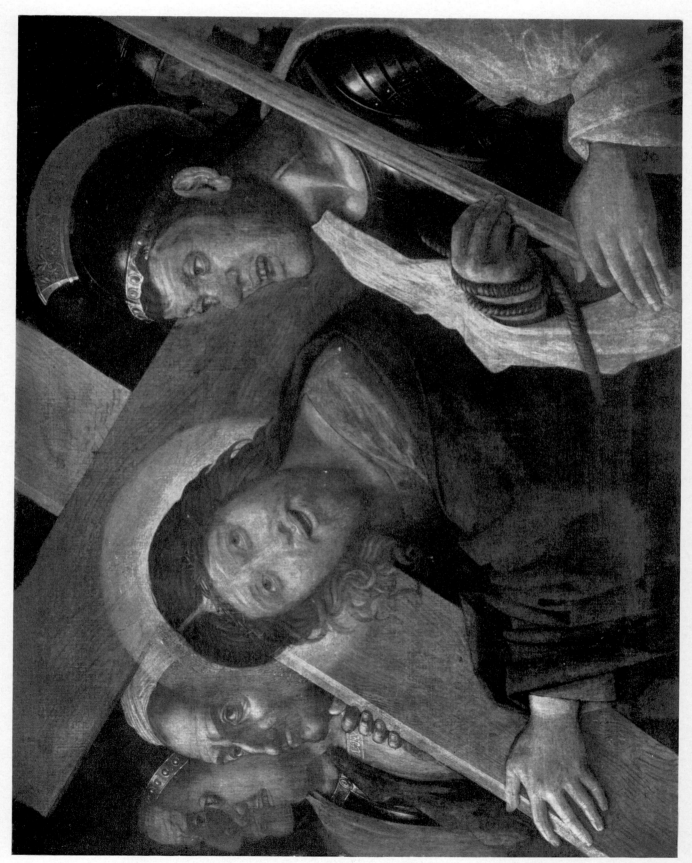

64. Studio of Andrea Mantegna: *Christ carrying the Cross* (Cat. No. 74)

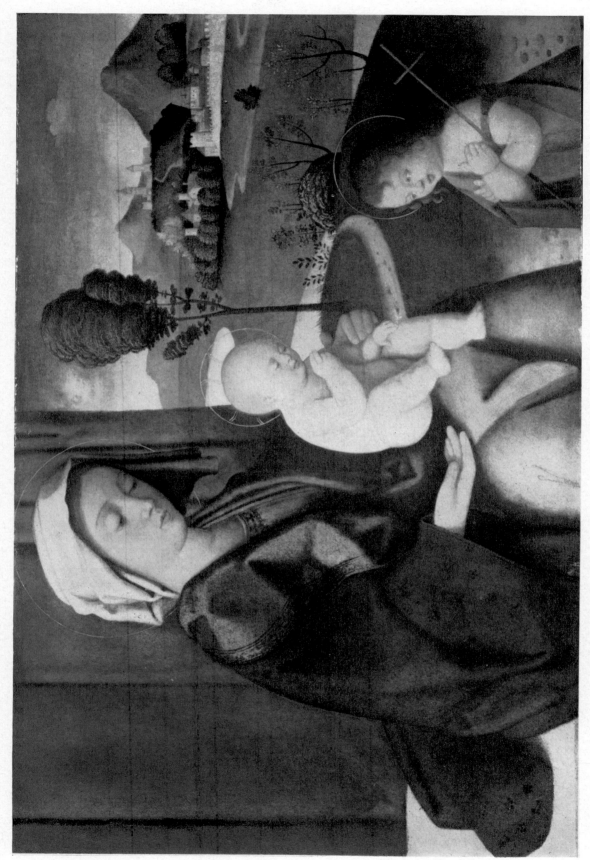

65. Attributed to Marco Bello: *The Virgin and Child with the Infant St. John in a Landscape* (Cat. No. 76)

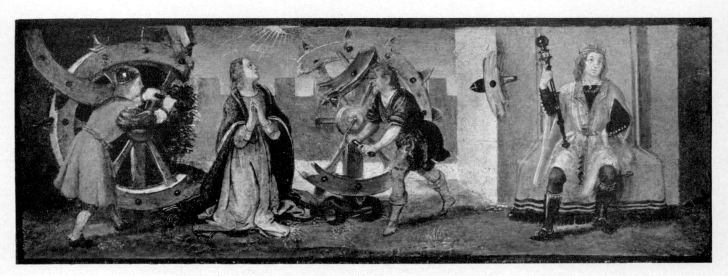

66. Giovanni Francesco Caroto: *The Martyrdom of St. Catherine* (Cat. No. 77)

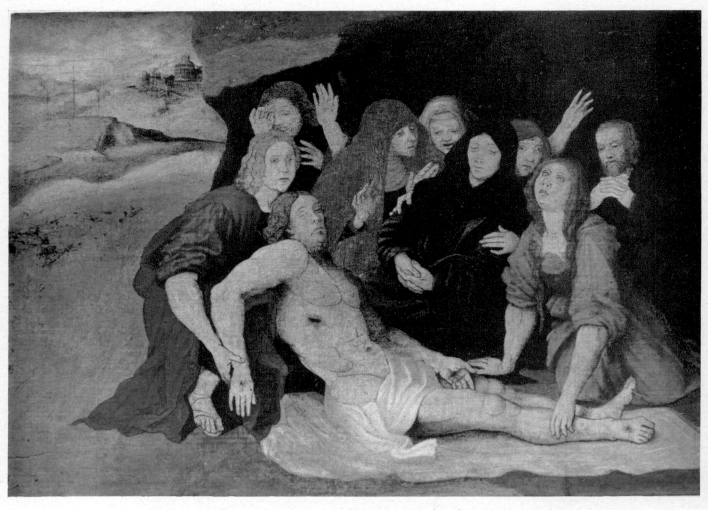

67. Giovanni Francesco Caroto: *The Lamentation for Christ* (Cat. No. 78)

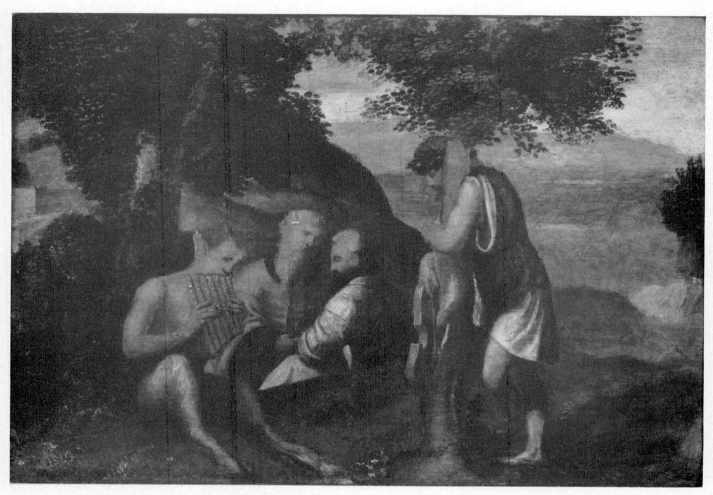

68. Venetian School, first quarter of XVI century: *The Judgement of Midas* (Cat. No. 87)

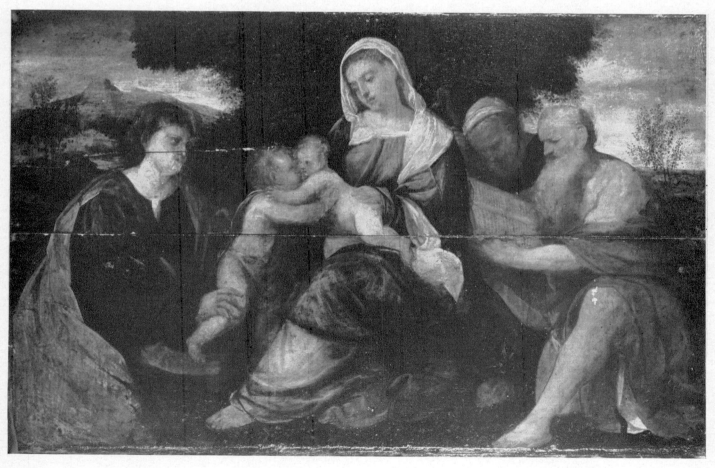

69. Bonifazio de'Pitati: *The Holy Family with St. Catherine, the Infant St. John and St. Mark* (Cat. No. 85) (Before restoration in 1967.)

70. Titian(?): *The Adoration of the Shepherds* (Cat. No. 79)

71. Girolamo da Treviso: *The Adoration of the Shepherds* (Cat. No. 88)

72. Detail from plate 71

73. Lorenzo Lotto: *The Supper at Emmaus* (Cat. No. 84)

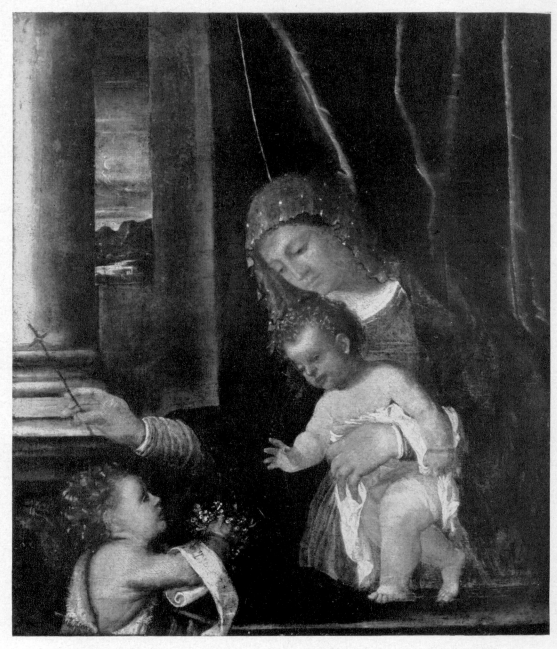

74. Follower of Titian: *The Virgin and Child with the Infant St. John* (Cat. No. 83)

75. Studio of Bassano: *Solomon and the Queen of Sheba* (Cat. No. 93)

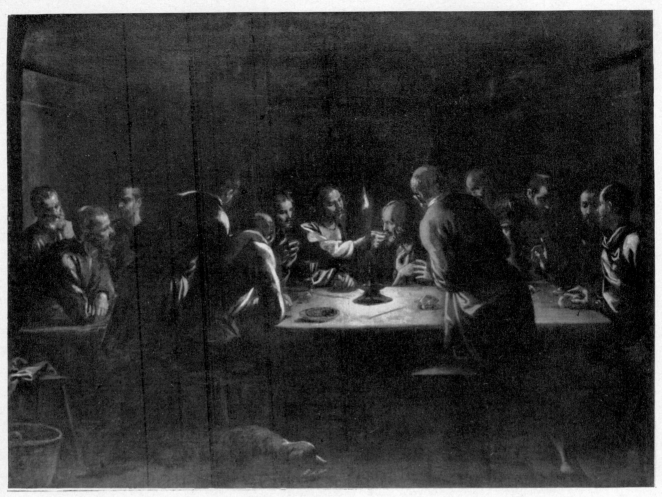

76. Venetian School, second half of XVI century: *The Last Supper* (Cat. No. 105)

77. Jacopo Bassano(*?*): *Christ crowned with Thorns* (Cat. No. 92)

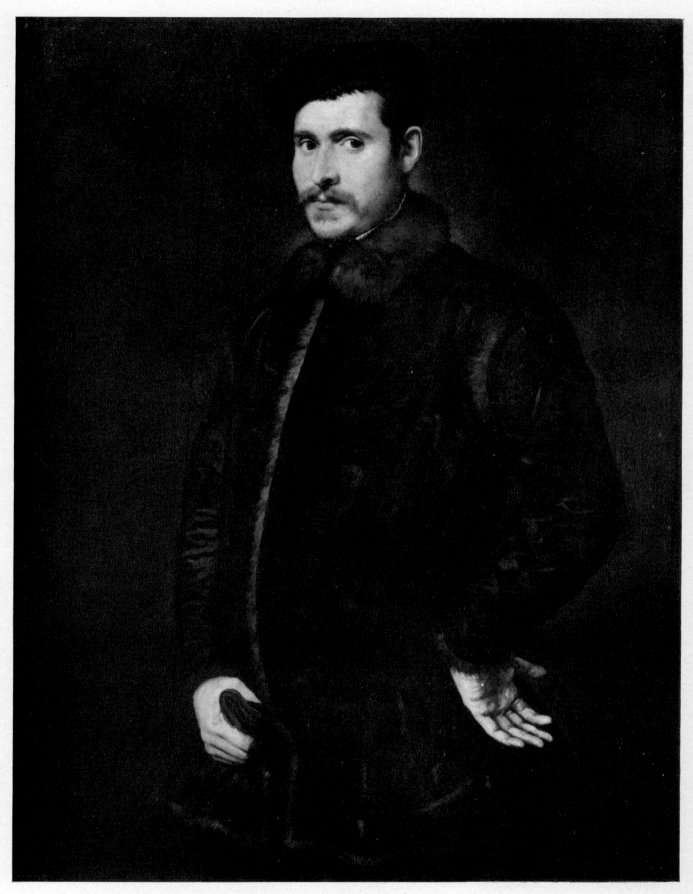

78. Tintoretto: *Portrait of a Gentleman* (Cat. No. 100)

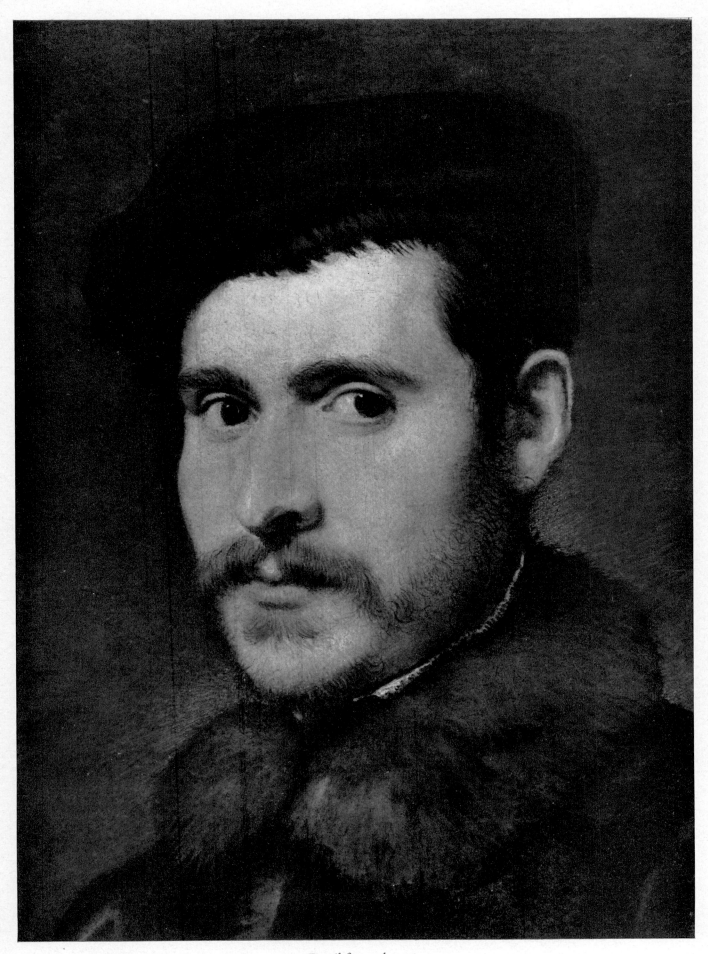

79. Detail from plate 78

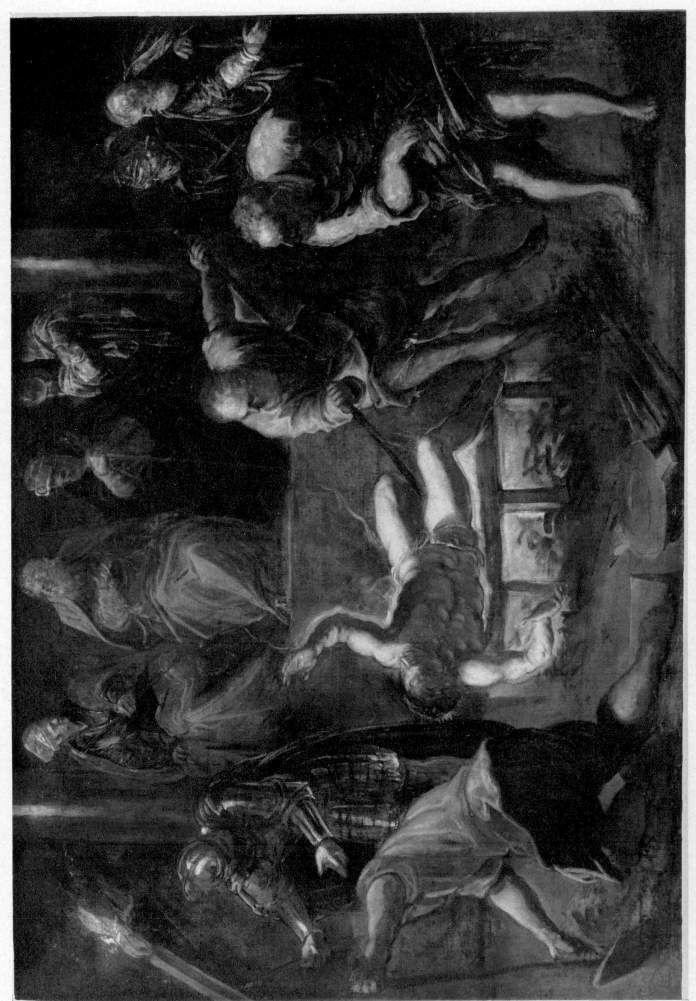

80. Tintoretto: *The Martyrdom of St. Laurence* (Cat. No. 101)

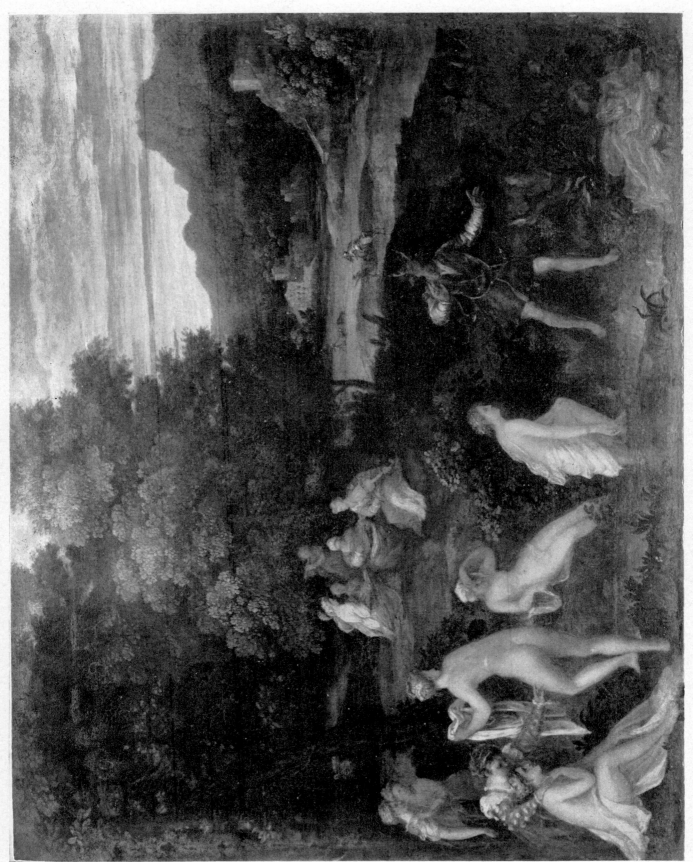

81. Lambert Sustris: *Diana and Actaeon* (Cat. No. 91)

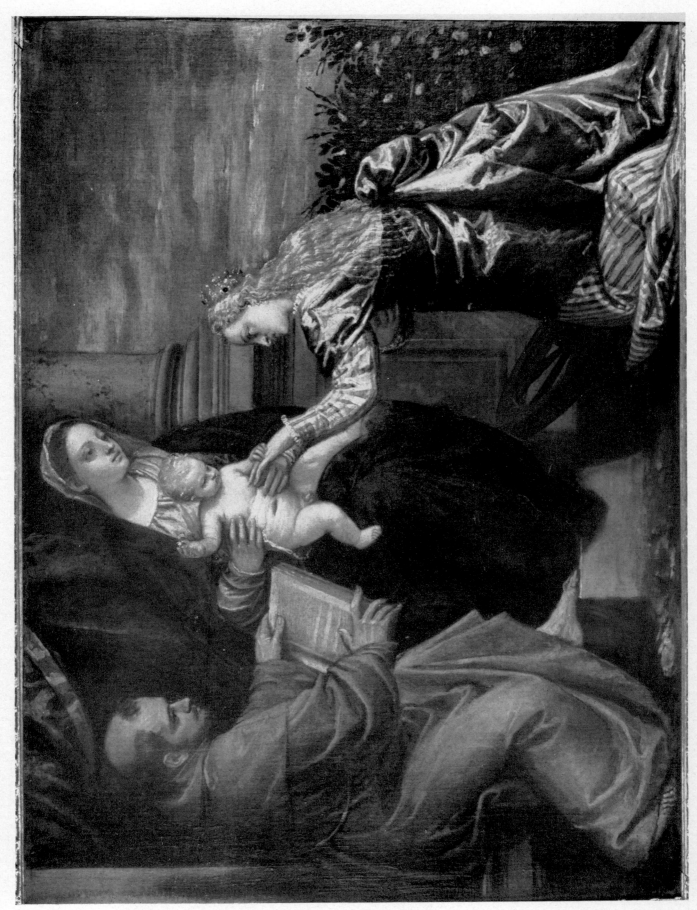

82. Paolo Veronese: *The Marriage of St. Catherine, with a Franciscan Saint* (Cat. No. 106)

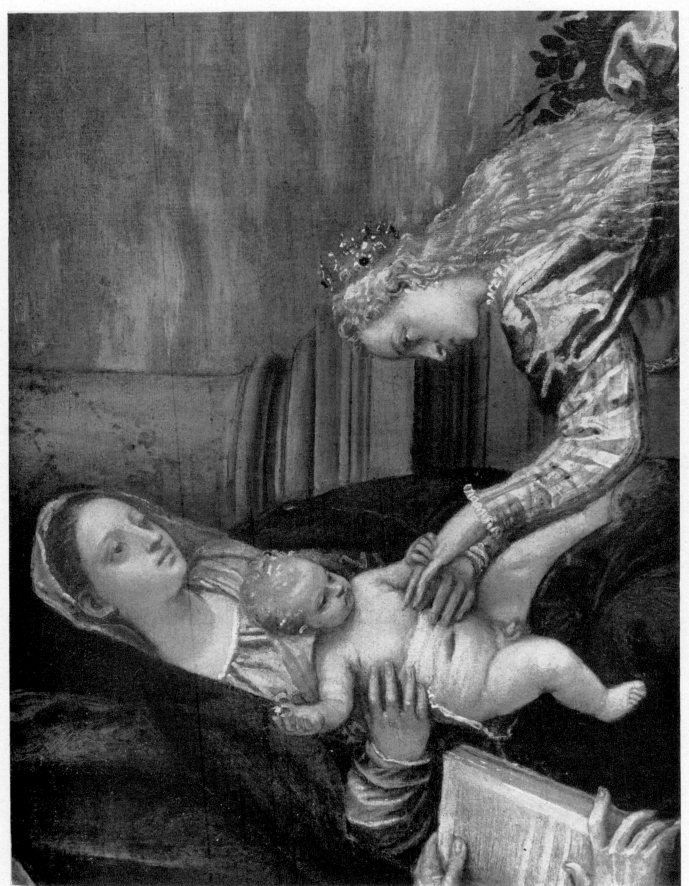

83. Detail from plate 82

84-85. Copies of Paolo Veronese: *Jupiter; Juno* (Cat. Nos. 107-108)

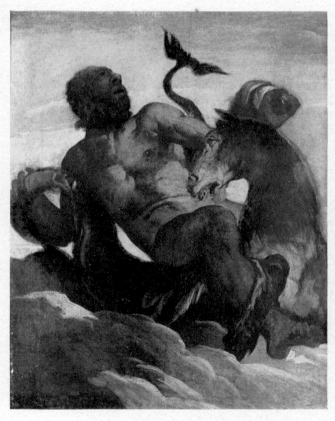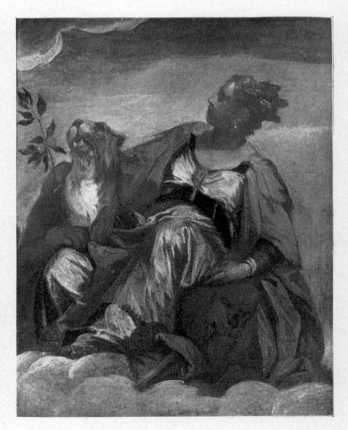

86-87. Copies of Paolo Veronese: *Neptune; Cybele* (Cat. Nos. 109-110)

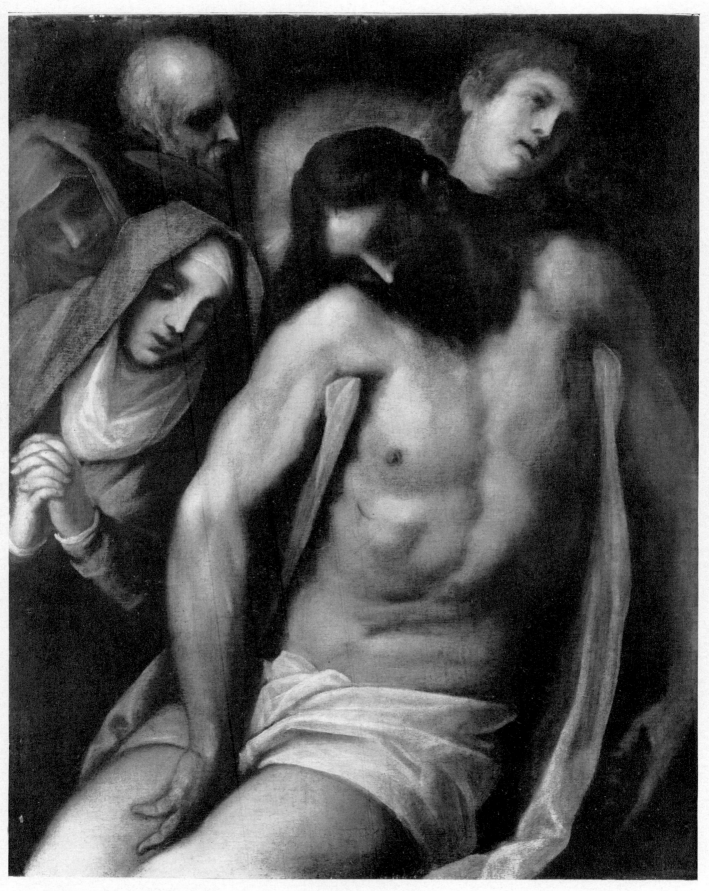

88. Palma Giovane: *The Lamentation for Christ* (Cat. No. 113)

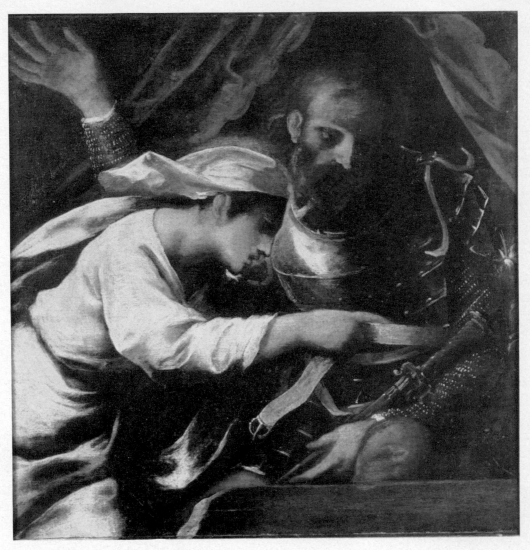

89. Pietro della Vecchia: *Faith arming a General* (Cat. No. 119)

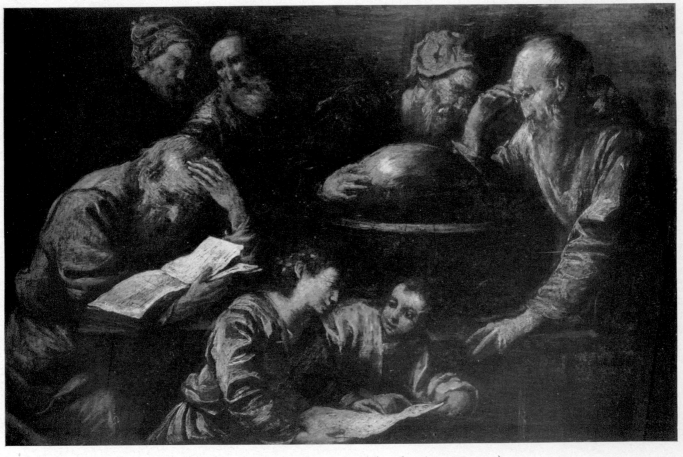

90. Pietro della Vecchia: *The Philosophers* (Cat. No. 120)

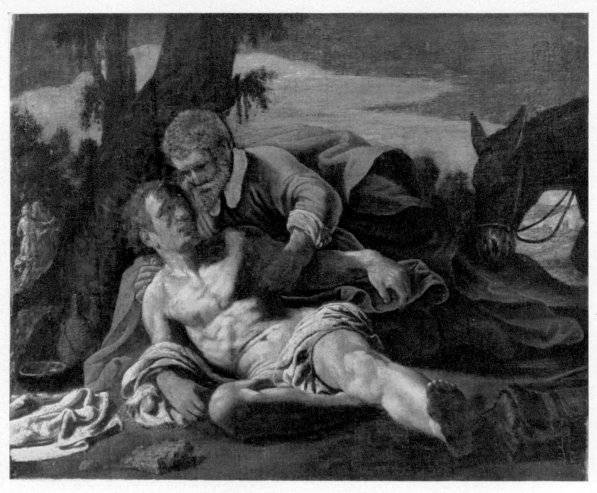

91. Marcantonio Bassetti: *The Good Samaritan* (Cat. No. 118)

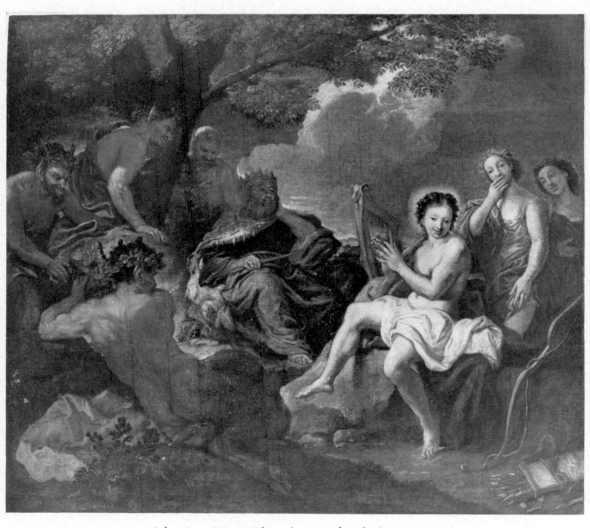

92. Sebastiano Ricci: *The Judgement of Midas* (Cat. No. 122)

93. Sebastiano (and Marco?) Ricci: *The Building of a classical Temple* (Cat. No. 123)

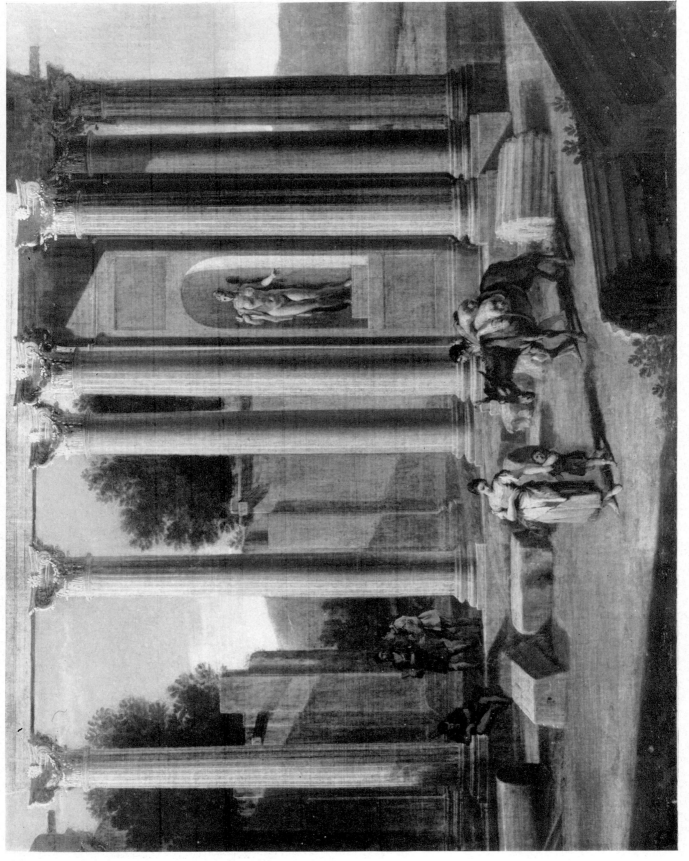

94. Detail from plate 93

99. Cavaliere d'Arpino: *The Expulsion from Paradise* (Cat. No. 135)

100. Follower of Federico Zuccaro(?): *The Nativity*
(Cat. No. 136)

101. Follower of Raphael: *Jupiter and Juno standing on Clouds*
(Cat. No. 131)

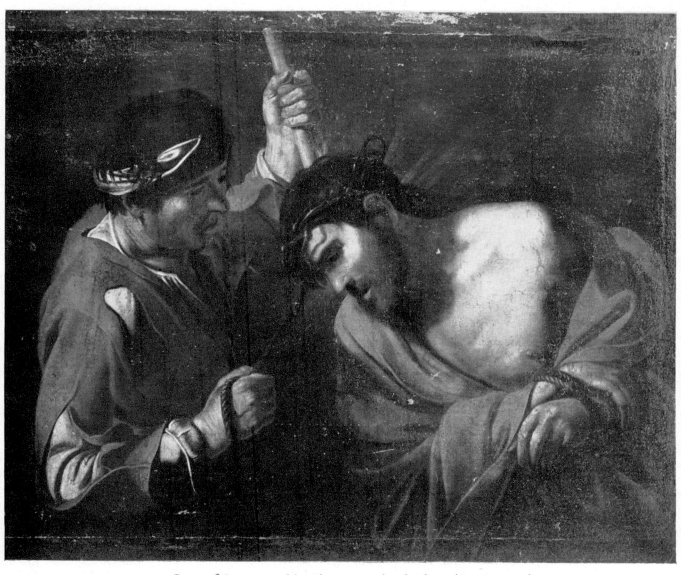

102. Copy of Caravaggio(?): *Christ crowned with Thorns* (Cat. No. 138)

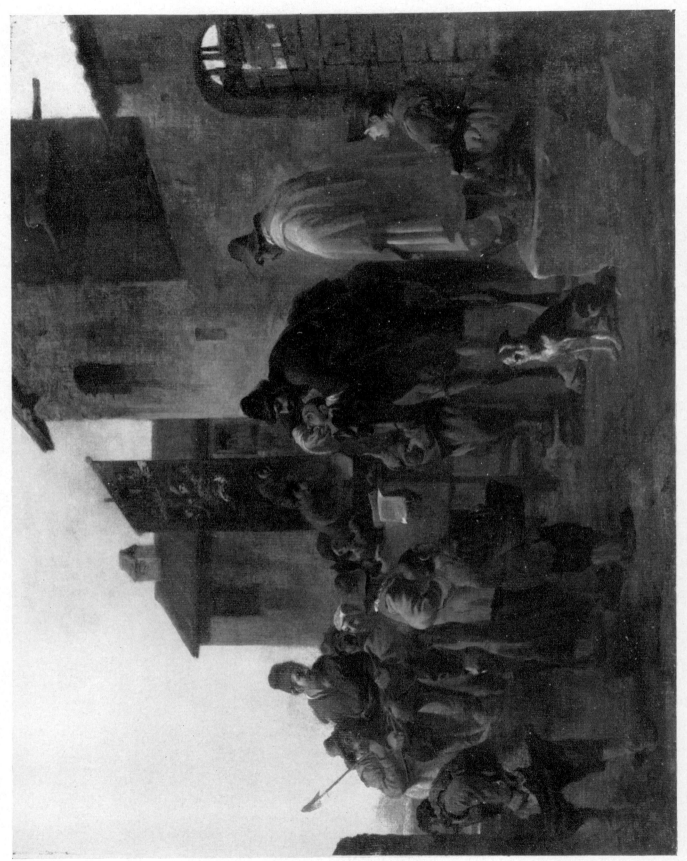

III. Formerly attributed to Michelangelo Cerquozzi: *The Quack Dentist* (Cat. No. 145)

112. Formerly attributed to Michelangelo Cerquozzi: *A Game of Bowls in a Roman Ruin* (Cat. No. 146)

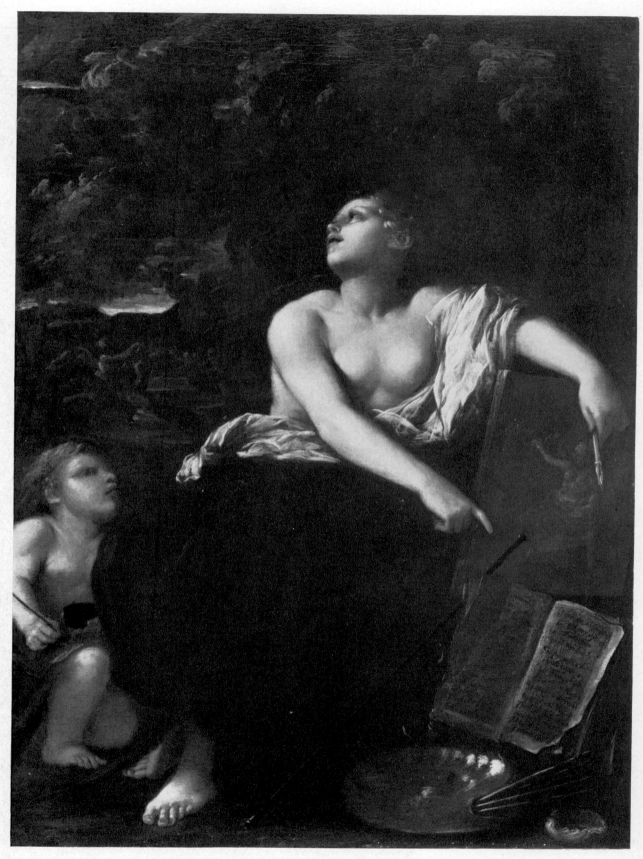

113. Girolamo Troppa: *Allegory of Painting* (Cat. No. 153)

LOMBARD AND EMILIAN PAINTERS

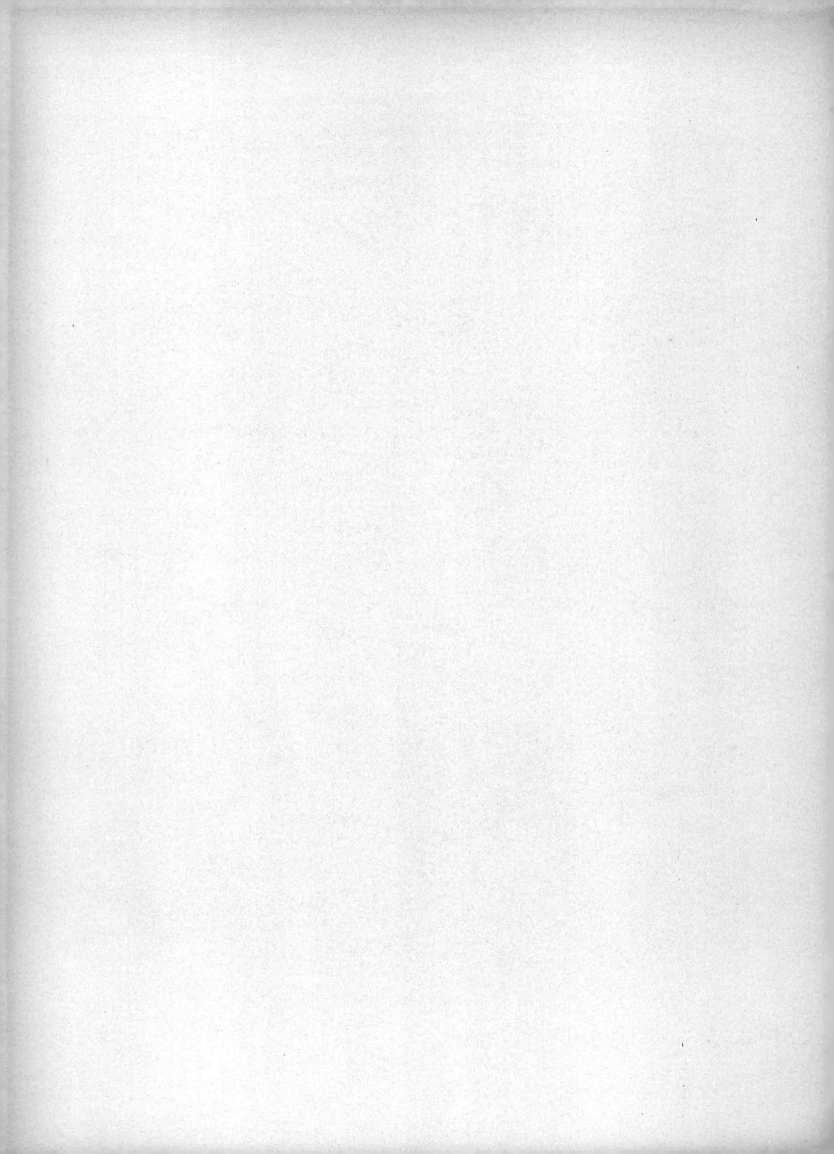

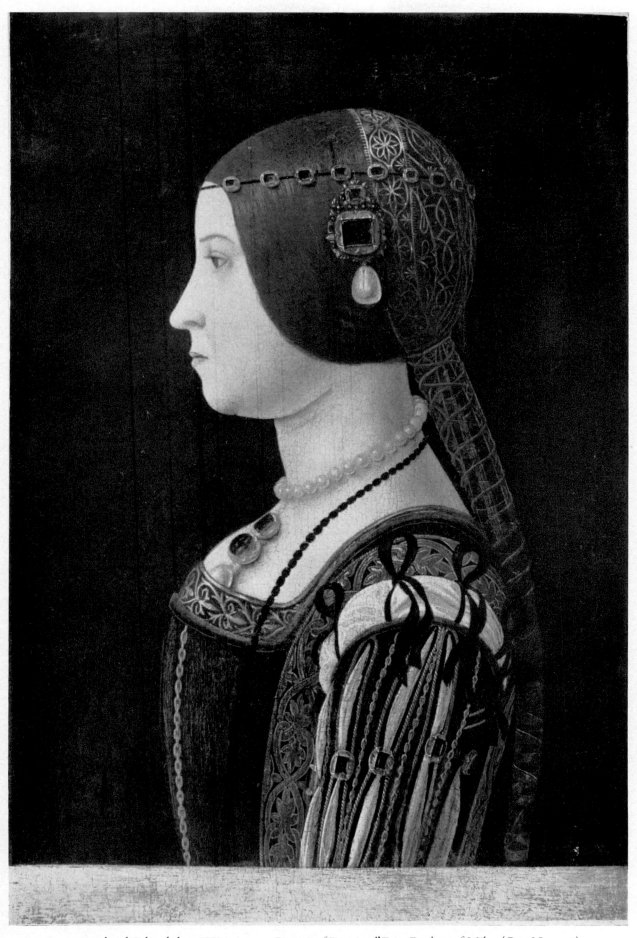

114. Lombard School, late XV century: *Portrait of Beatrice d'Este, Duchess of Milan* (Cat. No. 156)

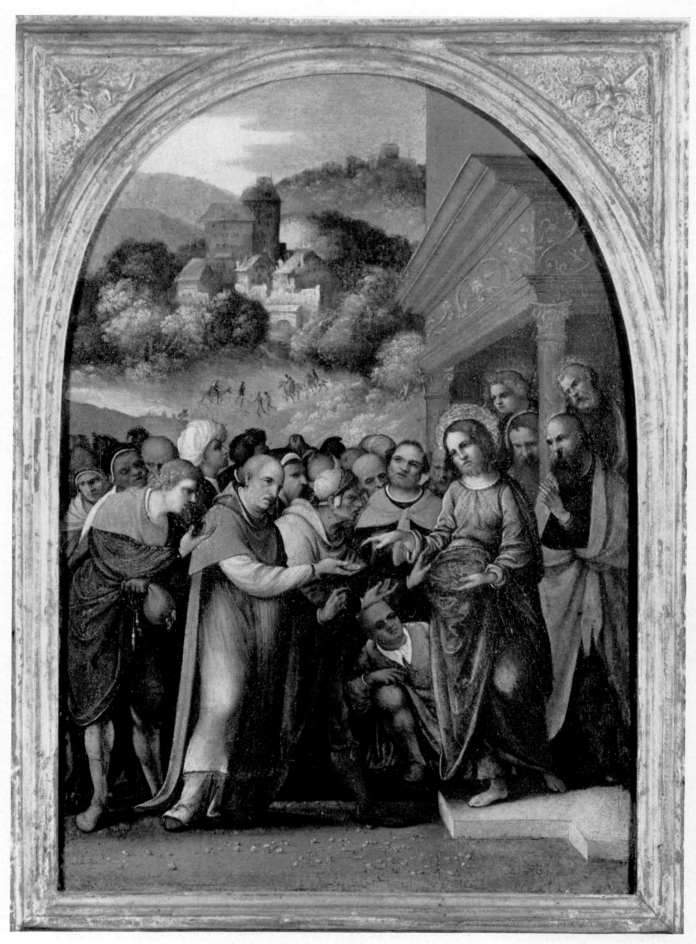

115. Ludovico Mazzolino: *The Tribute Money* (Cat. No. 157)

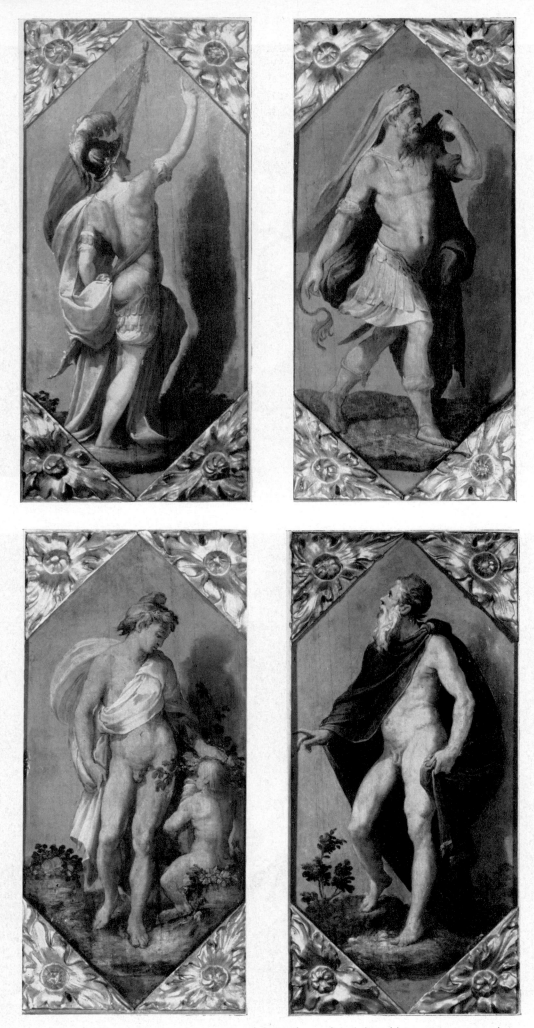

116-119. Jacopo Bertoia: *Mars; Hercules; Bacchus; a bearded God* (Cat. Nos. 168-171)

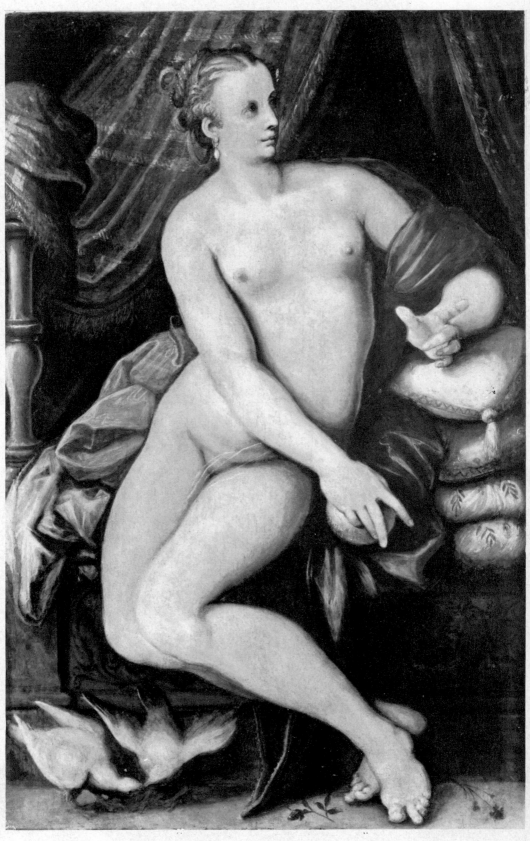

124. Attributed to Niccolò dell'Abbate: *Venus* (Cat. No. 167)

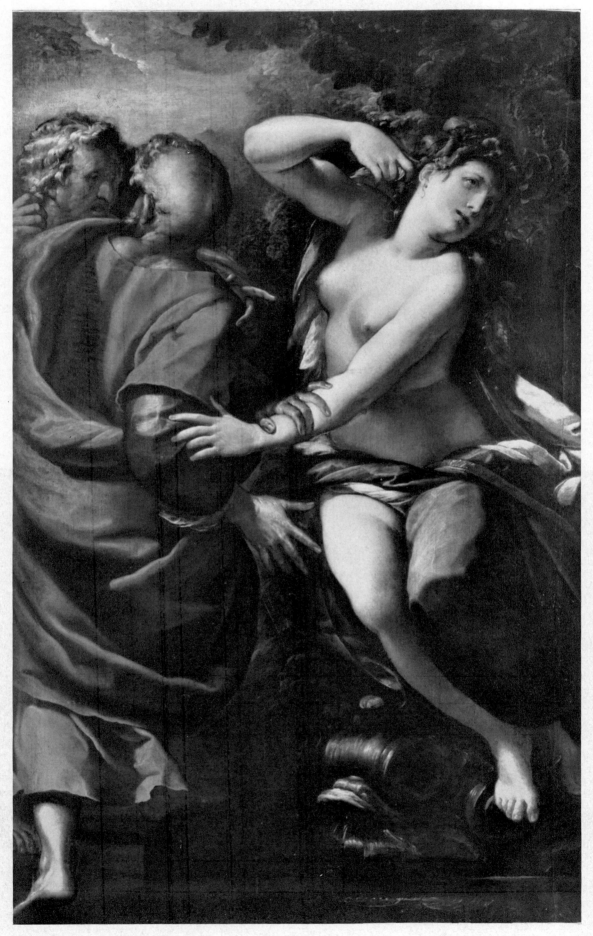

125. Giulio Cesare Procaccini: *Susanna and the Elders* (Cat. No. 177)

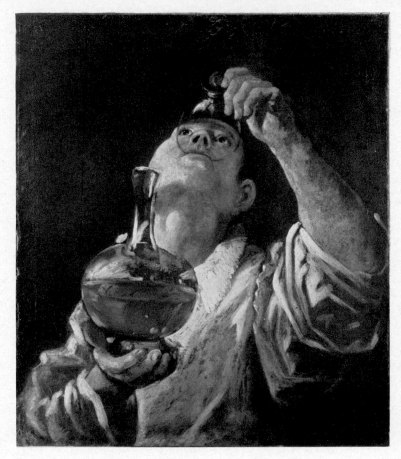

126. Annibale Carracci: *A Man drinking* (Cat. No. 180)

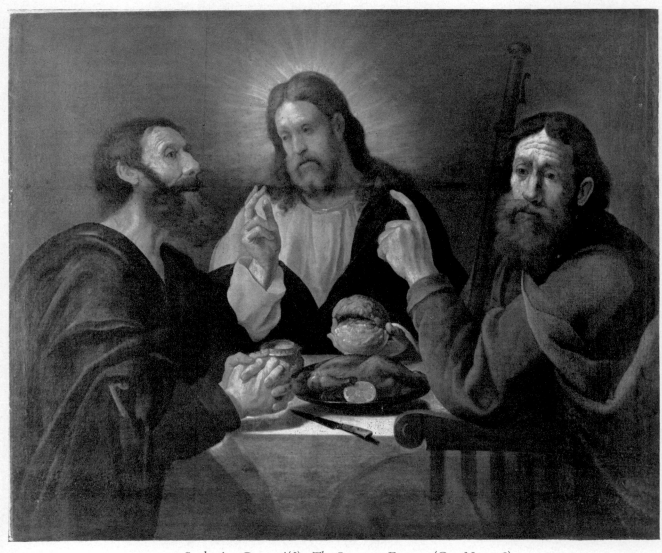

127. Ludovico Carracci(?): *The Supper at Emmaus* (Cat. No. 178)

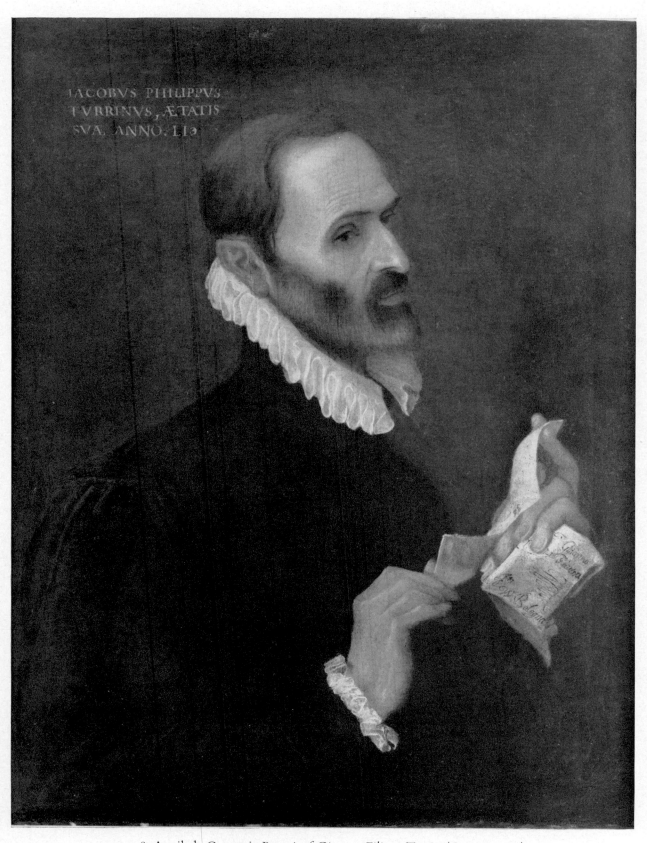

128. Annibale Carracci: *Portrait of Giacomo Filippo Turrini* (Cat. No. 182)

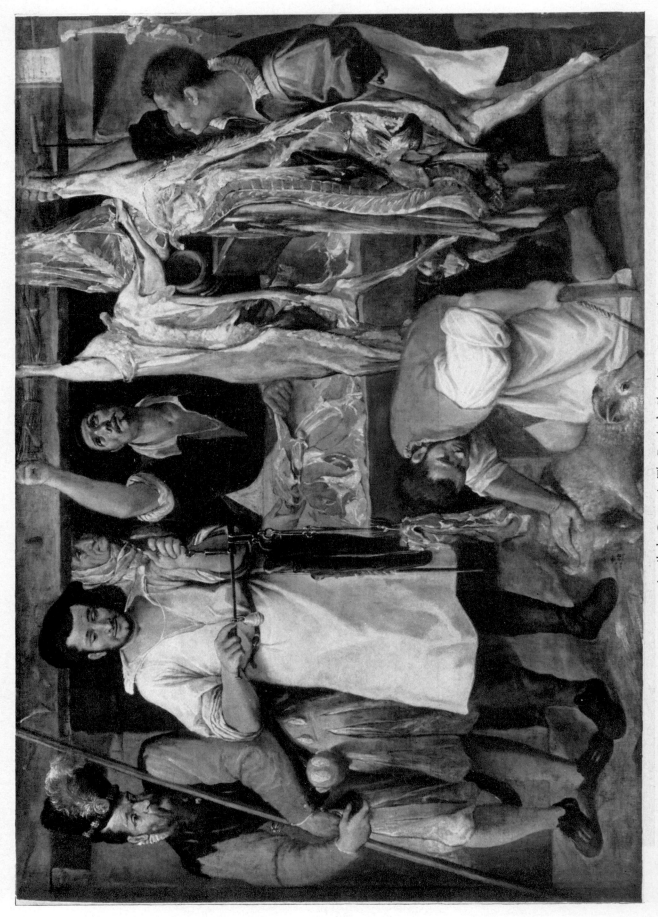

129. Annibale Carracci: *The Butcher's Shop* (Cat. No. 181)

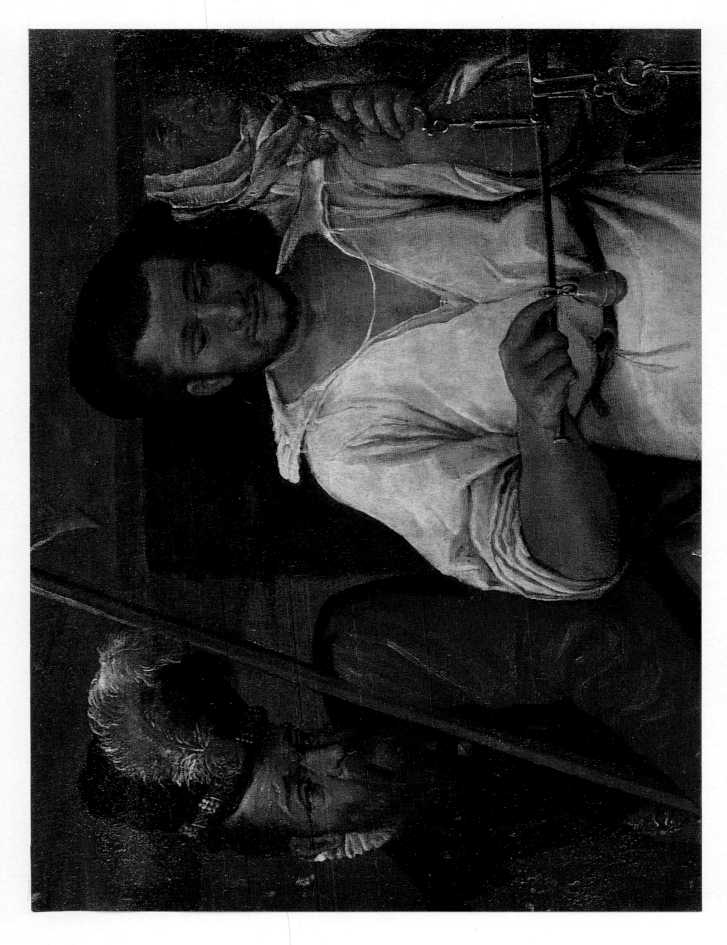

130. Detail from plate 129

131. Detail from plate 129

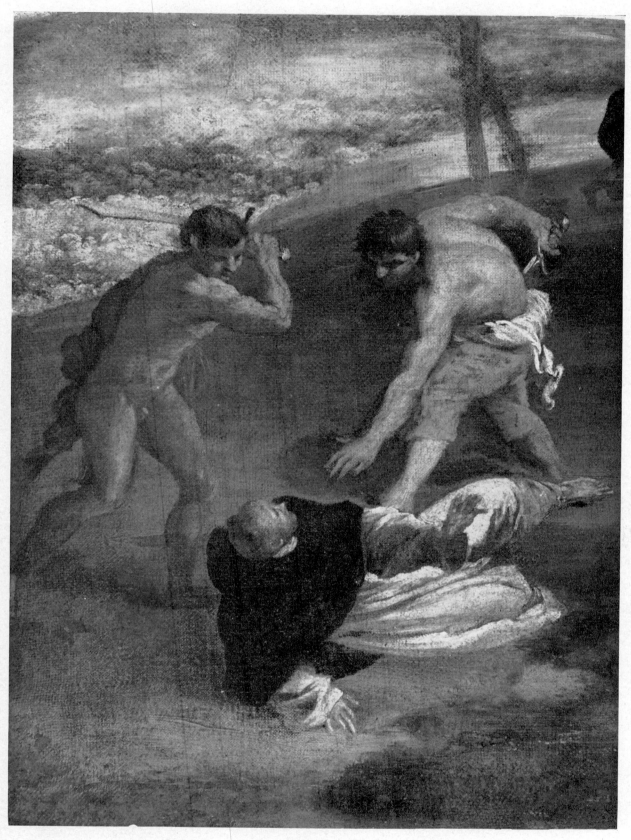

132. Detail from plate 133

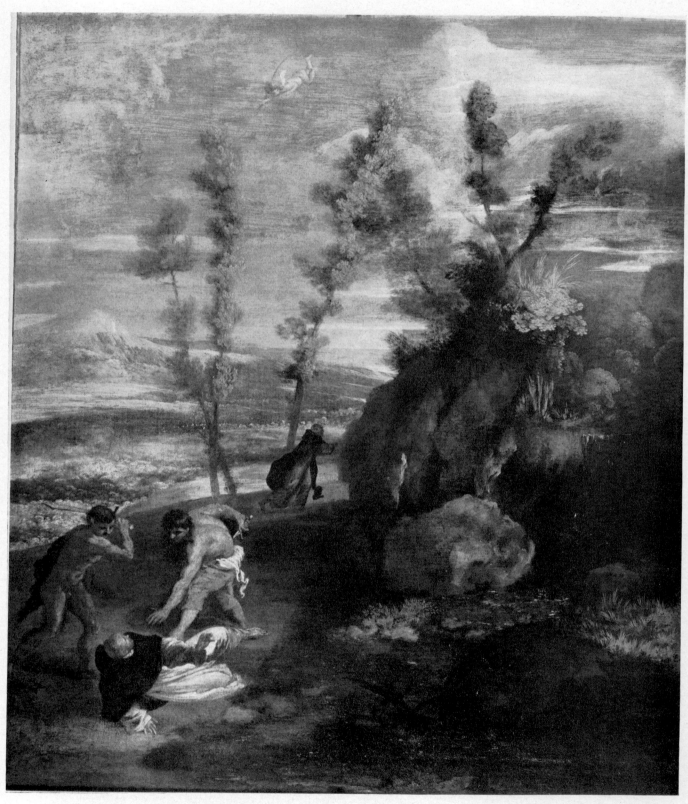

133. School of Annibale Carracci: *Landscape with the Death of St. Peter Martyr* (Cat. No. 187)

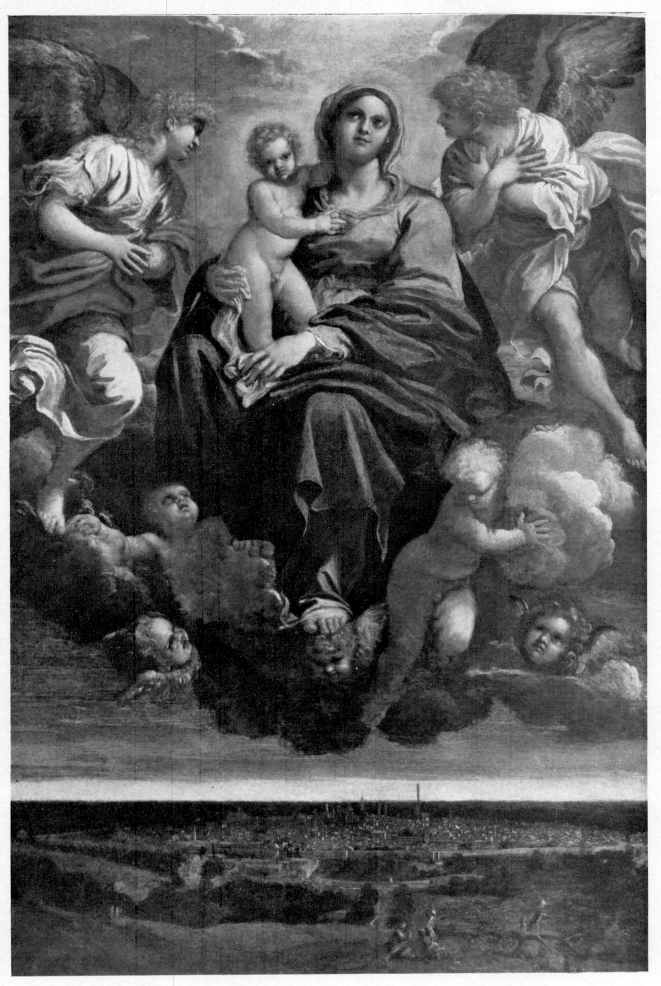

134. Annibale Carracci: *The Virgin and Child in the Clouds, with a View of Bologna* (Cat. No. 183)

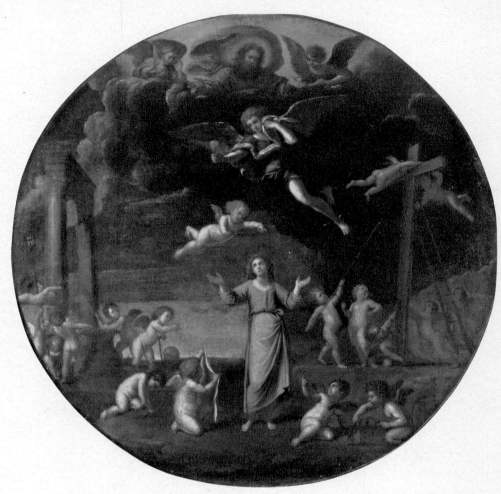

135. Francesco Albani: *Allegory of the Passion* (Cat. No. 195)

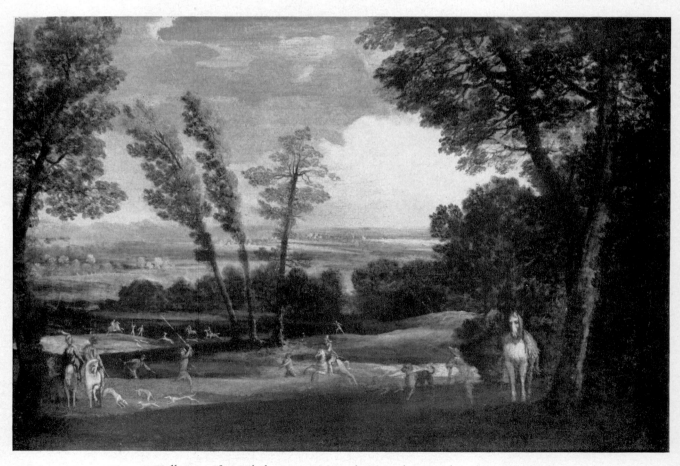

136. Follower of Annibale Carracci: *Landscape with a Stag-hunt* (Cat. No. 190)

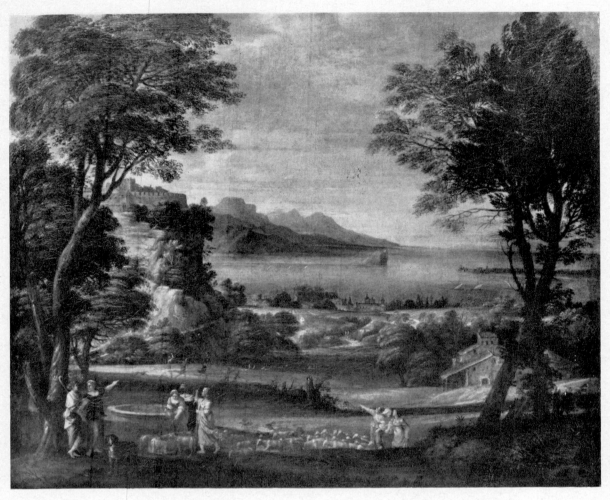

137. Domenichino: *Landscape with Moses delivering the Daughters of Raguel at the Well* (Cat. No. 196)
(Before restoration in 1967)

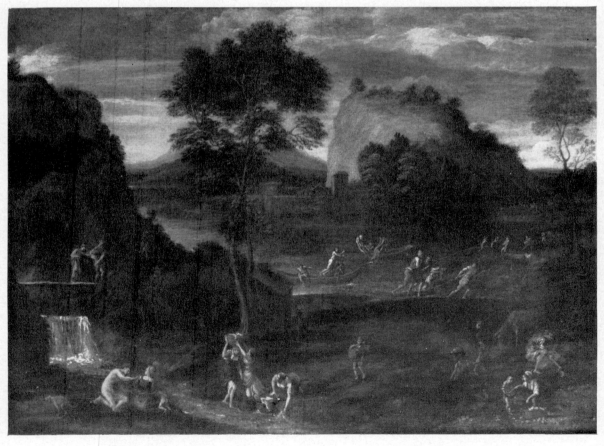

138. Domenichino: *River Landscape with Fishermen and Washerwomen* (Cat. No. 197)
(Before restoration in 1967)

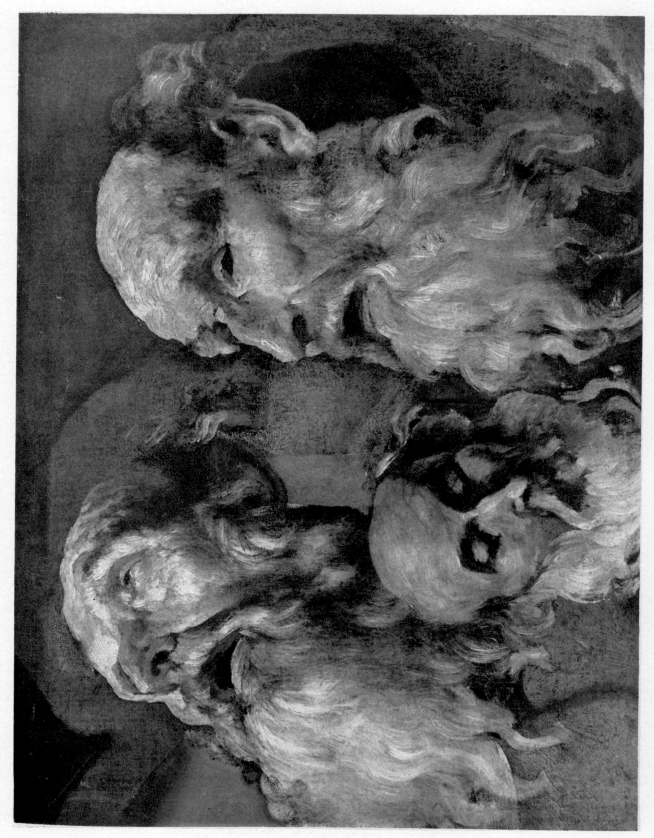

139. Attributed to Domenichino: *Three Studies of the Head of an old Man* (Cat. No. 198)

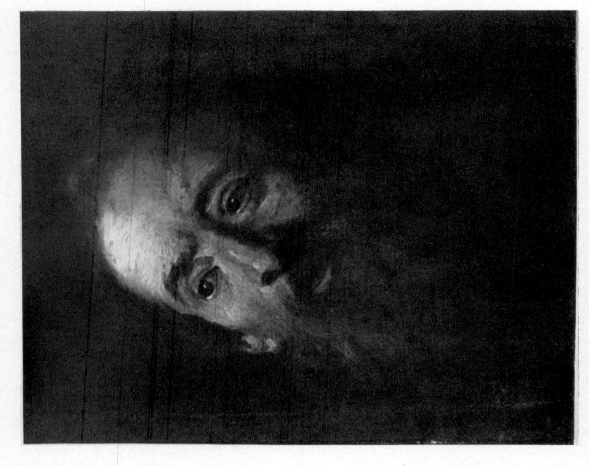

141. Lombard(?) School, XVII century: *Head of a bearded Man* (Cat. No. 212)

140. Guercino(?): *St. John the Baptist* (Cat. No. 206)

142. Marcantonio Franceschini: *Armida abandoned by Rinaldo* (Cat. No. 209)

GENOESE AND NEAPOLITAN PAINTERS

144. Luca Cambiaso: *David and Goliath* (Cat. No. 215)

143. Luca Cambiaso: *St. Christopher* (Cat. No. 214)

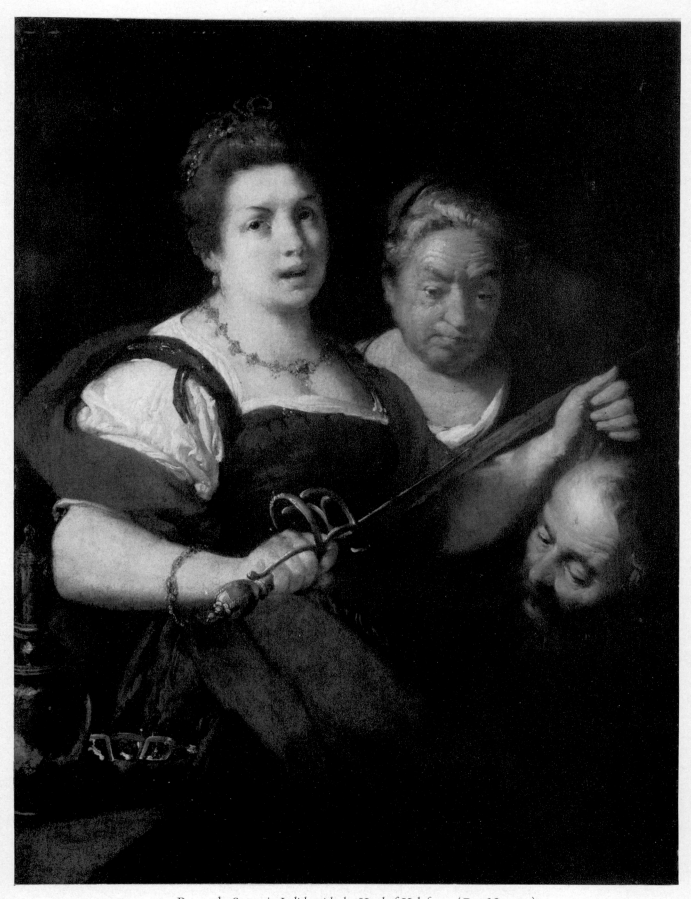

145. Bernardo Strozzi: *Judith with the Head of Holofernes* (Cat. No. 217)

146. Salvator Rosa: *A Hermit contemplating a Skull* (Cat. No. 220)

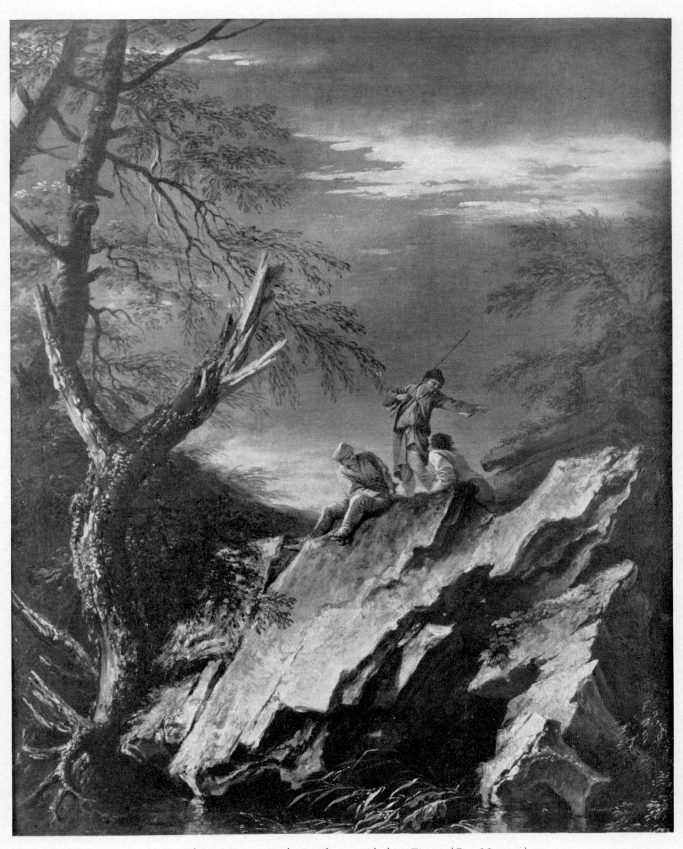

147. Salvator Rosa: *Rocky Landscape with three Figures* (Cat. No. 221)

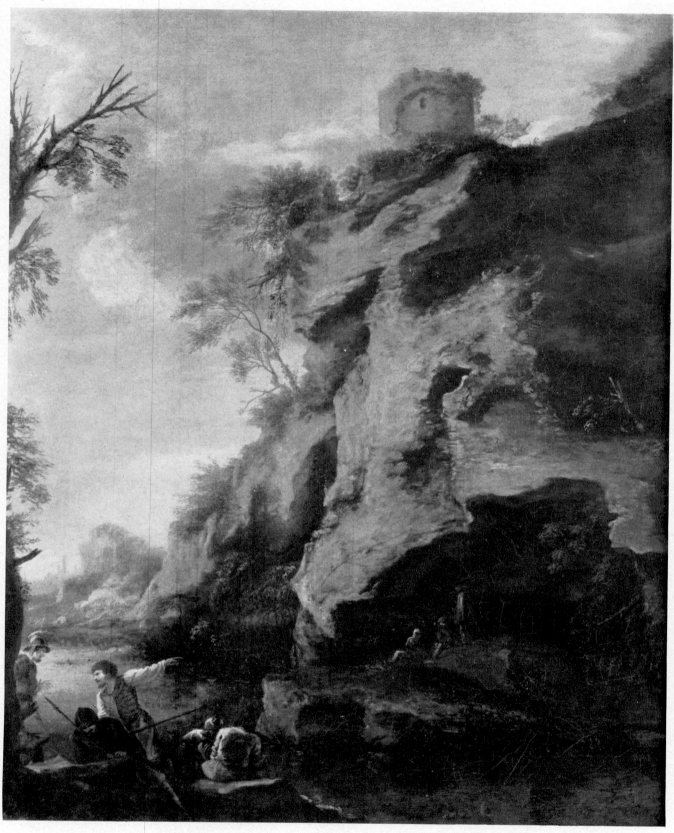

148. Salvator Rosa: *Rocky Coast, with Soldiers studying a Plan* (Cat. No. 222)

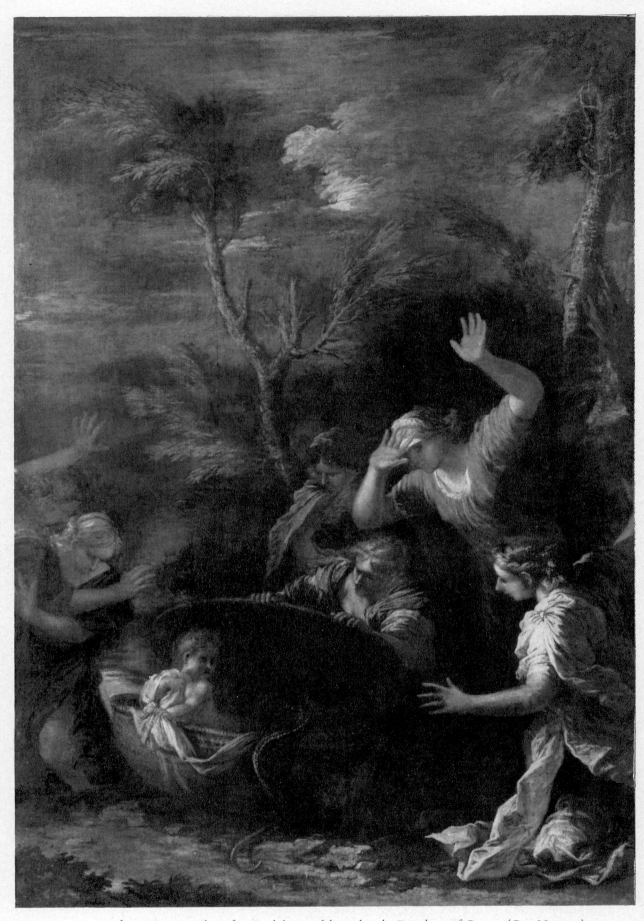

149. Salvator Rosa: *The Infant Erichthonius delivered to the Daughters of Cecrops* (Cat. No. 223)

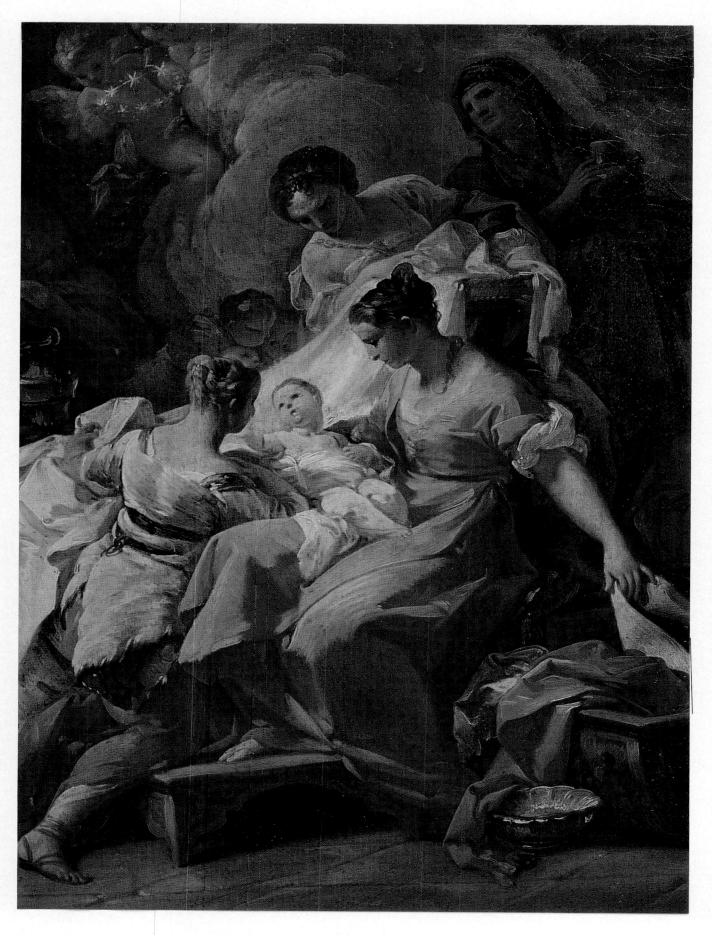

150. Detail from plate 151

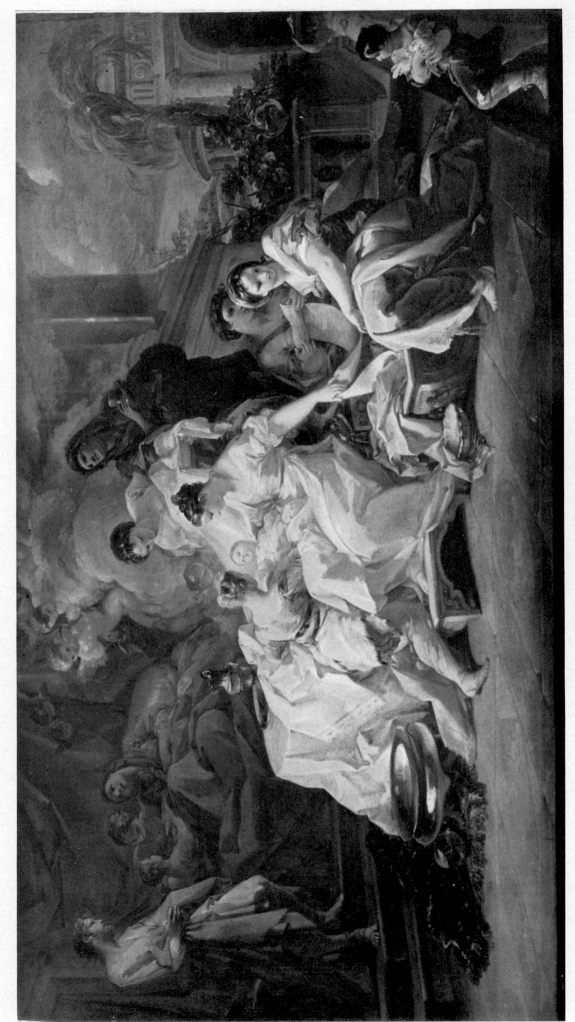

151. Corrado Giaquinto: *The Birth of the Virgin* (Cat. No. 229)

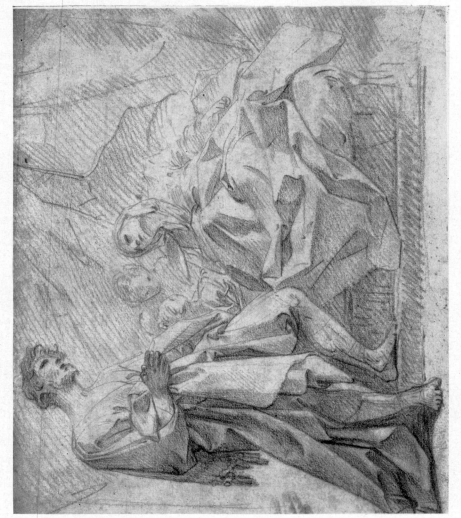

152a. Corrado Giaquinto: *St. Anne and St. Joachim.* Red chalk drawing. London, H.N. Squire Collection.

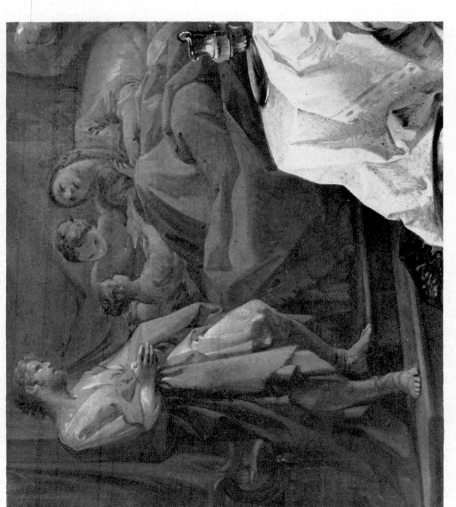

152. *St. Anne and St. Joachim.* Detail from plate 151

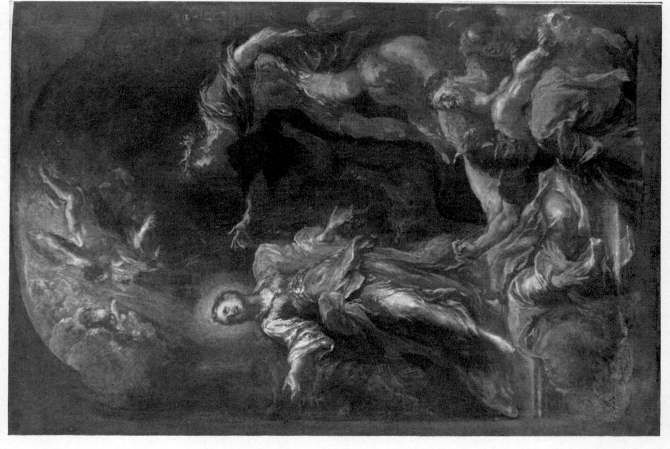

154. Giacomo del Pò: *St. Catherine(?) and other Victims before a Roman Emperor*
(Cat. No. 228)

153. Giacomo del Pò: *St. Catherine refusing to sacrifice to an Idol*
(Cat. No. 227)

NETHERLANDISH, GERMAN AND ENGLISH PAINTERS

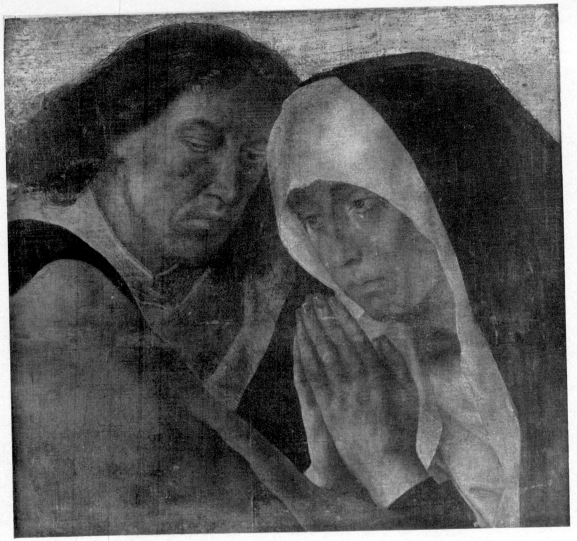

155. Hugo van der Goes: *Fragment of the Lamentation for Christ* (Cat. No. 231)

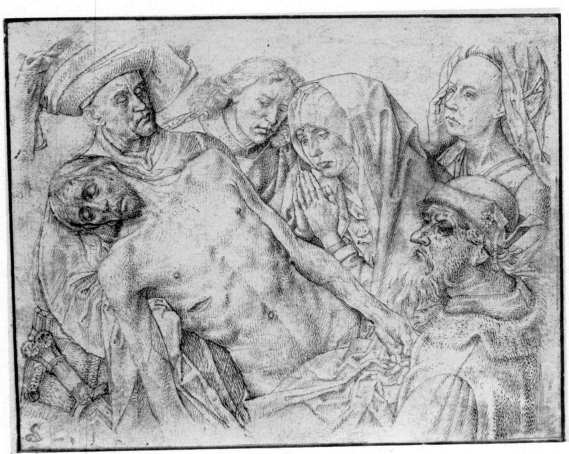

155a. *The Lamentation for Christ.* Pen drawing. Vienna, Albertina.

158. Dutch School, c.1520: *A Father and two Sons praying* (Cat. No. 233)

159. Netherlandish School, c.1540: *Portrait of a Man* (Cat. No. 234)

160. German School, c.1520–1530: *Portrait of a young Man*
(Cat. No. 256)

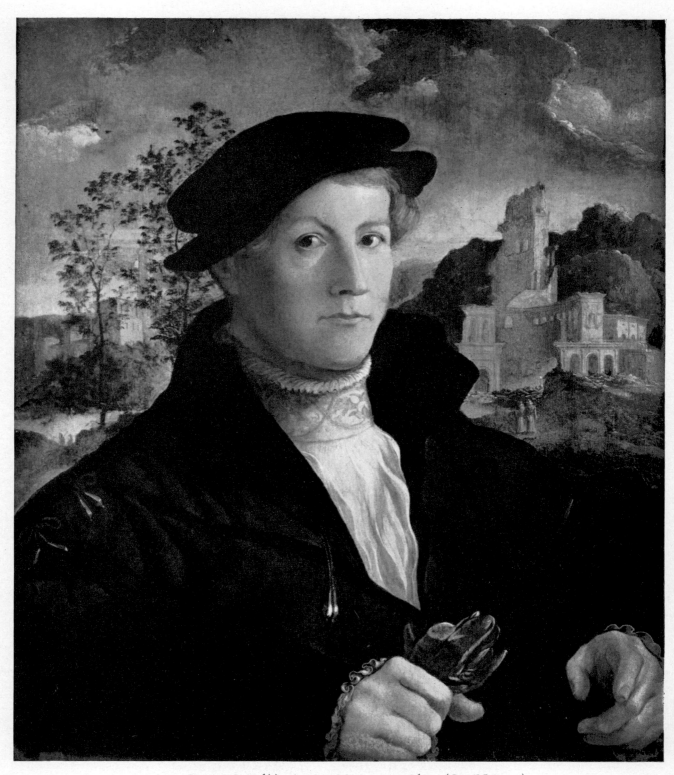

161. Jan van Scorel(?): *A young Man carrying Gloves* (Cat. No. 235)

162. Jan van Scorel(?): *A young Man gesticulating* (Cat. No. 236)

163. Attributed to Cornelis van Cleve: *The Adoration of the Shepherds* (Cat. No. 239)

164. Attributed to Bartolomeus Spranger: *Faith, Hope and Charity*
(Cat. No. 240)

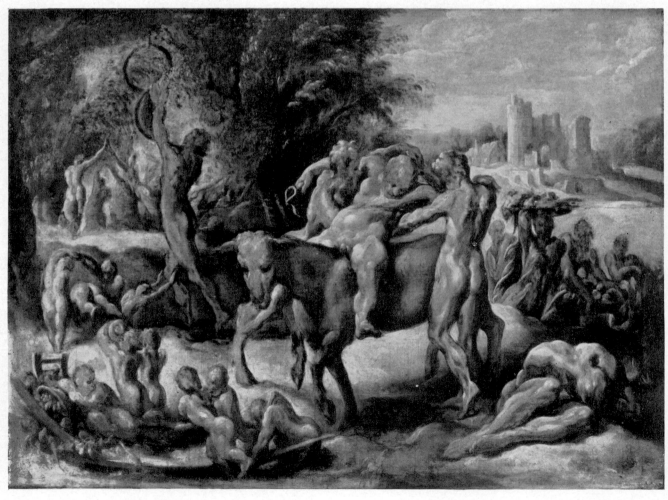

165. Netherlandish School, late XVI century: *The Triumph of Silenus* (Cat. No. 241)

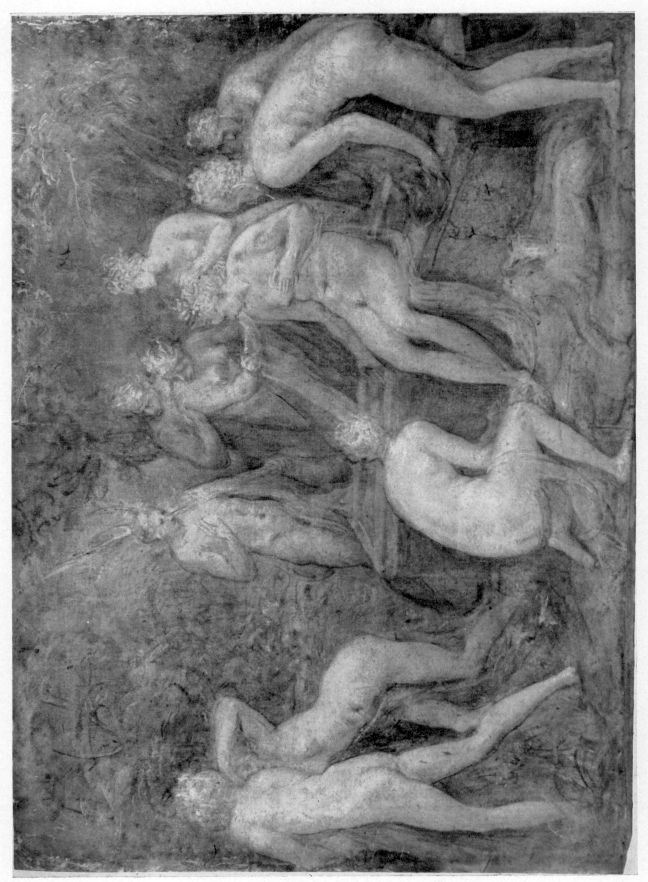

166. Frans Floris: *Diana and Actaeon* (Cat. No. 238)

167. Netherlandish School, c.1580–1600: *A Panorama of Venice from the Lagoon* (Cat. No. 242)

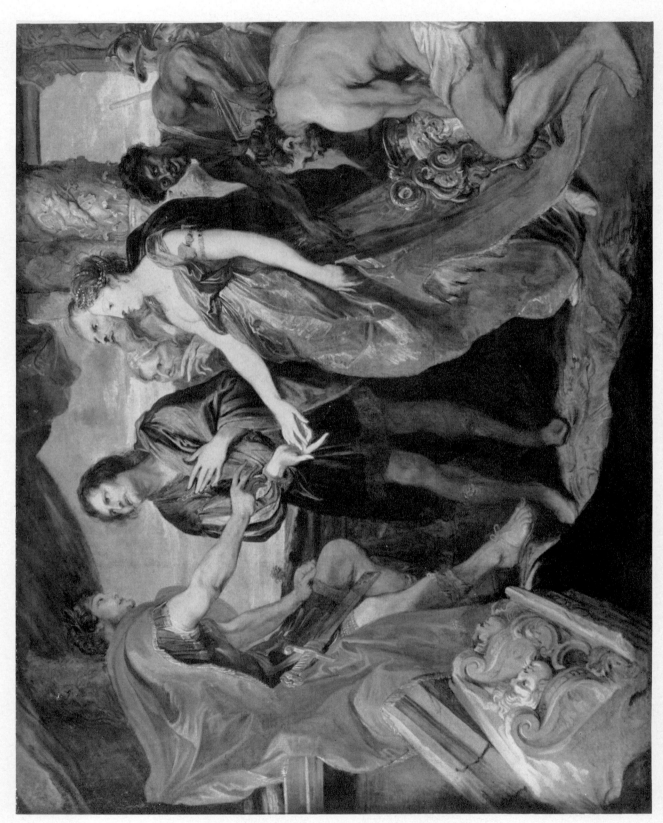

168. Van Dyck: *The Continence of Scipio* (Cat. No. 245)

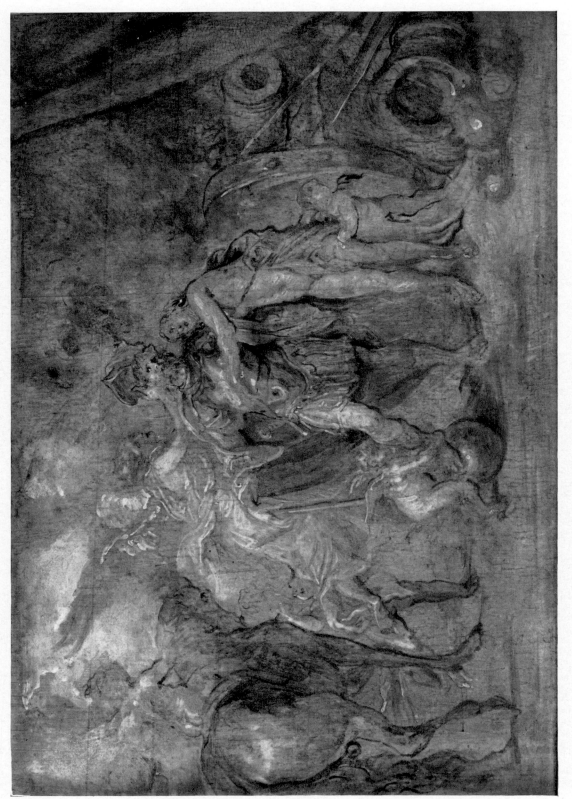

169. Van Dyck: *Mars going to War* (Cat. No. 248)

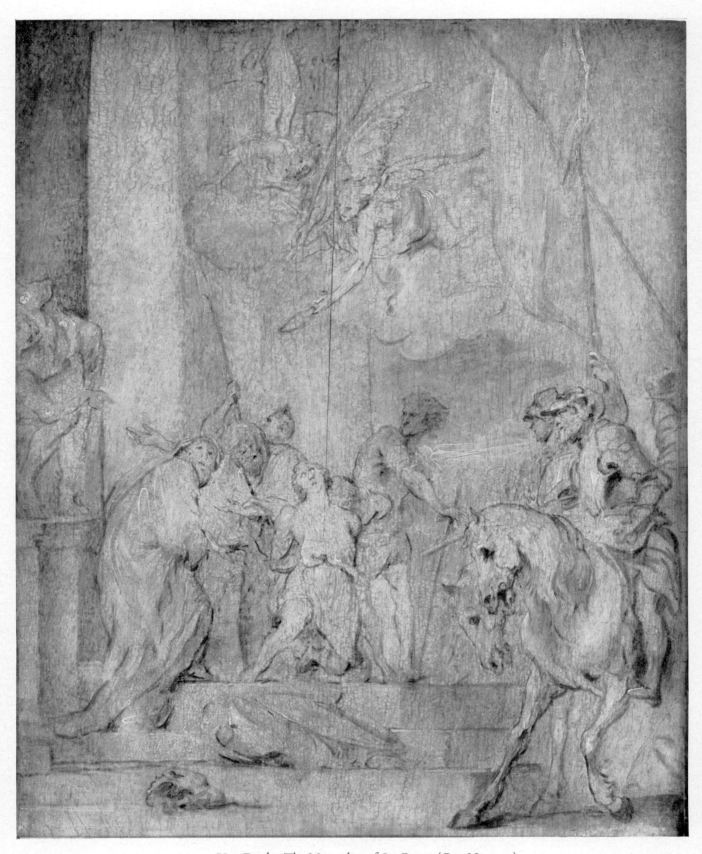

170. Van Dyck: *The Martyrdom of St. George* (Cat. No. 247)

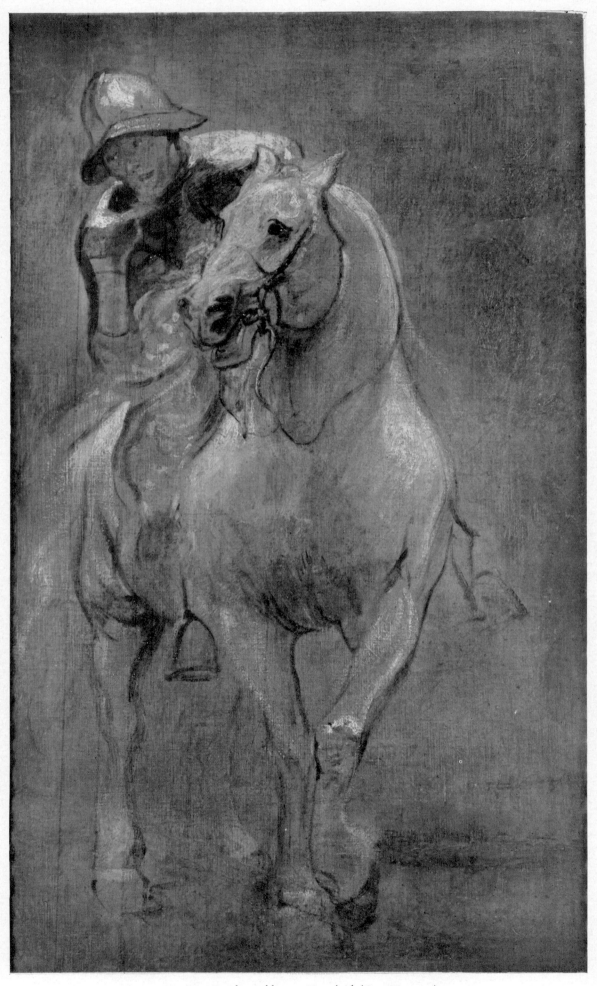

171. Van Dyck: *Soldier on Horseback* (Cat. No. 246)

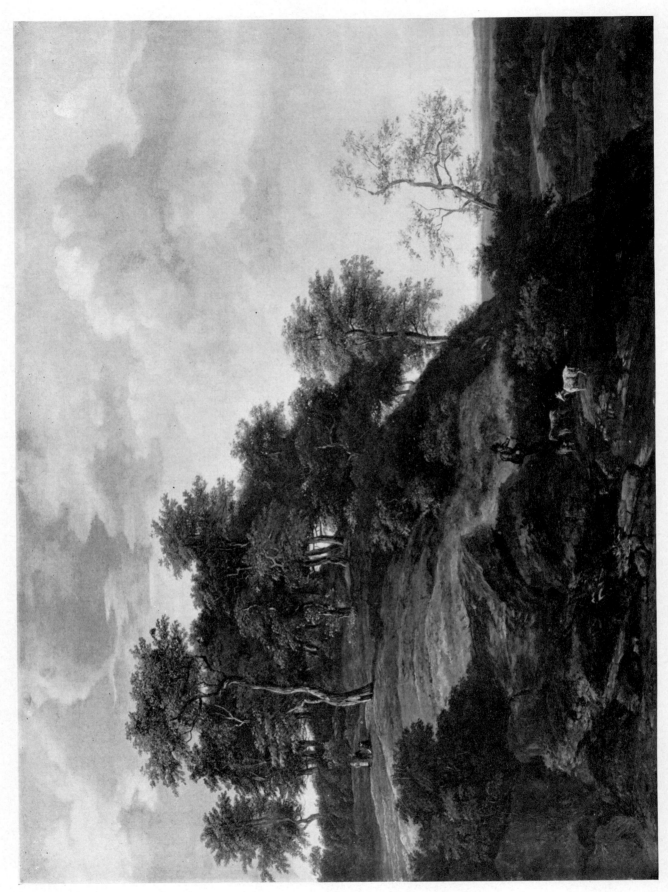

172. Jan Vermeer of Haarlem: *Landscape with a Herdsman on a wooded Hill* (Cat. No. 253)

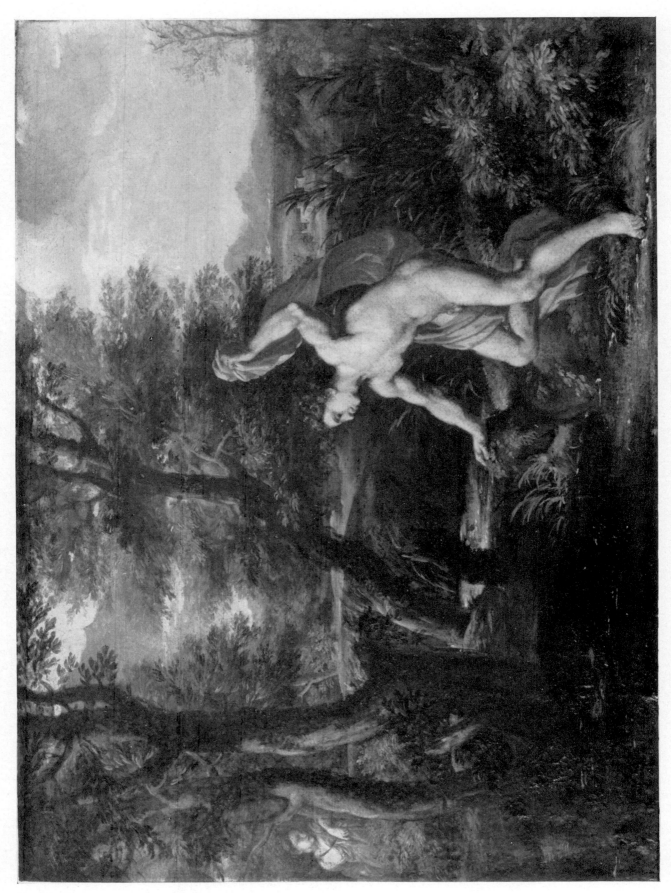

173. Frans de Neve: *Echo and Narcissus* (Cat. No. 252)

174. South German School, 1520-1530: *Man holding a Book* (Cat. No. 257)

175. John Riley: *A Scullion of Christ Church* (Cat. No. 263)

176. Sir Joshua Reynolds: *Portrait of General John Guise* (Cat. No. 264)

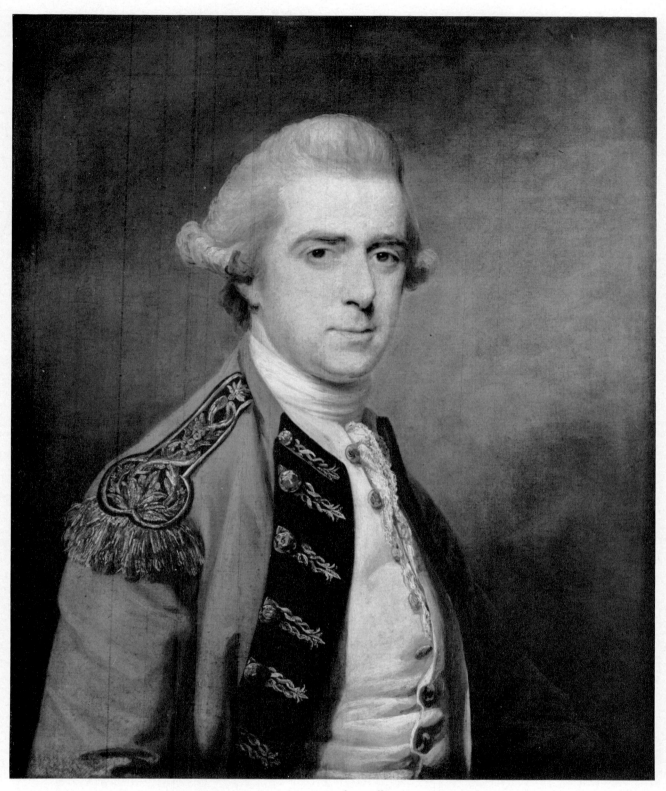

177. Francis Cotes: *Portrait of an Officer* (Cat. No. 265)

178. John Russell: *Colonel James Capper and his Daughter* (Cat. No. 266)

INDEX OF WORKS OF ART
AND
INDEX OF PAINTERS

U

INDEX OF WORKS OF ART

OTHER THAN THOSE CATALOGUED

INDEX OF PAINTERS

The numbers refer to the Catalogue entries. Numbers in bold type refer to paintings in the Christ Church Collection, catalogued as by the artist, attributed to him, from his studio, or copies.